Museums and Communities

Museums and Communities
Curators, Collections, and Collaboration

Edited by
Viv Golding and Wayne Modest

B L O O M S B U R Y
LONDON • NEW DELHI • NEW YORK • SYDNEY

Bloomsbury Academic
An imprint of Bloomsbury Publishing Plc

50 Bedford Square	175 Fifth Avenue
London	New York
WC1B 3DP	NY 10010
UK	USA

www.bloomsbury.com

First published 2013

British Library Cataloguing-in-Publication Data
A catalogue record for this book is available from the British Library.

ISBN: HB: 978-0-8578-5130-7
 PB: 978-0-8578-5131-4

Library of Congress Cataloging-in-Publication Data
Museums and communities : curators, collections and collaboration / edited by
Viv Golding and Wayne Modest.
pages cm
Includes bibliographical references and index.
ISBN 978-0-85785-130-7 — ISBN 978-0-85785-131-4 —
ISBN 978-0-85785-132-1 — ISBN 978-0-85785-133-8 1. Museums—Social
aspects. 2. Community life. 3. Museum curators. 4. Museums—Collection
management. 5. Cooperation. I. Golding, Vivien. II. Modest, Wayne.
AM7.M8811 2013
069—dc23 2012042523

Typeset by Apex CoVantage, LLC, Madison, WI, USA.
Printed and bound in Great Britain

Contents

PART III: AUDIENCES AND DIVERSITY

List of Illustrations

Figures

Plates

Contributors

Åshild Andrea Brekke is a senior advisor at the Arts Council Norway. She is an anthropologist who joined the Norwegian Museum, Library and Archive (MLA) Authority in 2007, where she has worked on a number of innovative projects, including digital storytelling; sensitive and contested topics; participatory and inclusive methods; and partnerships with correctional services and Alzheimer's patients.

Elizabeth Carnegie is the director of the MSc in Creative and Cultural Industries at the Management School, University of Sheffield. She holds a PhD in representation and has experience curating at Glasgow museums, including the St Mungo Museum of Religious Life and Art, and the People's Palace. Her current research examines the role of contemporary faith in society and the shaping of cultural and religious identities within diasporic communities. She is a member of the editorial board of the *International Journal of Heritage and Sustainable Development.* Her most recent publication is "Museums in Society or Society as a Museum? Museums, Culture and Consumption in the (Post) Modern World," in *Parcelling the Past: Selling Heritage in the Modern World, New Directions in Arts Marketing* (Taylor & Francis, 2010).

Karen Exell is an Egyptologist who holds a PhD in Egyptology. She is currently a lecturer in museum studies at University College London, Qatar, Doha. At the time of writing and throughout the consultation process described, she was the curator for Egypt and Sudan at The Manchester Museum, University of Manchester, UK. She has recently published an edited volume, *Egypt in its African Context. Proceedings of the Conference held at The Manchester Museum, University of Manchester, October 2009* (Archaeopress, 2011).

Kalliopi Fouseki gained a PhD in archaeology before conducting Arts and Humanities Research Council-funded research into museum visitors during the 2007 Bicentenary of the Abolition Act and subsequently at the Science Museum London. She is currently teaching at the University College London, Centre for Sustainable Heritage, Bartlett School of Graduate Studies. Her most recent publication is "Community Voices, Curatorial Choices: Community Consultation for the 1807 Exhibitions" (*Museum and Society* 8.3, 2010).

Petrina Foti is a PhD candidate in the School of Museum Studies at the University of Leicester. Her research focuses on how the rise of digital information has affected

material culture and what that means for both museums and the wider world. She is specifically interested in how the museums of the Smithsonian have collected and curated computer-based technology. She has held various museum positions, including a post from 2006 to 2011 in the Computers Collections at the National Museum of American History.

Eric Gable, PhD, is a professor of anthropology at the University of Mary Washington. His research interests are in village-level politics and religion in Guinea-Bissau and Sulawesi, Indonesia, and the politics of heritage in the United States. He is the author of *Anthropology and Egalitarianism* (Indiana University Press, 2010) and (with Richard Handler) *The New History in an Old Museum* (Duke University Press, 1997). He is currently a managing editor for *Museums and Society* and book reviews editor for *American Ethnologist.*

Viv Golding holds a PhD in museum studies. She is the director of research students and a senior lecturer in the School of Museum Studies, University of Leicester. Previously, she managed formal education provision at the Horniman Museum and further education art courses in London. Her research interests center on diversity, and her most recent publication is *Learning at the Museum Frontiers: Identity Race and Power* (Ashgate, 2009). Her current projects include two Arts and Humanities Research Council-funded projects, "Behind the Looking Glass 'Other' cultures within Translating Cultures" (2011–13) and "Mapping Faith and Place in Leicester" (2011–12); a Daiwa-funded project, "Museum Literacy" (2010–12); and a Japan Society for the Promotion of Science project "Museum and University Collaboration" (2012–13).

Helen Graham, PhD, worked on the Arts and Humanities Research Council-funded project "Northern Spirit: 300 years of art in the North East"—a permanent display at the Laing Art Gallery in Newcastle—with Rhiannon Mason and Christopher Whitehead. She is currently University Research Fellow in Tangible and Intangible Heritage and Director, Centre for Critical Studies of Museums, Galleries and Heritage at the University of Leads. Coming from a background working in museum learning, access and community engagement. Her recent research focuses on specific practices of access, inclusion and collaboration as a way of exploring the shifting public and democratic grounds of museums and "heritage."

Sally Hughes holds a PhD in museum studies from the University of Leicester. Her research centers on publication in museums that address issues of scholarship and power in the contemporary world. She is a principal lecturer at Oxford Brookes University, where she is responsible for the MA publishing program.

Mary Hutchison, PhD, is a visiting fellow at the Humanities Research Centre at the Research School of Humanities and the Arts and a research associate of the Institute of

Professional Practice in Heritage and the Arts. Her research projects include an Australian Research Council Linkage project with the National Museum of Australia, Migration Memories (2005–2008). She has worked professionally as a museum exhibition curator, oral historian, creator of interpretive public art, heritage researcher, adult educator, writer (including radio and theater), and community arts worker. Her most recent publication, co-authored with L. Collins, is "Translations: Experiments in Dialogic Representation of Cultural Diversity in Three Museum Sound Installations" (*Museum and Society* 7.2, 2009).

Serena Iervolino is a doctoral candidate in the School of Museum Studies at the University of Leicester, where she currently works as a learning and student support officer. Her research explores processes of change that ethnographic museums are undergoing in an attempt to redefine their place and role in postcolonial Europe. Her publications include (with R. Sandell) "The World in One City: The Tropenmuseum, Amsterdam," in *Curatorial Dreams: Critics Imagine Exhibitions* (Duke University Press, forthcoming).

Kirstin James is a PhD candidate in the School of Museum Studies at the University of Leicester. Taking inspiration from the Maussian concept of "gift exchange," her research explores how curatorial practice mediates an intensely visceral, narrative experience of objects-of-agency in display, potentially creating a healing environment where, through shared witnessing, broken narratives are mended and life is celebrated.

Rhiannon Mason has a PhD in critical and cultural theory and is a senior lecturer in museum, gallery, and heritage studies at the International Centre for Cultural and Heritage Studies, Newcastle University. She is the author of many publications in the field of national museums, heritage, and new museology, including *Museums, Nations, Identities: Wales and its National Museums* (University of Wales Press, 2007). She is currently working on an Arts and Humanities Research Council-funded project, "Northern Spirit: 300 Years of Art in the North East"—a permanent display at the Laing Art Gallery in Newcastle.

Wayne Modest has a PhD in cultural studies and is currently the head of the curatorial department at the Tropenmuseum in Amsterdam, the Netherlands. Previously, he was the keeper of anthropology at the Horniman Museum. He was also the director of the Museums of History and Ethnography at the Institute of Jamaica, where he curated exhibitions, including "Of Things Sacred" and "Materialising Slavery," which included an installation by internationally renowned American artist Fred Wilson. His research interests revolve around the material anthropology of urban life and material cultures of the Caribbean and critical museology. His most recent publication is "Slavery and the (Symbolic) Politics of Memory in Jamaica: Rethinking the Bicentenary," in *Representing Enslavement and Abolition in Museums: Ambiguous Engagements* (Routledge, 2011).

Bryony Onciul is a lecturer in history at Exeter University, Cornwall. She received her PhD in 2011 following extensive fieldwork with indigenous Blackfoot First Nations communities in Alberta, Canada, and she is now completing a book on this theme. She has also lectured in museum, gallery, and heritage studies at the International Centre for Cultural and Heritage Studies, Newcastle University, where she completed her PhD research.

Susan Pearce is Professor Emerita at the School of Museum Studies and former pro-vice chancellor at University of Leicester, and a former president of the Museums Association. She has published extensively on museum objects, ethnography and curatorship, collections, collecting material culture, and the archaeology of southwest Britain. Her seminal texts include *On Collecting: An Investigation into Collecting in the European Tradition* (Routledge, 1995).

Laurajane Smith has a PhD in heritage studies. She is a faculty member of the School of Archaeology and Anthropology at the Australian National University. Her research interests are in the field of heritage and museum studies. She is the author of numerous books, including *Uses of Heritage* (Routledge, 2006), and the editor, with Natsuko Akagawa, of *Intangible Heritage* (Routledge, 2009). Her current research project, Cultural Heritage and the Mediation of Identity, Memory and Historical Narratives, is funded by an Australian Research Council Future Fellowship. She is editor of the International Journal of Heritage Studies.

Brad Taylor holds a PhD in information studies. He is the associate director of the museum studies program at the University of Michigan, where he teaches in graduate, undergraduate, and public programs. His research interests include the innovative application of technology and its effect on the museum experience, and the evolving role of the museum in society. His most recent publication is "Reconsidering digital surrogates: towards a viewer-oriented model of the gallery experience," in *Museum Materialities: Objects, Engagement, Interpretation* (Routledge, 2009).

Hazel Tucker is an associate professor in the tourism department at the University of Otago. She is a social anthropologist whose PhD dissertation was an ethnographic study of tourism and social change in Göreme, a cultural tourism destination and World Heritage Site in central Turkey. Her research explores issues concerning tourism representations, identity, and sustainability. She is the author of *Living with Tourism: Negotiating Identity in a Turkish Village* (Routledge, 2003) and co-editor (with Paul Lynch and Alison McIntosh) of *Commercial Homes in Tourism* (Routledge, 2009).

Marzia Varutti is an honorary visiting fellow at the School of Museum Studies, University of Leicester. She received her PhD in anthropology for fieldwork in China, where she has conducted research on the museum representation of the nation. She has also conducted research in Norwegian museums on cultural difference and the politics of

display. She is currently conducting British Academy-funded research into the representation of indigenous groups in Taiwan. Her most recent publication is "The aesthetics and narratives of national museums in China," in *National Museums* (Routledge, 2010).

Christopher Whitehead has a PhD in art history and is currently a senior lecturer in museum, gallery, and heritage studies at the International Centre for Cultural and Heritage Studies, Newcastle University. He is the author of *Museums and the Construction of Disciplines: Art, and Archaeology in Nineteenth Century Britain* (Duckworth, 2009). He is currently working on an Arts and Humanities Research Council-funded project "Northern Spirit: 300 Years of Art in the North East"—a permanent display at the Laing Art Gallery in Newcastle.

Andrea Witcomb holds a PhD in media and communication studies. She is currently an associate professor at the Research Institute for Citizenship and Globalisation, Deakin University, Melbourne, Australia. Her recent research is funded by the Australian Research Council and aims to investigate museums and affect. She has published widely on museums and heritage and is the author of *Re-Imagining the Museum: Beyond the Mausoleum* (Routledge, 2003). Her latest book, co-written with Dr. Kate Gregory, is *From the Barracks to the Burrup: The National Trust in Western Australia* (University of NSW Press, 2010).

Elizabeth Wood has a PhD in education. She is an assistant professor with joint appointments in the museum studies program, Indiana University-Purdue University, School of Liberal Arts and Urban Education, and IU School of Education. In addition she serves as the public scholar of museums, families, and learning in a joint appointment at The Children's Museum of Indianapolis. Her research interests include object-based learning, informal learning in community settings, and critical museum pedagogies. Her recent publications include "The Meaning and Matter of Childhood through Objects," in *Unsettling the Past: Technologies of Memory in the Arts* (Palgrave, 2009).

Acknowledgments

Museums and Communities: Curators, Collections, and Collaboration has grown out of a number of important collaborations, most notably between the Horniman Museum in London and the School of Museum Studies at the University of Leicester. A number of chapters included in this volume were first presented and discussed at an international conference co-organised by both institutions in November 2009 and generously hosted by the Horniman. We would like to thank our numerous colleagues and students in both the museum and the university for their contributions at the conference and for their ongoing commitment to developing collaborative practices in and between museums and universities. Additionally, we want to thank our families and the good friends who are too numerous to name here but who have provided much needed support during the completion of this book.

Foremost among colleagues, Viv must mention Professor Richard Sandell at the University of Leicester's School of Museum Studies, whose comments on this work have been especially insightful. Viv also acknowledges the critical friendships and the challenging and illuminating conversations over the years of writing with several project partners. Notable in the United Kingdom is Professor Joan Anim-Addo (Goldsmiths College) and our colleagues in the AHRC-funded "Translating Cultures" network, as well as Dr. Ruth Young (University of Leicester) and colleagues in the AHRC-funded "Care for the Future" network. In Japan, Viv especially thanks her colleagues: Dr. Yoshikazu Ogawa and Reiji Takayasu (National Museum of Nature and Science), Dr. Hiroshi Kurushima (National Museum of Japanese History), Dr. Makoto Suzuki (Aoyama Gakuin), and Dr. Kunio Yajima (Meiji University), who completed an inspirational "museum literacy" project funded by the Daiwa Foundation and are now working on a Japan Society for the Promotion of Science project exploring the potential for collaboration between museums and universities in Japan.

Wayne would like to especially thank colleagues at the Horniman Museum, including Finbarr Whooley, Dr. Fiona Kerlogue, and all of the Stories of the World team. He is especially indebted to the "young curators," whose enthusiasm and critical, fresh perspectives about working with museums were important for raising a number of issues with which this volume engages. Ongoing discussions with colleagues such as Dr. Stefanie Lotter (former community curator at the Horniman) and Paul Halliday (Goldsmiths College) were especially important. Their critical insights and deep commitment to academic rigor and the principles of co-curation ensured the high quality of the youth engagement project. Wayne would also like to thank his colleagues at the Tropenmuseum who contributed to the sharpening of perspectives.

Together as editors we would like to thank the contributors to this volume, all of whom are committed to evolving new and innovative perspectives for museum practices in the twenty-first century. We would like to thank Sally Hughes for her help with picture editing. Finally, we would like to thank the editorial team at Bloomsbury for their support and for making this publication possible. Together we commend this publication to our readers and hope that it will contribute toward the ongoing and necessary shifts for the development of more collaborative paradigms and more democratic museum practices.

Introduction

Viv Golding and Wayne Modest

This international volume explores contemporary developments within museums that move beyond narrow, dualistic conceptions of curatorial practice versus community, marking current movements toward new collaborative paradigms within museums and at their frontiers (Golding 2009; Philips 2003). *Museums and Communities* unpacks notions often taken for granted, such as scholarly knowledge, community participation, and collaboration, terms commonly used in contemporary museum theory and practice that can gloss over the complexity of community identities, limit the ways in which curatorial practice (and the curator) is defined, and lead to tokenistic claims of inclusion by museums. Over sixteen chapters divided into three sections, we examine what, more precisely, is meant by these key terms and concepts and point toward new models of practice for working successfully with communities.

Each section addresses the essentially philosophico-political issues related to power and control between museums and their different communities, which is a major aspect of the contemporary museum (Genoways 2006; Karp, Kreamer, and Lavine 1991). Individual authors argue for risk taking; providing examples, they contend that contestation and controversy—if imaginatively, respectfully, and sensitively addressed in the museum with reference to wider concerns of equality, human rights, and social justice—may offer a potent means of building bridges and even overcoming divisions among disparate groups (Karp, Krantz, Szwaja, and Ybarra-Frausto 2006; Luke 2006). Each chapter demonstrates how the social role of the museum can be realized by working with discerning museum communities that are increasingly demanding fuller collaborative and polyvocal practices from their museums.

Such social work by museums must involve radical turns—more than mere consultation and inclusion of diverse perspectives. One such radical turn is already echoed in shifting terminology from education to learning in UK museums that denotes a concerted movement to locate diverse audiences at the heart of the museum. Becoming more audience-centered in the twenty-first century, museums are reexamining themselves in relation to community expectations of multi-sensory, educational, *and* entertaining experiences; strengthening learning teams; and improving the quality, range, and number of programs.

These shifts have included the sharing of curatorial authority with younger people such as art students and with marginalized groups, good examples of which can be seen

with Raw Canvas at Tate Modern and prisoners with the Throne of Weapons at the British Museum (Samuels 2008; Tate Modern 2012). Moreover, creative initiatives with artist-curators working from within the museum increasingly attempt to answer communities' calls for embedding collaboration into practice (Macdonald and Basu 2007). While such fruitful strategies have pushed museums to be more responsive and engaged, facilitating active dialogue on difficult contested histories that contribute to the promotion of a more just and humane society, the impact of these changes on curatorial practice is little explored (Macdonald 2009; Sandell 2007).

This book is an attempt to fill this gap in scholarship. In taking up the sometimes simplistic curator/community engagement dichotomy, the chapters compiled here also seek to push beyond other limiting *either/or* dualistic frameworks and social categories (good/white/Christian versus bad/black/Muslim), which we see as having a stubborn and often detrimental persistence in the modern world. We want to push toward more liberating *both/and* conceptions. In this way, the authors address a series of questions we believe are vital to advancing democracy, citizenship, and universal human rights, using the museum as a fulcrum around which such questions can be answered. How, if at all, can community perspectives and diverse new voices be integrated into curatorial practice in substantive ways, thus facilitating more democratic curatorship practices? What role can today's curator play in such integrated practices? How can new media and other technological innovations contribute to more genuinely inclusive engagement in museums? How can museums promote genuine intercultural understanding in place of fearful stereotypes? To address these questions, *Museums and Communities* brings together chapters by international scholars and practitioners from a wide disciplinary base, including anthropology, cultural studies, education, history, art practice, and visitor studies.

The book is organized around three major strands that logically divide the book into three sections. These chapters are followed by an afterword that features a discussion by Professor Susan Pearce. Part I, "Community Matters" considers co-curating and new dialogues with (source) communities; Part II, "Sharing Authority" looks at ways of representing the contested past/present/future; and Part III, "Audiences and Diversity" reflects on critical curatorial approaches to engagement and evaluation, including the perspectives of new audiences.

Authors offer different perspectives from a wide geographical range, covering diverse communities and different collaborative practices within the museum. In Part I, authors reflect on curatorial practice in relation to a broad range of communities, including American Indian and Japanese American communities, putting African American community histories into museums, and the community art practices of Tyree Guyton (Golding in Washington and Los Angeles, Gable in Virginia, and Taylor in Detroit); indigenous communities are considered (in Taiwan by Varutti and southeast Alberta, Canada by Onciul), as are teen-aged communities (in London by Modest). Authors contributing to Part II discuss the politics of display with Romani communities (Brekke in Norway), migrant communities (Iervolino in Italy and Hutchinson in Australia), specialist and nonspecialist communities of knowledge on ancient Egypt (Exell in Manchester), and the redisplay of art in the northeast of England (Mason, Whitehead, and Graham in Newcastle).

Together these two sections not only explore a wide range of collaborative practices, but also take a critical stance to the way museums have used community in recent years. In Part III, authors turn to audience experiences: youth communities and graffiti art (Golding in Leicester and Bristol), families and antiracist work in the United States (Wood in Indianapolis), enslavement during bicentenary exhibitions of the Abolition Act (Fouseki and Smith in England), tourists and locals at a world heritage site in Göreme, Turkey (Carnegie and Tucker), and affect at a Holocaust museum (Witcomb in Melbourne).

The chapters' authors reflect on past scholarly works on museums and communities, critically interrogating the multiple ways in which the relationship between museums and their communities have been theorized in recent decades, with special attention paid to curatorial practice. In this way *Museums and Communities* builds on earlier innovative scholarly work such as that of Peers and Brown, *Museums and Source Communities* (2004), addressing what is lost as well as what is gained—pointing to resonances and dissonances, successes and failures—in recent application of theory to practice. In outlining a range of critical pedagogies and presenting important case studies, this volume challenges us to move beyond shallow notions that both elide the complexity of community identities and make simplistic claims to engagement by museums.

One of the main contributions of the book lies in its focus on curatorial practice. This includes innovative artist and community collaborations that further push the authoritative turn from a textual focus toward diverse means of promoting a wider public engagement in responsible ways. We explore best practice examples in detail to highlight how these provide a better model of community collaboration, without abnegating curatorial responsibility and expertise, which may be seen as an inherent danger in the turns from objects and text toward audiences, and the recent attention to sensory knowledge and intangible heritage (Dudley 2009; Hooper-Greenhill 1994).

The book argues that museums should work collaboratively with communities—in non-tokenistic ways that bestow equal respect—on a platform to safeguard the fundamental ethical values surrounding international human rights. For example, strong challenges may be made to racist and sexist community views if curators' ethical voices can be raised, using evidence from the material world and the intangible heritage from which it emerges to justify more nuanced positions. Such collaborative work, as chapter authors show, requires risk and creativity. Overall, *Museums and Communities*, in reflecting on what a museum is (and may do) in the twenty-first century, opens questions of the potential role for museums in developing social cohesion within today's rapidly changing world, working with similarities while acknowledging and respecting differences.

The book covers difficult themes. We provide an outline of each chapter as a guide to our readers.

Part I: Community Matters

In Chapter 1, Viv Golding frames the themes and discussions with which the chapter authors engage. The notion of community and belonging are considered in terms of blood, in

the light of colonial oppression and at times of war, which presents particular challenges for museum curation in the present day. Specific reference to exemplary collaborative practice at the National Museum of the American Indian, the National Japanese American Museum, and the Museum of Tolerance serve to illustrate the complexity of the issues.

In Chapter 2, "The City, Race, and the Creation of a Common History at the Virginia Historical Society," Eric Gable considers the landscape of Richmond, capital of Virginia and of the Confederacy, which is marked by monuments celebrating Southern heroes of the Civil War, and the museum of the Virginia Historical Society, a virtual monument to the same era for much of its history. Gable examines the museum's quiet but pervasive shift of focus, for example in its entrance now privileging African American history over the Civil War story. Reflecting on what communities are, and in fact critiquing the way the term is often simplistically mobilized, the chapter considers this shift a visible result of the complex ways museums go about imagining, for publics, a shared sense of community. It explores the role local leaders (visible and public, invisible and private, representing minority communities and acting more or less organically as a community of civic elites) play in making shifts possible.

Bradley L. Taylor's Chapter 3, "Negotiating the Power of Art: Tyree Guyton's Heidelberg Project and its Detroit Communities," outlines an outdoor art installation in one of the most beleaguered U.S. city neighborhoods. Envisioned by the artist over twenty-five years ago as a means of engaging local children in positive alternatives to prevailing economic and social conditions, the project has been variously celebrated and vilified, often within the same communities. Taylor's chapter examines the relationship of Guyton with the multiplicity of communities within which his project exists (a powerful church community, the Detroit City Council, and two powerful city mayors), illustrating the concept of community as multidimensional and dynamic, with artist-curator and community holding different notions about who and what constitutes community, making engagement between them challenging.

In Chapter 4, "Learning to Share Knowledge: Collaborative Projects in Taiwan," Marzia Varutti examines Taiwanese government policy from 2000, which aimed to showcase the material culture, histories, and traditions of various indigenous groups. Varutti considers policy, which involved collaborative practice and knowledge sharing between curators in larger national museums and those in the small indigenous museums. Drawing on theorists, including Christine Kreps, the chapter observes tensions between urban professional curators and indigenous communities, notably over what counts as knowledge, which points to broader issues concerning the roles of indigenous museums in ongoing processes of definition and regeneration of indigenous cultures in contemporary Taiwan.

Chapter 5, "Community Engagement, Curatorial Practice, and Museum Ethos in Alberta, Canada," by Bryony Onciul, argues that while integrating community participation can greatly complicate curatorial work, it strengthens curatorial integrity and adds validity to interpretation by creating new cross-cultural ways of conceptualizing the world. Onciul examines a traditional museum, Glenbow in Calgary; and a community grassroots museum, Blackfoot Crossing Historical Park in Siksika Reservation, Alberta, outlining changes accommodating community expectations, from storage techniques and display

processes that respect the life force of objects, to curators becoming spokespeople and negotiators for both the museum and the community. Drawing on James Clifford, her model of the "engagement zone" acknowledges the social and temporal contexts, particularly institutional and political change, that add layers of complexities and limitations to integrating participation with a target community conceptualized as a living, fluid, changeable mass of people with their own agendas and agency (Clifford 1999).

Wayne Modest's Chapter 6, "Co-curating with Teenagers at the Horniman Museum," critically discusses a youth engagement program launched in January 2010 by the Horniman Museum as part of the London 2012 Cultural Olympiad. Modest, one of the curators involved in the project, describes the process of working with young people in collaborative ways, addressing questions such as: Who benefits from engagement, the museum or the community? How can we engage communities to their benefit? Who drives engagement, communities or the museum? Can teenagers in fact be regarded as a community for engagement in the same way other seemingly circumscribed groups such as refugees, blacks, or Polish can? In analyzing possibilities and problems of museums including young voices, he explores how working with young people can help us better engage with and involve different publics.

Part II: Sharing Authority

In Chapter 7, "Museums, Migrant Communities, and *Intercultural Dialogue* in Italy," Serena Iervolino focuses on an Italian pilot project called Museums as Places for Intercultural Dialogue (2007–2009), an initiative supported by the European Union, which sought to foster the role of museums as promoters of cross-cultural understanding. Iervolino argues that museums promoting collaborative curatorial practices can enable the participation of migrant communities in Italy, and that successful museums include excluded communities by acting as a "sharing space" where audiences participate in processes of renegotiation of cultural and national identity and cross boundaries of belonging (ERICarts 2008). Her chapter highlights the potential and the pitfalls of museums in countries of recent immigration.

"Community Consultation and the Redevelopment of Manchester Museum's Ancient Egypt Galleries," Karen Exell's Chapter 8, traces the process of redeveloping the ancient Egypt and archaeology galleries at Manchester University Museum to present a holistic approach to the past. Exell outlines the tension that pits the multiple and varied views of audiences against current academic thinking that regards ancient Egypt as a complex and evolving society integrated with the contemporary cultures of Africa and the Mediterranean. The chapter discusses a dialogical method of consultation (2008–2009), engaging a wide variety of individuals and groups, from Afrocentrists to Eurocentrists, pagans to Christians, schoolchildren to special interest groups, in heated and illuminating exchanges stretching traditional roles toward consultative curating, where issues of authority are central. Exell's chapter presents a case of the challenges to curatorial practice when museums must address the competing interests of different communities.

Mary Hutchison's Chapter 9, "'Shared Authority': Collaboration, Curatorial Voice, and Exhibition Design in Canberra, Australia," uses public historian Michael Frisch's concept of "shared authority" (1990) to consider "participants" not as representatives of a single social category, but rather as bringers of multiple perspectives with diverse experience and knowledge. Hutchison considers embedding the joint agency of curatorial and community participants in exhibitionary practice and making this visible and audible in collaborative displays. Her discussion is based on experimental research in Australia with multivoiced exhibitions in the context of local migration history. She focuses on a critical approach to design strategies and devices (graphics, audio, and scale) in relation to collaborative intentions, to suggest shared authority as a way of honoring audience knowledge and experience.

In Chapter 10, "One Voice to Many Voices? Displaying Polyvocality in an Art Gallery," Rhiannon Mason, Christopher Whitehead, and Helen Graham outline a university-museum collaboration that employed new inclusive methodological approaches of participatory research and an innovative use of digital media with members of the public to create a new polyvocal art display at the Laing Art Gallery in Newcastle. Mason et al. demonstrate how the institutional "voice from nowhere" can be challenged and supplemented for a model of polyvocality and a multiplicity of perspectives that relate to wider social trends such as "reflexive individualism" and a specifically political critique of museums' role in knowledge production, questioning whose expertise generates history and whose experience counts as history. The authors' use of "place" is a means of framing and enabling dialogue between different communities of practice and different potential audiences within displays.

Åshild Andrea Brekke's Chapter 11, "A Question of Trust: Addressing Historical Injustices with Romani People," outlines Romani collaboration with a traditional folk museum, the Norwegian Archive, Library and Museum Authority (ABM-utvikling). Brekke observes a background of brutal repression and forced assimilation since the Romanis' recorded presence in the early 1500s, including lobotomy, sterilization, and forced adoptions until the late twentieth century, explaining Traveller community distrust. She notes a twofold fear of drawing attention to the group (which may harm the community since prejudice persists) and losing Romani culture (which may be forgotten if their histories and contemporary presence remain hidden). Effective collaboration here involves a painstaking and sometimes painful methodology, facilitating dialogue through the creation of a Travelling culture exhibition, communicating a more nuanced history of Norwegian culture, and promoting Romani people's sense of ownership and pride in the Glomdalsmuseum.

Part III: Audiences and Diversity

In Chapter 12, "Creolizing the Museum: Humor, Art, and Young Audiences," Viv Golding draws on the concept of creolization and humor studies to explore how innovative artist interventions open the museum to new, "difficult or hard to reach" audiences aged

fifteen to twenty-five years and rejuvenate the experience of regular visitors. Her chapter is illustrated with examples from exhibitions, including Banksy Versus Bristol (2009), which raises concerns about power, control, and voice. Overall, she critically examines how imaginative and risky collaborations between museums and artists can engage those whose alternative cultures may be seen as marginalized in the context of high art spaces, but who may be drawn into reflexive dialogical exchange and creative activity through challenging displays.

Elizabeth Wood, in Chapter 13, "Museums and Civic Engagement: Children Making a Difference," discusses The Children's Museum of Indianapolis's permanent exhibition, The Power of Children: Making a Difference, which opened in 2007. Wood considers how the exhibition, providing families with an opportunity to explore racism and intolerance through the stories of three children in history, supports the development of empathy and commitment to create positive change within communities. She interrogates the principles of critical pedagogy employed in the exhibition, the conceptual design, and the ongoing efforts to promote dialogue around intolerance in a museum widely known for dinosaurs and carousel rides. Her chapter demonstrates that it is not just niche museums that can bring issues of civic engagement and social justice to the forefront.

Kalliopi Fouseki and Laurajane Smith's Chapter 14, "Community Consultation in the Museum: The 2007 Bicentenary of Britain's Abolition of the Slave Trade," reflects on the role of museums in England as places of social justice. The chapter examines, through interview material with curators and community activists, the successes and limitations of the consultation process with a range of community groups on the framing of bicentenary exhibitions. Tensions between the communities' political concerns and the museums' balanced exhibitionary practices, exacerbated by social inclusion policies and strategies of the British cultural sector, reveal a fundamental contradiction between the idea of museums as agents for social justice and the reality authorizing particular and often triumphant historical and cultural narratives. Ultimately, the authors urge museums to reorient consultation, negotiating with communities.

Elizabeth Carnegie and Hazel Tucker, in Chapter 15, "Interpreting the Shared Past within the World Heritage Site of Göreme, Cappadocia, Turkey," outline a collaborative research project situated within the field of tourism, which examines the extent to which local cultural identities are challenged and transformed in relation to the global context of migration. Specifically, Carnegie and Tucker explore the tensions rooted in differences of religious belief and sociocultural practices, notably the conflict between locals (Islam) and Western visitors (Christian) to the open-air museum (a World Heritage Site) at Göreme, Turkey, which fieldwork uncovered. The chapter points to ways of dealing productively with difficult issues that can arise from entrenched and essentialized positions, highlighting new possibilities of intercultural understanding in our twenty-first-century global village.

In Chapter 16, "Testimony, Memory, and Art at the Jewish Holocaust Museum, Melbourne, Australia," Andrea Witcomb draws on Charlotte Delbo's (1995) notion of sense memories (as distinct from narrative or vicarious forms of memory) to explore the communication of past trauma in the present at a community-based Holocaust museum where

giving testimony is paramount. Witcomb observes how artists register sense memories of different Holocaust experiences in sculptures, and how this helps create an ethical bridge between the survivor and the wider communities for active work against future genocides. She points to a mutual witnessing process, where sense memory constitutes affective experience for viewers and leads to the potential production of empathy, offering survivors some healing in the exchange of a "terrible gift" (Simon 2006).

Finally, in the afterword, Kirstin James, Petrina Foti, and the editors engage Professor Susan Pearce, an expert in the theoretical field of museum studies and a curator with some twenty years of experience, in conversation on curatorial work in the real world with objects and others, which unpacks museum material as a living part of time and change. Reflecting on her entry to the profession (aged eight!), Pearce illustrates how the power of the object, even in traditional contexts, transforms understandings and directs future lives, leading her to ponder whether what Greenblatt has termed "awe and wonder" in the face of the real thing might not be lost in the rush to digitize and make museums ever more interactive (Greenblatt 1991).

These are surely not the final words on the role museums and, in particular, curatorial practice, working with communities, can play in addressing some of the trenchant questions that animate our contemporary social world. However, as editors and authors, we hope these chapters will offer models that can inform practices. Moreover, we hope that the volume will encourage more critical practice from both museum practitioners and the academics that critique them as we embrace the shifting role museums can and are playing within our rapidly changing world.

References

Clifford, J. 1999. "Museums as Contact Zones." In *Representing the Nation: A Reader: Histories, Heritage and Museums,* eds. D. Boswell and J. Evans, 435–459. London: Routledge.

Cohen, R. and P. Toninato, eds. 2010. *The Creolisation Reader: Studies in Mixed Identities and Cultures.* London: Routledge.

Delbo, C. 1995. *Auschwitz and After,* trans. Rose C. Lamont. Yale University Press.

Dudley, S. 2009. *Museum Materialities.* London: Routledge.

European Institute for Comparative Cultural Research (ERICarts). 2008. *SHARING DIVERSITY: National Approaches to Intercultural Dialogue In Europe. An ERICarts Study for the European Commission.* Available at: www.interculturaldialogue.eu/web/files/14/en/Sharing_Diversity_Final_Report.pdf. Accessed February 16, 2010.

Frisch, M. 1990. *A Shared Authority: Essays on the Craft and Meaning of Oral and Public History.* Albany: State University of New York Press.

Genoways, H. 2006. *Museum Philosophy for the Twenty-first Century.* Altamira Publication.

Golding, V. 2009. *Learning at the Museum Frontiers: Identity Race and Power.* Surrey: Ashgate.

Greenblatt, S. 1991. "Resonance and Wonder." In *Exhibiting Cultures, The Poetics and Politics of Museum Display,* eds. I. Karp and S. Lavine, 42–56. Washington, DC: Smithsonian Institution Press.

Hooper-Greenhill, E. 1994. *Museums and Their Visitors.* London: Routledge.

Karp, I., C. M. Kreamer, and S. D. Lavine, eds. 1991. *Museums and Communities: The Politics of Public Culture.* Washington, DC: Smithsonian Institution.

Karp, I. and S. D. Lavine, eds. 1991. *Exhibiting Cultures, the Poetics and Politics of Museum Display.* Washington, DC: Smithsonian Institution.

Karp, I., C. Krantz, L. Szwaja, and T. Ybarra-Frausto, eds. 2006. *Museum Frictions: Public Cultures/Global Transformations.* Durham, NC: Duke University Press.

Luke, T. 2006. "The Museum: Where Civilizations Clash or Clash Civilizes?" In *Museum Philosophy for the Twenty-first Century,* ed. H. Genoways, 19–26. Alta Mira Press.

Macdonald, S. 2009. *Difficult Heritage: Negotiating the Nazi Past in Nuremberg and Beyond.* London: Routledge.

Macdonald, S. and P. Basu. 2007. *Exhibition Experiments.* Blackwell: Oxford.

Philips, R. 2003. "Community Collaboration in Exhibitions: Introduction." In *Museums and Source Communities,* eds. L. Peers and A. Brown, 155–170. London, Routledge.

Samuels, J. 2008. "The British Museum in Pentonville Prison: Dismantling Barriers through Touch and Handling." In *Touch in Museums: Policy and Practice in Object Handling,* ed. H. Chatterjee, 253–260. London, Routledge.

Sandell, R. 2007. *Museums, Prejudice and the Reframing of Difference.* London: Routledge.

Simon, R. I. 2006. "The Terrible Gift: Museums and the Possibility of Hope without Consolation." *Museum Management and Curatorship* 21: 187–204.

Part I
Community Matters

Collaborative Museums
Curators, Communities, Collections

Viv Golding

While I recognize that "racism is as healthy today as it was in the Enlightenment" (Morrison 1994: 63), I open this book in jubilation. This delight stems from my position as a curator and academic (of museum education, responsible for learning from anthropology collections) and an ethnic "other," who saw collaborative action affect social justice on January 4, 2012, when two racists, Gary Dobson, thirty-six, and David Norris, thirty-five, were sentenced to life imprisonment for the 1993 murder in Eltham, southeast London of Stephen Lawrence, a black British student just eighteen years old. During sentencing at the Old Bailey, Mr Justice Treacy warned the three or four other killers at large to heed the advances in science which brought two criminals to justice.[1] It was from one miniscule drop of Stephen's blood, lodged deep in the fibers of a jacket, that recent DNA testing could prove guilt so long after the crime and after such concerted effort on his behalf, led by Stephen's mother, Doreen, and her family.

The Lawrence case points to key factors addressed in this volume. First, it foregrounds the wider sociohistorical world, within which curatorial work with collection displays and programming for diverse communities takes place. As Carol Duncan notes, museums are "complex entities," not "neutral sheltering places for objects" (Duncan 1995: 1). Rather, in exhibitions, museums construct and communicate ideological positions from "fragments" (Kirschenblatt-Gimblett 1998: 18). Second, it highlights the importance of evidence and interpretation. In other words, *Museums and Communities: Curators, Collections, and Collaboration* is concerned with the situated nature of knowledge and the political positioning of museum authority, which can be challenged by the experience, beliefs, and emotions visitors bring with them.

In the United Kingdom at the time of Stephen's murder, near my onetime home and workplace at the Horniman Museum, I recorded the voices of young children (10–11-year-olds) as part of my antiracist research with local schools. One girl of "low" ability from Christchurch School spoke powerfully. "I can't understand it," she started. "Why kill him? . . . we are all human, we all have a heart, we all have blood running in our veins. I can't understand it," she sadly concluded. All year, at the frontiers between the museum and her school, she had been working at understanding across the whole school curriculum, visiting on a weekly basis, together with her class and their teacher,

Juliet Desailly. She was inspired by Frederick Horniman, the philanthropist founder of the museum, who was himself fascinated since childhood with the wonders of the natural world and the richness of human heritage around the globe, and who readily shared his natural history and material culture collections with visitors, regardless of their age, ability, and level of financial wealth.

The high-quality work of the children from Christchurch[2] also illustrates the ways in which museum curators today can work collaboratively and creatively with collections, not only to promote an understanding of cultural diversity and the often shameful histories of museums, but also to forge a contemporary connection with the lived experiences of present-day audiences, most importantly to progress critical thinking and point to collaborative action that we can take as responsible communities on matters of contemporary concern, such as white supremacism in this instance. In other words, at the museum we can display evidence of our common humanity and cultural diversity while posing questions about what a museum is and can be, which vitally includes addressing racism and working to dispel fearful stereotypes for more accurate perspectives.

The museum's social work of challenging stereotype and prejudice is difficult and continuous as fear is easily stirred in communities (Janes and Conaty 2005; Sandell 2007; Silverman 2010). Almost twenty-five years before Stephen Lawrence's murder, on Saturday, April 20, 1969, conservative Member of Parliament Enoch Powell gave voice to the fears of majority white communities. He stated: "As I look ahead, I am filled with foreboding. Like the Roman, I seem to see 'the River Tiber foaming with much blood'" (Powell 1969: 289–290).

In this speech, a model of persuasive rhetoric, miscegenation is feared as a catastrophic outcome of previously colonized peoples' migration to the United Kingdom. But more important than this mixing, as Paul Gilroy notes, is the reversal of imperial hierarchy, when as Powell's constituent fears, "the black man will have the whip hand over the white man" (Gilroy 2004: 110; Powell 1969: 282). Powell sees this fearful cultural change in the United Kingdom's "quiet streets" that had "became a place of noise and confusion" where immigrants "cannot speak English." In the context of the United States, as bell hooks notes, such dangerous fragmentation pushes the Indigenous civilized people "closer to nature, animistic, primitive"—those "Others" within "our" society (hooks 1992: 152).[3]

Powell's speech rests on stereotype and myth, which as Barthes observes, has a "double function" of meaning and imposition. He states "the relation which unites the concept of the myth to its meaning is essentially a relation of deformation" since myth arises from history, intention, and motivation, not the nature of things (Barthes 1993: n. 114). The myth Powell propounds is one of a post-World War II influx of "Others," whereas, in reality, evidence shows people of African heritage and their descendants making these islands home from the period of Roman occupation, coming by force or by choice (Amim-Addo 1995; Fryer 1984).

These UK cases of racist mythologies echo around the globe and throughout history. In the United States of the 1890s, the "one drop" laws determined the miniscule amount of blood deemed to denote blackness and subsequent second-class or subhuman status,

and provoked an increase in violent crime including lynchings against blacks, Jews, Chinese, and "Others" across the South (Sweet 2005). Racist legal systems such as the Jim Crow laws can be repealed, yet the underlying myths of pure blood and fear of miscegenation persist in the present, as a high-profile 2008 case illustrates, in which Barack Obama faced the charge of "Halfrican" with reference to his ancestry of a Kenyan father and a Hawaiian mother (Cohen and Toninato 2010: 1). Obama shares his mixed ancestry with the overwhelming majority of citizens in the United States today, as Ted Duplessis illustrates with his own Cherokee/French/black/Italian mother and French/Choctaw/black father (Cohen and Toninato 2010: 2). *racist laws*

Duplessis's ancestry is interesting in terms of the "blood quantum," which features in North American history and persists in the United States today, and contrasts with the "one drop" Jim Crow Laws. The "blood quantum" laws can be traced to a series of laws adopted in the colony of Virginia in 1705, denying civil rights to any "negro, mulatto, or Indian." At this time, *mulatto* was defined as "the child of an Indian[4], and the child, grandchild, or great grandchild of a negro," and the racist law may be seen as part of a genocide project against Indigenous peoples (Forbes 2000; Zotigh 2011).[5] In the late nineteenth century, the federal government began employing "degree of blood"—"full," "one-half," and so forth—to enroll people before the Dawes allotment commission, which extended the previous racist system and furthered the genocide movement. White blood entitled an American Indian citizen to privileges, including removal of "wardship" restrictions, rights to "witness," sell property, and vote in state and federal elections. Such benefits may account for people exaggerating their white ancestry at enrollment, since its absence determined control of their financial lives by the Bureau of Indian Affairs (BIA).

Today, certain rights and financial advantages are bestowed to registered citizens of any federally recognized "tribe,"[6] but first a Certificate of Degree of Indian Blood (CDIB), issued by the BIA, must be granted. With a CDIB, the United States government recognizes a specified degree of Indian blood and eligibility to membership as citizen of a particular Nation. People of full Indigenous racial ancestry and living on a reservation, but of different Nations, are counted as "mixed bloods," which means not only that they lose economic benefits, but also that gradually they will be legally eliminated as they marry out of their pure group into another Nation, to non-Indians, or into non-federally recognized groups. While many Nations include their own quantum restrictions for citizenship in addition to the CDIB (the Eastern Band of Cherokee Indians requires one-sixteenth or higher and the United Keetoowah Band requires one-fourth or higher), the Cherokee Nation has no quantum restrictions and is largely composed of people having one-fourth or less Cherokee blood. The allthingscherokee website points to the problem of diverse Nations themselves maintaining restrictive colonial laws for recognition in the present day: *quantum restrictions*

> We are not Gregor Mendel's cross-pollinated pea plants; we are people. Our ethnicity and cultural identity is tied to our collective and ancestral history, our upbringing, our involvement with our tribe and community, our experiences, memories and self-identity. To measure our "Indianness" by a number is to completely eliminate the human element. And to allow

others to judge us based on that number is to continue a harmful trend. [. . .] You're a whole person, not the sum of your "parts." If any "part" of you is Cherokee, then you are Cherokee. Period. (Anon, *All Things Cherokee* n.d.)

Access to scholarship funds for higher education is tied to tracing lineage to a bloodline. Many mixed-blood people who are not tribally enrolled do not qualify. Louis Whitehead observes the need to impose restrictions on scholarships to preserve their use for Indigenous people, many of whom suffer economic deprivation, but he questions the extent to which these are applied to the detriment of "mixed bloods" and further suggests such "legitimacy" as proven by blood quanta may be akin to "perpetuating genocide." He argues that "mixed-blood people deserve support too, so that they also can honor their roots and serve the People" (Whitehead 2011).[7]

How, if at all, do these ideas of blood and identity impact the twenty-first-century museum? How is the traditional role of curatorial scholarship affected by specific, possibly conflicting community concerns over museum collections? An outline of what may be regarded as best collaborative practice at certain key sites will illuminate the complexity of the field, beginning with a museum that directly addresses the "blood quantum" in display.[8]

National Museum of the American Indian (NMAI)

On September 21, 2004, the National Museum of the American Indian (NMAI) opened in Washington, DC. The geographical location at the symbolic heart of the city on the National Mall is important.[9] It stands alongside other sites of American identity such as the National Museum of American History (NMAH), the memorials to those who have died in war, and past presidents, but has a different ethos from the sometimes rather sentimental patriotism of its neighbors. Located within a 4.25-acre trapezoidal site above an active creek bed, the building's curvilinear structure evokes a wind-sculpted rock formation, designed as "a living museum, neither formal nor quiet, located in close proximity to nature" and making symbolic celestial references, notably "an east-facing main entrance and a dome that opens to the sky." Rich imagery offers layers of meaning, from the perfect alignment of the building to the cardinal directions and the center point of the Capitol dome, to the details of color and textures that "reflect the Native universe" (National Museum of the American Indian 2012).

The Indigenous sensibilities that resound throughout the museum building, landscape, and exhibitions have emerged from Indigenous dialogical method, employed by Founding Director Richard West (Cheyenne and Arapaho Nations) since the 1990s (West 2006).[10] These techniques to gather knowledge and opinions from cultural leaders and actively construct fresh narrative spaces between as well as within cultural groups at the museum "forum" (Cameron 1971) were seen as part of a decolonizing approach to reappropriate and subvert traditional museum forms, which the term "survivance" or "survival with dignity" (Vizenor 2008) denotes.[11] The decolonizing and democratizing ethos privileged new Indigenous voices to tell their own stories celebrating the endurance of

diverse cultures against a brutal historical background of oppression and dispossession, which left pernicious legacies of racism and stereotypes.[12]

With more than twelve hundred Indigenous cultures throughout the Americas, NMAI holdings of 825,000 documented objects as well as vast photo, media, and paper archives representing over 12,000 years of history, making a new collaborative exhibition was difficult.[13] New museology practice involved NMAI curators spending months in Indigenous communities and working alongside the communities at the Smithsonian, rather than simply inviting community representatives into the museum for advice, which was empowering to Indigenous curators (Shannon 2009).

The concept of "Museum Different" underpinned new collaborative relationships of respect and trust built up between the NMAI and Indigenous co-curators, which aimed for equality and movement beyond the "patronizing spirit inclusion" (Rand 2009: 130). Museum Different at NMAI is seen not only in privileging "Native Voice," the authored testimony in wall text and video throughout the exhibition, the objects collaboratively selected, but also in inviting visitors to engage in critical thinking and reflexivity. For example in Paul Chaat Smith (Comanche) and Herbert R. Rosen's script for an Our People video, notions of "truth" and "history" are raised as "a point of view, an agenda," which requires interrogation. In this video, actor Floyd Favel (Plains Cree) calls for us all to "Explore this gallery, encounter it, reflect on it, argue with it" (Brady 2009: 142).

Importantly, the NMAI stands as active monument to colonial oppression and its contemporary legacy of economic disadvantage, but operates in ways that do not cause further harm to Indigenous people. As Toni Morrison observes in terms of African American peoples, there is a duty to remember the suffering of the past, not to fix the living in a permanent negative state of paralysis, but to recall in a manner that "is not destructive" (Morrison 1994: 247–258). In other words, working with the tensions accruing from a past brutally erased in the Mall through centuries of genocide and yet kept alive and transformed by the people over the centuries, the NMAI seems to operate creatively in the spaces between—traditional and contemporary, histories of pain and cultural success, contemporary injustice and continuing struggles for human rights (Bhabha 1995). From our position as 2012 visitors outside of the culture displayed, stories of many contemporary Indigenous people's poverty are balanced with stories celebrating the richness of historical material culture, the myths, songs, and dances from which they emerge, as well as the new arts and crafts of the communities.

Community curators employ a variety of media in their interpretation and display techniques, including interactives and video. Indigenous voices are raised as individuals and as collectives to articulate politically charged messages for human rights and state responsibilities for education, health, and welfare, which overlap with the cultural rights to the repatriation of property and the need to preserve languages and oral traditions. For example, in Our Universe, under the starry canopy, traditional tales illuminating selected objects are narrated on video screens, and on the wall just inside the entrance to Our People a screen projects the names of hundreds of Native languages spoken by ancestors

who "are still here" and those "nine out of ten" who "perished," leaving an "inheritance of grief, loss, hope and immense riches" for which the NMAI is "accountable" and "responsible" today (Chaat Smith wall text).

Curatorial collaboration and polyvocality shape "the content, look and feel" of three permanent exhibitions, Our Universes, Our Peoples, and Our Lives, to awesome effect. I was deeply moved by the dazzling beauty of the aesthetics and the violence of the relatively recent past—the 400 years since the arrival of Europeans—as conveyed, for example, in Our Lives. Here I agree the personal stories of survival belong "to anyone who has fought extermination, discrimination, or stereotype" (Jolene Ricard, Cynthia Chavez, and Gabriel Tayac wall text).

However, controversy has plagued the NMAI, and it may be that "key aspects of traditional Indigenous knowledge are fundamentally incompatible with Western traditions of knowledge production" (Philips 2004: 25). Gwyniera Isaac provides an illuminating analysis of the polarized debate (Isaac 2006), which I briefly note here: the praise for demonstrating a "way of thinking that emphasizes multiple voices and playful forms of truth over the lazy acceptance of received wisdom, authority and scientific certainty" (Kennicott in Isaac 2006: 590 [September 19, 2004]), and the perceived lack of a singular guiding narrative "the glue of thought that might connect [diverse beaded objects, historical and contemporary, on display] one to another" (Richard in Isaac 2006: 588–589 [September 21, 2004]).

Another complaint revolves around restricted access to some collections for members from the originating group who treat the museum as a church. Jenkins argues that knowledge and truth do not come from our biology and background, rather "we can all attempt to comprehend our shared pasts through investigation, inquiry and debate, regardless of where we were born and to whom" (Jenkins in Isaac 2006: 589 [January 25, 2005]); indeed this is the museum's educational role. I recognize elder men often hold traditional power and that such views may be challenging to our antiessentialist positions today and to younger women. At the same time, I contend that while museum histories are so often, perhaps irrevocably, entangled in broader politico-philosophical ideas, such as imperialism and scientific racism, nevertheless strong arguments can be made for contemporary museums to embrace a social role—to become challenging museums enriched by diverse perspectives, not silencing or avoiding difficult themes connected to various dilemmas.

Issues of power and control underpin contemporary curatorial practice here. Complex considerations include presentations of differences *and* homogeneity by these cultural groups in the wake of historical prejudice suffered, and in seeking repatriation of cultural property. Yet concepts such as Sharon Macdonald's "democratic anthropology," practiced at Nuremburg, point to productive ways through difficulties, highlighting the potential of museums and heritage sites as locations of dialogical exchange that demand critical and ethical work from all participants, curators, communities, and audiences (Macdonald 2009: 191).

While my experience, facilitated by Indigenous guides' highlight tours and handling sessions,[14] refutes negative views such as Richard's and Jenkins's, interactive computer

screens now offer information at the entrance hall, and the ImagiNATIONS Activity Center caters to families, Kevin Gover, director since 2007, seeks to further address visitors' difficulties in redisplay plans scheduled for the ten-year anniversary in 2014. He states the aim first is to make the museum "more coherent to the public," specifically unifying the individual "tribal pods" in some way, and second to present "the broader Colonial history" of a "thriving place where civilizations had risen and fallen for millennia," including the points of contact between Europeans and the Americas (quoted in Kaufman 2012).

Yet majority audiences at the NMAI are not Indigenous people, many of whom are economically disadvantaged and unable to afford the luxury of travel. As Rand observes, "American Indian[s]" must largely access authenticity—objects and the many stories they hold—by means of the "Fourth Museum" (via the Internet and traveling programs), which is a weak substitute for the site on the National Mall (Rand 2009: 131). Furthermore, while negative stereotypes are dismantled in the displays, the extent to which NMAI is a "decolonizing museum" addressing the "hard truths" of political history, the "loss of land, life language" (Lonetree 2009: 33)) is contested.[15]

These clashing viewpoints may profitably be unpacked for the context of the museum by defining some slippery terms that underpin discussion in subsequent chapters.

Definitions

oh Lord

First, *culture*, as Raymond Williams observes, is an "exceptionally complex term" with roots in "cultivation" of horticulture, animal husbandry, which became increasingly attached to the development of the human mind or "spirit" and "a whole way of life," economic, political, and so forth by anthropologists in the late eighteenth and nineteenth centuries (Williams 1988: 10). The contemporary pluralist view of living "cultures," emerging in nineteenth-century anthropology, highlights hierarchies of the civilized and primitive, within which opposing values of objects are contested. In his discussion of the products and practices of intellectual and art and craft activity, asymmetries of "high" and "low" are seen in objects of "use"—shoes, pots—and "art"—painting, sculpture, which are "continually negotiated and re-negotiated" in the "profit governed market" (Williams 1988: 49, 107; Golding 2009: 27–31, 32, 46). *younh*

As Tony Bennett states with reference to Meiji Japan, "incomprehension and opposition" abound in cultural contact (Bennett 2005: 69). Women, Indigenous peoples, and oppressed groups around the globe point to the Eurocentric bias underpinning Mathew Arnold's claim for culture to be understood as "the best that has been known and said in the world," we ask "for whom, when, why?" (Arnold [1869] 1876). It also seems important to counter perceptions of cultures as fixed, separate, and bounded; rather, museums might profitably stress the dynamic nature of cultural change and the permeable borderlands between and within cultures. In summary, I agree with James Clifford's observation that culture is a "deeply compromised idea," which museums "cannot yet do without," and the authors in this volume proceed from a discussion of separate components: ideas,

arts, traditions, and then toward an examination of shared characteristics within the wider field of culture, while noting layers of complexity and change resulting from cultural meetings and resisting overarching simplistic views (Clifford 1988: 10).

Another problematic term employed throughout this volume is *communities*. While I recognize community as a "warmly persuasive word" describing an existing or "alternative sets of relationships," which "never [I would argue rarely] seems to be used unfavourably," chapter authors seek to unpack and problematize the notion in examining the similarities and differences among and within diverse cultural groups and their relationships with museums (Williams 1988: 76). In different ways, authors outline examples of collaborative museum practices to denote an active verb-like sense of communities, which, as Karp suggests, is a noun but not a thing (Karp 1991: 3–4).[16] Similarly, the museums' mission may be seen as highlighting museums' perpetual "becoming" rather than fixed being (Bhabha 1995).[17] The 2007 International Council of Museums (ICOM) definition illustrates this point.

A museum is a non-profit, permanent institution in the *service of society and its development*, open to the public, which acquires, conserves, researches, communicates and exhibits the tangible and intangible heritage of humanity and its environment for the purposes of education, study and enjoyment. (International Council of Museums 2007) [my emphasis]

Avoiding the word *communities*, ICOM's emphasis on the social role of museums resonates in Bikkhu Parekh's notion of "reimagining" the UK nation as a diverse "community of communities" with local, global, and transnational allegiances, which is useful in addressing essentialist views of "Self" as opposed to "Others" (Anderson 1983; Parekh 2000: iix). While *community* is most often used to describe positive aspects of a group, a community can also be exclusive, serving to divide and marginalize, as the American "Indian" examples demonstrated. In this volume, authors point to curatorial collaboration building bridges between "communities of difference," which denotes a wide diversity of people (in terms of ethnic and religious allegiances, ages, and ability levels, for example) coming together in a public museum space, with at least the possibility of gaining intercultural understanding (Young 1990). The meaning of communities for museums discussed here and in this volume, as Jennifer Barrett notes, resonates in the notion of "communities of practice" and is distinguished from homogenizing ideas of the "public" or publics (Barrett 2011; Gable in Chapter 2).

The term *curator* holds a range of meanings (custodian, steward, keeper, superintendent, guardian), which in a positive sense emphasize care while negatively foregrounding hierarchical lines of power and a rigidity of processes. A curatorial willingness to break down traditional power hierarchies, to engage in respectful collaboration and sharing of expertise, is a critical success factor of projects discussed in the chapters of this book. Ideally, collaboration is sustainable and distinct from tokenistic participation, consultation, and information gathering, although one-off collaborative activity may mark a beginning for museums to risk more inclusive ways of working. For us, collaboration in

collab v participation (handwritten)

museums is distinct from participation, as Sherry Arnstein's influential text makes clear. Arnstein's eight-step ladder offers a political model noting the lowest levels of *non-participation* (1 manipulation and 2 therapy) through *tokenism* (3 informing, 4 consultation, and 5 placation) to the higher levels regarded as *collaboration* or *citizen empowerment* (6 partnership, 7 delegated power, and 8 citizen control) (Arnstein 1969: 216–224; Onciul in Chapter 5). *interesting* (handwritten)

These ideas of curatorial collaboration with communities are rather abstract. To illustrate, I turn to specific collections.

Museums as Sites of Conscience

The International Coalition of Sites of Conscience was established in 1999 with six sites in five countries—South Africa, Senegal, Czech Republic, the United Kingdom, and two in the United States. The founding mission of the original coalition states:

> [I]t is the obligation of historic sites to assist the public in drawing *connections* between the history of our sites and their contemporary implications. We view stimulating *dialogue* on pressing *social issues* and *promoting humanitarian and democratic values* as a primary function. (Museums as Sites of Conscience 2012) [my emphasis]

Today the coalition has grown into a global alliance of nearly 300 museums, memorials, historic sites, and initiatives in forty-seven countries. The sites remain committed to engaging people through dialogical exchange, not only by remembering past struggles for social justice, but also by addressing contemporary pernicious legacies such as racism, which demands taking action to make a difference in the present. Each site aims to facilitate visitors' connections from their present-day lived experiences to the diverse stories told, which range from mass atrocities to daily, individual struggles and the preservation of cultural or environmental resources. In other words, thoughtful action following dialogue is regarded as a vital tool for building lasting cultures of human rights and democracy; by:

> initiating new conversations about contemporary issues through a historical lens, places of memory can become new centers for democracy in action. But the power of historic sites is not inherent; it must be harnessed as a self-conscious tactic in the service of human rights and civic engagement. (Museums as Sites of Conscience 2012)

From a range of excellent sites around the world I reference just two here, which particularly moved me during visits to Los Angeles for the 2010 American Association of Museums (AAM) annual conference. I select work at the Museum of Tolerance and the Japanese American National Museum, which exemplifies creative ways of progressing what Spivak terms a "planetary vision" (Spivak 2003: 101–102), citizenship, and what can be understood, according to Freireian pedagogy, as "critical" thought (Freire 1996).

Museum of Tolerance

Since opening in 1993 with a range of exhibitionary devices, such as the two doors "Un-prejudiced" (locked) and "Prejudiced" (unlocked) through which the visitor must enter, the curatorial team at the Museum of Tolerance (MOT) continues to facilitate a questioning attitude in audiences, not only to the material culture on display in museums—"how did this object get here, who owned/used it in the past, is the text to be trusted?" and so forth—but also to the sources and routes by which we hold certain deeply held beliefs and opinions for which we may be prepared to fight and even to die (Museum of Tolerance 2012).

The MOT is remarkable in encouraging youth audiences to interrogate ideas and issues that remain at a subconscious level, largely unexamined, through a variety of exhibitionary devices. For example, sitting in The Point of View Diner, a recreation of a 1950s diner that "serves" a menu of controversial topics on video jukeboxes, visitors first choose a topic focus, including bullying, drunk driving, and hate speech. Then, through interactive technology, they input their opinions on the scenarios seen and pose questions to relevant characters, accessing instantly tabulated results.

I saw the Diner engaging an international group of thirty adult museum professionals at the 2010 AAM conference, but it was a live dialogical workshop that most deeply facilitated this audience's imaginative connection with stereotype and prejudice of various kinds, notably racism and homophobia. At the MOT's "Hope not Hate" session, we had the privilege of listening to Matt Bolger. He began by relating his life story from age thirteen when, after coming out to his mother about his gay sexuality, he was ordered out of his Christian Fundamentalist home. Bolger spoke of arriving in Santa Monica, West Hollywood at one o'clock in the morning, with nowhere to go and nothing but one bag his mother had helped pack, surviving a dire life sleeping rough in the park with other young boys in similar situations, "doing what I had to" for food, and cleaning himself in public washrooms until the day he was forced to run for his life from a group of violent skinhead racists and their chants of "let's kill the faggots!" He remembers looking into the eyes of the perpetrator whose boot was coming toward his forehead before he lost consciousness.

My AAM group saw an excellent film reconstruction of the assault on Bolger, which dramatically imparts something of the emotional shock of horror, fear, and trembling (Bolger 2012).[18] Following this film, visitors are asked to ponder the real-life scenario: Matt Bolger, a young man, beautiful, but hated and hurt beyond recognition for his sexual preference, left for dead by thugs, yet managing to regain consciousness and crawl away. Recovering. Growing. Learning. Twenty years later, the young man owns property, works as a hair colorist to Hollywood stars, and after a period as a volunteer is now employed at the MOT, together with Tim Zaal, the ex-white supremacist whose boot almost took his life.

"Violence for me, back in those days, was like breathing," Zaal states. He further observes "a lot of fear" in becoming an extreme skinhead racist, which he traces to his teenage years, when a black gang gunned down his cousin. He recalls feelings of fear

and murderous antipathy for all black people that led to violent binges, until Zaal and his gang made a particularly bloody attack on an Iranian family, for which he was charged and sentenced to one year in jail on May 31, 1989. Following the birth of his son, he bravely determined to turn his life around and leave the group, knowing exit routes are fraught with danger for neo-Nazi members and their families, who must often change names and addresses to escape being executed for abandoning the faith. The motivating factor Zaal speaks of was his tiny son learning language, how alongside mommy and daddy, the child soon "knew how to say the 'n word'" and "Heil Hitler" and to do the Nazi salute, which Zaal realized was limiting his son's future horizons. *wow*

Today Bolger and Zaal unite to speak regularly with school groups on transformation, healing, success, and perhaps most extraordinarily, of forgiveness. Bolger speaks of regaining consciousness and seeing people's hatred of him for "something I am," which led him to use his voice to promote the idea of being a human first, not a black or a gay man; he engages in dialogue with Zaal, the man who "hated a lot of people, I hated Jews" and who now works for the MOT. Thus the MOT does not leave visitors in a state of despair for the hatred and lack of humanity in some people, but hopeful that lives can be transformed.

This educational work of the MOT seems to provide a conversational or dialogical model for diverse communities' learning in museums that does not rely on collections (Golding 2009). It prioritizes visitors entering into a dialogue with diverse histories that have resulted in contemporary prejudices and, most importantly, it seeks to establish points of contact between human beings of different cultures, ethnicities, and sexual preferences. The Japanese American National Museum, to which I turn next, shares this dialogical approach.

Japanese American National Museum

The Japanese American National Museum aims "to promote understanding and appreciation of America's ethnic and cultural diversity by sharing the Japanese American experience" (Japanese American National Museum 2012). For example, Common Ground: The Heart of Community is an ongoing exhibition that incorporates a collection of hundreds of objects, documents, and photographs, chronicling 130 years of Japanese American history from the early days of the Issei pioneers, through incarceration following the Japanese bombing of Pearl Harbor that plummeted the United States into World War II, to the present. Displays range from Heart Mountain barracks, an original structure preserved from the World War II concentration camp in Wyoming, to minute items of memorabilia in glass cases, which are brought to life through a series of thirty-second digital video shorts during which Japanese heritage volunteers share moving personal stories related to the exhibition artifacts.

Karen L. Ishizuka, who curated the 1994 exhibition America's Concentration Camps: Remembering the Japanese American Experience, recalls the controversy that arose over the term *concentration camp* applied to the United States when the display

was developed for traveling in late January 1998. The National Park Service contested the application of the words *concentration camps* to the unconstitutional incarceration of 120,000 Americans of Japanese ancestry, seeing the term associated solely with the Holocaust and Nazi death camps. Ishizuka explains the research and consultation underpinning the use of *concentration camps* in the 1994 exhibition. She notes the objections to the U.S. government's official use of euphemisms such as "evacuation," "relocation centers," and "non-aliens" to obscure the violation of the rights of American citizens, while government officials privately referred to the prisons as "concentration camps" (Ishizuka 2005: 103–104). The Japanese American National Museum, supported by its leadership, staff, colleagues in the field and outside, including U.S. senator Daniel Inouye, Norman Mineta, and the American Jewish Committee, stood firm on the issue, which highlighted the difficulty of the mission to tell the Japanese American story through insiders' perspectives. *and now again*

Irene Hirano, president and CEO, notes parallels between 1941 and 2001, when Arab American community experiences were connected with Japanese American experiences of sixty years earlier. In the post-9/11 era, some viewed Arab Americans with suspicion and hostility, which threatened the construction of an Arab American National Museum in Dearborn, Michigan, on which the Japanese American National Museum had been advising, notably to develop ways of seeing diversity as a vital part of the whole nation and central to democracy.

The principle that diversity and democracy are integrally related to each other and cannot be adequately discussed or taught separately lies at the heart of the Japanese American National Museum's teaching programs. As Dr. Gary Okihiro observes, "We, the people, shape democracy; I, too, shape democracy; Those who have struggled for freedom and equality have expanded democracy's reach for all people" (Okihiro 2012). The website resources further contend: "diversity is now seen in context with multi-ethnic American history, civil rights—and more significantly—civic engagement, because improving the understanding of diversity requires active participation by all citizens." A range of resources for teachers and their pupils includes historical material such as the Jim Crow laws, photographs, and poetry. One shocking image, dating from the 1923 campaign by the "Residents of Hollywood, California" to push Japanese Americans out of the community, shows a white woman pointing to a sign over the porch of a house that states "JAPS KEEP MOVING THIS IS A WHITE MAN'S NEIGHBORHOOD"; "MAN" presumably includes white women here (Japanese American National Museum 2012). A poem from 1927 by African American Langston Hughes points to unity in diversity and oppression during this period:

I am the poor white, fooled and pushed apart, I am the Negro bearing slavery's scars. I am the red man driven from the land, I am the immigrant clutching the hope I seek—And finding only the same old stupid plan
Of dog eat dog, of mighty crush the weak.

(Hughes in Japanese American National Museum 2012)

Concluding Thoughts

In this chapter, I first began unpacking myths such as those of "purity" and "blood" by drawing on legal and political examples from the United Kingdom and the United States to illuminate the complexity of the term *community* for curatorial practice, especially for curators concerned to tackle the economic inequalities that exist between and within all communities. Then I offered key examples of best museum practices to illustrate how creative work at the frontiers between subject disciplines, theory, and practice may in turn lead to the transformation of exhibition spaces, from sites where knowledge is transmitted to passive audiences to potential forums or contact zones where new voices and visibilities are raised and new knowledge(s) actively constructed (Clifford 1999; Golding 2009).

Drawing on theoretically grounded exhibitions and programs, including Sites of Conscience and the National Museum of the American Indian's (NMAI) shift away from the western model of museology, I pointed to collaborative work on a platform of local social justice *and* universal human rights. In other words, I have started to trace the possibility of curatorial work occupying a position that is mutually respectful toward local ideas and ways of life around the world and to universal laws upheld by democratic nation-states that secure individual liberty and freedoms.

Similarly, I have started to interrogate the term and idea of community as used by museums. Subsequent chapters will critically map ethically driven movements that have seen visitors turned into communities and the ways in which this has coincided with changes in exhibition spaces. For example, themes of co-curation and new dialogue offer nuanced distinctions of what a curator is and may be, who is empowered to represent the diverse communities, whose voices remain silenced or softer toned, and to what extent meaningful collaboration may differ from participation.

The chapter authors will proceed to examine the position of museum curators (including artists and community experts) and the shifting character of their professional role and practices in the twenty-first century. The changing roles and responsibilities of curators have been the subject of increasing attention in professional and academic discourse, but arguments have very often been presented in unhelpfully reductive and polarized terms. For some, curators have been persistently inattentive to the needs of diverse audiences (Lynch 2010). Others have accused curators of dumbing down complex concerns, often with too little academic content, into sanitized forms for lowest common denominator audiences or of acting inappropriately as social workers preoccupied with social concerns they are ill equipped to address at the expense of their core duties of collections care and research (Appleton 2001; Bennett 1996: 109–127). Such responses suggest a dualistic relationship that places curatorial integrity at one extreme and community engagement at the other. But, *Museums and Communities* asks, is such an oppositional perspective unavoidable? Might museums be led by a strong ethos of collaboration while at the same time maintaining strong curatorial integrity? Can museums be *both* about something *and* for someone (Weil 1999)?

The subsequent chapters in this volume engage such questions and point to a vital social role for museums in an "uneven world" (Rhadakrishnan 2003) characterized by economic inequalities, increasing insularity, and fear of "others"—especially following terrorist attacks such as those carried out on 9/11 and 7/7. Overall, this volume, by no means definitive on the theme, contributes to the argument for museums to embrace situated and activist positions, working creatively and collaboratively *with* diverse communities.

Notes

I am especially grateful to Rick West, Founding Director of NMAI, for his advice, support, and illuminating conversations during the writing of this chapter. This chapter also benefits from a Japan Society for the Promotion of Science award, which permitted discussions with Dr. Yoshikazu Ogawa at the National Museum of Nature and Science Tokyo.

1. Mr Justice Treacy's judgment can be seen at www.judiciary.gov.uk/media/judgments/2012/r-v-dobson-and-norris-sentencing-remarks.
2. The work includes an *Identity* poster and a forty-six-page illustrated booklet guide to the museum, *Mr Horniman and His Victorian Museum*.
3. hooks also observes the fear of black people entering all-white areas as we discuss elsewhere (Golding 2009: 48–50; hooks 1992).
4. The term *Indian* is quoted here and employed notably at the National Museum of the American Indian, although contested. While our preference is for *Nations*, which Paul Chaat Smith (2009: 17) discusses, we note *First Americans* and *Indigenous Peoples* are widely used.
5. Furthermore, "Indian blood" was limited to ancestry from a federally recognized tribe as listed in the Federal Register and recognized by the secretary of the interior, which excluded "American Indian or Eskimo-Inuit ancestry derived from a terminated tribe, from an administratively-deleted tribe, from a Canadian, Greenlandic, Mexican or other non-US group, or from any state-recognized tribe (as along the east coast), or perhaps from any newly-recognized tribe. Thus a person who is 1/2 Inuit from Alaska and 1/2 Inuit from Canada or Greenland can only be counted as 1/2" (www.yvwiiusdinvnohii.net/Articles2000/JDForbes001126Blood.htm).
6. *Tribes* is another problematic but widely used term for the different Nations.
7. Whitehead is a descendant of many nations, including Anishinaabe, Mohawk, and Miami peoples.
8. The NMAI outlines the issues in detail alongside a life-sized photograph of James Luna's Artifact Piece considered in Chapter 12.
9. The Mall was redesigned and rescued from Charles L'Enfant's plan of the 1790s by Daniel H. Burnham in 1901. In a burst of planning activity, Burnham had commissions around the United States, but also in Manila, where his design is closely related to U.S. imperialist activity. See Hines ([1974] 1979).
10. Important, the NMAI ethos—characterized by a postmodern aesthetic and multivocality—was seen in exhibitions from the 1990s, including Creation's Journey,

where visitors experience voices of the "art historian," "anthropologist," and "Native" on objects displayed in New York (Hill and Hill 1994).

11. Several text panels employ this term developed by Indigenous academic Gerald Vizenor, which Rick West notes at the " 'Other' Cultures Within: Beyond the Naming of Things" symposium (2012).

12. Paul Gardullo cites this approach as vital to building the forthcoming National Museum of African American History and Culture.

13. The collection was originally established by the "passionate," obsessive, and "buccaneer" collector George Gustav Heye from around 1904 (McMullen 2009: 65).

14. For example, Jose Montano (Ayama) facilitates an excellent session handling and smelling materials including cedar bark.

15. Paul Chaat Smith notes the museum making a "radical departure from normal museum practice" in privileging indigenous voices throughout, not just in parts (2009: 99) while observing the difficulty, or impossibility, of working with "fragments" such as "gold, guns, Bibles" to speak effectively of the complex inheritance within the specified timescales and designated budgets to which all exhibitions are subject (2009: 108). In the United States, where museums are so dependent on private funding, this curatorial point is critical.

16. Karp notes the way communities are given "thinglike" names although they are experienced as "encounters" through which "attachments" are formed.

17. The term *survivance* at the NMAI, which we see operating between verb and noun, resonates in Glissant's term *relation*, discussed in Chapter 12.

18. In the film, Matt cites similar attacks, notably an attack on another young man, Mathew Shepard, who was beaten to death in 1998.

References

Anderson, B. 1983. *Imagined Communities: Reflections on the Origins and Spread of Nationalism.* London: Verso Press.

Anon. n.d. *All Things Cherokee.* Available at: www.allthingscherokee.com/articles_gene_040101.html. Accessed January 12, 2012.

Anim-Addo, J. 1995. *Longest Journey, A History of Black Lewisham.* London: Deptford Forum Publishing Ltd.

Appleton, J. 2001. "Museums for 'the People'?" In *Museums and their Communities*, ed. S. Watson, 114–126. London, Routledge.

Arnold, M. [1869] 1971. *Culture and Anarchy: An Essay in Social and Political Criticism.* Indianapolis and New York: Bobbs Merrill.

Arnstein, J. 1969. "A Ladder of Citizen Participation." *JAIP* 35 (4): 216–224. Available at: http://lithgow-schmidt.dk/sherry-arnstein/ladder-of-citizen-participation.html. Accessed February 2, 2012.

Barthes, R. 1993. *Mythologies*, trans. A. Lavers. Vintage. London: Granada Publishing.

Barrett, J. 2011. *Museums and the Public Sphere.* Oxford: Wiley-Blackwell.

Bennett, T. 1996. *The Birth of the Museum.* London: Routledge.

Bennett, T. 2005. "Culture." In *New Keywords A Revised Vocabulary of Culture and Society*, eds. T. Bennett, L. Grossman, and M. Morris, 63–69. Oxford, Blackwell.

Bhabha, H. 1995. *The Location of Culture.* London: Routledge.

Bolger, M. n.d. "From Hate to Hope." The Museum of Tolerance. Available at: http://www.museumoftolerance.com/site/apps/nlnet/content2.aspx?b=6771093&c=tmL6KfNVL tH&ct=8002591. Accessed November 30, 2012.

Brady, M. J. 2009. "A Dialogic Response to the Problematized Past: The National Museum of the American Indian." In *Contesting Knowledge: Museums and Indigenous Perspectives*, ed. S. Sleeper-Smith, 133–155. London: University of Nebraska Press.

Cameron, D. 1971. "The Museum, a Temple or the Forum." *Curator: The Museum Journal* 14 (1): 11–24.

Chaat Smith, P. 2009a. "On Romanticism." In *Everything You Know about Indians is Wrong*, 13–27. Minnesota: University of Minnesota Press.

Chaat Smith, P. 2009b. "Standoff in Letbridge." In *Everything You Know about Indians is Wrong*, 103–112. Minnesota: University of Minnesota Press.

Clifford, J. 1988. *The Predicament of Culture. Twentieth-Century Ethnography, Literature, and Art.* Cambridge, MA: Harvard University Press.

Clifford, J. 1999. "Museums as Contact Zone." In *Representing the Nation: A Reader Histories, Heritage and Museums*, eds. D. Boswell and J. Evans, 435–459. London: Routledge.

Cohen, R. and P. Toninato, eds. 2010. *The Creolisation Reader: Studies in Mixed Identities and Cultures.* London: Routledge.

Duncan, C. 1995. *Civilising Rituals inside Public Art Museums.* London: Routledge.

Forbes, J. 2000. "Blood Quantum: A Relic of Racism and Termination." Available at: www.yvwiiusdinvnohii.net/Articles2000/JDForbes001126Blood.htm. Accessed January 12, 2012.

Freire, P. 1996. *Pedagogy of the Oppressed.* London: Penguin.

Fryer, P. 1984. *Staying Power: The History of Black People in Britain since 1504.* London: Pluto Press.

Gardullo, P. 2012. "Making a Way Out of No Way: The Challenge of Building a National Museum of African American History and Culture." Paper presented at "Other Cultures Within: Beyond the Naming of Things Symposium at the John W. Kluge Centre, Library of Congress, Washington, DC, April 4.

Gilroy, P. 2004. *After Empire Melancholia or Convivial Culture?* London: Routledge.

Golding, V. 2009. *Learning at the Museum Frontiers: Identity Race and Power.* Surrey: Ashgate.

Hill, T. and R. W. Hill, eds. 1994. *Creation's Journey Native American Identity and Belief.* Washington, DC: Smithsonian Institution Press

Hines, T. 1979 [1974]. *Burnham of Chicago.* Chicago: University of Chicago Press.

hooks, b. 1992. *Black Looks, Race and Representation.* Boston, MA: South End Press.

hooks, b. and W. Cornell. 1991. *Breaking Bread: Insurgent Black Intellectual Life.* Boston, MA: South End Press.

International Council of Museums, 2007. "Definition." *ICOM Statutes*. Adopted by the 22nd General Assembly, Vienna, Austria, August 24. Available at: http://archives. icom.museum/hist_def_eng.html. Accessed February 2, 2012.

Ishizuka, K. 2005. "Coming to Terms: America's Concentration Camps." In *Common Ground: The National Japanese American Museum and the Culture of Collaborations,* eds. A. Kikimura-Yano et al., 101–122. Boulder, Colorado: University Press of Colorado.

Isaac, G. 2006. "What are our expectations telling us? Encounters with the NMAI." *The American Indian Quarterly* 30 (3/4): 589.

Janes, R. and G.T. Conaty, eds. 2005. *Looking Reality in the Eye: Museums and Social Responsibility.* Calgary: University of Calgary Press.

Japanese American National Museum. 2012. Available at: www.janm.org/education/ ndep/; www.janm.org/exhibits/commonground. Accessed December 4, 2011.

Jenkins, T. 2005. "The Museum of Political Correctness." *The Independent Review* (January 25).

Karp, I. 1991. "Introduction: Museums and Communities: The Politics of Public Culture." In *Museums and Communities: the Politics of Public Culture*, eds. I. Karp, C.M. Kreamer, and S.D. Lavine, 1–17. Washington, DC: Smithsonian Institution.

Kaufman, S. 2012. "Indian Museum Plans Major Changes in Exhibits." *The Washington Post*. Available at: www.washingtonpost.com/blogs/arts-post/post/indian-museum-plans-major-changes-in-exhibits/2012/02/16/gIQAVN5xHR_blog.html. Accessed March 22, 2012.

Kennicott, P. 2004. "A Particular Kind of Truth: As the Culture Wars Rage, a Rare Victory Over Routes of Knowledge." *The Washington Post* (September 19). Available at: http://www.smithsonianconference.org/expert/wp-content/uploads/2010/04/ A-Particular-Kind-of-Truth-wp-9-19-04.pdf. Accessed November 30, 2012.

Kirschenblatt-Gimblett, B. 1998. *Destination Culture: Tourism, Museums and Heritage.* Berkeley: University of California Press.

Lonetree, A. 2009. "Museums as Sites of Decolonization. Truth Telling in National and Tribal Museums." In *Contesting Knowledge: Museums and Indigenous Perspectives*, ed. S. Sleeper-Smith, 322–337. London: University of Nebraska Press.

Lynch, B. 2010. *Whose Cake Is it Anyway? A Collaborative Investigation into Engagement and Participation in 12 Museums and Galleries in the UK*. Paul Hamlyn Foundation. Available at: www.phf.org.uk/page.asp?id=1417.

Macdonald, S. 2009. *Difficult Heritage: Negotiating the Nazi Past in Nuremberg and Beyond.* London: Routledge.

McMullen, A. 2009. "Reinventing George Heye: Nationalizing the Museum of the American Indian and Its Collections." In *Contesting Knowledge: Museums and Indigenous Perspectives*, ed. S. Sleeper-Smith, 322–337. London: University of Nebraska Press.

Morrison, T. 1994. "In the Realm of Responsibility: A Conversation with Marsha Darling." In *Conversations with Toni Morrison*, ed. D. Taylor-Guthrie, 247–258. Jackson: University Press of Mississippi.

Museums as Sites of Conscience. 2012. Available at: www.sitesofconscience.org/. Accessed February 28, 2012.

Museum of Tolerance. 2012. Available at: www.museumoftolerance.com. Accessed February 26, 2012.

National Museum of the American Indian. 2012. Available at: http://nmai.si.edu/home/. Accessed February 28, 2012.

Okihiro, G. "National Diversity Education Programme." Available at: www.ncdemocracy. org/sites/www.ncdemocracy.org/files/docs/edframework.pdf. Accessed December 2, 2011.

Parekh, B. 2000. *The Future of a Multi-Ethnic Britain, The Parekh Report.* London: Profile Books.

Powell, E. 1969. *Freedom and Reality.* Surrey: Eliot Right Way Books.

Philips, R. 2004. "Reply to James Clifford's 'Looking Several Ways: Anthropology and Native Heritage in Alaska.'" *Current Anthropology* 45 (1): 25.

Rhadakrishnan, R. 2003. *Theory in an Uneven World.* Oxford: Blackwell.

Rand, J. T. 2009. "Curatorial Practices: Voices, Values, Languages and Traditions." In *Contesting Knowledge: Museums and Indigenous Perspectives*, ed. S. Sleeper-Smith, 129–131. London: University of Nebraska Press.

Richard, P. 2004. "Shards of Many Untold Stories: In Place of Unity, a Mélange of Unconnected Objects." *The Washington Post* (September 21).

Sandell, R. 2007. *Museums, Prejudice and the Reframing of Difference.* London: Routledge.

Shannon, J. 2009. "The Construction of Native Voices at the National Museum of the American Indian." In *Contesting Knowledge: Museums and Indigenous Perspectives*, ed. S. Sleeper-Smith, 218–247. London: University of Nebraska Press.

Silverman, L. 2010. *The Social Work of Museums.* London: Routledge.

Spivak, G. 2003. *Death of a Discipline.* New York: Columbia University Press.

Sweet, F. 2005. *Legal History of the Color Line: The Rise and Triumph of the One-Drop Rule.* Palm Coast, Florida: Backintyme Publishing.

Tate Modern. n.d. Available at: www.tate.org.uk/modern.

Vizenor, G. 2008. "Aesthetics of Survivance." In *Survivance Narratives of Native Presence,* ed. G. Vizenor, 1–23. London: University of Nebraska Press.

Weil, S.E. 1999. "From Being about Something to Being for Somebody: The Ongoing Transformation of the American Museum." *Daedalus* 128 (3): 229–258.

West, R. 2006. "Becoming Mediators of the Law." *ICOM News* 59 (3). Available at: http:// icom.museum/fileadmin/user_upload/pdf/ICOM_News/2006-3/ENG/p3_2006-3.pdf.

West, R. 2012. "The National Museum of the American Indian as Forum: Representing 'Other' Cultures Within." Paper presented at "Other" Cultures Within: Beyond the Naming of Things Symposium at the John W. Kluge Centre, Library of Congress, Washington, DC, April 4.

Whitehead, L. 2011. "Denying Assistance to Mixed Bloods Perpetuates Genocide." *IMDiversity.* Available at: www.imdiversity.com/villages/native/history_heritage/ whitehead_mixedbloods_genocide.asp. Accessed December 22, 2012.

Williams, R. [1976] 1988. *Key Words A Vocabulary of Culture and Society*. London: Fortuna Press, HarperCollins.

Young, I. 1990. *Justice and the Politics of Difference*. New Jersey: Princeton University Press.

Zaal, T. n.d. *From Hate to Hope* [video]. Available at: www.museumoftolerance.com/site/c.tmL6KfNVLtH/b.4866123/#. Accessed February 26, 2012.

Zotigh, D. 2011. "Will Current Blood Quantum Membership Requirements Make American Indians Extinct?" The National Museum of the American Indian (blog). Available at: http://blog.nmai.si.edu/main/2011/09/will-current-blood-quantum-membership-requirements-make-american-indians-extinct.html. Accessed on February 2, 2012.

–2–

The City, Race, and the Creation of a Common History at the Virginia Historical Society

Eric Gable

This chapter is a preliminary and schematic sketch of a research project I planned in November 2010, but have yet to undertake. My plan was to frame an ethnographic research project about imagined community around the theme that a city's museums are active participants in efforts at civic amelioration (see Conn 2010). Museums and modern cities in effect grew up together. Museums are deeply entwined with the civic projects of cities. Museums are emblematic of the city. As urban places lose their connections to older economic structures, as they lose population to suburbs and exurbs, they struggle to maintain significance as cultural hubs and destinations for cultural tourism. This current struggle links them to the fate of museums and to the history of their cultural symbiosis. Museums of a certain size need cities to thrive. Such museums are also integral to the health of cities—to cities' image and to their bottom line.[1]

I wanted to map out the various ways in which museums engage both explicitly and implicitly in urban renewal—in making a city a more salutary place. I planned to explore how several museums in the city of Richmond, Virginia, among them the Virginia Historical Society, the Valentine Richmond History Center, the Virginia Museum of Fine Arts, and about a dozen others, attempt to create a common imagined past in a city with a history of racial division and mistrust. Richmond is at once typical of smaller cities in America, and also perhaps an exemplary place to look at museums' role in the production of community and in the creation of civic engagement in a fraught environment. Richmond, like many cities, has in the last forty years lost population and economic clout to its surrounding counties. Racial divisions are exacerbated with demographic change. African Americans inhabit the city; the counties are dominated by white majorities. Museums in Richmond have historically explicitly engaged in various projects of racial amelioration and civic renewal. My goal was to chart these engagements in museums of art, history, and science as museum directors attempt to make communities, heal racial wounds, address economic worries, and make themselves an indispensable part of the urban and regional fabric.

In a more general sense I was concerned with what community means for museums, how communities work in the museum, and how museums work in communities to make

the city better. I assumed that community in the context of a city is as much work of the imagination—is *imagined* in the sense Benedict Anderson uses the term *imagined community* when he writes about nationalism and nations—as it is an actual demarcated place with people who recognize one another in ways that hark to Toennies's definition of community or *Gemienschaft* as opposed to society or *Gesellschaft*. Nevertheless, it is clear that cities are composed of communities in the latter sense. Cities have neighborhoods with patterns of sociality that act like Toennies's *Gemeinschaft*. But also, just as clearly, cities are shaped by that more amorphous if encompassing notion of community as a product of imagination.

Cities as imagined communities can in a sense be conjured into being by acts of the imagination. Imagined community is an implicit correlative of how people who inhabit a space come to think of that space and their relationship to consocrates. It is also at once an outcome of conscious efforts to shape the imagination by institutions such as museums. And this work of imagining can entail ignoring or overlooking communities, that is, not entering into dialogue with them, in favor of creating the potential for more utopian visions or projects. Yet all imagining must contend with the recalcitrance of the materiality of the museum itself and of the urban landscape that surrounds it and provides it a context. Thus, the guiding themes of the sketch I present in this chapter will concern the paradox of ignoring what we might call organic or real communities in favor of imagined ones, and the problem of the recalcitrant materials. Museums can imagine. But they are hardly portable and not as malleable as one would like.

What I offer is only a sketch, because a certain density of ethnographic detail is missing. I have not, as yet, interviewed directors, curators, and other actors in the museum world in Richmond, and while curators may mount exhibits, one would want to know, by observing meetings or informal encounters, how much shaping their directors do. On this score, I would stress that, in Richmond, and in the United States more generally, museum directors receive much of the credit (or blame) for the kinds of imagining their museums do. This may reflect the entrepreneurial nature of American museums, which are usually private and ever in search of patrons with deep pockets, corporate or individual. In Richmond, this is true even for public museums. The Virginia Museum of Fine Arts, ostensibly a public institution under the aegis of the state, is among the ten best comprehensive art museums in the United States and boasts the fifth highest endowment solely devoted to acquisition.[2] It recently completed an extensive expansion at a cost of $150 million and decided to make general admission free of charge. Similarly, the Virginia Historical Society, which is private (although, unlike art museums, which often begin their institutional lives through the agency of a single benefactor, is an institution based on the collective interests of a coterie of members), expanded its footprint, again through philanthropic donation, dramatically expanded its membership base, and made admission free. Such dramatic moves would not have been possible without charismatic directors who secure the backing of private philanthropy.

Indeed, it could be argued that large donors are the kind of organic community that is more than merely imagined, but realized in terms of the kinds of overlapping and enduring ties of affection one expects of face-to-face communities. In any event, at least at this

stage in my research, such a community hides in plain sight. The VHS has its donors' names carved in the very stone of its entryway. You see them as a silent list. The list of names juxtaposes individuals and couples, coupled with corporations, some so large everyone has heard of them, some smaller, even obscure. When you hear the names of these corporate donors, it is in the bland boilerplate of the public statement. Similarly, unless you are well plugged in, the conversations that may transpire between individual donors and the museum barely register—except perhaps in the traces of their effects on the museum itself.

Thus, for example, the VHS has, on the top of the steps leading to its entrance on a busy street, a bronze statue of an emaciated and exhausted horse along with an absent rider's "cavalry sword, bedroll, canteen and cup . . . still strapped to the saddle" (Urofosky 2006: 93). The statue, so the plaque reads, is "In memory of the one and one half million horses and mules of the Confederate and Union armies who were killed, were wounded, or died of disease in the Civil War." The horse statue stands in such a prominent place because one of the VHS's major patrons, Paul Mellon, whose millions made the expansion possible, is a horse lover who wanted this statue. It is the last (and probably will be the last) memorial to the Civil War erected in America, and the last erected in this city of such statues. Like most monuments, what it says to the public is hard to ascertain. My guess is that whatever it says has little to do with the VHS's larger mission. Instead, it might count as a sort of monument to affections and sentiment. As I have not observed nor interviewed directors and curators regarding their intent and motivation, let alone that obvious (if usually invisible) community of big ticket donors, I can hardly even speculate. Instead what I have to offer is a sort of bird's eye view of a landscape, coupled with curiosity.

The City

Richmond, the capital of Virginia, is a city that I live in and love in the way one is said to love a country or a sports team. It is also a city that, even though I have been here for twenty years, remains perplexingly opaque and recalcitrant to easy analysis or description. Richmond is of a certain type, representative, but also quintessential, exemplary.

According to its recent demographic history, Richmond typifies a city of a certain size in the southern United States. It is characterized by residential stability rather than cosmopolitan movement. In the 2000 census, for example, 95 percent of the city's residents were born in the United States and 67 percent were born in Virginia. Half lived in the same dwelling they had inhabited five years before. Only 8.7 percent had lived in another state or nation five years before. It is a city characterized by demographic stasis, even decline (with a slight current upward trend). After the end of segregation, its white population shrank from 240,000 to under 200,000 as the population of the city's surrounding suburbs grew to close to a million people and prospered as farmland was given over to housing tracts and shopping malls. As revealed by the 2010 census, Richmond's population has grown slightly, by

3.7 percent to 204,214, but the counties have grown much more, by over 15 percent, in the same period.[3] Roughly 51 percent of its inhabitants are black; 40 percent are white. Of the 22 percent of its population that live below the poverty line, almost all are black, while of the 32 percent with college degrees or higher, a majority is white. The city is small, comprising a little over sixty square miles, yet the neighborhoods are diverse in their physical shapes. They range from the neighborhoods of the establishment in the city's West End with its leafy hills and meandering roads edging along the river, to neighborhoods on the Southside—patchworks of 1920s suburban dwellings and post-1960s apartments that are integrated when scanned by census tract, segregated when explored block by block. They comprise older, less integrated neighborhoods such as Jackson Ward—a place still marked by its origins as an antebellum free black neighborhood—and Oregon Hill—a white working-class enclave associated with an ironworks that made Richmond an industrial center from before the Civil War.

Meanwhile, the million people who live in the surrounding counties are mostly white and have household incomes more than double those of the city's residents. There too, the neighborhoods scan as economically diverse. Those closest to the city are composed of cookie-cutter tracts that once beckoned to post–World War II working-class families and have remained working class, though now less white, more black, and increasingly Hispanic and Asian. Farther out are newer neighborhoods, among them the ubiquitous gated communities with McMansions and nearby upscale shopping malls.

These differences between the city and the counties also are entwined with political differences. The counties vote Republican in national and local elections. The city is staunchly Democratic. Richmond, like other cities in the South, is characterized by a black population stagnating in poverty, even as members of the African American community have taken over leadership positions in municipal government and bureaucracy—among its police force, its teachers, and so on. Meanwhile, business and political leaders struggled to implement solutions to urban decline and de facto segregation. For decades such business leaders, who often are Republican but who live with their families in the city rather than in the suburbs where their middle-level managers choose to reside, have called for integration, have tried to make their boards more representative of local demographics, and have tried to build bridges between what everyone feels comfortable calling the "business community" and the "local community."

Their counterparts in city government have tended to bank their hopes on various projects to make the city more attractive to potential consumers from the counties and also to the more amorphous tourist market; more recently they have pinned their hopes on the kind of urban revitalization that will attract creative professionals in the knowledge-producing industries. Richmond is the home of one of the state's largest public universities. Engineering and medical facilities have an increasing large urban footprint and economic impact, and the university's highly respected art school is also seen as an important economic engine, especially as the idea of the city as a cultural space comes to take precedence in vision statements and strategic plans. So far, many of the more ambitious efforts have been expensive failures or have led to plans commissioned and

introduced with great fanfare only to be shelved or forgotten. The county tends to avoid the city even as the city's residents head to the counties' shopping malls and movie theaters; potential visitors from out of state tend to drive through it at sixty-five miles an hour on the interstate highway.[4]

If Richmond is typical, it is also exemplary, for it is the capital of Virginia, a state with an esteemed pedigree deeply entwined with the birth of the American nation, but, as the erstwhile capital of the Confederacy, it is also associated with the Civil War. Traces of these historical eras are everywhere, albeit in ways that reflect subsequent active memorialization as much as they do the survival of pieces of the past into the present. Thus perhaps the most obvious feature of Richmond's landscape are monuments celebrating Southern heroes of the Civil War (see Chesson 1981; Driggs 2001; Edwards 1992). These monuments were erected, usually despite loud protests from the African American community, in the era after Reconstruction—a time that came to be associated with the New South, that time when Southern cities industrialized and modernized while enshrining in law and informal practices an American system of racial segregation. The New South, as has often been said, depended on the "Old Negro"—docile, out of sight, apart, but hard working.

As the New South gave way to the era of enforced integration, many of its policies continued to reinforce racial segregation. Black neighborhoods were riven by freeway developments; whole neighborhoods were bulldozed into oblivion, ostensibly because the housing stock, often dating from before the Civil War, was deemed substandard. Today, these communities also have suffered from the insertion of planned (but ill-conceived) urban housing developments, which have become sites for drug dealing and places of horrendous violent crime. Richmond is one of the murder capitals of America. But murder happens in a space of a dozen or so blocks.

In the era of enforced integration, New South white city suburbs were walled off from the city by transportation arteries that acted like virtual moats around virtual gated communities. The richest of these, with the finest architecture, places which today are the neighborhoods of the city's white establishment, were built during the apogee of the New South at the ends of electrified tramlines and in the styles of colonial-era houses, making the city appear older than it actually is. One such neighborhood grew up around a wide boulevard laid out through farmland and punctuated by roundabouts with large statues commemorating the most famous of Virginia's Confederate generals. This boulevard, called Monument Avenue and heralded by the American Planning Association as one of the nation's ten most beautiful streets, is anchored by an equestrian statue of Robert E. Lee, who faces south as if marshaling his troops—it is America's second tallest equestrian statue. This statue has become a virtual totem of Richmond, appearing on roadmaps and in travel magazines, often depicted as the marker of the center of the city. Monument Avenue is punctuated by the smaller but no less dramatic equestrian statues of Stonewall Jackson and J.E.B. Stuart posed as if leading a charge north. Laid out in straight line through countryside, an avenue of stately mansions quickly sprang up, flanked by streets with smaller but also substantial dwellings; a neighborhood called the Fan, it remains a prestigious

address today. And it is the site of one of Richmond's iconic community traditions—the annual Easter Parade, where as many as thirty thousand people stroll the tree-lined street, many wearing campy hats, many walking similarly decked-out dogs, while families in the mansions throw porch parties and hire bands to entertain the passersby. The parade is a ludic enactment of a certain and quintessentially Richmond noblesse oblige.[5]

Perhaps even more prestigious, if less visible to tourists and less at the center of the city's landscape, is another planned community that grew up around a transplanted Revolutionary-era manor house shipped from its rural site. The community also features a Tudor mansion brought over piece by piece from England by the New South's newly rich. Today, in the richest of these communities, almost all school-aged children attend private schools and swim in largely segregated private country clubs or bath and racket clubs. Many of the schools and clubs were built in the style of the plantation estate, their white columns and brick facades mimicking the era of Thomas Jefferson and George Washington. Of the approximately twenty-three thousand students who attend public schools in Richmond, only about thirty-five hundred are white and almost all of these are concentrated in elementary schools in neighborhoods that, while integrated, remain majority white.

Given this pattern of landscape and practice, it is not surprising that white people in the counties think of Richmond as primarily a black space, even as they occasionally make forays into town to share in its celebrations of whiteness—the Easter Parade, for example. Given this social landscape, it is not surprising that African Americans in Richmond still feel irked and angered by an environment that seems constantly to aggrandize a white vision of the world that celebrates white accomplishments while erasing the struggles of African Americans to find a place to call home. These are artifacts of imagination.

Can museums of a certain size find constituencies that transcend the limits of their emplacement in this divided geography? Museums such as the Virginia Historical Society, the Valentine Richmond History Center, and the Virginia Museum of Fine Arts cannot be other than urban museums, but to thrive they must have a broader audience than that. And to make the city a better place, they must bring this audience into the city for the city's benefit. Can these museums reshape ways of imagining a city so as to make that city a better place? I first offer a glimpse at how museums make community a part of the discursive field in their public documents. Then I briefly address the recalcitrance of the museums' materiality. Finally, I give a snapshot of the paradox of ignoring community in order to imagine other more salutary versions.

What Community?

As several of the contributors to this volume note, *community* is an explicit term among museum professionals. They use the term when they talk about their publics. Just as clearly, though, some museum professionals rarely refer to community and instead might

talk of the public, their publics, their audience, or their consumers. Each term implies a potentially different relationship. In my research, I have scrutinized public statements from the museums in Richmond to arrive at a sense of the rhetorical landscape they create and inhabit. Here I would like to respond to some suggestions raised by Jennifer Barrett in her *Museums and the Public Sphere,* where she makes several points about the relationship between museums as institutions and the idea of "the public" in modern nation-states. She also notes that the idea of community at once overlaps with the public as a concept and also is often taken for granted as an alternative, in fact a more authentic alternative, to the public in the museum world. Museums, Barrett shows, invoke the public as a reason for their existence. People who work in museums and who manage them use the term "loosely" and often in ways that are "tendentious, even opportunistic," yet, also, she stresses, because their connection to the public is taken for granted (2011: 1). Museums see themselves (and wish to be seen) as serving the public, usually by providing a space for its members to be represented or by providing information for them to become better citizens, that is, more informed members of a political and cultural public. The public often is portrayed as an audience, which conveys the idea that a museum communicates to this audience in order to teach it something important. In this manner, museums imagine themselves as engaged in building more salutary democracies. They also use their service to the public good in justifying their ongoing support by the state. As public institutions (like, for example, universities), they are at once a part of the state and stand outside it, much as the public as a collectivity are constituent of the state and potentially critical of it.

Barrett stresses that because the public is an aspiration and a composite of real people in diverse circumstances and with often conflicting perspectives, the public is a clearly an abstraction to those who invoke it. Singular—the public—it is also always plural— publics. In recent years, with the rise of multiculturalism, museums are much more likely to emphasize the plurality of publics and to stress that it is their role to provide spaces for greater inclusion rather than spaces dedicated to the pedagogical task of turning diverse subjectivities into a universalized public. The public as a national or cosmopolitan project now is seen by some museum professionals and by many who study museums as smacking of statist authoritarianism or of cultural ethnocentrism or elitism. Better to democratize the museum by making the space congenial to diversity; better to stress difference and multiplicity. It is in this project (Bennett famously stressed that it is part of the wider populist tendency always inherent in the museum project broadly conceived) that, according to Barrett, the idea of community enters into the discourse, often as not imported with unconsciously essentialist overtones (see Barrett 2011: 131–135).

If those who work in museums recognize that the public is an abstract aspiration, they often assume, without really thinking all that much about it, that communities are real. Indeed, because community is entangled in the language of multiculturalism, community often stands in for culture—in the sense of a group of people with shared values, world views, memories, experiences—and usually as a stand-in for minorities, either racial, or ethnic, implying, of course, their inappropriate exclusion, or inadvertent

disenfranchisement from the majority, which is never considered a community in its own right, although it may be called (to stress its abstraction) "society." For museum professionals, communities are exactly the kinds of people they currently wish to represent, to make space for, to celebrate. By putting community into the museum, museums make the public more democratic.[6]

What we might be witnessing, in short, is the romance of community among those who work in museums. Or the current interest in community among museum professionals may be driven by the same combination of opportunism and taken for granted common sense Barrett discusses regarding the discourse in the museum on the public. In any event, it is crucial to ascertain empirically whether or not museum workers invoke community when they advocate shifts in policy, mounting exhibits, making decisions about architecture, and so forth. In short, is *community* (like *the public*) a native term, something that gives us, to borrow from the quintessential anthropologist, Bronislaw Malinowski, a sense of the world "from the native's point of view"? If, as Barrett demonstrates so convincingly, *the public, public, publics* are native terms in the museum, is *community* similarly a native term?

Among the museums I am interested in Richmond, it is only partially so, at least if one looks at publicly available documents such as strategic plans and annual statements. Here it is instructive to contrast the mission statements of the Valentine Richmond History Center and the far larger Virginia Historical Society. The Valentine mentions community often and in ways that echo commonsense understandings of community among museum professionals. Its plan stresses that the Valentine "plays an active role in community building throughout the region as it collaborates with local historical societies, strategically engages the broader museum community and further establishes itself as a voice for Richmond's downtown and future growth" (Sarvay 2010: 2). Thus the Valentine claims that it: "already is an established leader among Richmond's downtown community but, as the region continues to grow outward, the History Center should expand its scope to include the greater Richmond region. . . . How the organization integrates itself into the lives of the region's outer ring communities will be of increasing importance in the coming years" (Sarvay 2010: 10).

Or, "The wants and needs of the Richmond region will shift with its changing demographics: the Hispanic community for example, will be interested in its own local history" (Sarvay 2010: 10). In sum, the Valentine uses community the way Barrett assumes it would. We have minorities—Hispanics—who should be included by including their past in the larger narrative. We have the "downtown community" and we have communities of practice, the broader museum community. The Valentine has, since the late 1980s, been a leader among museums in what has come to be known as the "new museology."

Its chief goal over the years has been to turn a museum associated with a New South business magnate, inhabiting a mansion associated with an old South patriarch, who bequeathed the mansion and his collection to the museum, into a place that focuses on the usually fraught relationship between black and white populations in Richmond. The Valentine has done path-breaking exhibitions on labor history and on segregation (Bunch 1989, 1992; Rice 1997). It has been famously "dialogical" in bringing visitors into conversations about how to mount and interpret exhibits.

By contrast, the Virginia Historical Society has been less concerned with community in any overt sense. Rather it tends to portray itself as an institution concerned with the public in a more amorphous sense. As its 2010 "Strategic objectives for the next decade statement" notes:

> The VHS board of trustees and staff are excited to present the approved strategic objectives that will shape this institution's planning and growth for the next few years. They have been adopted by our governing board with the understanding that we will begin the important work as soon as possible. We will bring together political, social, and economic themes in a comprehensive manner to excite, inspire, and inform our growing and diverse audience about the national and international significance of Virginia's long history.

Built upon a strong foundation of extraordinary collections, effective programming, and a skilled staff, these objectives and the specific goals related to them will advance the VHS's mission to tell the story of all Virginians, to connect people to the American past, and to prepare the next generation to participate in a successful democracy. So here we have a sense of an older, perhaps more authoritarian, or at least authoritative, museum—an institution that teaches and therefore shapes "an audience," making that audience better prepared "to participate in democracy."

Yet even the VHS slips into the language of community as in these excerpts from the strategic plan under the heading "Connect people to America's Past" illustrate:

> The historic core of the VHS headquarters faces the Boulevard, Richmond's cultural artery. With the centennial of Battle Abbey in 2012, the time has come to celebrate this face to the community. We will redesign the Boulevard driveway so that approaching vehicular traffic has an unobstructed view of this magnificent historic landmark, and pedestrian traffic has a safe, obstacle-free walkway to the front door. Not only will we make the front terraces more inviting and more available for events and other informal gatherings, but we will restore the galleries to their original grandeur, will highlight the impressive architectural features, and will conserve the monumental Charles Hoffbauer murals.

Likewise:

> A new interactive website—myfamilycamefrom.org—will make the VHS a leader in providing resources to the ever-growing community of people discovering their roots. The site will allow people to search for their family history in thousands of digital images of genealogical documents in our collections. They may comment on and share electronic resources. We will refocus our efforts to acquire and process additional genealogical resources with special emphasis on more recent immigrant groups to Virginia.

Here community seems to be informed by the same semantics that shape the strategic plan of the Valentine, if perhaps less consciously. Community stands for Richmond as a whole, the passersby on busy Boulevard, or the kinds of "authentic" communities museum professionals assume as a given—"people discovering their roots," "recent

immigrant groups." Nevertheless the tenor of the VHS plan is to shoot for an audience much larger than the merely local and therefore more in the manner of community as an imagined collectivity as Anderson theorized it:

> The Virginia Historical Society is positioned to become the best historical organization in the country so that national and international attention is focused on Virginia's role in the founding of American democracy and the contributions of all Virginians to our shared history.

This community is a nation not a neighborhood. It is a state imagined as united in offering a positive image to an audience that comes from somewhere else. That this community is a construct, a fiction, does not, however, make it less important to museums, especially of a certain size.

Recalcitrant Space

Monument Avenue runs east to west from the old city center. Bisecting it is Boulevard, a street associated with the city's two most prominent museums—the Virginia Museum of Fine Arts and the Virginia Historical Society. The space the museums occupy was once the site of Camp Robert E. Lee, a home for invalided and impoverished Confederate veterans, dedicated in 1883. The land was deeded to the city in 1892 in return for an annual appropriation. In 1921 the Confederate Memorial Association opened what soon came to be known as the Battle Abbey. Inside was a mural painted by Charles Hoffbauer dedicated to the "four seasons" of the war from the perspective of the Confederacy. Prominent are images of the great Confederate generals astride their horses—Jackson waving his feathered hat as if to rally his troops, Lee poised and serious on his white horse, members of his staff arrayed behind him and all looking forward as if inspecting the progress of a battle. But there are also poignant images of wounded and dying men in the Winter mural, which depicts an artillery battery in retreat, and each scene is infused with a certain bucolic sense: spring leaves, fall color, snow in dead of winter. For a time the building also housed, in a glass cabinet, the stuffed body of Stonewall Jackson's war horse as well as battle flags and other objects such as rifles, canteens, and so forth associated with the Lost Cause.

In 1946 the Battle Abbey was acquired by the Virginia Historical Society and it became the site for the museum and for the library. Thus the VHS joined the VMFA, which had been on the site from 1936. Inserted between these two large structures, and constructed fully a decade after them as if to reassert a certain claim to this space, is a third building, clad in marble—the headquarters of the Daughters of the Confederacy (Cox 2003). Behind these three buildings, on land now controlled by the art museum, is a small, wood-framed chapel, built by funds collected from Confederate soldiers and dedicated to the sacrifices of their comrades invalided or killed during the Civil War. That these buildings share space speaks to the recalcitrance of the landscape in Richmond; or, as the VMFA website puts it: "Having recently marked its seventy-fifth anniversary,

VMFA celebrates not only its history and accomplishments as one of the nation's leading comprehensive art museums but also acknowledges and commemorates the site's compelling and important early history."

Over the years since the VHS moved to the Battle Abbey it has added considerable square footage to that initial space. Jackson's war horse is long gone. Much larger permanent exhibits have eclipsed the collections of Confederate-era arms. Featured among these exhibits is a summative history of Virginia that meditates on such themes as slavery and segregation and stresses that African Americans almost exclusively fought in Union uniform during the Civil War, thus deflating a Lost Cause and current claims among many white Southerners that blacks served voluntarily in the Confederate army. The language throughout celebrates African Americans, as for example: "The Civil Rights movement was as revolutionary in changing Virginia as the war of independence and the Civil War"; and is mildly critical: "The Civil Rights movement did not achieve its goals, particularly ending poverty, but Jim Crow . . . is gone." The overarching theme of the exhibit is aspirational. Virginians will become Americans once they achieve racial equality. It is at once an uncontroversial message and also a strong one, especially given its location.

In 2006 the museum made its largest expansion to date and modified where the typical visitor would enter. Before 2006 visitors would go through the entrance on Boulevard, passing into the museum with the murals on their left and the Becoming Virginians exhibit on the right. But in 2006 visitors would enter a more modern space in what had once been the back of the museum. They would pass by a gift shop and climb a staircase flanking the granite walls with the carved names of prominent donors. At the top of the stairs they would encounter an exhibit of artworks depicting African Americans in the antebellum and segregation eras; the exhibit would at once celebrate their achievements and comment on the hurdles they faced in achieving anything. By flipping the museum, as it were, the VHS seemed to be making a dramatic statement about what kind of community it wished to imagine.

But those murals still exerted their power. In 2012 the VHS received a large grant from the National Endowment for the Humanities to restore the murals and started a campaign to solicit matching funds from the public. An advertisement for the campaign (picturing Stonewall Jackson triumphant on that horse and waving that feathered hat) reads, "Help us Save the Hoffbauer Murals," followed by a plea to local pride:

> Attention Richmond! As Richmonders, we know our art and history often reach beyond the city's borders to have national significance. . . . Generations of visitors to Battle Abbey, now the historic core of the VHS headquarters building, have marveled at their scale and the emotional stories they tell of defeat and loss. But a century has taken its toll. Flaking paint, dust, dirt, and grime cover the lessons of history found within these murals.

Along with restoring the murals, the VHS plans to restore as an entrance the old entryway to the Battle Abbey. It will be wheelchair accessible and visually inviting. In effect the museum will have two entrances, one leading upstairs past the names of philanthropists

and corporations, the other leading past a bronze statue of an emaciated cavalry horse sans rider and into a building that privileges Hoffbauer murals. The murals history lesson is an ambiguous one. It all depends on what one sees when one looks at Stonewall Jackson waving that hat.

Ignoring a Community in Order to Imagine Another

In October 2011 a half dozen or so members of The Sons of Confederate Veterans carrying Confederate flags began a silent vigil on the sidewalk facing the VMFA's entrance. They were protesting a decision by the VMFA to remove Confederate flags that had flown over the chapel since the late 1880s.[7] Their protest has largely been ignored in the local media. They confine themselves to passing out a brief flyer to passersby and to postings on a website. And the museum itself has kept its comments brief. As reported in the local newspaper:

> In preparation for the Civil War Sesquicentennial, the VMFA conducted extensive research on the chapel and determined that a flag did not historically hang out front, Bonadies [spokesperson for the VMFA] said. When the lease was renegotiated with the Sons of Confederate Veterans in 2010, the museum asked that the flags be taken down. "We thought that was an appropriate step to take at that point," Bonadies said.
>
> The Flaggers' request to fly Confederate flags is not under consideration, he said.
>
> "We take very seriously our responsibility to understand and interpret the history of our site," Bonadies said. "Our decision is based upon that research."
>
> Hathaway [spokesperson for the flag protestors] says the VMFA protest gives members of her group an opportunity to interact with passersby and explain what they are seeking. "We've had a lot of changed hearts and minds," she said. (Green 2012: 1)

The protestors claim on their flyer that:

> [T]he Confederate Flags represent the struggle by the Southern States to achieve goals that the founding fathers of our country initially sought to achieve . . . to have a government which recognized and protected individualism with self-government at the state and local level. . . . For over four years the South fought gallantly against a country with over two and a half times its population and almost ten times its industrial infrastructure. Unfortunately nobleness of intention and righteousness of cause do not always win wars. Although the South lost the War Between the States and was occupied by United States forces, the Confederate flags remain, both as a symbol of the Southern republic's struggle for freedom and a commitment to limited constitutional government. They are symbols as well of the continuing struggle of Southern people to preserve their sacred heritage.

These ideas are as old as the ideology of the Lost Cause that endorsed the erection of the Lee statue on Monument Avenue and the construction of the Battle Abbey.[8] They are signaled on bumper stickers on local cars showing a Confederate flag and the words "Heritage not Hate" or "If It Offends You, You Offend Me." Such sentiments

are increasingly becoming minority sentiments in the South, though they have a certain staying power. Recently political scientists have come to see them as part of what some call a neo-Confederate agenda (see Hague et al. 2008; Loewen and Sebesta 2010). In this discursive field the Lost Cause, with its emphasis on Southern white heroism and sacrifice coupled with black docility, has transformed itself into the kind of conservatism Americans currently associate with the Tea Party and with the Republican right. Confederate flags are emblems of a vision of America that sees government as tyrannical and that imagines an unjust appropriation of resources from places like the largely white counties that surround the majority black city of Richmond. According to a recent poll by the Pew Center for the People and the Press (April 8, 2011), 58 percent of Americans have neither positive nor negative reactions when they see the flag; 20 percent of Southerners still have a positive reaction. But these Southerners remain, in many senses, a community as Toennies defined it, and certainly imagine themselves as a community in Anderson's terms.

Conclusion: Opacity and Intent

Unlike the Valentine, the Virginia Museum of Fine Arts and the Virginia Historical Society are big enough and well-endowed enough to imagine themselves not as local sites, tethered to local players and audiences, but as institutions of national stature. As such they cannot sully themselves in controversies about the Confederate flag, nor can they allow themselves to serve the interests, however indirect, of neo-Confederate agendas. By putting distance between themselves and such groups, they run the risk of alienating what might count as organic communities in the region—all those white people in the counties that have hitherto been the target of hope for economic regeneration in a city that always seems to stagnate. The museums' audiences seem to increasingly consist of people who come from farther afield than the counties, though both institutions have used their new financial strength to open their collections to the public for free. Thus they benefit from a rise in local visitation. The numbers look very good and can be reported as such. Thus, too they allow locals to participate in an emerging success story as a regional magnet. Because of these museums and the crowds they attract, the city can be proud, can develop a sense of identity as a center of cultural pleasures. Richmond can define itself, in part by pointing to these museums as exemplifications, as an emerging new city of creatives and creativity. But Richmond also needs to reimagine the past it inherits from the New South as something other than heritage as identity. Can the VHS run a campaign with the image of Stonewall Jackson and make it into a question of aesthetics and local pride without conjuring up the ideals of the Lost Cause and the ideas of the neo-Confederates?

It is hard to know, given the preliminary stage of my research, whether such a question entered into VHS's thinking as it planned a campaign around the restoration of these murals. I also cannot ascertain at this point whether there was any discussion about community when the Virginia Museum of Fine Arts decided to remove the Confederate flags

from public view.[9] Were my work ethnographically informed at this stage I could perhaps make stabs at answers. But I am as yet in the space of opacity.

Notes

1. Much of the current language contained in strategic plans and the like emphasizes this interdependence as cities of a certain size in the United States try to make themselves into tourist destinations and congenial habitations for the "creatives"— middle-class workers in the knowledge industry who crave urban environments (see Florida 2002).

2. The VMFA stresses its public/private character as in, for example, the website's summary of its history, which begins: "In the midst of the Great Depression, on January 16, 1936, Virginia's political and business leaders bravely demonstrated their faith in the future and their belief in the value of art by opening the Virginia Museum of Fine Arts in Richmond"; and goes on to stress: "The idea of a state-operated art museum in Richmond, and the beginnings of an unusual partnership between private donors and state legislators, actually surfaced long before the new museum was built" when "in 1919, Judge John Barton Payne, a prominent Virginian who held high offices in law and national politics, donated his entire collection of 50 paintings to the commonwealth." Here we also learn that Judge Payne "proposed a $100,000 challenge grant to build a museum" and that "the challenge was accepted by Virginia Governor John Garland Pollard," who "helped to raise funds from private donors, but also promoted the use of state revenues to support the new museum's operating expenses." With this effort and "additional funds from the Federal Works Projects Administration, Judge Payne's dream became a reality."

3. Nationally, cities tended to grow at a greater pace than Richmond, roughly 12.5 percent, and the nation's population as a whole grew by about 9.5 percent.

4. A recent article in the local newspaper captures a sense of the city's anxiously hopeful efforts. It reports that city planners note that "one hundred cars an hour" on an elevated freeway pass right next to the enticing spire of Richmond's now underused architectural jewel, its downtown train station. The plan is to build a glass-roofed open-air market to attract these vehicular passersby.

5. Another similar event occurs on Halloween on Hanover Avenue in the Fan, the upper-middle-class neighborhood of early twentieth-century row houses that is bordered by Monument Avenue. Inhabitants decorate in elaborate excess the facades of these large well-appointed houses and throw costume cocktail parties for friends, while hosting a couple of thousand trick-or-treaters, mostly from working-class African American neighborhoods just a few streets away from the Fan's more posh ambience. One county person, remarking on the general quality of this kind of community in Richmond called it "N's and F's," or to translate without the exact but offensive terms, "blacks and gays." Both the Easter Parade and the Hanover Avenue costume and haunted house scene have a certain quality of gay camp associated with them.

Indeed, much of the Fan itself was gentrified (after a post-segregation economic decline) by members of the gay community.

6. *Community*, as museum professionals understand the term, is also what Barrett calls a "community of practice" (2011: 135–136)—fellow professionals in the museum world more generally. Much of what museum professionals say or write—that is, their discourse—might be directed at this community in the kind of unconscious way that professional discourses are produced. Likewise, such communities can be local and not merely imagined. In Richmond, there is an effort to coordinate messages and plans among the museums, so that all can cooperate in the larger effort of making the city a better place.

7. The flags were taken down in the context of the VMFA's hosting of a temporary exhibit of a private collection of Picasso's paintings. This exhibit attracted over 230,000 visitors and generated, according to estimates, roughly $26 million in economic activity, as reported by the museum to the *Richmond Times Dispatch,* July 25, 2011.

8. They are also part of the traditions of the Daughters of the Confederacy (see Cox 2003; for rituals of massing of the [Confederate Battle] flags there and on Monument Avenue, see Avery 1967).

9. As Steven Conn (2010) stresses, urban museums create a sense of community as people mingle in the space of the museum itself. Clearly, exhibits focused on African American themes draw African American audiences to the VHS and to the VMFA which, one assumes, also shifts white perceptions about who their consociates are.

References

Avery, T. 1967. *Massing of the Flags Ceremony at the Jefferson Davis Monument, Richmond, Virginia, June 3*. Richmond: The United Daughters of the Confederacy.

Barrett, J. 2011. *Museums and the Public Sphere*. Oxford: Wiley-Blackwell.

Bunch, L. 1989. "Review: 'In Bondage and Freedom: Antebellum Black Life in Richmond, Virginia, 1790–1860,' by F. Jewell, G.D. Kimball, and M. Tyler-McGraw, Chester Design Associates, Inc." *The Journal of American History* 76 (1): 202–207.

Bunch, L. 1992. "Fueled by Passion: The Valentine Museum and Its Richmond History Project." In *Ideas and Images: Developing Interpretive History Exhibits*, eds. K.L. Ames, B. Franco, and L. Thomas Frye, 283–311. Nashville, TN: AltaMira Press.

Chesson, M.B. 1981. *Richmond after the War, 1865–1890*. Richmond: Virginia State Library.

Conn, S. 2010. *Do Museums Still Need Objects?* Philadelphia: University of Pennsylvania Press.

Cox, K.L. 2003. *Dixie's Daughters: The United Daughters of the Confederacy and the Preservation of Confederate Culture*. Gainesville: University Press of Florida.

Driggs, S. 2001. *Richmond's Monument Avenue*. Chapel Hill: University of North Carolina Press.

Edwards, K. 1992. *Monument Avenue: History and Architecture*. Washington, DC: U.S. Department of the Interior, National Park Service, Cultural Resources.

Florida, R. 2002. *The Rise of the Creative Class: And How It's Transforming Work, Leisure, Community and Everyday Life*. New York: Perseus Book Group.

Green, K. 2012. "Protesters want Confederate flag to fly over Virginia museums." *Richmond Times-Dispatch* (March 24). http://www2.wsls.com/news/2012/mar/24/tdmet01-group-wants-confederate-flag-to-fly-ar-1790088/

Hague, E., H. Beirich, and E.H. Sebesta, eds. 2008. *Neo-Confederacy: A Critical Introduction*. Austin: University of Texas.

Janes, R.R. 2009. *Museums in a Troubled World: Renewal, Irrelevance or Collapse*. London: Routledge.

Lindgren, J.W. 1989. " 'For the sake of our future': The Association for the Preservation of Virginia Antiquities and the Regeneration of Traditionalism." *Virginia Magazine of History and Biography* 97 (1): 47–74.

Loewen, J.W. and E.H. Sebesta, eds. 2010. *The Confederate and Neo-Confederate Reader: The "Great Truth" about the "Lost Cause."* Oxford: University Press of Mississippi.

Rice, K. 1997. "Review: 'Creating History: The Valentine Family and Museum. A Discussion about the Past, Memory and History' by Selma Thomas." *The Journal of American History* 84 (3): 997–1003.

Sarvay, J. (2010) *The Valentine Richmond History Center Strategic Plan*. Available at: http://www.richmondhistorycenter.com/about/strategic-plan.

Tartar, B. 2007. "Making history in Virginia." *The Virginia Magazine of History and Biography* 115 (1): 2–55.

Urofsky, M.L. 2006. *The Virginia Historical Society: The First 175 Years, 1831–2006*. Richmond: Virginia Historical Society.

Negotiating the Power of Art
Tyree Guyton's Heidelberg Project and Its Communities

Bradley L. Taylor

Within the realm of artist-curated community spaces, few locations are as engaging as Tyree Guyton's Heidelberg Project, an outdoor art installation located in the heart of Detroit, Michigan, where it has been in an ongoing state of evolution for over twenty-five years. The Heidelberg Project employs abandoned houses along a two-block stretch of Heidelberg Street as both canvas and backdrop for a series of artworks mostly comprised of found objects that are further integrated into Guyton's creations. The net effect is visually dazzling and larger than life—blocks of brightly painted houses, upright car bonnets painted with the "eyes of God," rows of broken hoovers standing at attention, tree branches sagging under the weight of hundreds of shoes, stuffed animals attached by the dozen to trees and the sides of buildings. The street surface itself springs to life, painted by neighborhood schoolchildren, with hundreds of polka dots offered as a tribute to Guyton's grandfather and his love of jellybeans. Guyton has described his Heidelberg Project as artwork intended to uplift the local community and show youth especially that positive choices exist in their lives. This notwithstanding, the history of the Heidelberg Project has involved considerable controversy within various communities, communities the Project actively engages and others it has chosen to critique. The purpose of this chapter is to use Tyree Guyton's Heidelberg Project to examine the complexities attendant in considering one individual artist-curator's role in what is all too simply referred to as "the community."

Evolution of the Heidelberg Project

The Heidelberg Project is situated in a residential neighborhood, in an area once known as Paradise Valley, a center of African American life in Detroit for much of the twentieth century. In fact, for much of the twentieth century it was the only section of Detroit in which African Americans were allowed to live. The Heidelberg Project's artist and creator, Tyree Guyton (b. 1955), grew up in a house on Heidelberg Street and was raised in this neighborhood—for many years he had family that lived on Heidelberg Street and

he himself now owns several of the remaining properties on the street. Guyton grew up in Detroit at the apex of Detroit's population growth, which, during the 1950s, approximated 1.8 million residents. Detroit is known to many as the capital of American automobile production, an industry that predominated for generations in Detroit, its suburbs, and the state of Michigan as a whole. Detroit was, for decades, one of the most populous cities in the United States, with thriving businesses, a number of well-funded and important cultural institutions (a leading symphony orchestra and the Institute of Arts among these), and a public school and library system envied by many other cities.

During the relative prosperity of the 1950s and 1960s, driven by the growth of the national interstate highway system that cut through many long-established neighborhoods in the city, many of Detroit's whites moved from the city to the rapidly expanding suburbs. This "white flight" was exacerbated over time by Detroit's infamous 1967 race riots, the relocation of American automobile production to other parts of the country, and a steady loss of American automotive market share to foreign automakers. The effect of these factors and others on Detroit was considerable: 2010 U.S. Census figures count Detroit's current population at just over 700,000; Detroit's African American population has grown to be 82 percent of the overall population (making it one of the most segregated cities in the country), much of Detroit's business base has disappeared, Detroit is plagued with disproportionately high crime statistics, and the travails of the U.S. automotive industry and its attendant impact on the economic and social life of Detroit (the permanent loss of tens of thousands of white and blue collar jobs, the erosion of Detroit's tax base as the auto industry contracts, and a steady decline in the middle-class standard of living) have garnered national attention.[1] This is the Detroit in which Tyree Guyton's Heidelberg Project first emerged.

Guyton, a graduate of Detroit's prestigious Center for Creative Studies, was, in fact, a formally trained artist when what many assumed to be the work of a folk or outsider artist, the Heidelberg Project, first appeared in 1986. It has been in a constant state of evolution since. For those who have never been there, the Heidelberg Project is almost impossible to describe—Simon Rodia's "Watts Towers" (built 1921–1953) in Los Angeles is often cited as sharing similarities; it is a kindred spirit perhaps, but it comes from a wholly different artistic tradition and fails to share the social agency that defines much of the Heidelberg Project. Both are large-scale urban art installations, mostly the work of a single artist and creator, that appear, to the unknowing, to be the works of untrained artists. Guyton's Heidelberg Project initially centered on abandoned houses along Heidelberg Street as both a canvas and a backdrop for a series of artistic creations, informed largely by the artist's biographical experiences and intended to be "medicine for all people."

The house exteriors were transformed using a variety of visual elements and artistic techniques, many bearing Guyton's signature brightly colored painted polka dots (a loving tribute to his maternal grandfather's love of jellybeans), the application of material artifacts to the surfaces of the houses (often stuffed animals, a reference to the return of wildlife—including wild turkeys, foxes, and coyotes—to Detroit's many nearly building-less streets), and a profusion of artifacts and color spilling forth from these houses in a

manner that appears to many to be chaotic, random, and supremely disorganized. Thus, on more than one occasion, Guyton's work has been dismissed as "junk" (Cattell 1999). Apart from the houses themselves, the Heidelberg Project also includes works or groups of works that populate the yards of the houses, the trees on the street, even the street itself. Guyton makes intentional use of found objects, almost always castoffs retrieved from frequent trips made in his lorry around Detroit's neighborhoods. These items may form the canvas for new works (there exists a series of car bonnets from abandoned automobiles that have been painted with the "eyes of God") or they may be used as themselves, sometimes in multiples, to create other types of work (a series of prearranged hoovers "that don't work" critique one-time members of the Detroit City Council in an empty lot along the street). One of the large trees teems with hundreds of pairs of shoes laced together and tossed up into the branches, the so-called tree of soles (souls?) evokes Grandpa Sam Mackey's childhood recollections of lynchings in the American South where, he remembered, "all you could see were the soles of the feet" (Cattell 1999). In short, the Heidelberg Project is all encompassing and powerfully evocative—houses, found objects, vacant yards, trees, the street surface itself awash in great daubs of color, richly textural, clamoring for attention. And, as with all complex works of art, one's understanding of it and response to it are continuously evolving; no two visits seem alike.

The growth of the Project did not occur in a straight line nor was the now celebrated work always received as such. At several points in its early evolution, portions of the Heidelberg Project were demolished by wrecking crews from the City of Detroit.[2] In November 1991, Mayor Coleman Young sent bulldozers to remove four abandoned houses that Guyton had utilized on property that had reverted to the ownership of the city. In September 1998, the Detroit City Council ordered the Department of Public Works to destroy everything Guyton had placed on city land (frequently private property that had reverted to city ownership for failure to pay back taxes). By the end of demolition, some reports stated that 70 percent of the Heidelberg Project had been destroyed. Finally, in February 1999, Mayor Dennis Archer ordered a subsequent demolition, which effectively removed another 35 percent of the remaining Project. In these instances, the removal of these abandoned homes also resulted in the loss of multiple individual artworks either stored inside the properties or displayed on the adjacent grounds. At the time of these demolitions, litigation was pursued and individuals from the art establishment and the academy emerged to advocate for Guyton and his work, but to no avail. Ironically, Guyton had been awarded the city's "Spirit of Detroit" Award by the Detroit City Council in July 1989, and he received numerous other awards and commendations during the course of his struggles with the city—from this period alone, the Michiganian of the Year Award (1991), the Governor's Arts Award (1992), and Wayne State University's Humanity in the Arts Award (1992). The demolitions cited here are but a small example of an extended cycle of destruction and litigation that characterized the life of the Project until only very recently.[3]

Neither was the Project universally embraced by community residents. Some of the residents of Heidelberg Street voiced objection to the Project on grounds of health and sanitation concerns and the very appearance of the Project itself. Over time, the Project

has mitigated some of this local opposition by becoming an employer for local residents and by touting crime statistics for the immediate neighborhood that compare favorably to the city as a whole, thought to be a result of the increased traffic volume the Project brings to Heidelberg Street. That said, local residents still object to the daily sea of faces peering out from the safety of locked automobiles moving slowly down the street; these residents resent having become part of the spectacle on the street and an attendant loss of privacy. Heidelberg Project staff are keenly aware of this sensitivity and caution others about the need to be respectful of local residents and their property, but it is difficult for visitors to distinguish where the Project proper begins and ends. Similarly, Guyton's pointed critique of Detroit's church community (a cash register on a lectern titled "Is Religion Big Business?" as an example) and the City of Detroit itself (the aforementioned inoperable hoovers) have fostered long-standing antipathy in those quarters, often resulting in an absence of important political support that might have proved useful in the early years of the Project. That the Project has also offered a unique and substantive model of community engagement is all the more interesting given the complex relationships that have characterized the Project for much of its history.

Experiencing the Heidelberg Project

Given the unique nature of the Heidelberg Project, it is important to gain a sense for how one experiences the site. Unlike many traditional cultural sites, there is no entrance point, no visitor center, no way-finding materials, no suggested route, no exhibit labels or other didactic materials. The site may be approached from various points of entry, though the most commonly used are from either end of Heidelberg Street. If Heidelberg Street in all is, perhaps, ten city blocks long, the Project itself takes up the better part of two blocks at the east end of the street, plus one or two properties on a cross street. Most visitors arrive by automobile and either park to explore further on foot or drive slowly up and down the length of the street, occasionally doubling back to see more. Many visitors can conclude their visit within fifteen to thirty minutes, though there is no set amount of time required for completing one's stay at the site. The entirety of the site is outdoors and length of stay and nature of the experience are likely to be influenced by the outdoor temperature (Detroit has hot, humid summers and very cold winters) since there is currently nowhere for visitors to escape the weather (other than inside their own automobiles). It is not uncommon to find Tyree Guyton working at the site (though there is no way of determining this in planning a visit) and, on occasion, one will hear music emanating from one of the Guyton-owned properties (he enjoys classical music) while he is on the site. While one may come across others experiencing the site on one's visit, there are rarely more than a handful of others visiting simultaneously.

The scale of the site and the vibrancy of the installations can be overwhelming to visitors. The Heidelberg Project is all encompassing and challenges one both cognitively (most have never seen the like of it before and cannot immediately reconcile it with its surroundings nor with any known precedent) and sensorially (the sense of scale, the

visual tumult, the assertive use of color, the use of utilitarian objects in new and unexpected contexts, the sounds of recorded music or adjacent street traffic, the repetition of iconographic elements [polka dots, shoes, stuffed animals, the "eyes of God"] in large multiples), as well as through a diversity of visitors to be encountered (a coming together of populations rarely experienced otherwise in a highly segregated region), a sense of movement and flow never captured in even the best photography, and the difference the seasons make on how the Project looks (colors become muted in a grey Michigan winter but dominate exuberantly in the spring and summer). The effect of the site on new visitors is fascinating to behold. As a frequent escort to the Project for scholars visiting my university, I often observe looks of wonderment if not outright disorientation on the faces of my guests. For a complete understanding of the effect of the site on visitors, it is essential to have this appreciation of the complex and dynamic nature of a visit to the site as it relates directly to the dialogic nature of the experience and is at the heart of Guyton's efforts to engage the community.

It is challenging to articulate the various ways in which the public interacts with the Heidelberg Project—those of us familiar with the ways in which traditional museums engage their communities (through targeted exhibits, on-site programming, and outreach activities) are confronted with new, subtly nuanced paradigms. For as much as the Heidelberg Project is intended as "a medicine for all people," this medicine is most often delivered on site through individual encounters with the artwork. While the Project is intended to "uplift," to "provide alternatives," and to "heal," the way it achieves this end is largely by encouraging personal creative exploration and experimentation in others. Guyton's work(s) remain autobiographical, individualized, and personal. The Heidelberg Project is *his* artistic statement. And while Guyton's work is dialogic, it is not collaborative.

Guyton has committed little to paper about the Heidelberg Project, preferring that the art speak for itself and that his audience members consider for themselves how the work speaks to them. Even in face-to-face conversation, Guyton shows little willingness to interpret his work. Additionally, there is no "community curation" in evidence here in the ways the concept is emerging elsewhere—members of the community, local or virtual, are not solicited for ideas for topics or themes for exhibits, asked to vote on pieces for inclusion, or to provide alternative points of view, levels of interpretation, or social tagging. Instead, a major objective of Guyton's artistic mission is, by example, to spark the creative spirit in *others*, helping visitors discover their own personal Heidelberg Projects.

That said, the Heidelberg Project is not exclusively an artistic undertaking. The Project's past has been associated with social change aspirations. The Heidelberg Project justifiably points to the positive impact its presence has had on the community—a drop in the local crime rate within the few blocks immediately surrounding the Project, a slight increase in local employment (due, in part, to the hiring the Project itself does), a modest increase in local property values, and the appearance of cleaner streets in the neighborhood. Other artists have been drawn to the energy of the Project, have purchased property on the street, and have moved their studios from the suburbs into Detroit. The Project has partnered with Ralph Bunche Elementary School (within sight of Heidelberg Street) and has become the de facto provider of art education to the students in the school. And staff

members at the Heidelberg Project can now proudly point to their role in drawing tourism to Detroit—it has become a destination point for fifty thousand visitors annually. Most significant, a recent study of the impact of the Project suggests that the total annual economic impact of the Heidelberg Project to Wayne County is approximately $3.4 million (Center for Creative Community Development 2011).

Jenenne Whitfield, executive director of the Heidelberg Project, limns a larger social agenda for the Project through shared stories of Guyton's long-standing concern with the high number of abandoned houses throughout the city, sites frequently associated with crime. Knowing that city leaders in the past were eager to contain the Heidelberg Project, Whitfield says that Guyton, on occasion, traveled to different parts of the city, where he painted several polka dots on abandoned houses not part of the Heidelberg Project. This caused the city to hastily dispatch crews to complete the process of demolishing these buildings. The city thereby contained the Project, and Guyton achieved his goal of reducing the number of abandoned buildings in Detroit. Traditional museums may not consider addressing the blight of abandoned houses in an urban environment a focal part of their outreach efforts, but such advocacy is considered an integral part of the Heidelberg Project's overall commitment to the local community. The Heidelberg Project is so integrated into its community and draws such inspiration from relationships with multiple groups that one simply cannot imagine it existing anywhere else.

The site is further engaged with the community through its intensely dialogic nature. While many traditional brick-and-mortar museums have interpreted community engagement through decidedly "institution centric" means (i.e., the museum itself is the driving force in the relationship, preparing programs and activities that it attempts to market to the public), the nature of the Heidelberg Project's community engagement is more multifaceted, less easily categorized. In this case, the Project's multiple communities do not simply exist to consume the programs and activities devised by the institution. Several of the Project's communities are partners in an extended dialogue carried out through volleys between Guyton (through his artwork(s)) and City Council/local churches (through official action/public condemnation/disgruntled neighbors). Others have the unique opportunity to engage with Guyton at the site: Jenenne Whitfield famously encountered Guyton and the Project for the first time when she turned the wrong way onto the street and subsequently found herself discussing the merits of the site with the artist himself. Guyton's desire to engage the viewer even when he isn't present extends to his use of interrogative titles in a number of his works ("Where Are You Going?", "Is Religion Big Business?" etc.). While others are often eager to discuss his artwork and its meaning, Guyton frequently returns questions with questions, suggesting a greater interest in dialogue than pat answers.

The Heidelberg Project within the Context of Museums

By focusing on the Heidelberg Project's unmistakable "otherness," most have overlooked how closely aligned it is, in fact, to an institutional model very familiar to us—the museum. Like museums, the Heidelberg Project maintains collections of artistic merit,

offers outreach and educational programs to its audience, attracts visitors who come from a distance to see it, is funded by a combination of grant monies, private philanthropy, and earned income, and is perceived as an asset of significant value to the community. And, among his many roles, Tyree Guyton serves not only as artist-creator but also as artist-curator, one who cares for his collections and presents them to the public. Far more than in any of these superficial similarities, however, it is in the unique integration of the Heidelberg Project in the surrounding geographical community that Guyton's work most closely resembles a museum—specifically, a model first promulgated in the United States over 100 years ago.

In his Newark (New Jersey) museum, John Cotton Dana (1856–1929) developed a unique institution, shaped in large part by Dana's tenure in the field of American public libraries, that existed for the benefit and the betterment of his local community—"something that would please, instruct, and provoke to thought and action those who used it" (Dana 1923: 581). To be sure, Dana wasn't the first to suggest the various economic, societal, and individual benefits that could accrue locally from the introduction of a museum to a community (much of the nineteenth century had borne witness to the evolution of this phenomenon in the Western world). But Dana sought both to engage and *serve* his community in ways novel for the time. He decried the model of the collecting institution, feeling that the energy and resources involved in building and maintaining museum collections directed attention away from what he believed to be the necessary focus of the museum—people—the shopkeepers, tradesmen, schoolchildren, laborers, the educated and undereducated, the overly well served and the underserved that formed the basis of Dana's home community. Dana's museum was populated with exhibits drawn from the community—art objects, stamps, and coins from the city's collectors, accumulations of plaster casts, fine art reproductions, and photographs of classic artworks intended to educate, frequent exhibits of locally produced manufactured goods (intended to promote civic pride and serve as lessons in good industrial design)—as well as collections that could be sent into local public classrooms for instructional use and a large collection of original artifacts that circulated to private citizens in much the same way library books might. While Newark's collections would never rival those of museums in nearby New York City, Dana allowed his museum to emerge from behind faux temple facades and park-like settings to achieve a level of integration with the local community that would have a notable—albeit not entirely sustainable—effect on other public museums in the United States.

While Dana's model innovated in its move away from collections-based museums and toward audience-based museums, it never strayed far from activities (i.e., exhibitions, education, programming) thought a legitimate part of museum work. Dana's advocacy led to a brief flowering of public museums in the early twentieth century in such American cities as Newark, Milwaukee, and Grand Rapids that existed to serve their communities through many activities that might surprise us today—not only exhibits of borrowed materials but literacy classes, voter registration drives, blood donation clinics, after-school programs for youth, assistance with housing for immigrant families, and so forth (Stivers 2004). A number of ethnic and cultural museums saw their origins in social

service programs for targeted populations (the Arab American National Museum, for instance, emerged from the Arab Community Center for Economic and Social Services).

In our own time, modern-day theorists like Elaine Heumann Gurian have asked if the real work of museums in today's economic climate might consist of running soup kitchens and making space to provide shelter for the homeless (Gurian 2010). This spirit of community advocacy seems to be best exemplified by the member museums of the International Coalition of Sites of Conscience, a consortium of member museums whose work encompasses dealing with the legacy of apartheid, issues related to terrorism, support to immigrant populations, and so forth. While these sites maintain historic sites and engage in activities related to collecting, educating, preserving, and so on, they likely see community advocacy as their primary reason for being. It is within this broader social role for the museum in the community that Guyton's Heidelberg Project can be considered—something at once rooted in historical precedent yet defined by the issues of its own time and place.

Assessing Impact

While recognizing the multiplicity of communities the Heidelberg Project engages—as objects for critique or populations to serve—it is imperative to become more precise in how we measure or assess the impact of museums within the community. Traditional brick-and-mortar museums have adopted a variety of measures to assess their impact in the community—increased ticket sales, the sale of museum memberships, the number of visiting school groups, an increase in general program attendance, attendance at exhibitions targeting a particular constituency, the number of hits on a museum website, greater media coverage, increased teacher involvement, and so forth. While museums eagerly embrace such quantifiable measures as a means of underscoring their value to the community, such data are difficult to tie directly to outreach efforts, and these measures in and of themselves do not constitute the truly transformative outcomes museums like to think they can effect.

From the very start, Guyton's Heidelberg Project was grounded in an awareness of people—the residents of Heidelberg Street, the schoolchildren at Ralph Bunche Elementary School, Detroit's church community, the politicians at City Hall, the media, suburbanites who eagerly visited to see his colorful creations, fellow artists who moved to Detroit to draw from the energy of Heidelberg Street, international visitors who came and extended invitations to create elsewhere, art collectors, and individuals from across Detroit who came out of curiosity. Guyton's eagerness to engage with the *multiple* communities (there is no single, monolithic community here) that exist for his work has infused the Project with a deep sense of humanity, because the focus of the Project has always been people, even if the message used to connect has been art.

In fact, Guyton's work does much more than serve its public; it utilizes the material detritus of the community in the creation of (re)new(ed) works of art, and it encourages the community to become part of the ongoing creative process at the Heidelberg Project. In one of Guyton's most recent ventures, a call went out for donations of shoes and stories

to become part of a new installation on Heidelberg Street. Many of the donated shoes would be incorporated into the artwork and even more would be distributed to those who needed shoes, but *all* of the shoes would serve to connect people with other people since each donor was asked to include a story in a message tucked inside the shoes. Similarly, plans have been developed for extending Guyton's work off Heidelberg Street into the long abandoned Brewster-Douglass Housing Projects. This site was home to the three young women who would become best known as Diana Ross and the Supremes, exemplars of Detroit's singular contribution to popular music in the late twentieth century, the Motown Sound. It is believed that the Brewster-Douglass Projects are soon to be razed to make way for a new sports arena; before that happens, Guyton is eager to celebrate and document the Supremes' contribution to Detroit's cultural scene by using several of the housing towers as a canvas for new art. In the cases of the shoe project and of the Brewster Project plans, it can be seen that Guyton's work transcends a mere extension out to serve or solicit interaction from the community; the Heidelberg Project engages the community itself as raw material, subject matter, canvas, collaborator, and audience. As museum critic Stephen Weil might have observed, Tyree Guyton produces work that is not just "for" the community; it is truly "of" the community. In this sense, Guyton's work transcends the service-based museum embraced by Dana, expanded in places like Grand Rapids and Milwaukee in the early twentieth century, and linked to community activism by organizations like the International Coalition of Sites of Conscience to create a new model for museums to consider in our own century—the truly inclusionary museum.

Whitfield and Guyton resist comparisons of the Heidelberg Project to the institution of the museum. For now at least they find the work they do (creating a site to inspire and uplift activism on behalf of the local community) to fall outside the scope of activities they associate with museums. And while local museums (the Detroit Institute of Arts, the University of Michigan Museum of Art, the Charles H. Wright Museum of African American History) eagerly collect and exhibit Guyton's artwork, I don't imagine they would any more readily embrace the comparison. And yet, all these institutions share far more similarities than differences, especially when it concerns a sincere desire to involve the public with their collections, foster a personal connection to art, even in their desire to effect positive change, regardless of their differences in doing so. Still, while traditional museums are often proscribed in their ability to achieve these ambitious ends, Guyton's Heidelberg Project, drawing inspiration from and aiming to assuage the most pressing issues facing Detroit's poor—a *people*-based, not *collections*-based institution—has successfully engaged that community and, doing so, has gone on to engage many others. Who would have imagined that in all of the seemingly random and chaotic work on Heidelberg Street, Tyree Guyton was actually building a space for all of us?

Notes

1. The crisis in Detroit has come to stand as a proxy for the recent economic downturn in cities across the country, and is thought so significant that *Newsweek*, a New York-

based national weekly magazine, has assigned a reporter to live in the city to cover the story firsthand.

2. A richly detailed bibliography of the Project's history as depicted by local media (newspaper and television coverage especially) can be found on the Project's website: www.heidelberg.org.

3. Guyton eventually purchased numerous properties and empty lots on Heidelberg Street so that the Project no longer sits on city-owned property.

References

Alexander, E. 1995. "John Cotton Dana and the Newark Museum: The Museum of Community Service." In *Museum Masters: Their Museums and Their Influence*, 377–411. Lanham, MD: AltaMira Press.

Beardsley, J. 2007. "Art or Eyesore?" In *Connecting the Dots: Tyree Guyton's Heidelberg Project,* 39–47. Detroit, MI: Wayne State University Press.

Carducci, V. 1990. "Artnotes: Detroit's inside 'outsider.'" *New Art Examiner* (January), 64.

Cattell, N. 1999. Inside "Outsider;" *Come Unto Me: The Faces of Tyree Guyton* [film]. New York: Naked Eye Productions.

Center for Creative Community Development. 2011. *A Brief Summary of the Economic Impact of The Heidelberg Project on Wayne County, Michigan.* Williamstown, MA: Center for Creative Community Development.

Connecting the Dots: Tyree Guyton's Heidelberg Project. 2007. Detroit, MI: Wayne State University Press.

Cubbs, J. 1994. "Rebels, Mystics, and Outcasts: The Romantic Artist as Outsider." In *The Artist Outsider: Creativity & The Boundaries of Culture*, eds. M. Hall and E. W. Metcalf, 76–93. Washington, DC: Smithsonian Institution Press.

Dana, J. C. 1916. "Increasing the Usefulness of Museums." *American Association of Museums Proceedings* 10: 80–87.

Dana, J. C. 1917a. *The Gloom of the Museum (with Suggestions for Removing It).* Woodstock, VT: Elm Tree Press.

Dana, J. C. 1917b. *The New Museum.* Woodstock, VT: Elm Tree Press.

Dana, J. C. 1920. *A Plan for a New Museum: The Kind of Museum It Will Profit a City to Maintain.* Woodstock, VT: Elm Tree Press.

Dana, J. C. 1922. "Use of Museums." *Nation* 115: 374–376.

Dana, J. C. 1923. "A Museum of Service." *Survey Graphic* 49 (February): 581–585.

Graham, S. 2004. "Detroit pretty city: The Heidelberg Project." *Archis* 3: 34–38.

Gurian, E. H. 2010. "Wanting to Be Third on Your Block." Ann Arbor, MI: University of Michigan. Working Papers in Museum Studies.

Guyton, T. 2004. "The Heidelberg Project: Detroit, Michigan." *Places* 16 (3): 14–17.

Hall, M. and E. W. Metcalf, eds. 1994. *The Artist Outsider: Creativity & The Boundaries of Culture.* Washington, DC: Smithsonian Institution Press.

Hodges, M. 2007. "Heidelberg and the Community." In *Connecting the Dots: Tyree Guyton's Heidelberg Project*, 49–69. Detroit, MI: Wayne State University Press.

Jackson, M. 2007. "Trickster in the City." In *Connecting the Dots: Tyree Guyton's Heidelberg Project*, 23–37. Detroit, MI: Wayne State University Press.

Jones, M.O. 1994. "How Do You Get Inside the Art of Outsiders?" In *The Artist Outsider: Creativity & The Boundaries of Culture,* eds. M. Hall and E.W. Metcalf, 312–330. Washington, DC: Smithsonian Institution Press.

McClean, L. 2007. *The Heidelberg Project: A Street of Dreams*. Northville, MI: Nelson Publishing.

Metcalf, E. 1994. "From Domination to Desire: Insiders & Outsider Art." In *The Artist Outsider: Creativity & The Boundaries of Culture*, eds. M. Hall and E.W. Metcalf, 212–227. Washington, DC: Smithsonian Institution Press.

Minar, R. 1994. "Case Studies of Folk Art Environments: Simon Rodia's 'Watts Towers' and Reverend Howard Finster's 'Paradise Garden'." M.A. Dissertation, Rice University, Texas.

Stivers, J.C. 2004. *The Presence of the Past: The Public Museum of Grand Rapids at 150*. Grand Rapids, MI: The Public Museum of Grand Rapids.

Taylor, B.L. 2011. "Heidelberg and Community: A Space for Us All." In *Heidelberg 25: A 25 Year Retrospective, 1986–2011*, 3–4. Detroit, MI: Charles H. Wright Museum of African American History.

Walters, W. 2001. "Turning the Neighborhood Inside Out: Imagining a New Detroit in Tyree Guyton's Heidelberg Project." *The Drama Review* 45 (4): 64–93.

Wheaton, M. 2007. "Heidelberg and the City." In *Connecting the Dots: Tyree Guyton's Heidelberg Project*, 71–83. Detroit, MI: Wayne State University Press.

Whitfield, J. 2000–2001. "Thoughts on Tyree Guyton's Heidelberg Project." *The Southern Quarterly* (Fall–Winter): 187–196.

Wojcik, D. 2008. "Outsider Art, Vernacular Traditions, Trauma, and Creativity." *Western Folklore* 67 (2/3): 179–198.

–4–

Learning to Share Knowledge
Collaborative Projects in Taiwan

Marzia Varutti

In the early 2000s, the Taiwanese government established a number of small-scale museums located in Taiwan's indigenous areas; these museums were meant to showcase the culture, history, and traditions of the various Taiwanese indigenous groups. It soon became apparent, however, that very few visitors frequented these museums, which became known as "mosquito museums," since mosquitoes were their main "visitors."

This chapter discusses the phenomenon of indigenous museums in Taiwan and examines the governmental strategies set up to address the poor visitor records of these museums. Such strategies include the national "Big Museum Leads Small Museum" program, which involves the collaboration of national and indigenous museums. Special focus will be devoted to the collaboration between the National Taiwan Museum and the Chimei Amis Indigenous Museum. This will provide the framework for a critical analysis of the relationships between urban professional curators and indigenous communities, as well as between curatorial and indigenous forms of knowledge.

The data, insights, and observations on which my arguments are based were collected during six months of field research in Taiwan in 2010. I examined museum displays of indigenous cultures, interviewed museum curators, government officials, academics, and members of indigenous communities, and in some instances, I practiced participant observation, joining museum curators in their activities in both national and indigenous museums. I endeavor to bring to the fore the uniqueness of the Taiwan case study (due to the country's historical trajectory and distinctive cultural features) and the possible analogies with other instances of collaboration between museums and indigenous communities around the world.

The postcolonial era has brought a self-reflective and critical perspective on museum practices, notably with reference to the representation of non-Western cultures. Concepts such as "Other," "othering," and cultural appropriation (Clifford 1988; Hallam and Street 2000) have become salient to these analyses and have greatly influenced my own reading of practices of cultural representation in museums. To put into a critical perspective my observations in Taiwan, I have found it particularly useful to draw on this literature, specifically critical discussions of the authority of museums, with special reference to the definition and categorization of identities (e.g., Karp et al. 1992), and the representation

of non-Western cultures (e.g., Ames 2004; Clifford 1997) and subaltern subjects (e.g., Hallam and Street 2000; Hein 2011, Marstine 2011). These studies constitute a theoretical background for more specific, practice-inspired, scholarly revisitations of notions often taken for granted, such as "inclusion" and "collaboration" (Golding 2009; Peers and Brown 2003). Moving along this critical literature on the relationship between museums and communities, my analysis of museums in Taiwan has greatly benefited from the works of Christina Kreps (2003, 2008) and Miriam Clavir (2002), signaling a move toward more culturally sensitive museum practices and the development of museological approaches alternative to the paradigms imposed by the West.

Indigenous Groups in Taiwan

The cultures of the indigenous groups of Taiwan are relatively little known internationally. Indeed, until relatively recently, they have been marginal even on the Taiwanese social, cultural, and political scene. Yet Taiwan has long been multicultural. First colonized by the Qing Empire in the sixteenth century, Taiwan became a Japanese colony in 1895. It was re-annexed to China in 1945, after the Japanese defeat in World War II, and became the stronghold for the Chinese Nationalist Party—the Kuomintang, or KMT—which established a dictatorial regime that ended in 1987.

Over the centuries, different waves of migration from China and Japan have transformed Taiwan into a multicultural country. Taiwan's population today includes the descendants of seventeenth-century immigrants from the Fujian and Guandong provinces of China (around 85 percent of the population); "Mainlanders," that is, Chinese nationalists who migrated after the civil war with Communist China in 1949 (around 13 percent of the population); and indigenous groups, representing around 2 percent of the total population (Allio 1998: 54). Fourteen indigenous groups have been officially recognized (the last in 2008), and several others, such as the Pazeh and Siraya, are seeking recognition.

In spite of their relatively limited number, over the last three decades the indigenous groups of Taiwan have started to gain national visibility and political weight. Since the late 1980s, in connection with the transformation of the country into a democracy and the development of a Taiwanese national identity, Taiwan's multicultural roots and indigenous cultures have been gradually rediscovered and reevaluated. This political reorientation was further stimulated by the parallel development of a discourse promoting Taiwan's cultural and political independence from mainland China (Rudolph 2001). The position of indigenous groups within the Taiwanese political arena changed from marginal, passive, and invisible to proactive, empowered, and vocal, thanks to the advocacy of organizations such as the Alliance of Taiwan Aborigines (ATA) and the Presbyterian Church (Hsiao 1990; Hsieh 2006; Ku 2005). The gradual recognition of Taiwanese indigenous groups can thus be interpreted as part of a broader process of cultural construction and political legitimization of the Taiwanese state. As anthropologist Francesca Merlan notes with reference to the international movement of indigenous recognition

that took place after World War II, "[*indigenous*] recognition occurred within the terrain of the state itself and became an important criterion of state legitimacy" (2009: 306). The political recognition of indigenous groups in Taiwan was further stimulated by the international movement for the promotion of the rights of indigenous peoples that gained momentum in the 1980s (Ku 2005), which subsequently led to the globalization of the concept of "indigeneity" (Merlan 2009). Indeed, the framing of the indigenous question in Taiwan in terms of violation of human rights enabled indigenous groups to establish important connections with international human rights organizations and to adopt the United Nations Universal Declaration of Human Rights (1946) and the UN Draft Declaration on the Rights of Indigenous Peoples (1985) as reference documents for their campaigns (Ku 2005: 101). Such international connections were further eased by the shift in the 1980s from claims pertaining to the rights of the individual to demands for indigenous collective rights and self-determination (Ku 2005: 101–102). Today in Taiwan, indigenous campaigns aim to redress the historical discrimination, social marginalization, and economic exploitation indigenous groups have suffered since the seventeenth century. Consequently, indigenous rights claims tend to focus on ownership of land, the retrieval of indigenous names and languages, and the right to nondiscrimination, both socially and on the labor market (Faure 2009: 102).

As part of this dynamic of indigenous political empowerment, Taiwanese indigenous groups have started to play an increasingly active role in the politics of representation of indigenous cultures in Taiwan. Through the acts of the Council of Indigenous Peoples—a ministry-level body created by the Taiwanese government in 1996 composed of indigenous representatives—indigenous issues have started to receive public attention and governmental funds. Museums play a central role in the framework of cultural and ethnic policies (Chen 2008: 127–128), and have been the object of ad hoc governmental initiatives such as the "Big Museum Leads Small Museum" program I discuss later in this chapter. These developments led to an increased awareness among indigenous communities of the importance of museums as showcases of indigenous cultures.

These processes, however, are not unproblematic. It is known that the practices of cultural "representation," "display," "interpretation," and "translation" through museum exhibitions imply the exercise of authority and inevitably establish relations of power between representers and represented (Hallam and Street 2000; Karp et al. 1991, 1992). As James Clifford notes, "What counts as 'tradition' is never politically neutral [. . .], and the work of cultural retrieval, display, and performance plays a necessary role in current movements around identity and recognition" (2004: 8). Scholarly analyses, however, have also revealed how such museum practices are appropriated, transformed, negotiated, and contested by the subjects represented (e.g., Clifford 2004; Cooper 2008; Hendry 2005), thus contributing to a more accurate and balanced assessment of the power relations involved in museum work. The museological implications of collaborative practices of cultural representation remain relatively opaque, however. What is their significance for indigenous groups and museum professionals? What lessons can be learned from both sides? Commenting on collaborative projects between museums and First Peoples in Canadian museums, anthropologist and museum professional Michael

Ames aptly asked: "How does this collaboration challenge the traditional curatorial prerogative and affect the quality of the works displayed?" (2004: 73). Ames notes that when museums use First Peoples as resources (recruiting them as consultants, advisers, or artists-in-residence) "the traditional curatorial prerogative usually prevails because of academic training, connoisseurship built on years of experience, and control over the exhibition schedule and budget" (2004: 77–78). This suggests that in the same way as the end result—the display—the multiple components and phases of the collaborative effort (consultation, decision making, exchanges of knowledge and skills, learning experiences, etc.) are inevitably entangled in political issues. Building on this assumption, this chapter uses the case study of collaborations between mainstream and indigenous museums in Taiwan to probe this question.

The "Mosquito Museums"

The objects collected by Japanese and Chinese anthropologists in the first part of the last century (Hu 2007) represent the bulk of indigenous collections housed today in the oldest and most prestigious Taiwanese museums, such as the Museum of Ethnology of the Academia Sinica, the National Taiwan Museum, and the Museum of Anthropology of the National Taiwan University.

Since the late 1990s, more than a dozen museums and galleries devoted to indigenous cultures have been created or renovated in Taipei, Taichung, and Taitung.[1] The proliferation of museum projects focusing on indigenous groups in Taiwan maps a trajectory of increasing attention to and visibility of indigenous cultures in Taiwanese museums. The trend of inclusion of indigenous cultures in the displays of national museums has been accompanied by a parallel process of establishment of small-scale museums devoted to indigenous cultures and located in indigenous areas, and which one may call "indigenous museums."

In this context, the use of the concept of inclusion calls for a closer and critical examination to cast light on its ambivalent significance and implications. Almost paradoxically, inclusive practices can in fact reinstate the superiority of one actor over another, through the very act of "invitation," of "letting one in," which in itself constitutes an exercise of authority. Feminist theory provides a valuable framework to analyze relations of authority through the conceptualization of the "other" as female—hence subordinated and marginal (Hallam and Street 2000: 3; Hein 2011: 119). Gaby Porter notes that, in exhibitions, "women and the feminine become, literally, the frontiers by which space and knowledge are defined: they are the more distant and imprecise elements, in the background and at the edges of the picture" (2004: 109). Likewise, the feminine, the Other (the "different," the "deviant," the indigenous) lies at the margins of a core (male, "normal," authoritative) that it actually contributes to create and reinforce. Inclusion presents thus an ambivalent character: while it may lead to integration, it may also reinforce the central, dominant position of those who "include."

In Taiwan, since 2000, on the impetus of the Democratic Progressive Party (DPP), favoring the integration and reevaluation of indigenous cultures, the Taiwanese government

has funded twenty-eight indigenous museums,[2] mostly located in indigenous villages in the eastern and southern areas of the country, where most indigenous communities are located. In line with the political goal of integration of indigenous groups into mainstream Taiwanese culture, indigenous museums aim to make local cultures better known in Taiwanese society at large, and to develop tourism in often economically depressed indigenous areas. A decade after their inception, however, the balance of indigenous museums is not positive: in most instances, they failed to attract tourists and transformed into static, empty containers of poorly presented exhibits. The expression "mosquito museums" was coined to describe these uninspiring venues. Linking the problems of indigenous museums exclusively to the number of visitors is nevertheless simplistic; the very conceptualization and development of these museums present problematic features. As we shall see, the participation of indigenous communities in the set-up of indigenous museums has been limited, and the collaboration between professional, urban curators and local indigenous museum staff is often entangled in unequal power relations. In addition, the curators, government officials, and academics I interviewed are unanimous in attributing the lack of dynamism of indigenous museums to the deficit of financial resources for the long-term management of these institutions: funds were available at the outset for buildings, but not for more sustainable projects, nor for long-term expenses, such as salaried curatorial positions, staff training, acquisition policies, and general maintenance of the museums and their collections. The curatorial accuracy of displays in indigenous museums is also perceived as a problematic area.[3]

Intriguingly, government-funded indigenous museums look surprisingly similar: they are recognizable for their architectural styles combining concrete supporting structures, solid pillar columns, geometric and austere shapes, and emphatic entrances reminiscent of supposedly traditional indigenous houses. This generic type or basic, standard architectural format is then adapted to the different indigenous groups through the addition of decorative elements: etches, mosaics, straw-covered roofs, wooden sculptures, and so forth.

The standardization, however, transcends the architectural design and affects the very functions of museums. Indigenous groups have been variously successful in appropriating these standardized institutions. In some instances, indigenous museums provide an authoritative backdrop for initiatives implying varying degrees of commodification of indigenous intangible heritage, including song and dance performances designed for tourist consumption. This is often the case for museums located in larger towns such as Taipei or Hualien.[4] In other cases, indigenous museums have morphed into cultural centers where communities meet for activities or socializing.[5]

This suggests that the phenomenon of mosquito museums should not be interpreted as a paucity of vibrancy of indigenous cultures. Indigenous communities often organize intense cultural programs at the margins of museums. But why, then, didn't Taiwanese indigenous museums succeed in grounding themselves in the social and cultural fabric of indigenous communities? A possible reason might be that indigenous museums in Taiwan have been conceptualized at governmental level, with limited consultation with indigenous communities. Local communities have been presented with the final

product and expected to take over the management of institutions they did not participate in developing. As a result, indigenous museums in Taiwan may ultimately be perceived by indigenous communities as unfamiliar, and will only succeed in certain conditions, for instance in the presence of an active and committed indigenous museum staff that mediates, "interprets," and adapts the museum concept and practices to local indigenous customs, world views and cultural practices, as in the case of the Chimei Museum, discussed below.

It should also be stressed that the "failure" of indigenous museums has been announced by the central government on the basis of criteria of mainstream museology—such as the number of museum visitors—which cannot be unproblematically applied to museums in remote indigenous villages, where the large majority of visitors consists of locals.[6] This suggests that the assessment of indigenous museums should not be based on the same parameters used for mainstream museums, but rather requires a set of evaluation criteria that take into account the specific prerogatives of each museum—including its mission and role within the local community—and of its audiences.

The "Big Museum Leads Small Museum" Program

In 2008, in response to the problems experienced by indigenous museums, the Taiwanese government, through the Council of Indigenous Peoples, launched a program called "Big Museum Leads Small Museum." In line with international trends of democratization of museums, and the development of participatory museological approaches stressing the need to bring professional museum curators together with local communities (see Kreps 2003, 2008), the "Big Museum Leads Small Museum" program aims to establish a platform for collaborations between mainstream national museums in Taiwan and local indigenous museums. The core idea of the program is to use the expertise and the collections of major national museums to improve the quality and appeal of displays in indigenous museums. The final goal is to help indigenous museums set up new exhibitions to attract visitors and to inject new life in their activities. The program resonates strongly with similar international governmental initiatives such as "Renaissance in the Regions" in the United Kingdom, aiming to empower non-national museums through special projects and earmarked funding, and to ultimately enable local museums to play a more incisive role in the areas of education, social inclusion, and community regeneration. At the international level, these governmental programs point at generalized issues of unbalance between the funding allowances of national museums located in major cities, and minor and peripheral museums whose activities are often undermined and limited by the lack and uncertainty of funds.

The "Big Museum Leads Small Museum" program has been coordinated by a museum professional, Mrs. Li Sa-li, a non-indigenous anthropologist and the director of the Taiwan Folk Arts Museum, Taipei. Mrs. Li and her team organize workshops to provide guidance for indigenous curators on preparing exhibition posters, writing reports for the government, and organizing museum-guided tours and activities for children.[7] According

to Mrs. Li, the "Big Museum Leads Small Museum" program has been successful: there has been a rapid improvement in museum professionals' expertise, and in the first year of the program, the number of museum visitors (mostly non-indigenous Taiwanese) has doubled. Also, more and more indigenous museums are willing to take part in the program, which will, as a result, continue for other six years. However, some of my informants expressed concern about the program's long-term financial sustainability and the possibility that the government single-handedly interrupts it because of lack of funds (as mentioned, a similar situation is perceived to be at the roots of the phenomenon of so-called "mosquito museums").

The "Big Museum Leads Small Museum" program involves the most important national museums in Taiwan.[8] Each museum is granted the liberty to choose how to implement the program. For instance, the Shung Ye Museum of Formosan Aborigines organizes a competition for students who are invited to design a poster promoting indigenous cultures. The National Museum of Natural Sciences in Taichung collaborates with indigenous artists and produces traveling exhibitions (with replica objects) that circulate in indigenous villages.[9]

The National Taiwan Museum is the institution that has utilized the most resources in the implementation of the program. Among others, the National Taiwan Museum entertains an ongoing collaboration with an Amis indigenous museum in Chimei village. In what follows, I focus on this specific collaborative instance to explore a number of questions pertaining to the problematic process of transmission and exchange of expertise between curators and indigenous communities.

The National Taiwan Museum and the Chimei Museum

Mr. Li Tzu-Ning, head of collections and curator of the anthropological section of the National Taiwan Museum, explains that there is a special political pressure on this museum to collaborate with indigenous communities. This is because of the museum's historical anthropological collections of indigenous material culture, among the richest and oldest in Taiwan. Mr. Li is emphatic about this: "We have old collections, we have a responsibility. We always suffer from the criticism that we don't engage enough with indigenous communities."[10] The "Big Museum Leads Small Museum" program provided, therefore, an ideal framework within which such collaborations could be developed. Indigenous groups can reestablish contact with the material culture that was collected in their communities in the early twentieth century by Japanese anthropologists; at the same time, this is an opportunity for the National Taiwan Museum to gain valuable information about the objects' meanings and functions.

The most important collaborative project set up by the National Taiwan Museum under the umbrella of the program has been with the Amis indigenous community in the village of Chimei, in the mountains of the east coast of Taiwan.[11] The local curator, Mrs. Falahan, acknowledges taking inspiration for the interior exhibition styles from mainstream museums in Taipei such as the Shung Ye Museum of Formosan Aborigines and

the National Taiwan Museum of Fine Arts. "At the beginning the museum was empty," says Mrs. Falahan,[12] "since our focus has always been on people, not on objects. We were concerned with ways through which we could revive our culture and find cohesion as a community." Currently, the museum has a small but growing permanent collection of objects, including traditional basketry, fish traps, wooden bowls and containers, cooking and pounding vessels, and ceramic pots.

Annexed to the exhibition rooms are a large Internet room, a library, a room for meetings, and the office of Mrs. Falahan. The furniture was handmade by local people, books have been bought with donations, and computers are secondhand. The museum regularly organizes activities and workshops, including textile weaving, ceramics and pottery workshops, as well as language courses taught by the village elders.

In the words of Mrs. Falahan, "today the museum aims to be a cultural centre for traditional but also for modern Amis culture." The initiatives of the museum have been fully embraced by villagers; young men (usually absent from indigenous villages due to employment in larger towns) are especially active as museum volunteers. The museum has also become the cornerstone for projects to develop tourism in Chimei.

A Hundred Years of Waiting

In 2008, representatives of the Amis community of Chimei, guided by Mrs. Falahan, asked the National Taiwan Museum to see the objects originating from their village in the museum's collections. This led to a loan request and to the idea of a collaborative display in the framework of the "Big Museum Leads Small Museum" program.

The exhibition, co-curated by Mrs. Falahan and inaugurated in August 2009, was entitled "A Hundred Years of Waiting: Chimei Heritage Goes Back to Chimei." The National Taiwan Museum lent forty-seven objects from its collections, including traditional Amis clothing items, ritual headdresses, body ornaments, basketry, pottery items, and wooden tools for food preparation. Most of these objects had originally been collected in Chimei by Japanese anthropologists in the 1930s; since then, they had never left the National Taiwan Museum's storage. The first encounter with the objects in the storage of the National Taiwan Museum provoked excitement among Amis elders and elicited comments about their uses and features—comments later incorporated in the exhibition texts and labels. Subsequently, the visits of Amis members to the exhibition in Chimei were punctuated by questions to Mrs. Falahan about the objects, the process that brought them to the village, and the possibility of keeping them there on a permanent basis.[13]

In the Chimei Museum, the juxtaposition of objects from the permanent collections (mostly items collected among local villagers) and the objects of the temporary exhibition borrowed from the National Taiwan Museum collections reveals intriguing differences in modes of display and interpretation. The display of items from the permanent collections—including basketry, fish traps, wooden bowls, cooking and pounding vessels, ceramics, and textiles—includes limited amounts of texts and labels, and does not

involve the use of glass boxes, but rather alternative creative display solutions. For instance, display shelves are handmade using local wood trunks; handmade Amis artifacts are located throughout the museum: between computers in the Internet room and on the library's top book shelves; locally produced textiles are used as curtains, table covers, and decorative backgrounds for exhibits. This approach produces a creative blurring of the boundaries among museum objects, artworks, functional items, and interior decoration, as well as between exhibition space and the administrative and service areas of the museum. Most of these objects are not "musealized"—they are not catalogued, labeled, or explained. Svetlana Alpers notes that one of the implications of the "museum effect"—which she defines as "turning all objects into works of art"—is that the "visual distinction" among objects tends to prime over their cultural significance (1991: 26–27). In the absence of the museum effect, objects may appear less valuable, but also more accessible (they can be freely handled and used) and culturally and spatially integrated (they are not closed in the glass cases confined to the dark exhibition room, but they sit behind the computer; they populate the everyday working space of the museum's users). If one agrees with Stephen Greenblatt's proposition that the label, together with the set of tools that aim at introducing, describing, and explaining the object—introductory panels, catalogue, audio or video material—is meant to stand for the original context in which the object was created (1991: 44), then one can infer that the artifacts disseminated in the Chimei Museum do not necessarily need to be labeled and contextualized, simply because they have not been severed from their context of origin. As such, these artifacts are a diffused but powerful rendition of the cultural dynamism, vitality, and creativity of the local community.

In contrast, the items on loan from the National Taiwan Museum are presented using a more traditional display approach employing glass cases where items are subject to more orderly arrangements, precisely illuminated by spotlights, and correlated by labels. These objects are encapsulated in their glass boxes, sealed off from the surrounding museum environment.

In the exhibition, each object was illustrated by a short label indicating the object's name in the Amis language and a short description in Mandarin Chinese.[14] For the writing of exhibition texts and labels, Mrs. Falahan did not simply rely on the records of the National Taiwan Museum (which proved to be inaccurate or patently wrong in some instances), but she showed photos of objects to Amis elders in Chimei and asked to comment on them. This provided fresh insights on specific Amis uses, understandings, and cultural significance of objects, as in the case of a headdress, which will be discussed later, erroneously attributed to another group in the records of the National Taiwan Museum, that elders in Chimei were able to identify as Amis.

Learning to Share Knowledge

Relations of authority between national and indigenous museums, as well as between curatorial expertise and local, indigenous knowledge, are an important factor in

collaborative endeavors such as the one between the National Taiwan Museum and the Chimei indigenous museum.

At the inception of the project in Chimei, in March 2009, a group of Amis elders had been invited to the National Taiwan Museum's storage to examine the museum's collections and select objects for display in Chimei. Among the objects was one elaborate ceremonial headdress which, according to the National Taiwan Museum's records, belonged to the Tsou indigenous group. The Amis representatives, however, pointed out that this attribution was erroneous, and identified the headdress as Amis (although a similar headdress was in use among the Tsou group).

The realization of Amis representatives of their own competence and ability to correct the records of the National Taiwan Museum represented a turning point in the collaboration: this episode strengthened the self-confidence of the Amis representatives, as it cast light on the value of their contribution and their expert knowledge. The Amis headdress subsequently became the star object of the display in Chimei—almost a signifier of the reappropriation and repatriation of Amis knowledge, authority, and identity.

Establishing categories, taxonomies, drawing conceptual distinctions and associations are all strategies through which the power of the museum manifests itself. Anthropologist Shelley Errington notes: "Discourse creates objects. . . . Objects may physically pre-exist those discourse and their institutions, and they may persist beyond them; but appropriated by new institutions, their meanings are remade and they are transformed into new kinds of objects" (1998: 4). Not only are objects made anew through new categorizations, but so are the identities those cultural artifacts subsume. As Karp put it, one of the prerogatives of museums is precisely the "capacity . . . to classify and define peoples and societies" (Karp et al. 1992: 1). In the postcolonial era, awareness of this has reshaped the relationships that museums holding ethnographic collections entertain with the communities from which those objects originate. Such relationships are now based on the recognition that museums are no longer the sole legitimate and authoritative interpreters of cultural artifacts. Increasingly, the involvement of source communities in museum decisions affecting their cultural heritage is perceived as a moral—if not a political—imperative (Peers and Brown 2003: 5).

The exchange that took place between curators of the National Taiwan Museum and Amis elders placed museum professionals and indigenous communities on an equal footing. By making apparent the historical and cultural knowledge entertained by the Amis indigenous community—which proved able to correct the prior so-called expert interpretation of Japanese anthropologists—this exchange endowed Amis representatives with the right to interpret their own cultural heritage, at least in the framework of the temporary exhibition in Chimei.

This exchange was also of pivotal importance for the curators of the National Taiwan Museum. In a paper reflecting on the exhibition held at the Chimei Museum, the head curator of the anthropological section of the National Taiwan Museum, Mr. Li Tzu-Ning, invoked James Clifford's (1997) concept of the "contact zone" (Li 2009) to describe the collaborative endeavor. In elaborating on Clifford's seminal metaphor, museum studies

scholars and practitioners have rightly focused on museums' propensity to act as spaces of cross-cultural dialogue and on the outcomes of such intercultural encounters. However, as Gwyneira Isaac cautions, "if the focus is on the hybrid product or contact zone, the dynamic practices that determine what is retained, marginalized, or forged together become obscured" (2007: 17). In the case of the Chimei Museum, a closer look at the dynamics of collaboration between museum professionals and the local Amis community reveals processes of negotiation of authority, and of retention of knowledge, whereby the position of authority of museum professionals from major national museums is strengthened through the withholding of elements of technical knowledge, which are not passed on to local indigenous curators.

In July 2010, a team of curators from the National Taiwan Museum visited Chimei to dismantle the A Hundred Years of Waiting exhibition and to bring the objects back to the museum's storage. Some of the objects had been affected by mold due to the high humidity levels in Chimei (air conditioners, available in the museum, were shut down at times to limit expenses). The discovery of the mold precipitated the National Taiwan Museum's decision to dismantle the display and bring the objects back to Taipei. During three days of work, the staff of the National Taiwan Museum emptied the glass cases, photographed and examined the objects, drafted condition reports, and carefully repacked the artifacts for transportation. Throughout the work, the involvement of the local museum curators, Mrs. Falahan and her husband, in the implementation of all these curatorial tasks was minimal. Mrs. Falahan did initially help with the most practical tasks such as removing the seals from the glass cases, but she did not handle objects, nor did she take part in the examination of objects or writing condition reports; most of the time, she worked in her office.[15] While she was in no way purposefully kept at a distance by the National Taiwan Museum staff, it did not seem necessary to involve her in the dismantling of the exhibition. The lack of discussion and consultation prior to and during the dismantling activities in Chimei suggested a tacit understanding between the National Museum staff and the local curators that the curatorial operations had to be conducted by the National Taiwan Museum staff. This might have been a consequence of the conservation issues engendered by the objects' display in inappropriate climatic conditions. Nevertheless, the presence of the National Taiwan Museum staff in Chimei village did not in this instance become an occasion to share curatorial expertise with local curators (for instance about mold prevention, conservation measures, or appropriate object handling, storage, and packaging). Rather, this instance produced the unwanted effect of underscoring the expert competence of museum professionals vis-à-vis the local community.

This effect might be interpreted as the result of a "museum effect within the museum effect," that is, the production of meanings and values of museum objects generated directly by curatorial practices and indirectly by the displacement of such curatorial practices from the museum stores of a mainstream institution such as the National Taiwan Museum, to the unusual setting of an indigenous museum. All the more when performed by the professional staff of an authoritative national museum in the context of an indigenous museum, curatorial practices play a crucial role in the production and transmission

of meanings and values that may build upon, complement, ignore, or delegitimize preexisting indigenous understandings and forms of knowledge. This also raises the question of whether the Amis people in Chimei would have displayed their cultural artifacts in a different way had they enjoyed complete autonomy—in intellectual, creative, technical, financial, and political terms—in the process of exhibition set up.

Such displacement of museum practices, however, also produced another important effect: it enabled the Amis community in Chimei to see its cultural heritage through new eyes. The Amis community learned to see familiar, everyday objects as valuable museum exhibits able to enhance cultural pride and increase self-esteem.[16]

Yet one question remains unanswered. In spite of the clear commitment to collaboration established in the initial meeting between the staff of the National Taiwan Museum and the representatives of the Amis community in Chimei, why did it become difficult to uphold the ethos of collaboration throughout the project? Admittedly, I did not witness the whole collaborative project in Chimei. Still, why was the dismantling of the temporary exhibition not perceived as an opportunity for exchange and mutual learning?

Indigenous and Curatorial Knowledge

The very existence of a program such as "Big Museum Leads Small Museum" in Taiwan suggests that, at the governmental level, there is not only full awareness of the difficulties indigenous museums are navigating, but also the political will to tackle them. Moreover, the full and ground-breaking engagement of the National Taiwan Museum with the national program also signals that at least some museums scholars and professionals are truly committed to the principles of participative museology. In parallel, local indigenous communities are increasingly interested in the preservation of their cultural heritage (Ryan et al. 2007). These seem suitable preconditions for the development of collaborative museological projects between museum professionals and indigenous curators and communities. However, collaborations can be difficult processes, and the degree of actual inclusion of source communities may vary significantly from one collaborative project to another. There is a significant distinction to be made between collaboration and mere involvement in museum work. In the latter case, communities may be simply invited to provide input, often in a consultative status, to a specific project (such as the set-up of an exhibition) that is wholly managed by the museum. Collaboration, conversely, implies shared authorship and responsibility as part of an ongoing, long-term relationship. It demands "full and equal partnership in all stages of a project" (Peers and Brown 2003: 9), and overall, it requires time, trust, and commitment from all partners. This involves much more than just inviting non-indigenous curators to serve as consultants; it implies an overall rethinking of museum priorities and modes of action. As Michael Ames notes with reference to Canadian First Peoples:

> Equal collaboration more likely will require the restructuring of the entire enterprise and its value system in order to recognize the primal and sovereign status of First Peoples and

their right to the possibility of radically different claims to truth, beauty, and the exhibition thesis. (1994: 15)

One of the elements that emerged as problematic in the establishment of collaborative relationships in Taiwan is a persistent perceived dichotomy between indigenous and curatorial knowledge. In the context of the collaborations between museum professionals and indigenous groups, two complementary (and often overlapping) kinds of knowledge are at play. While indigenous communities are usually familiar with objects' origins, uses, functions, and symbolic meanings, non-indigenous museum professionals tend to contribute practical curatorial expertise. Such diverse orientations may be expressed by diverse approaches to indigenous objects. In such instances, the collaboration between indigenous communities and museum curators becomes a framework through which to observe the negotiations—of knowledge, status, authority, identity—at play between actors and made apparent in discussions about museum objects.

In late spring 2010, the National Taiwan Museum started to organize a collaborative exhibition with Atayal indigenous communities to set up a temporary exhibition in the indigenous museum of Datong Atayal village in northeastern Taiwan. In a preparatory meeting,[17] a group of Atayal elders had been invited to the storage facilities of the National Taiwan Museum to view and select objects from the museum's Atayal collections for inclusion in the exhibition in Datong. One of the objects examined was an ancient, mostly damaged, and very fragile bodice made of leather and fur. The object was carefully laid on the table for examination, and expectedly, it readily prompted a discussion about its use. In the midst of the discussion, one of the Atayal elders raised the bodice and held it up to himself to show how the item was supposed to be worn. The museum staff immediately intervened to stop him since he was not handling this fragile object correctly (that is, from a conservation point of view). In this instance, knowledge about the appropriate *use* of the object contrasted with knowledge about the correct *conservation* of the object. This episode captures a revelatory discrepancy in the approaches to material culture that may be held by museum staff and indigenous communities. This discrepancy resonates with a range of divergent features in Western and indigenous museology identified by Canadian museum professional Miriam Clavir (2002). In particular, Clavir notes that while Western museology tends to focus on the preservation and display of objects, indigenous museological approaches are more concerned with the preservation of cultural practices and values and the use of objects; while Western museology attributes importance to object-based knowledge, indigenous perspectives place the individual living cultures at the core of processes of knowledge production (2002: 76–77).

The "Big Museum Leads Small Museum" program was born out of the recognition of the need to bring mainstream and indigenous museum staff and communities together. This is the first step in a process that may result in indigenous communities independently curating their cultural heritage, also drawing on indigenous traditions and creativity to develop unique approaches to display and conservation, such as architectural styles that adopt traditional materials and systems for aeration in replacement of air conditioning. Such experiments might have significant implications, not only in terms of increased

empowerment and self-reliance of indigenous communities, but also with respect to the development of indigenous museological approaches drawing on local indigenous traditions, skills, and forms of knowledge, which may complement mainstream, standardized museum practices. As anthropologist Christina Kreps notes:

> Such traditions deserve recognition and preservation in their own right, since they are part of people's tangible and intangible cultural heritage and contribute to world cultural diversity. . . . Recognition and use of traditional curatorial methods should not compromise the integrity or value of standard, professional museum practices. (2008: 25)

The "Big Museum Leads Small Museum" program is proving effective in establishing links where they did not exist: links between national and indigenous museums, between urban and indigenous curators, between museum collections and indigenous communities. The program brought representatives of indigenous communities in the museums of the capital, and conversely, it brought objects out of national museum storages and into indigenous villages. In all these respects, the program is a commendable initiative.

What could be further developed is a focus on the transfer of knowledge in both directions, from professional curators to indigenous communities and vice versa. While an exchange of knowledge is at play between mainstream museum curators and indigenous curators, this exchange might not always be balanced. When indigenous communities visit the national museum in the capital, their knowledge about indigenous heritage objects in the museum's collections is precious to enrich and amend museum records. In the context of the "Big Museum Leads Small Museum" program, indigenous curators do receive guidance on how to manage government funds to the benefit of their institution. However, urban curators seldom spend time in indigenous museums to acquire, transfer, and exchange knowledge with indigenous communities.[18] This is of crucial importance since the lack of curatorial expertise of indigenous staff and the inadequacy of appropriate display and conservation conditions are most often invoked by national museums as reasons for *not* lending objects to indigenous museums or for reducing the scope of the collaboration (such as the discovery of mold on objects in Chimei Museum prompting the early dismantling of the exhibition). Perhaps a more sensitive, culturally informed museological input—possibly in the form of collaboration with university departments of museology and/or anthropology and indigenous studies—might be conducive to more satisfactory forms of collaboration.

Conclusions

Museums in Taiwan are part of centralized efforts of the Taiwanese government to promote indigenous cultures. More than a decade ago, the government established a network of museums in indigenous villages aimed at enhancing the visibility of indigenous cultures. More recently, in response to the difficulties experienced by these indigenous museums, the government has launched the "Big Museum Leads Small Museum" program. Its importance cannot be overemphasized: this is a major, unprecedented initiative

bringing committed curators in national and indigenous museums to walk together on the uncharted terrain of collaboration—with its load of uncertainties, compromises, negotiations, anxieties, and frustrations.

Whilst the program is to be saluted as a sign of concern of the central government about the fate of indigenous museums, in its concrete implementation, it might actually strengthen the notion that there is one correct paradigm of museum practice that simply needs to be taught to indigenous curators; this in turn, would naturalize the idea that the practices of national museums should inform those of indigenous museums.

Museum scholar and professional Robert Janes (2010) talks of "positive deviance" to describe the capacity of some individuals (or organizations) to think outside the box and find original solutions to problems. "The Positive Deviance process," writes Janes, "invites the community to identify and optimize existing and sustainable solutions from within the community, and not rely on external resources to solve problems." In the light of Janes's words, one may wonder whether the "Big Museum Leads Small Museum" program—despite its laudable remit to help indigenous museums out of their difficulties—might actually discourage the forms of positive deviance some indigenous museum might develop, such as alternative modes of display and interpretation of objects, and unconventional approaches to what the museum space is and how it should be used by curators and local communities.

In her analysis of the problems of rural museums in North Sumatra, Indonesia, Christina Kreps argues that the poor care for collections and inadequate training of museum staff may be attributed both to the "top-down, expert and outsider-driven approaches to museum development and training" and to the "direct transfer of museum models, technologies, and practices developed in cultural and socio-economic contexts dramatically different from those in which most Indonesian museums exist" (2008: 25). These considerations suggest at least three directions to rethink the collaborations between mainstream and indigenous museums: the actors of museum training and development (who are they, what is their background, and how do their skills, competence, and cultural sensitivities relate to those of local communities); the modalities of work (mono-directional, consultative, participative, collaborative, or partnership); and the knowledge passed on or shared (are principles, approaches, techniques of museum work considered universal, or are they adapted to and respectful of local traditions and conditions). In 1994, anthropologist Michael Ames argued for the need for museums to take into account "The Native perspective" or "the Native metaphysic" (1994: 10). Reflecting along these lines, Christina Kreps has developed the concept of "appropriate museology"; that is:

an approach to museum development and training that adapts museum practices and strategies for cultural heritage preservation to local cultural contexts and socio-economic conditions. Ideally, it is a bottom-up, community-based approach that combines local knowledge and resources with those of professional museum work to better meet the needs and interests of a particular museum and its community. Appropriate museology also suggests that indigenous museological traditions should be explored and integrated into museum operations where suitable. These may include indigenous models of museums, curatorial methods, and concepts of cultural heritage preservation. (2008: 26)

Applied to the "Big Museum Leads Small Museum" program, an appropriate museol-ogy approach might, for instance, lead national curators to tailor their training programs and curatorial practices to the needs, curatorial competences, priorities, and cultural sen-sitivities of local communities—the mismatch between national or international training programs and the skills and resources available in indigenous museums has been identi-fied as one of the main problems of indigenous museums (Kreps 2008: 25).

An appropriate museology approach would also enable national curators to be more attentive to the lessons that can be gained from listening to indigenous perspectives and taking them into account to reformulate *ad hoc* locally and culturally specific museum practices. Drawing on her study of a Zuni tribal museum in the United States, scholar and museum director Gwyneira Isaac argues, "if museums are indeed manifestations of their cultures of origin, we need to initiate a new framework for understanding tribal museums, one that is also sensitive to internal tribal politics and to tribes' mechanisms for the control of knowledge" (2007: 13), and, I would emphasize, the need for museums to be receptive to tribal or indigenous *forms* of knowledge, world views, and approaches to museum practices.

The format of the collaboration between national museums and indigenous mu-seums in Taiwan currently places national museums in the position of the leading actor, with an emphasis on the end result of setting up new exhibitions in indigenous museums. By shifting the focus on the process of collaboration, and by enhancing the receptivity of professional curators to local needs, priorities, cultural values, and approaches, the collaboration between curators and indigenous communities might be-come the framework for mutually enriching learning processes, ultimately resulting in the set-up of exhibitions that celebrate the cultural distinctiveness of each indigenous group and offer insights into unconventional and thought-provoking museological approaches.

Notes

Research in Taiwan was made possible thanks to a small grant from the British Acad-emy (ref. SG-54072), which I gratefully acknowledge. I wish to acknowledge the institutional support of the Graduate Institute of Museum Studies, Taipei National Uni-versity of the Arts, for assistance during my stay in Taiwan. Special thanks to Ms. Lin Huai Huai (Lyra) for her invaluable help during field research in Taiwan; Ms. Huang Shu-Ping for her insights; and Mr. Li Tzu-Ning for his comments and for providing me access to the National Taiwan Museum activities involving indigenous communities. Finally, my thanks to Dr. Viv Golding for her helpful editorial comments and sugges-tions.

1. For instance, the Shung Ye Museum of Formosan Aborigines, a major private mu-seum entirely devoted to traditional and contemporary indigenous arts and crafts, opened in Taipei in 1994. Also in Taipei, the Ketagalan Culture Center—a ten-floor

building devoted to the display and promotion of indigenous cultures—was created in 2002 by the Council of Indigenous Peoples (Indigenous Peoples Commission, Taipei City Government). In the same year, the National Museum of Prehistory, boasting a rich Austronesian gallery, opened in the southern city of Taitung. In 2008, the National Museum of Natural Sciences in Taichung inaugurated its refurbished gallery of Austronesian peoples. The Museum of Ethnology of the Academia Sinica has been recently reorganizing its galleries displaying indigenous cultures, and the National Museum of Taiwan is currently revamping its anthropological galleries. Similarly, the new National Museum of Taiwan History in Tainan has inaugurated its permanent exhibition on the multicultural history of Taiwan; with the exhibition examines, for the first time, the historical interactions between indigenous groups and foreign settlers.

2. The term *museum* is used here as the translation of several Chinese terms: *bowuguan* (museum), *wenhua huiguan* (cultural hall), *wenhua guan* (culture center), *wenwu guan* (cultural relics hall).

3. For instance, Professor Yu Guang-Hong (personal communication, August 12, 2010), non-indigenous scholar and former head curator at the Museum of the Institute of Ethnology of the Academia Sinica, recalls how he was called to "correct" displays in a museum devoted to the Atayal indigenous group, where displays had been set up by a non-Atayal journalist and anthropologist. The museum originally displayed miniature reproductions of Atayal traditional houses made of horizontal bamboo trunks, while bamboo trunks are traditionally used vertically in Atayal housing.

4. For instance, the Hualien County Indigenous Museum is a very large auditorium surrounded by narrow corridors where indigenous costumes and wooden sculptures are on display.

5. For instance, in the Rukai Museum in the Tarumak Rukai indigenous village near Taitung, displays are complemented by a multipurpose room for Rukai language courses, craft activities, and a meeting place.

6. For instance, the visitors of the Chimei Museum in the mountains of Taiwan's eastern coast are mainly local children and teenagers who visit the museum to browse the Internet, use the library, and do their homework, and local women who stop by for a chat or to enjoy the cool air conditioning (Mrs. Falahan, curator of the Chimei Museum, personal communication, July 20, 2010).

7. Mrs. Li, personal communication, June 22, 2010. Mrs. Li also produced two publications for indigenous museum curators: a 112-page manual entitled *How to Promote Your Museum* (which includes guidance on how to draft project applications to obtain government grants) and a guide to the twenty-eight indigenous museums.

8. Including the National Taiwan Museum, the Shung-Ye Museum of Formosan Aborigines, the National Museum of Natural Science, the National Museum of Prehistory, the Shisanhang Museum of Archaeology, the National Palace Museum, and the National Museum of Taiwan History, among others.

9. Professor Ho Chuan-Kun, National Museum of Natural Sciences, Taichung, personal communication, June 4, 2010. Far from satisfactory in terms of cultural authenticity, the use of replicas in traveling exhibitions may be considered a useful strategy to

initiate a dialogue between national museums and indigenous communities, which may eventually lead to the repatriation of original indigenous artifacts to indigenous villages.

10. Mr. Li Tzu-Ning, personal communication, April 30, 2010. This responsibility is particularly felt in this moment because of ongoing discussions to bring the museum, currently under the management of the Council of Cultural Affairs, in the area of competence of the Council of Indigenous Peoples. This institutional shift would further emphasize the importance of indigenous collections and displays at the National Taiwan Museum.

11. Mrs. Falahan, a young anthropologist married to a local (Amis) man, was instrumental to the establishment of the Amis Museum in Chimei in 2007; today she is in charge of the museum together with her husband.

12. Mrs. Falahan, Amis Museum, Chimei, personal communication, July 20, 2010.

13. Ibid.

14. All the texts in the Chimei Museum are in Mandarin Chinese (including the exhibition's introductory panel). Only specific terms referring to Amis cosmology, hierarchical age system, or botanical species are in the Amis language.

15. My presence might also have affected the interactions taking place in the museum, as Mrs. Falahan and her husband took time to show me the museum and talk to me about its history and significance.

16. Mrs. Falahan notes that, initially, local people hesitated to lend objects to the museum. But since the A Hundred Years of Waiting exhibition it has been no longer a problem for her to obtain loans from local families: the temporary exhibition increased the local community's awareness of the cultural and historical value of its heritage.

17. The meeting took place at the National Taiwan Museum storage in Taipei on May 24, 2010.

18. With exceptions. For instance, a curator at the National Museum of Prehistory in Taitung spent months in an indigenous village collaborating with the curator of the local indigenous museum.

References

Allio, F. 1998. "The Austronesian Peoples of Taiwan: Building a Political Platform for Themselves." *China Perspectives* 15: 52–60.

Alpers, S. 1991. "The Museum as a Way of Seeing." In *Exhibiting Cultures: The Poetics and Politics of Museum Display*, eds. I. Karp and S. Lavine, 25–32. Washington, DC: Smithsonian Institution Press.

Ames, M.M. 1994. "The Politics of Difference: Other Voices in a Not Yet Post-colonial World." *Museum Anthropology* 18 (3): 9–17.

Ames, M.M. 2004. "Are Changing Representations of First Peoples in Canadian Museums and Galleries Challenging the Curatorial Prerogative?" In *The Changing*

Presentation of the American Indian: Museums and Native Cultures, ed. R. W. West, 73–88. Washington, DC: University of Washington Press.

Chen, K.-N. 2008. "Museums in Taiwan and the Development of Cultural Awareness." *Museum International (UNESCO)* No. 237–238, 60 (1–2): 123–131.

Clavir, M. 2002. *Preserving What is Valued: Museums, Conservation, and First Nations.* Vancouver: UBC Press.

Clifford, J. 1988. *The Predicament of Culture: Twentieth-century Ethnography, Literature, and Art.* Cambridge, MA: Harvard University Press.

Clifford, J. 1997. "Museums as Contact Zones." In *Routes: Travel and Translation in the Late Twentieth Century,* 188–219. Cambridge, MA: Harvard University Press.

Clifford, J. 2004. "Looking Several Ways: Anthropology and Native Heritage in Alaska." *Current Anthropology* 45 (1): 5–30.

Cooper, K. C. 2008. *Spirited Encounters: American Indians Protest Museum Policies and Practices.* Lanham, MD: AltaMira Press.

Errington, S. 1998. *The Death of Authentic Primitive Art and Other Tales of Progress.* Berkeley: University of California Press.

Faure, D. 2009. "Recreating the Indigenous Identity in Taiwan." In *Austronesian Taiwan: Linguistics, History, Ethnology, Prehistory,* ed. D. Blundell, 101–133. Berkeley: University of California Press.

Golding, V. 2009. *Learning at the Museum Frontiers: Identity, Race and Power.* Farnham: Ashgate.

Greenblatt, S. 1991. "Resonance and Wonder." *Bulletin of the American Academy of Arts and Sciences* 43 (4): 11–34.

Hallam, E., and B. V. Street, eds. 2000. *Cultural Encounters: Representing "Otherness."* Sussex Studies in Culture and Communication. London: Routledge.

Healy, C. and A. Witcomb, eds. 2006. *South Pacific Museums: Experiments in Culture.* Clayton, Victoria: Monash University E-Press.

Hein, H. 2011. "The Responsibility of Representation. A Feminist Perspective." In *The Routledge Companion to Museum Ethics: Redefining Ethics for the Twenty-First Century Museum,* ed. J. Marstine, 112–126. London: Routledge.

Hendry, J. 2005. *Reclaiming Culture: Indigenous People and Self-representation.* Palgrave Macmillan.

Hsiao, H. M. 1990. "Emerging Social Movements and the Rise of a Demanding Civil Society in Taiwan." *The Australian Journal of Chinese Affairs* (24): 163–180.

Hsieh, J. 2006. *Collective Rights of Indigenous Peoples: Identity-Based Movement of Plain Indigenous in Taiwan.* London: Routledge.

Hu C.-Y. 2007. "Taiwanese Aboriginal Art and Artifacts: Entangled Images of Colonization and Modernization." In *Refracted Modernity: Visual Culture and Identity in Colonial Taiwan,* ed. Y. Kikuchi, 193–216. Honolulu: University of Hawaii Press.

Isaac, G. 2007. *Mediating Knowledges: Origins of a Zuni Tribal Museum.* Tucson: University of Arizona Press.

Janes, R. R. 2010. "Museum directors and curators: managers or spectators?" *Theoretical and Practical Issues of Management—the Official Journal of the International*

Scientific and Research Institute for Management Issues, Russian Federation. Available at: www.uptp.ru/content/Disp_Art.php?&Num=2306&Lang=EN.

Karp, I. et al., eds. 1991. *Exhibiting Cultures: The Poetics and Politics of Museum Display.* Washington, DC: Smithsonian Institution Press.

Karp, I. et al., eds. 1992. *Museums and Communities: The Politics of Public Culture.* Washington, DC: Smithsonian Institution Press.

Kreps, C. 2003. *Liberating Culture: Cross-Cultural Perspectives on Museums, Curation, and Heritage Preservation.* London: Routledge.

Kreps, C. 2008. "Appropriate Museology in Theory and Practice." *Museum Management and Curatorship* 23 (1): 23–41.

Ku, K. 2005. "Rights to recognition: Minority/Indigenous Politics in the Emerging Taiwanese Nationalism." *Social Analysis* 49 (2): 99–121.

Li, T.-N. 2009. "Revisiting the Contact Zone: Notes on the Special Exhibition of Chi-mei Artifacts Returning to Chi-mei by Chi-mei Aboriginal Museum and National Taiwan Museum" (in Chinese). Paper presented at the Anthropological Collection, University Museum and Community Workshop, National Taiwan University, December 14.

Marstine, J. 2011. *Routledge Companion to Museum Ethics: Redefining Ethics for the Twenty-first Century Museum.* New York: Routledge.

Merlan, F. 2009. "Indigeneity Global and Local." *Current Anthropology* 50 (3): 303–333.

Peers, L. L. and A. K. Brown, eds. 2003. *Museums and Source Communities.* London: Routledge.

Porter, G. 2004. "Seeing through Solidity. A Feminist Perspective on Museums." In *Museum Studies: An Anthology of Contexts,* ed. B. Messias Carbonell, 104–116. Oxford: Blackwell.

Rudolph, M. 2001. "The Emergence of the Concept of 'Ethnic Group' in Taiwan and the Role of Taiwan's Austronesians in the Construction of Taiwanese Identity." Available at: www.taiwanfirstnations.org/mem.html. Accessed June 2011.

Ryan, C. et al. 2007. "The Aboriginal People of Taiwan: Discourse and Silence." In *Tourism and Indigenous Peoples: Issues and Implications,* eds. R. Butler and T. Hinch, 188–204. Oxford: Butterworth-Heinemann.

Community Engagement, Curatorial Practice, and Museum Ethos in Alberta, Canada

Bryony Onciul BLACKFEET!

Current museology presents community engagement as a positive, mutually beneficial way to improve and democratize representation. However, analyzing participation in practice reveals many forms of engagement, each with different advantages and challenges, none of which solve the problems associated with representing complex, multifaceted communities. Despite the positive assumptions, engagement has the potential to be both beneficial and detrimental. This chapter argues that while a worthy and honorable pursuit, engagement is limited as to what it can achieve within current museological practice, and engagement does not automatically grant integrity or validity to museum exhibits.

This chapter analyzes community engagement in theory and practice at three Canadian case study museum and heritage sites, each illustrating a different approach to collaboration with local Indigenous Blackfoot First Nations communities. The chapter proposes that, when museums work with communities, an *engagement zone* is created. This concept builds on James Clifford's (1997) theory of the museum as a contact zone and emphasizes the importance of inter- as well as cross-cultural relations, the sharing of on- and off-stage culture, and the potential risks, costs, and benefits for participants who enter into the complex and unpredictable space of engagement zones.

Engagement often produces results such as coproduced exhibits, museum programming, community employment, collection loans, repatriations, community participation on museum panels, and changes to museum practice and ethos. These products can be seen as the tangible manifestations of power negotiations between participants in engagement zones. What occurs in an engagement zone and what it produces depends upon the collaborative approach used, the participants involved, the way the process unfolds, and the context in which it occurs. This chapter introduces the concept of engagement zones and then focuses on two engagement zone products: indigenized curatorial practice and coproduced exhibits.

Methods and Case Studies

This chapter draws on original data I collected over twenty-four months in the field between 2006 and 2009, researching the case studies and conducting forty-eight in-depth

digitally recorded interviews with museum and community members supplemented with participant observation, archival research, and exhibit analysis. Interviewees reflected upon their personal experiences of engagement, and while it must be acknowledged that they may have had vested interests and agendas for presenting a particular view (Hollway and Jefferson 2000: 26), interviewees were generally open, thoughtful, and reflective and invested time and energy in sharing their experiences.

The three case studies are located in southern Alberta, Canada, and each sought to work collaboratively with local Indigenous Blackfoot communities, in particular Black-foot Elders,[1] to create coauthored exhibits on Blackfoot culture, and each adapted its curatorial practice and ethos to some extent to accommodate Blackfoot cultural protocol. The case studies were: Head-Smashed-In Buffalo Jump Interpretive Centre[2]; Glenbow Museum; and Blackfoot Crossing Historical Park (BCHP).

The first to embark on engagement was the Head-Smashed-In archaeological inter-pretive center. In the early 1980s, it opted to involve the Piikani and Kainai Blackfoot Nations in the development of a center for the interpretation of the buffalo kill site. Pre-NAGPRA (United States 1990) and pre-Task Force Report (Canada 1992), Head-Smashed-In was under no legal or professional obligation to engage. However, the prox-imity of the buffalo jump to the Piikani Reserve and the community's knowledge of and connection with the site influenced the archaeologists' decision to consult the community (Brink 2008: 272–275). Head-Smashed-In used a consultation model ranked as token-ism on Arnstein's Ladder of Participation (1969); however, it was a progressive step in museum-community relations at the time.

In the early 1990s, the ethnology team at Glenbow Museum began developing re-lationships with Elders from the four nations of the Blackfoot Confederacy. Through participation in community events and by cultivating personal relations with Blackfoot members, the museum developed culturally appropriate loan and repatriation practices. This relationship was formalized with the signing of a Memorandum of Understand-ing in 1998, which led to the establishment of a partnership to develop the Blackfoot gallery: Nitsitapiisinni: Our Way of Life. Glenbow sought to acknowledge the Task Force Report (1992), and the exhibition "embodies the spirit of those recommendations" (Conaty 2003: 237). As a result, "Nitsitapiisinni was one of the first permanent galleries in Canada to be built using a fully collaborative approach" (Krmpotich and Anderson 2005: 379).

Opening in 2007, the newest of the case studies is Blackfoot Crossing Historical Park (BCHP). It was developed by the Siksika Blackfoot community, for the community, with community money,[3] on community land, and is run and staffed by the community. As a facility of 37,000 square feet located on six square miles of park land (Bell 2007: 10–11), combining "a museum exhibition with recreational and other outdoor offerings [it] is an entirely new type of venture for the community and possibly unique in Canada" (Bell 2007: 5). BCHP's curators are both trained museum professionals and practicing community Elders. As such, they bring together professional and Blackfoot cultural approaches to heritage management and attempt to meet both museological standards and Blackfoot protocol. Despite being community controlled, BCHP faces

problems common to any kind of representation and has to negotiate and balance competing stakeholder interests and differences of opinion within the community.

Unpacking the Terms Museum, Community, *and* Engagement

In this chapter, the term *museum* is used to refer to museums and interpretive centers, as the case studies reflect a combination of both. The term *museum* is often misleadingly associated with an idea of a neutral place where cultural and historical facts can be learned. Museums are political spaces where society frames its authorized culture, history, and identity. As Sharon Macdonald states, "any museum or exhibition is, in effect, a statement or position. It is a theory: a suggested way of seeing the world" (1996: 14). Museums can influence the way people conceive and understand one another and the world they live in. They can help define who can claim certain cultures and identities; who are insiders and outsiders; and whose perspectives or versions of history should be recognized as valid. And yet museums are also reflections of the societies that create them. Consequently, museums are contested terrains and common focal points of cross-cultural political debates.

The *communities* this chapter specifically refers to are the four Blackfoot Nations within the Blackfoot Confederacy. They are known as Siksika (Blackfoot), Kainai (Blood), and Piikani (Peigan) in southern Alberta, Canada, and as Amsskaapipiikani (Southern Piikani or Blackfeet) in Montana, USA. However, *community* is a problematic term as it describes a myriad of complex relations and groupings of individuals. Despite the implication of being grouped under the term *community,* communities are not homogenous, well-defined, static entities. On the contrary, they are porous, multifaceted, ever-shifting, loosely connected groups of people. *Community* as a concept ceaselessly creates, struggles, renegotiates, transforms, destroys, and renews itself, constantly redefining what and who is and is not community. Communities' members may be knowingly or unknowingly involved, they may be insiders and outsiders, members of multiple communities, and self- and not self-identifying. Membership of a community may be fleeting, partial, or innate, lifelong, and unshakeable, often irrelevant of an individual's wishes. Thus, *community* is used as a poor substitute, or shorthand, for a complex, rich, and ever-changing interaction.

In addition to the problems surrounding the use of the term *community,* it must be remembered that when speaking of museum community engagement, it is neither the museum nor the community that is engaged, but individuals from each camp who come together to represent their source bodies and negotiate engagement. Consequently, every engagement zone is unique because of the individuals involved, as well as the context, time, place, and amount of power shared.

The term *engagement* has been used in academia and in practice to describe such a myriad of relationships that the label can often conceal more than it reveals about the realities of collaborative practice. There are as many approaches to engagement as there are museums, communities, and individuals to participate in them. Nevertheless,

theorists have attempted to group engagement into categories based on the level of power sharing involved (Arnstein 1969; Farrington and Bebbington 1993; Galla 1997; Pretty 1995; White 1996). A dated and yet still relevant and frequently borrowed model is Sherry Arnstein's *Ladder of Participation* (1969). She groups participation under three main categories: non-participation; tokenism; and citizen power. Using the ladder format enables ranking of each form with manipulation at the bottom and citizen control at the top.

- Citizen power
 - Citizen control
 - Delegated power
 - Partnership
- Tokenism
 - Placation
 - Consultation
 - Informing
- Non-participation
 - Therapy
 - Manipulation

Arnstein notes that each grouping is a simplification of participation in practice, yet useful because it shows the power dynamics between groups:

> The ladder juxtaposes powerless citizens with the powerful in order to highlight the fundamental divisions between them. In actuality, neither the have-nots nor the powerholders are homogeneous blocs. Each group encompasses a host of divergent points of view, significant cleavages, competing vested interests, and splintered subgroups. The justification for using such simplistic abstractions is that in most cases the have-nots really do perceive the powerful as a monolithic "system," and powerholders actually do view the have-nots as a sea of "those people," with little comprehension of the class and caste differences among them. (Arnstein 1969: 219)

The three case studies reflect three of the top five categories on Arnstein's ladder: Head-Smashed-In used consultation (tokenism); Glenbow used partnership (citizen power); and BCHP's community model represents the top of Arnstein's ladder as citizen control.

Despite echoing the model, the case studies do not completely reflect the hierarchy implied by their placement on Arnstein's ladder. Five factors can account for this: first, the realities of engagement are much more untidy and fluid than any model or category can account for. Second, during the process of engagement all the different kinds of participation listed in typologies such as Arnstein's may occur at different stages (Cornwall 2008a: 273–274). Third, museums and communities do not enter into engagement with a predetermined or fixed amount of power; it is always open to negotiation, theft, gifting, and change. Fourth, influences beyond the engagement zone such as logistics

and institutional requirements limit what is made possible by engagement. Finally, the top rung of the ladder, citizen control, does not solve the problems of representation or relations between individuals within a community or an institution such as a museum. Community control still requires methods of power sharing and consensus forming, because every individual cannot make all the decisions, in fact the whole community may not be engaged or kept up to date. Some community members will be empowered at the top of the ladder, while others will be involved in tokenistic ways or may not participate at all. By not addressing internal group power relations among individuals, the model oversimplifies engagement in practice.

Engagement Zones

Since current models and terminology do not fully encapsulate the complex realities of engagement in practice, I sought other ways of conceptualizing the process. James Clifford's (1997) use of Mary Pratt's (1992) term *contact zones* provided one such model, however it too underplays internal community collaboration.

Pratt used the term *contact zone* to describe "the space of imperial encounters, the space in which peoples geographically and historically separated come into contact with each other and establish ongoing relations" (2008: 8). Clifford applied the term to museums, explaining that "the organising structure of the museum-as-collection functions like Pratt's frontier" (1997: 192–193). From the beginning, Clifford acknowledged "the limits of the contact perspective" (1997: 193). Describing Portland Museum's consultation with Tlingit Elders about the museum's Rasmussen Collection, Clifford notes that "some of what went on in Portland was certainly not primary contact zone work"; among the Tlingit, "interclan work" occurred that was "not directed to the museum and its cameras" (1997: 193). He adds:

> [I]t would be wrong to reduce the objects' traditional meanings, the deep feelings they still evoke, to "contact" responses. If a mask recalls a grandfather or an old story, this must include feelings of loss and struggle; but it must also include access to powerful continuity and connection. To say that (given a destructive colonial experience) all indigenous memories must be affected by contact histories is not to say that such histories determine or exhaust them. (Clifford 1997: 193)

Thus I propose the use of the term *engagement zones* to incorporate what *contact zones* cannot: the intercommunity work that occurs in cross-cultural engagement and is prominent in citizen-controlled grassroot community developments such as BCHP. Engagement zones emphasize the agency of participants and the potential for power fluctuations despite inequalities in power relations. They enable consideration and exploration of internal community engagement, culture, and heritage prior to and beyond the experience of colonialism and allow for indigenization of the process. The concept does not supersede the idea of contact zones, but is an overlapping and compatible notion. Contact zones can occur within engagement zones and engagement zones produce outputs such as public exhibits that often become contact zones, as Figure 5.1 illustrates.

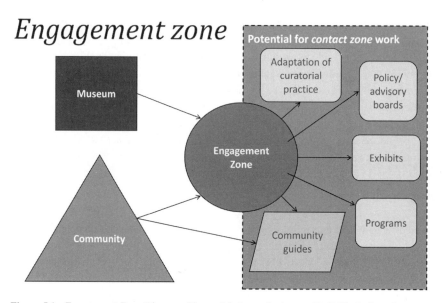

Figure 5.1 Engagement Zone Diagram. The model shows the input of individuals from the museum and community into the engagement zone and potential products or results of engagement work in the form of adaptation to curatorial practice, community participation or influence on policy/advisory boards, coproduction of exhibits, program development (often connected with exhibits), and the employment of community members possibly in the form of guides. The model highlights the potential for contact zone work (Clifford 1997), but also for engagement zones to occur without necessarily being, or including, contact zones. Model created by B. Onciul 2011. *ah yes how well I remember*

The engagement zone is a physical and conceptual space in which participants interact. It is created when individuals from different groups enter into engagement and closed when those participants cease engaging. If participants change, so do the parameters of the zone and the interaction within it. It is a temporary, movable, flexible, living sphere of exchange that can occur spontaneously or be strategically planned. Engagement zones occur on frontiers, within groups, and as a result of border crossings. They are semiprivate, semipublic spaces where on-stage and off-stage culture can be shared and discussed and knowledge can be interpreted and translated to enable understanding between those without the necessary cultural capital or to facilitate cross-cultural access. If required, offstage information may be disclosed to facilitate the process, although it is generally not intended to leave the engagement zone, nor is it for public dissemination in products such as exhibits.

Within the engagement zone, power ebbs and flows, continually being claimed, negotiated, and exchanged, not predetermined or innate, but situated within the context of the interaction, echoing Foucault's notion of power as "the name that one attributes to a complex strategical situation in a particular society . . . produced from one moment to the next, at every point, or rather in every relation from one point to another" (1976: 93). Conflict, compromise, and consensus can occur. Participants continually negotiate the

rules of exchange, challenging and debating power and authority. Cultural concepts such as expertise, customary boundaries, and hierarchies come into question and negotiation and can change individuals' roles and status within the zone. Boundaries between insider and outsider blur, and temporary boundary crossings are enabled. For some participants, stepping out of traditional roles and crossing boundaries causes feelings of risk, along with the potential for individual participants to be judged by the action of the engagement zone group, irrespective of internal power relations or individual contributions.

Despite the fluidity of power within engagement zones, structural inequalities weight interaction between museums and Indigenous communities. The Make First Nations Poverty History Expert Advisory Committee reported: "in 2009, First Nation communities are still, on average, the most disadvantaged social/cultural group in Canada on a host of measures including income, unemployment, health, education, child welfare, housing and other forms of infrastructure" (2009: 10). Museums generally hold the majority of the power as cultural authorities and the host of the "invited spaces" (Cornwall 2002; Fraser 1987, 1992) of engagement. Nevertheless, Indigenous communities still have power and agency to negotiate terms, particularly because they have the leverage of holding desperately sought after Indigenous knowledge that cannot be found beyond the private sphere of the community.

As spaces of power flux, engagement zones are an unmapped, unpredictable, and inconsistent terrain that has the capacity to produce unexpected outcomes. To borrow Lisa Chandler's expression, community engagement is a "journey without maps" (2009: 85), and what will be discovered, shared, and changed along the way can only be known through doing and experiencing the process. If temporary changes are carried beyond the engagement zone and incorporated into each group's work, or the products they coproduce, the results can be transformative. However these zones do not operate in isolation, but are influenced by the wider context in which they are situated.

Adapting Curatorial Practice to Cultural Protocol

One of the potentially transformative products of the engagement zone is the indigenization of curatorial practice. According to Simpson, "To many Indigenous peoples, western-style museums are laden with associations of colonialism, cultural repression, loss of heritage, and death" (2006: 153). So much so that when the Kwakwaka'wakw developed U'Mista Cultural Society in Alert Bay, BC, the board of directors said, "We're not building a museum. Museums are for white people and are full of dead things" (Gloria Cranmer Webster quoted in Mithlo 2004: 754). Traditional museum practices of collecting and storing Blackfoot material had similar negative effects on Blackfoot life. It disrupted cultural practices by removing items from circulation and use. Sacred items, believed to be living beings by Blackfoot people, entered museums and were treated as inanimate objects, a practice that went against traditional protocol. Indigenizing the way sacred Blackfoot items are treated by museums can improve museum-community relations and support living Blackfoot culture.

Engaging with Indigenous communities can bring alternative concepts of cultural heritage management into museums and create museum practices sensitive to cultural protocol. Understanding and following cultural protocol can help museums become places that support living Indigenous cultural practice, rather than storehouses for disused relics considered dead or dormant by their source communities. To address these issues, some Indigenous groups have sought to work with mainstream museums to change the way they represent and treat Indigenous objects and culture. Many have created their own centers for the care and promotion of their cultural material, knowledge, and practices (Simpson 2007). The Blackfoot have done both, with Elders working with mainstream museums to change practice and the Siksika Blackfoot Nation opening its own center, BCHP, in 2007.

Both Blackfoot Elders and Western museum professionals have complex and intricate practices and procedures that determine the way they manage cultural heritage and materials. Both undergo extensive training with their respective educational authorities and both are valued by their communities as having particular knowledge and expertise that enables them to care for material culture and cultural knowledge on behalf of the wider community. While museum professionals tend to gain their qualifications through university courses, Blackfoot Elders train through apprenticeships in age-graded sacred societies and study for years before earning the right to become a keeper of an object, song, dance, story, or ceremony, which they must maintain and pass on according to strict cultural protocol. As such, it should come as little surprise that, when working with museums, Blackfoot Elders feel suitably qualified to question Western practices and suggest the adoption of Blackfoot protocols for the conservation and exhibition of Blackfoot materials in museum collections.

Museums can benefit from sharing and adapting to non-Western cultural curatorial practice, as Kreps explains: "Indigenous museum models and curatorial practices have much to contribute to our understanding of museological behaviour cross-culturally, or rather, of how people in varying cultural contexts perceive, value, care for, and preserve cultural resources" (2003: 146). Engaging with communities and adapting museum practice in response demonstrates a museum's willingness to share power and to respect cultural practices, which can in turn strengthen relations between museums and the communities they represent. Simpson argues that: "Through the incorporation of indigenous concepts of cultural heritage, curation, and preservation, the idea of the museum is evolving to accommodate the needs of diverse cultural groups, both as audiences for museums and as presenters of culture and custodians of tangible and intangible heritage" (2006: 173). Such adaptation and indigenization can be seen in the case studies to differing extents.

At Head-Smashed-In, Piikani Elder Joe Crowshoe served as the main Blackfoot consultant during the development of the center. Through a combination of consultation with Elders and employment of community members as guides and interpretive staff, the non-Blackfoot management at Head-Smashed-In has learned about Blackfoot protocol and adapted practice to accommodate some cultural approaches. They created a space where smudging[4] and prayer can take place without disturbance, such as the triggering of fire

alarms. They facilitate an annual renewal ceremony for a sacred skull they display and have acknowledged cultural restrictions about photographing this sacred item. However, they have not always acted on the community's advice, and images of the sacred skull continue to be used in marketing materials and products, causing controversy within the Blackfoot community. As Arnstein's model indicates, consultation favors the consulters over the consulted. In addition, the very presence of the sacred skull and two replica bundles in the display causes some upset as there is debate within the community as to the appropriateness of these displays (despite them being sanctioned by the original consultant). Thus Head-Smashed-In has made cultural adaptations, but not to the satisfaction of all members of the Blackfoot community; and it has institutionalized Blackfoot participation through employment, but power remains with the non-Blackfoot government employees who manage the site.

Like Head-Smashed-In, Glenbow made changes to allow space for prayers and smudging. But unlike Head-Smashed-In, Glenbow holds collections and has adapted its curatorial practice further to accommodate Blackfoot protocols that the ethnology team learned through participation in Blackfoot society, repatriation of sacred items, and the partnership they entered into with Blackfoot Elders to develop the Nitsitapiisinni: Our Way of Life gallery. Former CEO Robert Janes explained the learning process and the adaptations it inspired:

> We had a standard conservation practice of putting sacred bundles in a freezer so that they wouldn't contaminate the rest of Glenbow's collection when they came back from a loan. But then we found out that the Blackfoot view these bundles as living children. We had a choice: we could continue to uphold the museum's conservation standards; or, with our growing awareness and our evolving respect for Blackfoot traditions, we actually listened to the Blackfoot ceremonialists and no longer put the bundles in freezers. (Robert Janes, personal communication, 2008)

Traditionally, Blackfoot Elders keep sacred bundles in quiet, safe places; only those who have earned the appropriate sacred rights can handle them, as they are believed to be powerful living beings. Following Blackfoot protocol, Glenbow has removed sacred items from display, either repatriating them or keeping them in separate, designated areas in storage restricted from general access with clear labeling to avoid unintentional exposure. Glenbow follows traditional Blackfoot practice and restricts women accessing the sacred storage areas during their menstrual cycle or when pregnant, which has required Glenbow staff members to adapt their work schedules to accommodate these cultural protocols.

Glenbow recognizes that adaptation requires both granting and restricting access, and has opened up its collection to Blackfoot visitors, allowing object handling in response to Blackfoot traditions of using items to maintain the tie between the tangible object and the intangible knowledge it relates to. Some community members go into storage to see their ancestors' possessions and to reconnect with and renew culture, for example by studying traditional items of dress to inspire the creation of new regalia for cultural events.

Curatorial adaptation is an ongoing learning process informed by working with the community. The aim is to be sensitive to community beliefs and practices and to build relations that facilitate knowledge sharing between the museum and community. At Glenbow, partnership, collaboration, and adaptation have helped to build a strong and respectful relationship between ethnology curators and Blackfoot Elders. This relationship has enabled the repatriation of sacred bundles; the participation of museum employees in cultural and ceremonial events; a Memorandum of Understanding with the Kainai Mookaakin Society; the development of the Nitsitapiisinni permanent gallery; Blackfoot employment at Glenbow; annual community exhibits; programs; and outreach. This co-operation has helped to maintain and renew tangible and intangible Blackfoot culture and enabled knowledge sharing across the network of engaged people, which has improved both the museum's and the community's understanding of Blackfoot culture (Conaty 2008: 255).

At BCHP, the situation is somewhat reversed. Its curators are Blackfoot Elders trained in Western museology and Blackfoot traditions. They hold the rights to handle and keep sacred objects and knowledge granted through their participation in sacred societies. As such, BCHP keeps sacred items in a separate storage area cared for by ceremonialists following traditional protocol, an area also environmentally controlled to meet museo-logical standards. Photography is not allowed at all within the gallery, and the curators are conscious of noise levels within the museum to avoid disturbing the sacred items they house. BCHP has a tepee-shaped space for Elders to use for ceremonies and prayers, and it encourages its community to use the museum and archives to access and keep cultural items and information.

Limitations to Indigenization

Some adaptations can be made relatively easily, such as removing sacred items from display, but some are more complicated and require new ways of thinking about collections, such as enabling communities to use certain collection items. For museums like Glenbow that hold collections from many communities and employ staff members from different social and ethnic backgrounds, it is worth considering how museums should balance rights and values across cultures as each adaptation has costs and benefits.

Glenbow has collections from around the world, and although it has worked closely with some communities such as the Blackfoot, it does not have the resources to engage with and embrace all cultural protocols relevant to the diverse communities represented within its collections. Incorporating Blackfoot protocol alone has created challenges. Restricting women's access to sacred material during their menstrual cycle or pregnancy, although done with good intentions, could prevent a member of staff from performing her duties in relation to that collection. This raises a dilemma, because it places additional demands upon staff that may be contrary to their own cultural values and societal rights.[5] Deciding whose values to respect and prioritize can be difficult because to work with Blackfoot Elders and then ignore their cultural protocol for their most sacred and

powerful objects would make the process of engagement tokenistic and without validity or integrity. Currently, Glenbow ethnology staff willingly respect and accommodate these restrictions.

Interesting, it appears that adaptations that affect the institution as a whole, rather than individual employees or departments, are more strongly resisted. Miranda Brady (2009), in her analysis of the National Museum of the American Indian's collaborative approach to representation, identified five residual, naturalized practices that were maintained despite attempts to be a "museum different" (Rand 2009: 130). Brady identified these practices as: object-orientated museology (2009: 144–145); the commodification of Native culture for a mostly non-Native audience (2009: 136–137); failure to consider museum framing on self-representation (2009: 137); funding from sources that potentially contradict the community message (2009: 147); and the naturalization of the need for museums (2009: 148).

These naturalized practices can be identified at Head-Smashed-In and Glenbow despite their engagement with communities and their cultural adaptations. Both present to a predominantly non-Blackfoot audience. Their sources of funding are bodies frequently in dispute with Blackfoot communities: Head-Smashed-In is funded by government, and Glenbow often receives funding from major oil companies. Both frame the community voice in a non-community venue and naturalize the need for their existence.

BCHP has critically considered these residual practices and attempts to unsettle them by moving away from Western object fetishes and instead focusing on maintaining both tangible and intangible Siksika culture. While the dedicated museum area cares for its material collection, the center as a whole promotes intangible culture: interpreting sense of place in the river valley park area; providing language and cultural programs; and by hosting community events such as the Annual World Chicken Dance Competition and Siksika Has Talent. BCHP was created for the community as well as tourists, and provides interpretation in Blackfoot and hosts community-dedicated events, preventing it from being simply a commodification of Blackfoot culture for a non-native audience. Although Glenbow and Head-Smashed-In also give tours in Blackfoot and provide community-focused events, their overall primary responsibility is not to the Blackfoot community. In contrast, BCHP is directly answerable to the Siksika community. The community was conscious of how to frame its message, and all aspects of the architectural and interior design of BCHP's building add to the interpretation and maintain Blackfoot voice and perspective. Plate 5.1 shows Blackfoot Crossing Historical Park, which as the architect company explains: "The building is intended to be a literal metaphor of traditional Blackfoot iconography" (Fellow Architecture Ltd. n.d.).

Funding was and continues to be a key concern for the Siksika community, who self-funded the majority of the costs to minimize external pressures on how they represent themselves. The BCHP director explained that if they accepted government funding, they would become subject to funding agreements, policies, terminology, and medium requirements, which could undermine and limit the community's freedom to tell its own story at BCHP (Royal, personal communication, 2008).

It is reasonable to ask why BCHP seeks to use Western practices at all, considering the Blackfoot have maintained their culture and heritage for thousands of years. Why not follow traditional practice alone? The answer can be found in the wider context in which BCHP operates. The Alberta Museums Association requires museums meet its definition of a museum (based on a modified version of the International Council of Museums definition, see ICOM 2007) for them to be formally recognized and designated by the association (AMA 2010; McLean 2007). If BCHP wishes to be considered for loans and repatriation of Siksika material from other museums, it has to meet certain museological standards. The apparent naturalized need for a museum on the Siksika reservation is partly due to the desire to have material repatriated and partly due to the status and recognition representing culture in a museum currently affords. As Barbara Kirshenblatt-Gimblett states, "Claims to the past lay the foundation for present and future claims. Having . . . institutions to bolster these claims, is fundamental to the politics of culture" (1998: 65).

Thus restrictions dictate how far a museum can indigenize without stepping outside the professional community of practice. This illustrates that citizen control (Arnstein 1969) does not result in total empowerment or resolve all the challenges of representation, because there are limits to what can be done and recognized, as museums must operate within the context and power relations of their time. As such, combining Western and Blackfoot approaches to curation is currently beneficial for BCHP.

Engagement and the Integrity and Validity of Exhibits

Another common product of engagement zones is coproduced community exhibits. Through collaboration, museums can gain access to traditional community knowledge, deepening their current understandings and interpretation of collections; and communities can shape the representation of their culture in mainstream museums. This is commonly seen as a way to improve representation, increase the integrity and validity of exhibits, and signal community approval. However, in practice this is not an automatic consequence, but heavily dependent upon how the relationship and power negotiations unfold in the engagement zone. As Miltho astutely notes, the "incorporation of Native bodies does not necessarily indicate incorporation of Native thought" (2004: 744).

If museums, intentionally or unintentionally, fail to listen to the people they engage with, do not share power with them, or refuse to act on community advice (potentially due to unforeseen circumstances or institutional requirements), then the exhibitions they produce may have no more validity, integrity, or community approval than if the community had been excluded. In fact, tokenistic engagement can be significantly detrimental to community-museum relations and the museum's reputation within the source community. As Brown and Peers state, "Projects undertaken by museums and archives with source communities need to be more than just attempts to satisfy ideas of political correctness" (2006: 196).

The relationship Glenbow built with the Blackfoot has generally been viewed positively by those who participated (Conaty 2008: 255). Nevertheless, participants acknowledge there is still room for improvement. Not everything could be shown, included, or discussed in the exhibit, and they were limited by the collections available to them. As such the Nitsitapiisinni gallery still presents a simplified and essentialized narrative that only reflects a fraction of the complex and intricate Blackfoot culture, peoples, and history. Further still, the gallery does not fully represent the whole Blackfoot Confederacy, as community participants were not equally balanced from each Blackfoot Nation, nor was everyone involved. Curator Gerry Conaty noted that there was not an equal balance between men and women during consultation, and a different exhibit could be developed from a female perspective (Conaty, personal communication, 2007). The partnership received more involvement from the Kainai Blackfoot Nation than other nations, making the exhibit vulnerable to claims that the narrative favors a Kainai perspective, even though it was a collaborative project built on consensus across the representatives of the four nations.

Bridging the differences between the communities was achieved through traditional Blackfoot processes of consensus forming amongst the Elders, which often entailed long discussions in the Blackfoot language and excluding non-community participants from discussions until an agreement had been made. One example was the use of the Blackfoot language. With no official written language, the spelling of Blackfoot words in the exhibit had to be discussed and agreed upon. Differences in spellings are sometimes viewed as errors by community visitors, as former Glenbow curator Beth Carter explains:

> We've had some people who come into the gallery and question the content, saying: "well that's not right" and "where did you get that information?" So we say: "okay, these were the members on our committee." And they respond "Oh . . . well!" So they may disagree, but they know at least where we got the information, that it's not just pulled from a book or from the stratosphere somewhere . . . (Carter, personal communication, 2008)

In the first instance, this quote highlights that community engagement can give validity and authority to exhibits, as participants can be cited as references for certain information. This was done with the best intentions and is culturally appropriate as Blackfoot people cite their Elders to show that the information came from an authorized and knowledgeable source.

Nevertheless, it is worth considering the potential consequences for participants who are identified in coproduced exhibits, as they can be held personally accountable by the community they live in for the representation they helped produce in the museum. And yet to create a collaborative exhibit and not identify participants would potentially undermine the participants' agency in the process and be culturally inappropriate in a Blackfoot setting. A compromise would be to try to show that there was a balance of power between the community and museum by identifying the non-community members who also participated in the development of the exhibit. Glenbow and BCHP take this approach and name all participants, including the non-community members (although Glenbow only

includes the community members in the photo display at the end of the exhibit). In doing so, visitors can see who the power was shared between and the balance between museum employees, community members, and external consultants. Although this does not reveal the nature of power sharing within the engagement zone, it does increase transparency and indicates the agency of both the museum and community members.

However, whether this message would be received and understood by visitors appears less likely, as Krmpotich and Anderson explored in their analysis of visitors' responses to the Nitsitapiisinni gallery: "Interviews conducted with visitors . . . demonstrate that museum visitors rarely recognized the extent of the collaboration, and thus rarely equated Niitsitapiisinni with concepts of self-representation or self-determination" (2005: 377). This can be explained in part by Elaine Heumann Gurian's suggestion that: "While visitors expect to see the authors of works of art, music and fiction identified, they are not used to perceiving exhibitions as the personal work of identifiable individuals" (1991: 187). Krmpotich and Anderson go on to explain, "If visitors are not accustomed to thinking critically about who is creating exhibitions in the first place, they are unlikely to consider the processes of exhibition building and hence not fully appreciate the cultural representations embodied in collaborative exhibitions" (2005: 399).

The problematic nature of communicating power sharing to a public audience is unsurprising when considering the complexity of power relations found in engagement zones. Engagement is an ongoing process which may have peaks and troughs, and the integrity and validity of the relationship may vary at different points in the process. As Glenbow curator Gerry Conaty explains, "Institutions must realize that such programs are very long term and that the returns on investment may be a long time in coming and may arrive in unanticipated ways" (2008: 256). Engagement relationships tend to experience periods of activity and commitment followed by periods of stagnation. Although resource heavy, museums can help to sustain the integrity of community engagement by planning how to maintain relations during and after the life of the exhibit, and, if necessary, how to end engagement in a mutually acceptable way. To keep an engagement zone open and active requires good communication to facilitate ongoing power sharing, decision making, and the exchange of information. This enables consent renewal and updates; helps to prevent representation from becoming dated or no longer appropriate; enables participants to be involved in the closure of exhibits; and helps to shape future engagements. Engagement relations need to be worked at, prioritized, and to some extent institutionalized into the ethos and daily workings of the museum. Maintaining relations ensures engagement is not just tokenism or a new form of collecting, but a genuine and potentially empowering and transformative experience for all involved.

Conclusion

Engagement has great potential to benefit museums and communities, to share knowledge, create new relationships, exhibits, programs, policies, and curatorial practices. It can give cultural representations greater integrity and validity and enable alternative

narratives, new perspectives, and voices to be heard within museums. However, these are not automatic products of engagement, but depend upon the process and power sharing within the engagement zone and how relations are maintained after the initial process of engagement comes to an end.

Within the engagement zone, the lines between what is and is not possible and/or ethical can be blurred and complicated when cross-cultural dialogue identifies areas governed in different ways by different cultures, such as women's rights, or balancing current access with maintaining collections for future access. As such, curatorial adaptation and exhibit production are often tangible sites of power negotiation.

Engagement is an unpredictable process and even when levels of power sharing are apparently established at the outset, that is, in the form of a certain model of participation, power can still be negotiated within the engagement zone and participants may experience moments of empowerment and disempowerment over the course of the engagement. Engagement is complex and unpredictable and can be both beneficial and detrimental to those involved. As publicly acknowledged members of an engagement team, individual participants can be held accountable for the products of these processes, even if they were not (entirely) personally responsible for them. As such, participating in the unmapped territory of engagement zones is risky and has real consequences for the participants, museums, and communities involved.

Engagement can create new challenges that unsettle naturalized museum practices. For engagement to have validity and integrity, institutions need to share power, take on community concerns, and adapt. Otherwise engagement can become what Bernadette Lynch and Samuel Alberti term "participation-lite" (2010: 17), drawing on Andrea Cornwall's development studies concept of "empowerment-lite" (2008b). To engage simply to meet current expectations of political correctness, and to do so in a tokenistic way, undermines the spirit of engagement. Lynch and Alberti propose the idea of "radical trust" to overcome the problems of "participation-lite" (2010). "In practising radical trust," they argue, "the museum may control neither the product nor the process. The former—if there is one—will be genuinely co-produced, representing the shared authority of a new story . . . the process itself is the key issue. [. . .] Consensus is not the aim; rather, projects may generate 'discensus'—multiple and contested perspectives that invite participants and visitors into further dialogue" (Lynch and Alberti 2010: 15–16).

Whilst admirable, "radical trust," like "citizen control," does not fully address the practical challenges of sharing power within a group through the unpredictable process of engagement. Nor does it address the outside factors that influence engagement zones and their products, such as institutional, professional, cultural, and societal pressures, requirements, and expectations. Even citizen-controlled community developed museums like BCHP must abide by certain standards to function within the professional field and be accepted as a museum by wider society. They also have to consult and negotiate with their own community, despite being community run. The challenge of how to empower a community and "genuinely coproduce" (especially when given a starting point of unequal power relations and institutionalized expectations) and still be recognized as a museum remains unsolved. As discussed earlier in this chapter, attempts to

show collaborative working or "discensus" of views within a museum product such as an exhibit are often misread or unread by visitors who are not accustomed to thinking about museums in this way.

Current engagement is limited by the context in which it occurs and the extent to which a museum is willing to take on, adapt, and indigenize its practice, products, and ethos. As Lynch and Alberti note, "participation within a museum system that continues to disadvantage participants may give them some tools but, as Audre Lorde argued, 'the master's tools will never dismantle the master's house'" (2010: 18). Nevertheless, community engagement (however limited by context and power disparities) does still influence museums and the exhibits they produce, which in turn influences the audiences who come to view them, even when they are not read as works of coproduction or self-representation. Thus, community engagement with museums holds the potential to gradually change the society that frames current power relations, enable better cross-cultural understanding, and move towards wider empowerment of Indigenous Peoples. The development of genuine interpersonal relations, open, honest communication, and institutional commitment can develop models of engagement that will benefit both groups and give engagement the validity and integrity to improve current relations and approaches to representation.

Notes

I acknowledge the AHRC for funding the research outlined in this chapter.

1. The term *Elder* is capitalized because it is a title given to members of the Blackfoot in recognition of their status. An Elder is a member of one or more sacred societies, who has earned ceremonial rights and holds a certain level of traditional knowledge. The title does not refer to age, although Elders are often elderly because of the time taken to reach this level.

2. The name of the Jump is disputed. According to archaeologist Jack Brink, the name Head-Smashed-In comes from a traditional Blackfoot story about a young man who hid beside a cliff during a hunt and was crushed by falling buffalo, resulting in his head being smashed in (2008: 24–25). However, there is dispute as to the location of that buffalo jump, and Piikani Elder Allan Pard asserts that the center's cliff is called Ancient Jump (Allan Pard, personal communication, 2008). Brink acknowledges these discrepancies in his book, but notes that the name is now branded and unlikely to change (2008: 26).

3. Initial capital contributions prior to 2008 to fund the development of BCHP were $9,174,523 from the Siksika Nation, $6,000,000 from the federal government, and $4,500,000 from the Province of Alberta (Bell 2007: 19).

4. Blackfoot people use smudging (the burning of sweet grass, sage, tobacco, or sweet pine) to spiritually cleanse people and objects.

5. This could potentially be taken forward as a grievance against the employer under the Canada Fair Employment Act (1953).

References

Alberta Museums Association (AMA). 2010. *Recognized Museum Program.* AMA. Available at: www.museums.ab.ca/files/Recognized%20Museum%20Program%20Overview_2010.pdf. Accessed June 26, 2011.

Arnstein, S. R. 1969. "A Ladder of Citizen Participation." *JAIP* 35 (4): 216–224.

Bell, J. K. 2007. *Blackfoot Crossing Historical Park Business Plan July 2007.* Ontario: Bell and Bernard Limited.

Brady, M. J. 2009. "A Dialogic Response to the Problematized Past: The National Museum of the American Indian." In *Contesting Knowledge: Museums and Indigenous Perspective,* ed. S. Sleeper-Smith, 133–155. London: University of Nebraska Press.

Brink, J. W. 2008. *Imagining Head-Smashed-In. Aboriginal Buffalo Hunting on the Northern Plains.* Edmonton: AU Press.

Brown, A. K. and L. Peers, with Members of the Kainai Nation. 2006. *"Pictures Bring Us Messages"/ Sinaakssiiksi Aohtsimaahpihkookiyaawa: Photographs and Histories from the Kainai Nation.* Toronto: University of Toronto Press.

Chandler, L. 2009. "'Journey Without Maps': Unsettling Curatorship in Cross-cultural Contexts." *Museum and Society* 7 (2): 74–91.

Clifford, J. 1997. *Routes: Travel and Translation in the Late Twentieth Century.* London: Harvard University Press.

Conaty, G. T. 2003. "Glenbow's Blackfoot Gallery: Working Towards Co-existence." In *Museums and Source Communities: A Routledge Reader,* eds. L. Peers and A. K. Brown, 277–241. London: Routledge.

Conaty, G. T. 2008. "The Effects of Repatriation on the relationship between the Glenbow Museum and the Blackfoot People." *Museum Management and Curatorship* 23 (3): 245–259.

Cornwall, A. 2002. "Locating Citizen Participation." *IDS Bulletin* 33 (2): 49–58.

Cornwall, A. 2008a. "Unpacking 'Participation': Models, Meanings and Practices." *Community Development Journal* 43 (3): 269–283.

Cornwall, A. 2008b. *Democratising Engagement: What the UK Can Learn from International Experience.* London: Demos.

Farrington, J. and A. Bebbington, with K. Wellard and D. J. Lewis. 1993. *Reluctant Partners: Non-governmental Organisations, the State and Sustainable Agricultural Development.* London: Routledge.

Fellow Architecture Ltd. n.d. *Blackfoot Crossing Historical Park—Interpretive Centre. Design Metaphors and Concepts* [unpublished]. Calgary: Fellow Architecture Ltd.

Foucault, M. 1976. *The History of Sexuality: Volume 1: An Introduction.* London: Penguin Group.

Fraser, N. 1987. "Women, Welfare, and the Politics of Need Interpretation." *Hypatia: A Journal of Feminist Philosophy* (2): 103–121.

Fraser, N. 1992. "Rethinking the Public Sphere: A Contribution to the Critique of Actually Existing Democracy." In *Habermas and the Public Sphere,* ed. C. Calhoun, 109–142. Cambridge, MA: MIT Press.

Galla, A. 1997. "Indigenous Peoples, Museums, and Ethics." In *Museum Ethics,* ed. G. Edson, 142–155. London: Routledge.

Gurian, E. H. 1991. "Noodling around with Exhibition Opportunities." In *Exhibiting Cultures: The Poetics and Politics of Museum Display*, eds. I. Karp and S. D. Lavine, 176–190. Washington, DC: Smithsonian Institution Press.

Hollway, W. and T. Jefferson. 2000. *Doing Qualitative Research Differently: Free Association, Narrative and the Interview Method.* London: Sage Publications.

ICOM. 2007. *Museum Definition.* Available at: http://icom.museum/hist_def_eng.html. Accessed May 7, 2011.

Kirshenblatt-Gimblett, B. 1998. *Destination Culture: Tourism, Museums and Heritage.* London: University of California Press.

Kreps, C. F. 2003. *Liberating Culture: Cross-cultural Perspectives on Museums, Curation and Heritage Preservation.* New York: Routledge.

Krmpotich, C. and D. Anderson. 2005. "Collaborative Exhibitions and Visitor Reactions: The Case of Nitsitapiisinni: Our Way of Life." *Curator* 48 (4): 377–405.

Lorde, A. 1984. *Sister Outsider: Essays and Speeches.* Freedom, CA: Crossing Press.

Lynch, B. and S.J.M.M. Alberti. 2010. "Legacies of Prejudice: Racism, Co-production and Radical Trust in the Museum." *Museum Management and Curatorship* 25 (1): 13–35.

Macdonald, S. 1996. "Theorizing Museums: An Introduction." In *Theorizing Museums*, eds. S. Macdonald and G. Fyfe, 1–17. Oxford: Blackwell Publishers.

Make First Nations Poverty History Expert Advisory Committee. 2009. *The State of the First Nations Economy and the Struggles to Make Poverty History.* Available at: http://abdc.bc.ca/uploads/file/09%20Harvest/State%20of%20the%20First%20Nations%20Economy.pdf. Accessed March 2011.

McLean, M. 2007. *Museum Affirmation Program: Findings & Analysis 2007.* Alberta Museums Association (AMA). Available at: http://www.museums.ab.ca/files/Museum AffirmationProgramFinalReportSept11.pdf. Accessed June 26, 2011.

Mithlo, N. M. 2004. "'Red Man's Burden': The Politics of Inclusion in Museum Settings." *American Indian Quarterly* 28 (3/4): 743–763.

Pratt, M. L. 1992. *Imperial Eyes: Travel Writing and Transculturation.* London: Routledge.

Pretty, J. 1995. "Participatory Learning for Sustainable Agriculture." *World Development* 23 (8): 1247–1263.

Rand, J. T. 2009. "Museums and Indigenous Perspectives on Curatorial Practice." In *Contesting Knowledge: Museums and Indigenous Perspective,* ed. S. Sleeper-Smith, 129–131. London: University of Nebraska Press.

Simpson, M. G. 2006. "Revealing and Concealing: Museums, Objects, and the Transmission of Knowledge in Aboriginal Australia." In *New Museum Theory and Practice: An Introduction,* ed. J. Marstine, 153–177. Oxford: Blackwell Publishing.

Simpson, M. G. 2007. "Charting the Boundaries. Indigenous Models and Parallel Practices in the Development of the Post-museum." In *Museum Revolutions: How*

Museums Change and are Changed, eds. S. J. Knell, S. McLeod, and S. Watson, 235–249. London: Routledge.

Task Force on Museums and First Peoples. 1992. *Turning the Page: Forging new partnerships between museums and First Peoples.* 2nd ed. Ottawa: Assembly of First Nations and Canadian Museums Association.

White, S. C. 1996. "Depoliticising Development: The Uses and Abuses of Participation." *Development in Practice* 6 (1): 6–15.

–6–

Co-curating with Teenagers at the Horniman Museum

Wayne Modest

In January 2010, the Horniman Museum launched a youth engagement program as part of the London 2012 Cultural Olympiad.[1] Designed with established participatory models for working with young people and communities such as *hear by right* and *revisiting collections*[2] in mind, the project represented an attempt to engage the concerns and interests of the young as part of the practice of the museum. The idea was that young people would no longer be passive visitors arriving with schools or other organized groups, but active participants involved in appropriate decision-making aspects of collection and exhibition practices. As part of their integration within the protocols of the museum, youth were to work with learning and curatorial staff who would introduce them to the different facets of the curatorial process. The work produced during this process would be included in the Horniman Museum's 2012 exhibition for the Cultural Olympiad, entitled The Body Adorned: Dressing London.

While working with teenagers was a long-standing interest of the Horniman, including young voices in this particular project was not the museum's idea. In fact, it was the Cultural Olympiad organizers who, as part of their hopes to make London 2012 "the largest cultural celebration in the history of the modern Olympic and Paralympic Movements," developed what they called the "Stories of the World" project that would enable "people of all backgrounds, from across the UK, to become 'curators' of the collections and objects held in museums, libraries and archives." Stories of the World, according to the planners, would "get young people working with curators, filmmakers, artists, writers and musicians to explore and reinterpret museum collections, giving a new perspective on the stories that tell us about our place in the world."[3]

As curator of the proposed Horniman exhibition for 2012, I was charged with developing a theme around which the museum could work with young people. After consultation, it was decided to use the museum's large collection of objects related to dress (fashion, adornment, self-fabrication) as a starting point for both the exhibition and the accompanying youth engagement project. Developing the exhibition, at that time called The Body Adorned: Dressing the World City, was to be the core around which the youth engagement project would be organized; the "youthful" results of this cross-generational and cross-institutional encounter would be included in the exhibition.

Though collaborative work with children and within communities was not new to the Horniman, developing a coherent and sustainable collaborative practice with young people presented its own challenges. This chapter aims to explore a number of the issues arising out of the Horniman's Cultural Olympiad youth project. My intention is not so much to find answers or models for working with young people in museums, but to, through a *thick description* (Geertz 1977) of the processes involved in this project, present a case study, one picture of the possibilities and challenges of including young people's voices in the museum, as well as a more general understanding of how better to engage and involve different publics. The analysis I present here is in many ways triggered by an incisive question posed by a young participant during one of the training sessions: "You're all just using us right, to do your work for you?" His comment threw into sharp relief several of the concerns of the project planners and resonated quite directly with me in my capacity as curator.

When is engagement real as opposed to symbolic? Who benefits from engagement, the museum or the community? Who drives the encounter, communities or the museum? And can the young (teenagers and young adults) be regarded as a constituency for engagement in the same way other groups such as refugees, blacks, or Polish can? In other words, how does one best understand the diverse needs of a highly complex demographic?

Collaboration in Museums

As several scholars have noted, one of the most significant turns in museum practice in recent years has been the changing nature of the institution's relationship with (source) communities. Much of this change can be traced to the new museology movement of the 1980s and further movements by museums in the 1980s and 1990s toward civic engagement (Cameron 2007). Peers and Brown have described "the dramatic change in the nature of relationships between museums and their source communities, the communities from which museums' collections originate," as "one of the most important developments in the history of museums" (2003: 1). They note that while previously only a one-way process existed whereby objects and information about particular groups found their discrete ways into museums and were researched and interpreted by museum practitioners, academics, and critics, today more emphasis is placed on a two-way, dialogic process such that "information about historic artefacts is now being returned to source communities" and community members are "working with museums [and] are now recording their perspective on the continuing meanings of artefacts" (2003: 1). Museums, then, at least as far as these authors are concerned, have begun to see source communities as an "important audience for exhibitions, and to consider how museum representations are perceived by and affect source community members" (2003: 1).

Phillips sees this shift toward more collaborative paradigms as raising fundamental questions about "the ways that contemporary museums are repositioning themselves as they respond to the powerful currents of cultural pluralism, decolonisation, and

globalization" as well as about "the changing relationship between museums and the societies within which they operate" (2003: 155). She identifies this *collaborative turn* as beginning in the 1990s, identifying two emergent models for collaborative exhibition practices. In what she describes as the "community based model," the role of the curatorial staff is more one of a facilitator in support of community members who decides on content, text, and other aspects of the exhibition (2003: 163). In the second model, what she describes as polyvocal approaches, "museum staff and community consultants worked to find a space of coexistence for multiple perspectives" (2003: 164).

As suggested, engaging with the diverse communities that house and animate their museums is not exactly new, even if Phillips, like Peers and Brown, rightly identifies key shifts in relationships of power with respect to how objects are collected, cared for, and displayed within museums. In the United Kingdom, for example, inclusive models for museum practice have a longer history, especially within social history museums, and can be traced back to at least the middle of the twentieth century. Yet new models of museum practice are being developed that include sharing decision making in the collecting, curating, and exhibiting of collections with peoples from source communities.

While these collaborative models have indeed resulted in significant shifts in how museums see their role working with communities, it is important to think through how the Stories of the World Cultural Olympiad project would be different from other forms of museum collaborations. I was especially interested in what yield could be gained by working with a group of people based around age categories as opposed to a source. Were they also a source or even a community? Moreover, what would their "different backgrounds," one of the criteria of the Cultural Olympiad planners, contribute to how the project was understood and framed? Could this appeal to working with diverse backgrounds provide a different model for working with communities?

Collaborative at the Horniman

For the Horniman, collaborative exhibition practices were not a new endeavor. In fact, one of Phillips's examples of an exhibition that attempted polyvocality, which I discussed earlier, was the development of the African Worlds gallery at the Horniman. As part of the process to design a gallery dedicated to Africa, the Horniman established a curatorial and advisory team comprising people from Africa, the Caribbean, and the United Kingdom, and included the participation of members from London's African diaspora. Through this collaborative process, the gallery addressed some of the myths and misunderstandings within academic and popular imagination about the African continent. Misconceptions as simple as "Africa is one country" to more complex issues such as ideas that Africa has no history were addressed in the gallery with the collaboration of members of the source community (Shelton 2003).

I have discussed elsewhere how this exhibition provides a good example for thinking about how collaborative exhibition practices can strive toward addressing social justice (2011). At the same time I have also questioned whether everyone who sees himself or

herself as part of the African diaspora can so easily be regarded as part of the source community for objects from Africa (2011). In that article, my concern, which I will also come back to later in this chapter, was to ask what we understand the term *source* to mean. Can people from the Caribbean, for example, truly represent a source for an African collection? Does the museum stand a risk by conflating ideas of "blackness" with African? That notwithstanding, the development of African Worlds is a good example of the museum working within a new collaborative paradigm with communities.

Similar attempts at collaboration could also be seen with other projects by the Horniman, including the development of the Utsavan—Music from India exhibition, which opened in 2010. Here the Horniman worked with Indian communities in London and in India itself.

Stories of the World at the Horniman Museum

Collaborative museum practices were, therefore, not new to the museum. In fact, it could be said that collaboration had become standard practice for many museums across the United Kingdom. However, I want to suggest that working with young people provided different possibilities as well as challenges as compared with (source) community-based curatorial or learning projects. For example, even with the growing numbers of collaborative projects in museums in recent years that uncritically conceive of Africans or people from the African diaspora, for example, as a single group, the African community as a group can be seen as having a different kind of internal coherence in comparison with a category such as young people or teenagers.

This is not to suggest that ethnic identities are themselves fixed, coherent, or without internal dissonances. Numerous scholars have already cautioned against such reification of culture as a fixed "thing," belonging to a fixed and unchanging community (Bauman 1996). Much of this criticism emerged in response to the cultural identity turn of the 1990s and 2000s. My purpose here is rather to mark the fact that the age category *young people* does not cohere around similar political discourse around which other group identities are mobilized. Any behavior, trait, or attribute deemed to belong to young people strictly as a result of their age category will eventually disappear—or at least so we hope.

The challenges this particular project raised were related more to how to recruit young people, and how, when they are often thought of as having a limited attention span, to keep their interest over a long period of time. The Stories of the World youth engagement projects started in 2010; the final output was not expected until the summer of 2012, during the Cultural Olympiad. In addition to maintaining their interest, the question of how to develop an interest in the museum in the first place was also an issue.

Of course, similar questions could be asked about any community-based project. Yet more cogent questions related to age were also raised. While getting young people working with curators was a good goal, questions were raised about whose goal this was, the museum's, the Stories of the World planners', or the young people's. Moreover, would the young people be ready to take the responsibility that *we* wanted them to take, especially

as many of them did not and may not even have thought of working in a museum before this point? Perhaps one of the most important, and some may think it mundane, point was the fact that working in a museum came with certain risks, especially concerning the high health and safety standards most museums are required to uphold in the United Kingdom. This is especially the case when dealing with young people.

In an attempt to find an appropriate model for working with young people, the museum created a project team comprising members from the museum's learning (education) team, the curator of the proposed exhibition, a project manager, and a community curator. In addition to helping with the Horniman's youth project, the community curator and the project manager were to work closely with other Stories of the World projects across London, especially with a group of smaller museums that elected to partner with the Horniman for its project.[4]

That community engagement programs are led by learning (education) staff in museums is now a well-established practice. Curators are often not part of these programs. This in many ways has its own history, framed in how the role of the curator has been traditionally understood. Museum curators are regarded as scientists and believed to use language and concepts not always accessible to a broad public. It could be argued that these attitudes, at least in part, resulted in the emergence and later professionalization of learning (education) departments in museums as they felt the need to more effectively address their different publics. What effect this has had on the value of curatorial knowledge and how curators are viewed in museums remains underexplored, except through anecdotal discussions about the dumbing down of exhibition content.

The choice to include curatorial expertise in the team of the Horniman was a direct response to the desires of the Stories of the World organizers for curatorial contact with young people, and therefore intended to emphasize the project's goal as a curatorial intervention and to stress that the young people were invited to join a curatorial process.

An exhibition project was designed and framed around the Horniman's large collection of items related to dress, and the museum carried out two projects in which the young people were involved. Both projects were structured around the idea of co-curatorship and shared responsibility, where together, the traditional curators and the young curators would develop ideas and material for the exhibition in 2012.

Youth Identities through Peer Ethnography

The museum recruited young people through established contacts and by visiting local schools in south London. This had the shortcoming that, while it would attract a varied group through the different schools, it still provided limited diversity—all of the schools were close to the museum. It was decided to also advertise within the museum, and flyers and cards were designed and visibly placed in the museum. The project was also advertised on the Internet. Young people interested to participate were asked to write a short statement of about 100 words saying why they were interested and what they hoped to achieve from the program. One of the issues that had to be solved early was what kind of

incentive would be offered to the young people. Some members of the project team felt that giving financial incentives was wrong. While no general consensus emerged, many of the young people did not want compensation. Some saw the program as an important addition to their resume, as they would be preparing their application to university shortly. Several of the participants said that they were interested in theme of identity, which the project would help them explore. The young people recruited were between fourteen and eighteen years old.

Once the group was recruited, the project team worked to acquaint the youth with the different aspects of creating an exhibition. They were introduced to working with collections, exhibition concept development, and exhibition proposal writing. They learned about conducting fieldwork and read old field notes from former curators of the museum. While questions were raised about the appeal of some of the things we were doing, some people in the team felt this was part of taking the young people seriously. The curators on the team even wanted to take the young people on fieldwork in another part of the country—taking them out of their setting for a short period. Fieldwork was, in the end, not possible, as the health and safety risks were deemed too high.

It was decided early in the process not to decide on the exact outcome for the project but to allow the young people to have a say in defining those outcomes. This caused some concerns for the curatorial members of the project team. Having little experience with working with young people and frightened by the uncertain outcome, they felt that the young people should be given more direction. The learning team, on the other hand, wanted to encourage more democratic processes for the involvement.

The young people were trained to conduct "peer ethnographies," observing and interviewing their peers to try to better understand the role that dress played in how they understood and presented themselves. The results from their studies would, it was hoped, form part of the Horniman exhibition for 2012. Throughout the process, we conducted ongoing discussions, during which the different ways of understanding the relationship of dress and identity were explained. We also used this as an opportunity to hear from the young people about their ideas on what dress meant for youth identities. These discussions, we hoped, would get them to critically reflect on what they were seeing around them and prepare them for the interviews they were going to conduct with their peers later in the project. This was done at the same time that we tried to develop goals with the young people about what they wanted to get out of the process and what they imagined the exhibition could be.

Just before sending the youth out on their own to conduct interviews with their peers, the project team organized a series of mock interviews with different members of staff in the museum. The young people, with the help of the curatorial team, developed a set of questions to guide the interviews. They were also taught to use recording equipment and cameras. It was only after this initial training that the young people went out and interviewed their peers. Choosing someone who was safe but not very well known to them (the sister or brother of a good friend, for example), they interviewed individuals about the different items in their wardrobes. At the end of this process, the young people used this material to develop a small exhibition shown at the museum for a day.

One other aspect of the project was to organize a youth conference, where academics and young people discussed some of the ways in which young people were represented both in the popular press and in academia. The idea was to create an environment where academics could discuss some of their work about young people with young people. In return, young people could respond to some of the issues raised about them as well as talk about some of their concerns. At the end of the conference, the young people organized a youth takeover and party in the museum targeted at their peers. Over 100 young people attended the event.

While not all of the desired outcomes were achieved in this project, including the fact that it did not generate the output for the final exhibition in 2012, it raised both theoretical and practical questions about how to work with young people. I will return to these issues later in this chapter. One thing that did result from this project was the setting up of a long-term youth panel in the museum that advises the museum on various issues related to young people. The youth panel is still functional, with several of its members drawn from the original group of young people.

The Urban Portraiture Project and the Multicultural Narrative in London

If the peer ethnography project had fallen short of producing the desired results, as a pilot project it provided some guidelines for the follow-up. It was evident that young people were not only interested to work with the museum but were also prepared to address some complex questions, about contested identities, for example. Also, while they were willing to take responsibility and wanted to be listened to, they wanted guidance about the parameters within which they would work, especially within the strange context of the museum. As curator, working with the young people provided me with an opportunity to rethink the exhibition, its basic concepts, and what it would comprise. In this regard, the young people, even outside of them knowing, were thinking partners for how the exhibition would develop.

For the second project, it was decided to adopt a more product-oriented strategy, focusing more on the desired output for the exhibition. Working with a sociologist and urban photographer from Goldsmith College and the community curator, the young people were to focus on producing a series of high-quality photographs for the exhibition. Again, the approach was that, with sufficient training and if given the responsibility and trust, they could produce exhibition-quality material. After several training sessions in urban portraiture, (very) basic concepts of urban studies, and detailed discussions about the proposed exhibition and what it was supposed to achieve, the young people were sent into the streets to explore with cameras the ways in which contemporary Londoners used dress to negotiate a sense of self and belonging to the city.

As part of the project outline, we offered incentives such as photographic training, the inclusion of their work in a major exhibition, and, important, the inclusion of their photographs in their portfolios for university applications. The museum project team

would also help the young people prepare these portfolios. It is important to note here that about half of the young people involved in this project are now in an arts track project in universities across the United Kingdom.

Young people were recruited from further education colleges across London, but primarily in south London. Many of the participants were interested in art, photography, design, and fashion, among other subjects. Some of the young people from the peer ethnography group were also brought back to be part of this project. This group of students was also older and therefore presented fewer safety and security concerns for the museum.

For over a year, the young people worked throughout the city of London photographing people in the street. Some of them brought friends to the urban studio to be photographed. In addition to taking photographs, they were also required to approach people, discuss the project with them, and fill in the relevant permission forms for the use of the photographs in the exhibition. Some of the young people expressed anxieties about approaching people at the beginning; over time they became more confident.

Although initial anxieties existed among the museum staff about whether the young people could produce photographs of a high enough quality for the exhibition, we decided to work with whatever they produced. We also discussed whether the exhibition should be seen as the end in itself, or whether the process of working with the young people was sufficient. At the end of the project, more than 120 high-quality images were produced by the young people, and approximately 60 images were used in the exhibition. The young people were also involved in deciding how their works would be mounted in the exhibition, as well as writing the captions for the exhibition.

Young People, Participation, and Museums

For the remainder of the chapter, I would like to examine some of the issues raised by both these projects. I want to ask about the yields to be gained by focusing attention on young people for museum collaboration. Recalling some of the questions I raised in the opening pages of the chapter, I am interested to understand how to make youth engagement in museums real as opposed to symbolic and how both communities and museums can benefit from the engagement. I also wanted to know who drives engagement, communities or the museum, and whether young people can be regarded as a constituency for engagement in the same way other groups can.

One important issue that emerged during the youth engagement projects, especially in the peer ethnographies, was the striking differences of expectations and method between what the curators thought could be done in working with young people, what the learning team expected, and the desires expressed by the young people themselves. For the curators, the best thing was to quickly introduce the young people to curatorial practice, to the general concepts the exhibition would address, and to how to conduct research both in the museum and in the field. Thereafter, the young people would be expected to go out and learn through trial and error (of course with the necessary guidance). More highly

trained in dealing with young people, the learning team quickly recognized the foolhardiness of such an approach and raised important issues about the young people becoming frustrated if they did not feel they could properly accomplish the tasks assigned, as well as about the safety and security of the young people. It became apparent that the limits of what a young person is and is not allowed to do because of his or her age constrained how much responsibility he or she could be given.

The learning staff were very well attuned to some of the needs of the young people and were strong advocates for listening to what they had to say. This worked well to ensure that the project team always focused its attention on making certain that the young people were truly involved in the decision-making processes. Yet at times it seemed there was too heavy a reliance on external facilitators as a way to reach the young people. Facilitators were brought in to do icebreakers or for team-building workshops before the project actually started. While trusting the learning team about the necessity for doing such sessions, it highlighted the emergence of a heavy (and expensive) infrastructure around museums trying to work with different stakeholders that has emerged in recent years. Could this point to devolution of responsibility by museums or other cultural institutions in a time of participation? Could it also serve, within the participatory models that are now prevalent, to devolution of professional expertise, such as curatorial expertise, in museums?

As a project team, both the learning and curatorial teams learned from each other to come up with a suitable model that could be regarded as co-curation and not just participation. Yet it was also striking that there were, within some quarters of the museum at least, many assumptions about what young people would and would not do. What was clear was that even within the museum, some of the negative mediated ways of viewing young people were also present. Young people, we often imagine, get bored easily and therefore need constant stimulation; they all have specific aesthetic interests and therefore would only be interested in a particular exhibitionary language; they are all interested in technology and new media; young people would never like conferences. During the conference and party arranged at the museum, a feeling emerged that the young people could be disruptive and therefore must be watched. These ideas about young people, while well intended, did not always map onto how young people presented themselves within the museum. Moreover, they also suggested that, contrary to my earlier statement about reification of culture and community, there was this category called "young people," which people saw as having certain presupposed behaviors associated with it.

Another, perhaps more important, issue was raised by one of the young participants. During one of the open workshop-style sessions at which we discussed issues from youth identity to the content of the exhibition, the idea of a shared decision-making process was again raised. The idea that as museums we share decision making with collaborators is now a well-established and unquestioned practice. In response to the statement that as co-curators they would also be expected to contribute to the development of the goals of the project, including the final exhibition, one young participant questioned the museum's intention by asking, "You're all just using us right, to do your work for you?" Until that moment, questioning the reason for doing such a project was never raised. For me as a curator, it went without saying that such collaborative practices were to be done.

Moreover, we were responding to the challenge set out by the Stories of the World planners to include young voices in museum practice. But why was this desirable and who made this decision? Were young people consulted about whether they were interested? As government policies are implemented to encourage museums to play a social role in society, to what extent are these programs geared more at achieving targets than fulfilling the desires of our target audiences? Of course many minority groups, in the United Kingdom and the United States, for example, have lobbied for greater inclusion in the decision-making practices of museums. Yet, at the moment the question was raised, I was led to ask who is benefiting from these programs of engagement—the museums or the communities? Are the young people benefiting?

Raising such a question here is not intended to question the need of museums to remove the barriers to inclusion and therefore ensure that the heritage they preserve is available to all within the society they serve. I am more interested in thinking through the political field in which notions of participation play out, especially around young people's participation. Moreover, what can young people's participation offer to museums? The projects as I have just described them cannot be bracketed from a broader policy framework, implemented by the MLA, for example, to encourage more democratic processes in how museums function. At the same time they can be viewed within what Bessant has described as a growing urgent advocacy by some Western governments for enhanced youth participation as part of a "discourse about modern citizenship . . . while tackling a range of social problems" (2004: 387). Writing about young people's participation in democratic political processes in Australia, Bessant highlights the contradiction between government's "policy clichés" about participation and the actual structures in place to facilitate a true or successful claim to participation of young people (2004). It is interesting to compare the language used in Bessant's Australia case (2004) and that adopted to speak about young people and ideas of democracy as used within the Hear by Right framework of the National Youth Agency in the United Kingdom. Much of the Hear by Right framework suggests the importance of youth participation in more democratic provision of (local) government services. Yet, as Matthews et al., writing about the United Kingdom, note, "where adult-dominated agencies initiate participation, there may be ulterior motives such as risk management or crime control" (quoted in Bessant 2004: 400).

Thinking about young people's participation in these exhibition processes within a framework of the Stories of the World project can be seen as part of inviting young people into more democratic dialogue about their heritage and how it is to be preserved for them in the future. Yet it could also be seen as part of a broader way of viewing young people as problems needing to be occupied; as part of a social problem. Of course, the first reason inspired the Horniman's project (and one would hope the Stories of the World team as a whole) even if anxieties about young people being disruptive were still a fear for some in the museum. If anything else, these projects could be seen as playing a role in changing how the wider public perceives young people.

To close, I would like to suggest some preliminary answers to the question about young people as a source community, as well as a more general question about what

working with young people can offer museums. While such an appeal to young people as a discrete group might be attractive, and as I have suggested, some people try to reduce youth to a single category with associated behaviors, the nature of working with young people in this way confirms my earlier statement of them not being a fixed group. What bound them together in this project was not so much their age category but rather a commitment to the common goals of the project. Perhaps a binding factor, and one which was unexpected, was the fact that, in addition to working together, these young people became friends.

So if the Stories of the World organizers wanted to get a diverse group of people from different backgrounds to work with and reinterpret museum collections, this project could be regarded as a success. I think working with young people might push museums to move beyond the reification of culture and communities toward addressing the stakeholder with broad topics around which a diverse group of people can come together and share.

Notes

1. Cultural Olympiad website: http://festival.london2012.com/about/culturalolympiad/stories-of-the-world.php. Accessed March 4, 2012.
2. Hear by right is a framework developed by the national youth agency to help organizations working with young people to ensure their safe, full, and democratic participation in the activities in which they are involved. See www.nya.org.uk/quality/hear-by-right. Accessed April 1, 2012.
3. Revisiting collections is a tool that "supports museums and archives to open up their collections for scrutiny by community groups and external experts and to build and share a new understanding of the multi-layered meaning and significance of objects and records." See http://www.collectionslink.org.uk/programmes/revisiting-collections/849-revisitingcollections. Accessed April 1, 2012.
4. Five museums comprised what is called the London HUB museums, each of which collaborated with several local history museums in London. Each local history museum had to apply to work with one of the five HUB partners.

References

Bauman, G. 1996. *Contesting Culture: Discourses of Identity in Multi-ethnic London.* Cambridge: Cambridge University Press.

Bessant, J. 2004. "Mixed Messages: 'Youth Participation and Democratic Practice'." *Australian Journal of Political Science* 39 (2): 387–404.

Cameron, F. 2007. *Moral Lessons and Reforming Agendas: History Museums Science Museums, Contentious Topics and Contemporary Societies.* London: Routledge.

Geertz, C. 1977. *The Interpretation of Culture.* New York: Basic Books.

Matthews, H., M. Limb, and M. Taylor. 2000. "Young People's Participation and Representation in Society." *Geoforum* 30: 135–144.

Matthews, H., M. Limb, L. Harrison, and M. Taylor. 1998/99. "Local Places and the Political Engagement of Young People: Youth Councils as Participatory Structures." *Youth and Policy: The Journal of Critical Analysis* 62: 16–31.

Modest, W. and H. Mears. 2012. "Museums, African Collections and Social Justice." In *Museums, Equality and Social Justice,* eds. R. Sandell and E. Nightingale, 294–309. London: Routledge.

Peers, L. and A.K. Brown, eds. 2003. *Museums and Source Communities: A Routledge Reader.* London; New York: Routledge.

Phillips, R.B. 2003. "Community Collaboration in Exhibitions: Towards a Dialogic Paradigm: Introduction." In *Museums and Source Communities: A Routledge Reader,* eds. L Peers and A.K. Brown, 155–170. London: Routledge.

Shelton, A. 2003. "Curating African Worlds." In *Museums and Source Communities: A Routledge Reader,* eds. L Peers and A.K. Brown, 181–193. London: Routledge.

Part II
Sharing Authority

Museums, Migrant Communities, and *Intercultural Dialogue* in Italy

Serena Iervolino

Over the last two decades museums have sought to increase the diversity of their audiences and modify museum practices in order to become more democratic and inclusive institutions. In seeking to challenge the dominant view of museums as hegemonic institutions, museums have started looking beyond their walls and have attempted to involve different communities in their activities. Some museums have paid particular attention to disadvantaged groups, such as disabled people, sexual minorities, indigenous people, migrants, and ethnic minority groups that may experience different forms of exclusion (Sandell 2002).

In this chapter I focus on migrant communities and on the relationships museums have recently created with those communities. If projects aiming to increase migrant participation were initially confined to education and outreach departments, curatorial teams have increasingly been asked to revise permanent displays and organize temporary exhibitions with the participation of migrant communities. The fact that forms of collaboration with migrant communities have impacted upon curatorial practices has raised several criticisms. Some have argued that a participatory approach is usually achieved at the expense of curatorial practices and that it represents a threat to museums' traditional activities of collection, conservation, research, and display (Appleton 2001). This chapter seeks to challenge such a dichotomous approach, which conceives of community participation as necessarily in conflict with curatorial practices. Drawing on Creatures of Earth and Sky, a project organized by the Natural History Museum at the University of Parma (Italy) together with the Cultural Association Googol, I argue that the project enabled the participation of African migrants, who had usually stayed away from museums, while providing the museum an opportunity to review two of its African collections, the Bottego and the Piola collections, and present them in an intercultural perspective. Since their acquisition in the nineteenth century the museum has interpreted these collections according to a Eurocentric approach. In other words the Bottego and Piola collections have been studied from a rational, scientific, European perspective and their objects have been displayed as scientific or educational objects. By conserving and displaying its African collections, the museum has aimed to educate the general public on the different fauna existing in Africa, as well as to provide students and academics within the Department of

Evolutionary and Functional Biology at the University of Parma (to which the museum is attached) with real exemplars to study.

Creatures of Earth and Sky provided the Natural History Museum an opportunity to explore its African collections from alternative viewpoints, drawing on the participants' previous experiences of these objects while living in Africa and on the stories and legends told about the objects in various African countries. The reinterpretation of the collection also enabled the museum to start a dialogue between people of different cultures and to transform the museum and its exhibiting space into a "sharing space" (ERICarts 2008) for intercultural dialogue where its audience—Italians and African migrants—was invited to cross boundaries of belonging and to participate in a dialogic process of renegotiation and reconstruction, not only of the meaning of the collection but, more broadly, of national and cultural identities.

Museums and Migrant Communities

Since the emergence of the New Museology movement, museums have sought to respond to the needs of their communities and to create more dialogic relationships with them (Witcomb 2003: 79). The link between communities and museums has been strongly stressed in the national public policy of some countries, such as the United Kingdom and Australia. The recent large-scale migratory movement to Europe and North America, in particular, has resulted in significant changes in national and international approaches to migration and cultural diversity (Martiniello and Rath 2010: 7). Multiculturalism and cultural diversity policies have gained momentum and have increasingly shaped the ways museums and other cultural institutions address issues of cultural diversity.[1] Museums have become more and more intertwined with community agendas as well as with national and international multiculturalism and cultural diversity agendas (Crooke 2007: 82–87). Moreover, they have increasingly taken an active role in the acceptance of diversity and promotion of dialogue and understanding between diverse communities.

In an attempt to involve migrant communities, different museums have deployed several strategies often pursuing very diverse objectives. Some museums have promoted access initiatives that focused on those communities as potential audiences and sought to address their underrepresentation in the visitor profile (Sandell 2004). Other museums have attempted a more challenging approach and have sought to revisit their established working practices by reviewing their curatorial approaches and rethinking their entire collections, displays, and exhibitions. In general, museums have tended to apply a topdown approach, often restricting the collaboration to consultation practices. In some cases communities have been given the opportunity to manage museums' community-led initiatives, such as Community Access Galleries (Witcomb 2003: 79–101).

One of the museums' main goals is to educate the general public in the respect and acceptance of cultural diversity, often by presenting exhibitions that represent minority communities. Collaborative or self-representation exhibitions also aim to provide

migrant communities with the opportunity to—directly or indirectly—access practices of representation in a public space so as to transform the exhibiting space into a social space to rethink power relations between museums and their communities.

When museums work with migrant communities, they have great potential to promote intercultural dialogue and cross-cultural understanding and to foster interaction between majority and minority groups (MAP for ID 2009). Such potential is often overlooked by museums even as they have embraced cultural diversity and multicultural principles in their agendas. In order to promote intercultural dialogue, museums need to identify new models for working with communities and to develop appropriate strategies that transform the exhibiting space into a "sharing space" (ERICarts 2008) for intercultural dialogue. In such a space people of different cultural backgrounds are brought together and can work collaboratively and succeed in negotiating their cultural differences. By bringing different people close together, museums create opportunities for more democratic forms of communication and for fighting against the socio-spatial segregation of ethnic minorities that characterizes cities in the "western" world and reinforces societal divisions under racial and ethnic lines (Musterd and Osterdorf 1998).

Italian Museums: A Lethargic Interest in Migrant Communities

While museums in many Northern European states began to promote more active participation of migrant communities in the 1990s,[2] museums in Southern Europe only recently started working with migrants. It could be argued that Italian museums have tended to lag behind, being quite reluctant to promote more active engagement of migrants in their practices. The causes of such lethargic interest in migrant participation stem from several factors: a still predominant "old museology" approach to heritage and museums practice that focuses on traditional museum processes while the people museums serve tend to be overlooked; lack of comprehensive national approaches to migration and integration policies; and more recent histories of immigration into the country. The following briefly presents the history of migration to Italy and national policies in the area of migrants' cultural and social integration.

A Country of Recent Immigration

Italy became a destination country for migrant flows only in the 1970s and 1980s, when immigrants started coming from many different countries and continents of origin (Parati 2005: 11). Prior to that, migration had largely been out of the country as, beginning at the end of the nineteenth century, Italians moved to Northern European states, the Americas, and Australia. Moreover, since the unification of Italy in the nineteenth century and more strongly after World War II, internal movements from the rural regions of the south to the industrial north have been—and continue to be—a distinctive characteristic of the migration patterns of the country.[3] As a result, although Italy was not new to

migration patterns, it proved largely unprepared for the wave of immigrants that began arriving (particularly from "non-Western" countries) in the latter part of the twentieth century.

The long history of Italian emigration and internal migration could be a sufficient reason to (erroneously) consider Italy more open to minorities and immune to racism in comparison to other former imperial countries such as Great Britain, France, and the Netherlands. However, Italy has gradually adopted rigid positions against immigration, contributing to the effort of constructing a European fortress (Parati 2005: 6).[4] The increasing cultural and ethnic diversity has sparked negative reactions within political and media discourses and in the public imagination. Italian mass media have promoted a highly stereotyped image of immigrants, and xenophobic or racist attitudes have found their way into public attitudes and political discourses.[5]

Immigration tends to be seen as a socioeconomic emergency and a security threat and as a menace to social cohesion and to Italian national identity and culture. Such a perceived menace has facilitated processes of construction of Italian-ness as a culturally and politically unified entity, and religion has increasingly been interpreted as a strong marker of Italian identity (Kosic and Triandafyllidou 2007: 194). The homogeneity of Italian national and cultural identities is not confirmed in the cultural, economic, and social divisions that continue to characterize the country. In fact, the political unification of Italy was completed only in the 1860s and the political agenda of cultural unification attempting to create a national culture and language was unsuccessful for a long time. Only in the 1950s and the early 1960s did the process of cultural unification begin to take place as a result of the introduction of television and mandatory schooling (Parati 2005: 6). Strong efforts have been made to "whiten Italian culture and create a European (Northern and white) identity for a culture that lies at a cultural and geographical crossroads in the middle of the Mediterranean Sea" (Parati 2005: 12). However, such a process has never succeeded in creating a homogenous culture and the country still lacks a strong sense of nationhood.

Cultural Policies

Very little exists in terms of national cultural policies that attempt to reflect the country's growing cultural diversity as well as to foster intercultural dialogue between migrants and Italians. Non-state agencies such as foundations, associations, and charities dominate the field of cultural and social integration.[6] The importance Italy has placed on its heritage could mistakenly suggest that national cultural policies have assigned a central role to heritage in the promotion of cross-cultural understanding—as has happened in other countries. However, the safeguarding and enhancement of Italian heritage and the regeneration of deprived areas through the arts have represented the two main focuses of national cultural policies. These policies fail to recognize the central role cultural and heritage institutions—including museums—can play in fostering mutual understanding and social cohesion in an increasingly diverse society. Nevertheless, measures recently introduced at regional and local levels have stimulated some interesting projects.[7]

A few museums have responded to these policies by promoting initiatives that seek to favor a higher participation of migrant communities. In this respect museums based in the north of Italy, especially in Emilia Romagna, Lombardia, and Piemonte, have been particularly active. However, the majority of these projects have addressed mainly the Italian public and attempted to promote a better understanding of the country's cultural diversity among Italians, while other initiatives have aimed to increase migrants' access to Italian culture. It can be argued that in general Italian museums tend to follow either a knowledge-oriented multiculturalism—which identifies the value of the cultures of migrant and minority communities in their potential to enrich the dominant cultures—or they seek to assimilate immigrants into the mainstream culture (Bodo 2007). In fact, Italian museums usually fail to promote opportunities of cross-cultural interaction across their entire audiences.

Museums as Places for Intercultural Dialogue

Groundbreaking intercultural work has recently been undertaken in Italy where a few museums have succeeded in operating as meeting spaces where cultural and social interactions between Italians and migrants take place. The most recent successful projects are those supported by Museums as Places for Intercultural Dialogue (2007–2009), a project initiated by the Institute for Cultural Heritage and funded by the Lifelong Learning Programme of the European Union. The project aimed to promote a more active engagement of museums with their migrant communities and to develop their potential as places for intercultural dialogue. The Institute for Cultural Heritage worked in partnership with the Chester Beatty Library (Dublin), the City of Turin's Department of Cultural Heritage Education, Foundation Imagine Identity and Culture (Amsterdam), the British Museum (London), the Museo de America (Madrid), Museo degli Sguardi and Amitié (Bologna, Italy), and the Foundation for Museums and Visitors (Budapest).[8]

The European project embraced a pluralistic idea of cultures conceived as dynamic processes—always in the process of becoming—and it also stressed that cultures differ not only across continents or nations, but also within the same nation, community, family, and social group. In doing so, the project succeeded in overcoming outdated dualistic distinctions between us and them. Notably this European initiative promoted concrete actions by supporting thirty pilot projects in four partner countries—Italy, Spain, the Netherlands, and Hungary—whose museums had never previously worked or had only recently started working with migrant communities. The project started by creating a research group that sought and analyzed examples of good practices so as to identify a number of guidelines that were subsequently implemented in thirty pilot projects.

Museums located in each partner country were invited to submit proposals in order to be selected as pilot cases by the national or local partner of the project. The proposals had to be inspired by the guidelines of good practices defined by the research group focusing on a specific area of research and experimentation. The selected projects received funding as well as scientific support from the members of the partner committee.

All the projects sought to promote intercultural learning opportunities and cross-cultural understanding between migrants and members of the majority. One of the Italian pilot projects of Museums as Places for Intercultural dialogue was Creatures of Earth and Sky, to which I now turn my attention.

Creatures of Earth and Sky

Creatures of Earth and Sky was organized by the Natural History Museum at the University of Parma, which worked in partnership with the Cultural Association Googol. The museum and Googol joined forces to promote a project that sought to initiate a dialogue with African migrants living in Parma. To achieve this, the two organizations used the African collections held by the museum[9] and the African starry sky projected within a movable planetarium, Starlab, owned by Googol.[10] The project sought to create a dialogue between the African animals on the earth displayed by the Natural History Museum and the zoomorphic constellations of the African sky projected in the Starlab planetarium using stories and legends still told by African migrants living in Parma.

People in every part of the world have studied the sky and its celestial bodies and have grouped them together to form different constellations based on the patterns they appear to create in the sky. Different constellation systems have been developed around the world, but everywhere human beings have tended to identify animal figures in the patterns formed in the sky by celestial bodies. Legends and stories inspired by animals have been created around the constellations in every continent, and those stories are still told in many societies (Albanese and Colombi 2010: 9–10). Originally the African objects were brought to Parma to educate Italians on the different fauna existing in Africa, and since then the museum has presented them as scientific and educational objects. During the project, these objects were used, together with the oral heritage of Africans living in Parma and the constellations of the African sky shown in the planetarium, to activate a dialogue between different cultures. These three instruments were used to enable a dialogue not only between the sky and the earth but also between people of different cultural backgrounds living in Parma.

As Professor Maria Grazia Mezzadri—scientific director of the museum and project leader—argued,[11] the selection of adult members of African communities living in Parma as the group to work with was influenced by two factors: the possession of two considerable African collections by the museum as well as the presence in Parma of numerous African communities and of several associations representing those communities.

The Three Phases

The project was realized in three phases. The first phase focused on the organization of an event that took place on October 21, 2008, the aim of which was to present the initiative to the town of Parma so as to draw the interest of its citizens. The event took the shape of

three encounters, two open to schools and one to the rest of the citizens. During the encounters an African astronomer, Thebe Medupe, introduced the theme of the African sky, weaving together notions of astronomy with his personal life experience. Poet Cleophas Adrien Dioma—who moved to Parma from Burkina Faso—explained the difficulties that he encountered when he first arrived in Parma by reciting his poetry.[12] The encounters included the performance of an Italian storyteller, Paola Ferretti, who told a story by Nelson Mandela.[13] The telling of Mandela's story by an Italian storyteller operated as a precursor to what would have been the heart of the project, that is, the narrations performed by the Africans. The events concluded with the presentation of the African collections of the Natural History Museum by its previous director, Professor Vittorio Parisi.

The second phase of the project was the most challenging. This phase started with what Professor Mezzadri calls "the pursuit of the African citizens"—using a phrase rich in colonialist reminiscence (2009). If the project's organizers initially thought to identify the African people to work with by contacting the associations of African communities located in Parma, such a strategy was soon abandoned as too formal and time-consuming. A more direct way of contacting participants was selected as it was thought that this would motivate them more strongly. In this regard, the poet Dioma's work as a mediator and a course of Arabic attended by Professor Mezzadri played a central role in providing more direct and human contacts between the museum and African people living in Parma. Apart from Dioma the following individuals coming from several sub-Saharan African countries agreed to participate in the project: Madi Ouandaogo and Mohamadi Sana from Burkina Faso, Bertrand Guy from Republic of Cameroon, Fall Papa Ngalgou from Senegal, Kinfe Yeayat-Lij from Ethiopia, and Griot Soualio Sanogo from Côte d'Ivoire. The museum sought to involve primarily people from the sub-Saharan area of the African continent, where the objects of the Bottego and Piola collections were first collected.

It could be argued that the museum identified the project participants in a rather problematic way. By grouping together migrants coming from different African countries who cannot be regarded as a single group (unless we refer to an imagined, constructed entity—Africa), it could be claimed that the museum applied a pan-African approach. Undoubtedly, "the wrong-headed simplicity that files people by skin colour or continent is just not tenable."[14] Although I agree with this statement, I wish to expand on it by arguing that it is too simplistic to regard even migrants coming from the same country as a uniform community. Migrants whose origin lies in the same country very rarely form a homogenous group—a community—and profound differences may exist among them. Community studies have stressed the frequently intended nature of communities that are often "constructed" in order to respond to community development public policies rather than reflecting an existing reality (Crooke 2007: 27). Andrea Witcomb, for example, stressed the internal differences that often exist within supposed homogenous migrant communities in her account of the Travellers and Immigrants: Portuguêse em Perth exhibition shown at the Fremantle History Museum, which was intended to represent the Portuguese community living in Perth (2003: 79–101). When museums work with migrant groups, they do not simply mirror a reality that concretely exists out there in the

real world, but rather tend to actively construct such a reality by attempting to represent a homogenous group (Bennett 1990). As a result, I wish to argue that it would be errone-ous to accuse the Natural History Museum of filing people according to their continent of origin by choosing to work with migrants coming from Africa. Conversely, I would suggest that the museum should be praised for working with people who had in common only the experience of migration to Parma from Africa, while not attempting to identify and construct a supposedly uniform community. By applying this strategy I would argue, the museum instead took an audacious approach and accepted to work with people likely to inspire different views on the collections. Participants also took a risk and agreed to work not only with an institution they had never collaborated with, but also with people they had never met before and with whom they had little in common other than a similar experience of migration and their continent of origin. In addition, participants selected objects that held a particular significance for them or reminded them of a story or a legend from their countries of origin. Indeed, the selection of the objects was not made because they were necessarily directly related to participants' cultural background. Par-ticipants instead tended to select objects that sparked their creative imagination or simply reminded them of particular events of their lives, thus inspiring their storytelling.

The participants were accompanied—either individually or in small groups—on a visit during which the African collections were presented to them. As Mezzadri (2009) stated:

> [T]heir first visits were very emotional moments. The participants found themselves sur-rounded by animals and everyday objects that they know very well, and recollections emerged from the contact with the objects. A dialogue was stimulated so that they started telling us stories and life anecdotes almost naturally, without even being asked. We simply showed them the collections and they immediately found a connection with their life, their culture. Subsequently, they visited again the museum but the impact of the first visit and the contact with the objects was crucial.

Second, the participants were asked to collect stories and legends told in their native countries that feature animals displayed in the museum and in the zoomorphic constella-tions of the African sky. Mezzadri continues:

> We were interested in their oral heritage. Certainly, there are plenty of books of African stories but we were interested in African stories that are actually told in their native countries in everyday life, that is, those stories similar to the ones that were told once by the fireside in Italy.

I would argue that by focusing on the oral heritage of the participants and on their stories and legends similar to those once told in Italy, the project sought to stress the similarities between the culture of the participants and Italian culture.

The collection of stories was complicated by practical issues, such as participants' working commitments. When participants were asked to think of stories and legends, it was also noticed that some of them could not remember any story as if "all the concerns

of their everyday life had wiped out their memories and diminished their fantasy" (Mezzadri 2009). In addition, it seems that the museum struggled to mediate between differences in approaches to time management shown by the museum and project's participants. Indeed, Mezzadri referred to "the relaxed attitude that traditionally distinguishes Africans" as one of the main practical challenges of the project.[15] In making such a statement it could be argued that Mezzadri made a problematic generalization and did not take sufficiently into account that the participants came from different countries where approaches to time might not be uniform. I would suggest that the practical difficulties as well as their rather simplistic interpretation on the museum side suggest that even if museums have come a long way in their attempts to challenge traditional approaches and to become more democratic and inclusive, they still have far to go in the ongoing processes of decolonizing museological practices and becoming truly postcolonial institutions. In this respect it should be added that museums holding ethnographical collections face a harder task as the objects they contain and display are still engrained with the colonial, hierarchical, and often racist ideologies and attitudes that guided their collection. The Natural History Museum and its African collections do not escape these issues. They still represent products of colonialism and reveal the legacy of their Eurocentric epistemological biases and assumptions.

The last phase took place over four days (April 20–23, 2009), which saw the participation of a large public formed by schools and adults, during which the Starlab planetarium was set up in the museum. The African migrants who had taken part in the earlier phase played a central role, acting as guides and leading the visitors on an ideal journey from the sky to the earth. The visits started in the planetarium, where visitors were shown the constellations of the African sky and, subsequently, the groups could admire those animals together with objects of everyday life within the museum collection.

Drawing on the objects and the stuffed animals on display, the African migrants explained the traditions of their native lands and performed the stories they had collected. With their act of storytelling they created a connection between the African animals of the earth and the sky and they enchanted both children and adults.

From Spectators to Actors

By playing the role of guides and storytellers during the visits, the African participants became the main actors of the event and, in a certain sense, it might be said they regained possessions of those objects collected in sub-Saharan Africa. The participants moved from being *spectators,* that is, receivers of the culture of the majority—a position they conventionally occupy in the host society—to being *actors,* that is, playing an active part in shaping and sharing knowledge. Participation in the project gave them the opportunity to use their knowledge and play the role of actors in a cultural activity that did not only seek to address members of their communities or families but rather the entire society. As a result, Italian visitors faced an unexpected situation as they found themselves in the position of those who did not know and needed to be told, while African migrants

acted as guides and explained the museum's collections to them. As Professor Mezzadri maintains, "it should be positively stressed that the Italian public accepted that black people, who are not museum staff, were called upon to speak" (2009). She also adds with a veil of cynicism, or rather realism, in a country such as Italy that has recently witnessed increasingly racist and xenophobic attitudes, "it was already a great achievement that no one stood up and left the museum."

Renegotiating the Meaning of the Collection

The storytelling strategy chosen enabled the addition of new layers of meaning to the objects on display. The storytellers could draw on their experiences of those objects in their everyday life while still living in their native lands and, in doing so, they gave new interpretations to those objects that Europeans would usually present as scientific artifacts. By using storytelling as the main interpretative strategy, the project encouraged a new reading of the collections and renegotiated and reconstructed their meaning by highlighting the rich and diverse significance those objects simultaneously bear for communities and individuals with different cultural backgrounds. In addition, it can be argued that the storytellers acquired ownership of the museum through the same act of storytelling. Professor Mezzadri has argued, "I had the clear sensation that they felt at home in the museum" (2009).[16]

The Several Shapes of Intercultural Dialogue

I would argue that the project successfully encouraged intercultural dialogue between all the communities or individuals that took part in the several phases of the project and transformed the museum into a "shared space" (ERICarts 2008), a "third space, unfamiliar to both [sides], in which different groups can share a similar experience of discovery" (Edgar quoted in Khan 2006). First, intercultural dialogue took the shape of a "bi-directional process involving both autochthonous individuals and those with an immigrant background" (ERICarts 2008: 125), that is, both Italians and African migrants. In this concern intercultural dialogue was cultivated between participants and visitors during the last phase of the project, although it did not take the form of a real debate.

Nevertheless, Mezzadri stated that during the visit she felt "there was a real tension in the audience" (2009), suggesting the creation of a profound emotional engagement between visitors and storytellers. Intercultural dialogue, more broadly understood as "a process that comprises an open and respectful exchange or interaction between individuals, groups and organisations with different cultural backgrounds and world views,"[17] was also activated between the African participants. The participants came from different African states and are members of different communities and various cultural associations and they did not know each other before participating in the project. During the final events they succeeded in working as a team in a respectful and cooperative way by managing to alternatively act as guides and storytellers.

Finally, throughout all the phases of the project, a dialogue took place between the museum and its staff, the participants, and the other organizations involved. The African participants took part in "all the phases of the initiative by giving their opinions and making demands on the development of the project."[18] Undeniably, the Natural History Museum, as every museum, has "a tradition, a way of doing things, a culture" (Witcomb 2003: 90), and it has to make adjustments when it works with other communities or organizations. Some of the difficulties the museum encountered during the project seem to derive from the fact that the museum and the African participants were learning to work with each other and they both found it difficult to change their ways of doing things and adapt to the needs of the other.

The collaboration with Googol was decisive in the selection of a "serial production" strategy, which was chosen for both the first and the third phase. As a result, the same event was repeated for different groups of visitors on the same day, and this strategy enabled the museum to reach a large public in a short time. Finally, the participation in MAP for ID not only enabled the museum to access European funding, but also suggested and stimulated a new interpretation of the collection which, Professor Mezzadri maintained, "would have probably not been explored unless stimulated." She also added that "such stimulation has been central for us. I am very grateful to the European project."

It could be argued that the real impetus behind the project was what Edelman would call "symbolic politics" aimed at acquiescence and the European funding rather than at making a significant impact on migrants' feeling of belonging to their new country. If we follow Edelman's understanding of symbolic politics (1964), the symbolic side of the project could be regarded as more relevant than its intention to positively influence migrants' real circumstances. In this respect, the project could be cynically interpreted as an act that had symbolism as its exclusive goal, aiming to evoke the acquiescence of African migrants and, therefore, to promote social harmony. If we take this approach, the real aim of the project could be identified as providing migrants with reassurance that their hosting country pays attention to their needs (while reducing their concrete demands),[19] as well as obtaining European funding. However, such a position seems fictitious as the participation in the European project gave the museum access to only four thousand euros, while the cost of the project was much higher.

In addition, the selection of the people to work with seemed guided by the museum's attempt to have a positive impact on the life of African migrants living in Parma who may experience discrimination and racism in their lives. Although I would argue that the promotion of migrants' feeling of belonging was an unplanned positive outcome of the project, I wish to maintain that the prime intention behind the project was to provide the African migrants with an opportunity to feel valued in an institutional space in the public sphere of their hosting country. Besides, the project sought to provide Italian visitors with an opportunity for a personal emotional encounter with African migrants. It was hoped that those encounters might have positively changed the attitude of the Italians toward African migrants outside the museum. As Mezzadri maintained, the Italian visitors must have understood that African migrants "possess an inward richness, as my staff and I did too. They must have realised that when they meet an African

person in the street, they are not simply meeting an object, but rather a person with an unexpected inward richness" (2009).

I would suggest that the financial support Creatures of Earth and Sky received from Museums as Places for Intercultural Dialogue was not particularly crucial to the success of the project. Of much more use was the free system of advice, training, and evaluation provided by the access to the European project. I argue that in this respect the central role played by the European initiative seems to imply that in a country such as Italy, whose museums have only recently started promoting a more active migrant participation, the intervention of supranational institutions (such as the EU) can be crucial to transforming museums into more socially responsible institutions. The importance of MAP for ID suggests that it is oversimplistic to regard museums as institutions subjugated to cultural and social policies. Conversely, the project demonstrates that the advent of intercultural dialogue as a European policy for the management of diversity was crucial for the development of MAP for ID and it positively influenced the thirty pilot projects, Creatures of Earth and Sky included.

Conclusions

I would like to conclude by arguing that Creatures of Earth and Sky proves that a dichotomous approach that views community participation as necessarily in conflict with curatorial practices is used by those who would like to prevent museums from embarking on the process of democratization and becoming more responsive to the needs of our contemporary societies. In fact, the project demonstrates that when museums work with migrant communities and with communities in general, they can preserve their traditional activities, especially curatorial practices. During the project, the traditional curatorial practices of the Natural History Museum were preserved and the stuffed animals of the Bottego collection continued to be displayed according to the same strategy and in the same old-fashioned display cases used in the nineteenth century. Although a redisplay of the collection seems appropriate, if not urgent, currently it is not feasible for lack of funding and appropriate spaces.

The project, in particular the participation of African migrants, provided the museum with an opportunity for reviewing the meaning of one of its collections, by highlighting an interpretation of the stuffed animals—expression of a Eurocentric scientific culture—under an intercultural perspective. By working with migrants and using storytelling as the main interpretative strategy, the museum succeeded in introducing viewpoints and perspectives alternative to those of the dominant culture. The project also became an opportunity to spread knowledge about nature by providing visitors with information about the African animals displayed in the museum as well as the zoomorphic constellations of the African sky. Creatures of Earth and Sky also sought to promote a better knowledge and greater appreciation of those "others" who live in Parma, whose origins lie in the same continent where the animals and objects on display were collected. Moreover, the project made it evident that today migrants live among us and have become an integral

part of what Parma is as a city and Italy is as a nation. In doing so, the project succeeded in transforming the National History Museum into a "sharing space" (ERICarts 2008) where participants, visitors, and museum staff were induced to cross the boundaries of belonging and take part in processes of constructing more inclusive ideas of national and cultural identities.

I wish to clarify that it is not my intention here to maintain that by taking part in the project the African migrants become *more Italian.* Indeed, it could be stated that the only way African migrants can ever become Italians is by taking up Italian citizenship. In my view the entitlement to full national citizenship rights is not sufficient in itself to create a sense of inclusion in the "imagined community" (Anderson 1983). In most states, the entitlement to civic rights is culturally rooted, associated with a certain degree of involvement in the culture of the nation (Hindess 2000).[20] Although citizenship is considered by many as the most influential political instrument that not only defines duties and rights but also structures membership in a nation, I regard belonging as a thicker concept than citizenship (Crowley 1999). In my opinion, politics of belonging may represent a more appropriate policy instrument than that of citizenship, which have the potential to develop feelings of inclusion and a wish to participate. Belonging refers not just to rights, duties, and national membership but also to the emotions such a membership generates, which relate to important social bonds and ties (Yuval-Davis 2005). The concept of belonging has a social and relational nature as it results from the way individuals perceive their position in the social world and the emotions attached to this perception (Yuval-Davis 2005).

In this respect, I wish to argue that participation in the project enabled the emotional identification of the African migrants with the Italian nation and its people and increased their feeling of belonging. Simultaneously, the project attempted to downplay the importance of adherence to central hegemonic values in its attempt to the creation of a more inclusive society. By acting as storytellers and gaining possession of the museum, the African participants were not simply able to talk with their own voices about the cultures of their continent of origin but also to assert their belonging to Parma and, more broadly, to Italy and to prove the fluidity, dynamism, and multiplicity of their cultural identities without denying their origins. In doing so, the project demonstrates the involvement of migrant communities can be beneficial to museums and migrants.

Although Creatures of Earth and Sky clearly represents a case of best practice, particularly in a country such as Italy whose museums have long been reluctant to work with migrant groups, the project failed to ensure the maintenance of a more active participation of African migrants in the long term. Yet the limited duration of project and the lack of any plan to develop a follow-up initiative—building on the positive outcomes of the project—suggest the project is doomed to remain a one-off initiative without long-term effects for the museum or the African migrants. Drawing on the success of the project, the museum should develop further initiatives to strengthen the relationships developed with the African migrants as well as initiating new collaborations with other migrant groups.

However, plans for future actions have not been pursued, mainly because of lack of funds. In addition, the initiative seems to prove that the revision of the permanent

displays and its reinterpretation under an intercultural prospective is quite urgent if the museum wants to be relevant for its increasingly diverse audience. When museums seek to promote intercultural dialogue, it is necessary that the outcomes of single intercultural activities are built into the museums' institutional fabric in order to sustain a transition from a sporadic engagement with intercultural dialogue to a long-term commitment. In doing so, museums may concretely become sharing spaces for intercultural dialogue, that is, institutions in the public sphere where people of different backgrounds can gather and mediate their differences. In this way museums may succeed in actively contributing to the construction of more peaceful societies.

Notes

I am grateful to Margherita Sani, project manager of Museum as Places for Intercultural Dialogue; to Professor Maria Grazia Mezzadri, former scientific director of the Natural History Museum at the University of Parma; as well as to Lara Albanese and Emanuela Colombi of the Cultural Association Googol. I am especially thankful to Mezzadri for providing me with plenty of support during the phase of data gathering. Without her assistance and enthusiasm toward my research, this chapter could have not been written.

The photographs included in the book were taken by Nicola Franchini and belong to the Natural History Museum at the University of Parma. I would like to thank the Natural History Museum for permission to reproduce the images.

Finally, I am grateful to Professor Richard Sandell, School of Museum Studies, and Dr. Ciaran O'Neill, Department of History, Trinity College, who commented on the draft paper. However, the ideas expressed in the paper remain solely my responsibility.

1. The UNESCO Universal Declaration on Cultural Diversity was adopted in 2001 and since then has strongly influenced the development of multiculturalism and cultural diversity policies. The UNESCO declaration can be regarded as the first legal instrument that recognized cultural diversity as the "common heritage of humanity" and referred to intercultural dialogue as the best guarantor of peace. The declaration laid down general guidelines that member states of UNESCO had the responsibility to turn into effective cultural policies in close collaboration with the civil society and the private sector. Each state developed different national policies to give concrete applications to the principles the Universal Declaration promotes. However, its principles have also found application in projects at both regional—such as the EU—and international levels (for concrete examples, see UNESCO 2009: 23–29).
2. See, for example, Hooper-Greenhill (1997).
3. See Impacciatore and Dalla Zuanna (2009).
4. After the victory of a right-wing coalition guided by Silvio Berlusconi in spring 2008, a security package passed that includes more restrictive measures through which the new government sought to satisfy the promise made during the election campaign.

5. The "Lega Nord," or Northern League, a political party founded in 1991, has made intense use of "racist and xenophobic propaganda" (ECRI 2001).

6. For example, Fondazione ISMU and Caritas Italiana.

7. A few regions, such as Emilia Romagna and Liguria, have passed laws that attempt to promote intercultural education initiatives. The Department for Heritage Education of the Turin City Council has recently developed the "Heritage for All" program.

8. Further information about Museums as Places for Intercultural Dialogue can be found in MAP for ID (2009).

9. The museum houses two relevant collections of African origin: the Bottego collection—which includes stuffed animals collected in Eritrea—and the Piola collection—which consists of mainly ethnographical but also zoological materials collected in Congo.

10. The Cultural Association Googol is a nonprofit association whose primary aim is to promote scientific culture to the general public, with special attention to children, by organizing hands-on activities and making science exciting and accessible to everyone. The movable planetarium Starlab owned by Googol can be easily set up in public and private spaces, and within it the skies of the entire world can be projected and people can learn to recognize the constellations.

11. Professor Mezzadri was the scientific director of the museum at the time of writing. She retired at the end of December 2009.

12. Dioma is a representative figure of the African communities in Parma. He is a member of the Cultural Association Le Reseau, the aim of which is to promote a better understanding of Africa's various and diverse cultures in Italy. The Cultural Association Le Reseau organizes the African October Festival, which celebrates the presence of African people in Parma by promoting a month-long series of cultural events. In 2010 the African October Festival reached its tenth edition (see www. ottobreafricano.org/).

13. Paola Ferretti works at the Theatre Laboratory Gianni Rodari in Reggio Emilia (see www.reggionarra.it/2010/labrodari.htm).

14. See CLMG, *Cultural Shock: Tolerance, Respect, Understanding . . . and Museums. Main Report*, 7. Available at: www.cultureunlimited.org/pdfs/CS-Main.pdf.

15. See also MAP for ID (2009).

16. In this respect I believe Professor Mezzadri's point of view is relevant as it could be argued that, by closely working with the African participants during the entire project, she was in a position to develop a good insight into their experiences. Nevertheless, it would have been interesting to hear the African participants' retrospective thoughts about the project and how their participation made them feel. Several practical constraints made this impossible and during the data-gathering process I was unable to approach and interview the African participants. As a result, I could only give them voices through Professor Mezzadri's words. I wish to stress that I very much regret not being able to give the African participants—the main actors of the project—the opportunity to tell the reader their thoughts about the project in their own words.

17. See www.mapforid.it/index1.htm. Accessed November 17, 2009.
18. See MAP for ID (2008).
19. Edelman argues that "groups which present claims upon resources may be rendered quiescent by their success in securing non tangible values" (1964: 40).
20. The entitlement to full citizenship right has been proven insufficient to generate a real feeling of inclusion. This seems to be proven by the experience of second-generation immigrants born in states that apply an *ius solis* (right of soil) citizenship principle. Although entitled to full citizens rights, second-generation immigrants often display a deep sense of alienation and feel they are not included (Crowley and Hickman 2008).

References

Albanese, L. and E. Colombi. 2010. "Leggere il Cielo." In *Animali in Cielo e in Terra. Guida alla Lettura del Museo Passando per il Cielo Stellato,* ed. M.G. Mezzadri, 9–37. Parma: Planorbis Editore.

Anderson, B. 1983. *Imagined Communities: Reflection on the Origin and Spread of Nationalism.* London: Verso.

Appleton, J. 2001. *Museum for the People (Conversation in Print).* London: Institute of Ideas.

Bennett, T. 1990. "The Political Rationality of the Museum." *Continuum* 3 (1): 35–55.

Bodo, S. 2007. "From 'Heritage Education with Intercultural Goals' to 'Intercultural Heritage Education: Conceptual Framework and Policy Approaches in Museums across Europe'." Paper commissioned by the ERICarts Institute in the context of its "Sharing Diversity" (2008) study.

Crooke, E., ed. 2007. *Museums and Community: Ideas, Issues and Challenges.* London: Routledge.

Crowley, J. 1999. "The Politics of Belonging: Some Theoretical Considerations." In *The Politics of Belonging: Migrants and Minorities in Contemporary Europe,* eds. A. Geddes and A. Favell, 15–41. Aldershot: Ashgate.

Crowley, H. and M.J. Hickman. 2008. "Migration, Postindustrialism and the Globalized Nation State: Social Capital and Social Cohesion Re-examined." *Ethnic and Racial Studies* 31 (7): 1222–44.

Edelman, M. 1964. *The Symbolic Uses of Politics.* Urbana: University of Illinois Press.

European Commission against Racism and Intolerance (ECRI). 2001. *Secondo Rapporto sull'Italia.* Strasburg: Council of Europe.

European Institute for Comparative Cultural Research (ERICarts). 2008. *SHARING DIVERSITY: National Approaches to Intercultural Dialogue In Europe. An ERICarts Study for the European Commission.* Available at: www.interculturaldialogue.eu/web/files/14/en/Sharing_Diversity_Final_Report.pdf. Accessed February 16, 2010.

Hindess, B. 2000. "Citizenship in the International Management of Populations." *American Behavioral Scientist* 43 (9): 1486–97.

Hooper-Greenhill, E. 1997. *Cultural Diversity.* London: Leicester University Press.

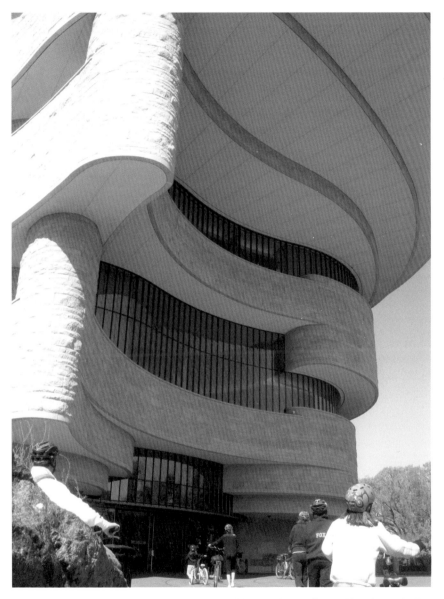

Plate 1.1 Main Entrance to the National Museum of the American Indian. Smithsonian Institution, Washington, DC. Photograph © Viv Golding

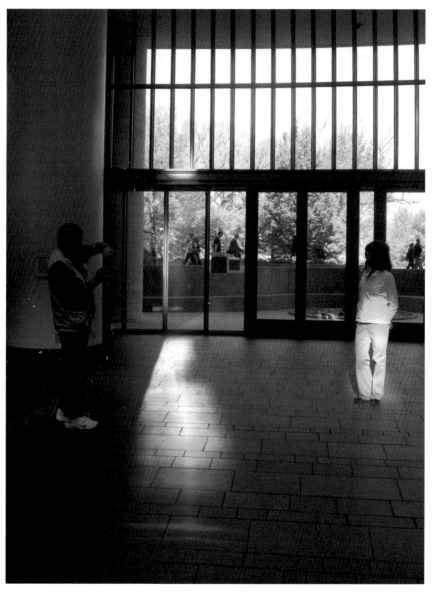

Plate 1.2 Entrance Hall at the National Museum of the American Indian, Smithsonian Institution Washington, DC, with art work. Photograph © Viv Golding

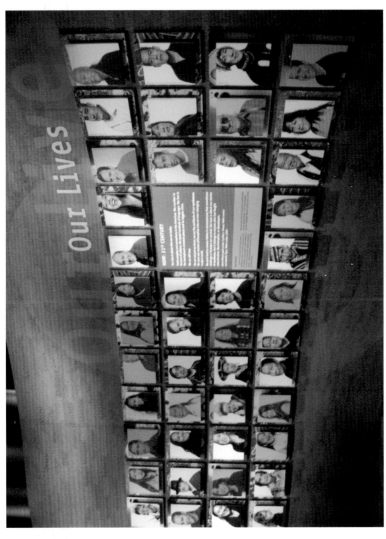

Plate 1.3 Our Lives Exhibition at the National Museum of the American Indian, Smithsonian Institution, Washington, DC. Photograph © Viv Golding

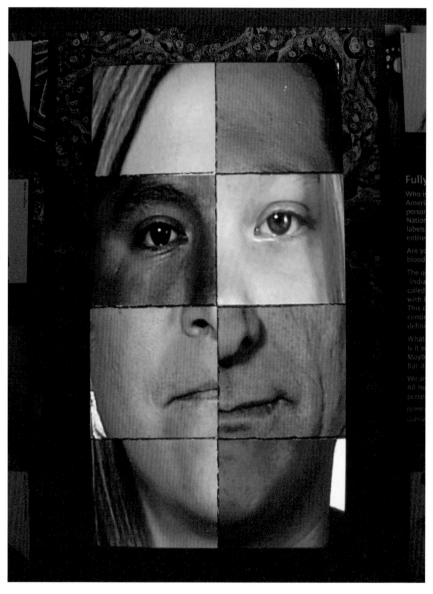

Plate 1.4 Our Lives digital exhibition detail demonstrating the absurdity of racism. Photograph © Viv Golding

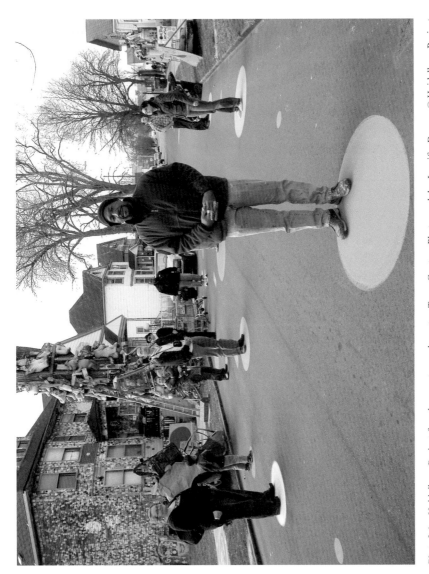

Plate 3.1 Heidelberg Project founder, creator, and curator, Tyree Guyton. Photograph by Jennifer Baross. © Heidelberg Project Archives

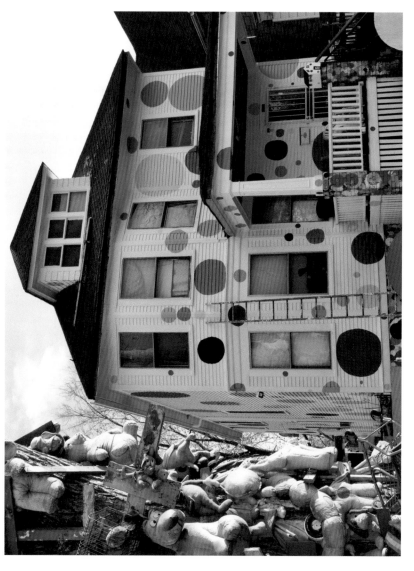

Plate 3.2 Tyree Guyton uses his emblematic polka dot—here, on the Dotty Wotty House—as a tribute to his late grandfather's love of jellybeans. Photograph by Geronimo Patton. © Heidelberg Project Archives

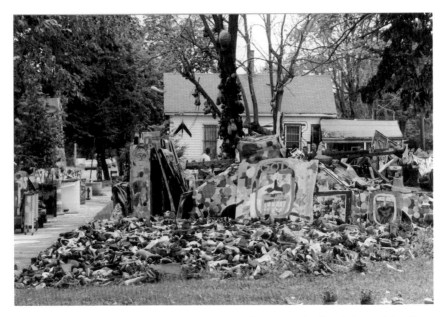

Plate 3.3 The basis for much of the work on Heidelberg Street is discarded material artifacts. Photograph by Jenenne Whitfield. © Heidelberg Project Archives

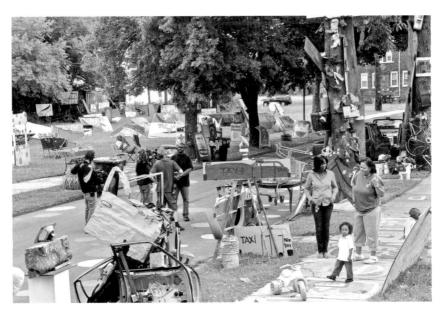

Plate 3.4 Tyree Guyton's Heidelberg Street installation attracts visitors from varied backgrounds eager to share in the vitality of the project. Photograph by Geronimo Patton. © Heidelberg Project Archives

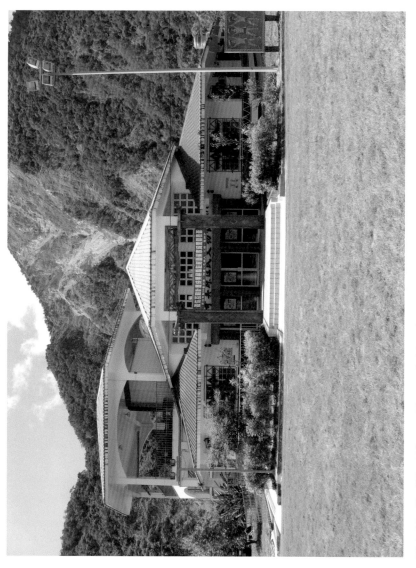

Plate 4.1 The Chimei Museum. Photograph © Marzia Varutti

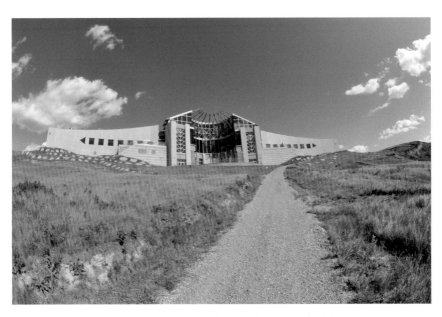

Plate 5.1 Blackfoot Crossing Historical Park. Photograph © Bryony Onciul

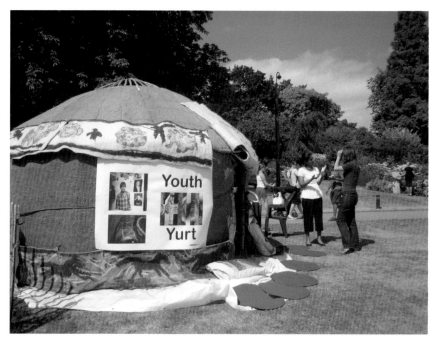

Plate 6.1 External view of Youth Yurt, where the peer ethnography team first presented the results of its research to a large public. Photograph © Horniman Museum and Gardens

Plate 6.2 Urban portraiture student getting consent form signed by member of the public whose photograph was taken. Photograph © Horniman Museum and Gardens

Plate 6.3 Goldsmiths tutor and student volunteer looks on as Urban Portraiture student shows photograph to person whose photograph was taken. Photograph © Horniman Museum and Gardens

Plate 6.4 Group photograph of Urban Portraiture team. Photograph © Horniman Museum and Gardens

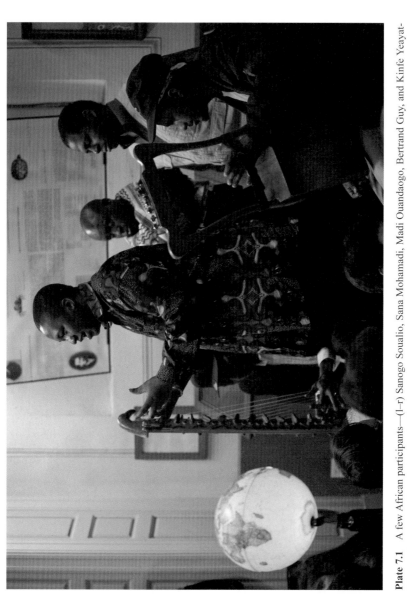

Plate 7.1 A few African participants—(l–r) Sanogo Soualio, Sana Mohamadi, Madi Ouandaogo, Bertrand Guy, and Kinfe Yeayat-Lij—perform storytelling during the final days of the Creatures of Earth and Sky project. Photograph © Nicola Franchini, The Natural History Museum at the University of Parma

Plate 7.2 Visitors get ready to enter the moveable planetarium Starlab and explore the animals of the sky. Photograph © Nicola Franchini, The Natural History Museum at the University of Parma

Plate 7.3 The African Collection of the Natural History Museum known as the Eritrean Zoological Museum, Vitorrio Bottego. Photograph © Nicola Franchini, The Natural History Museum at the University of Parma

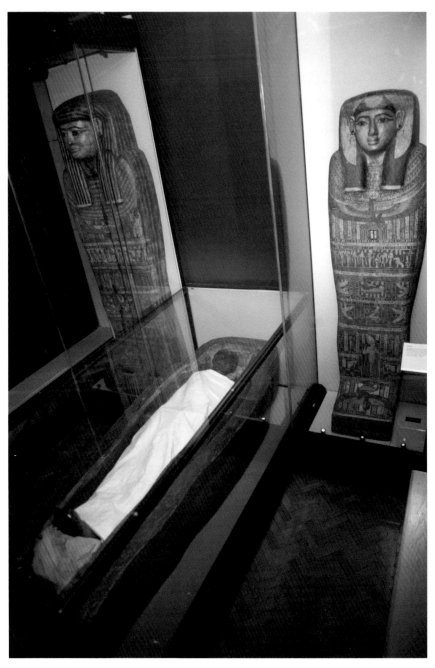

Plate 8.1 The mummy of the temple singer, Asru, in her inner and outer coffins (c. 650 BCE), on display in 2010 in the Death and the Afterlife gallery at the Manchester Museum. The cloth covering the body of Asru is modern. Photograph © The Manchester Museum/Steve Devine

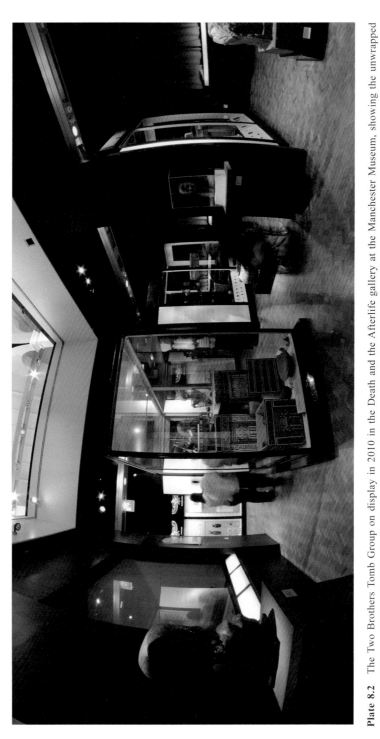

Plate 8.2 The Two Brothers Tomb Group on display in 2010 in the Death and the Afterlife gallery at the Manchester Museum, showing the unwrapped skeletons of Khnum-Nakht and Nakht-Ankh. The tomb group is from Deir Rifa, Egypt (Twelfth Dynasty, 1985–1795 BCE). Photograph © The Manchester Museum/Oliver Smith

Impacciatore, R. and G. Dalla Zuanna. 2009. *Una difficile mobilità sociale. L'istruzione dei figli degli emigrati verso il Centro e il Nord Italia.* Available at: http://gsp.stat. unipd.it/files/Paper_DallaZuanna-Impicciatore.pdf. Accessed October 31, 2009.

Khan, N. 2006. "The Road to Interculturalism: Interstate Highway or Dead Alley?" Paper prepared for the EFAH conference "Islands & Bridges," Helsinki, October.

Kosic, A. and A. Triandafyllidou. 2007 "Italy." In *European Immigration. A Sourcebook,* eds. A. Triandafyllidou and R. Gropas, 185–195. Aldershot: Ashgate.

Martiniello, M. and J. Rath. 2010. "Introduction: Migration and Ethnic Studies in Europe." In *Selected Studies in International Migration and Immigrant Incorporation,* eds. M. Martiniello and J. Rath, 7–18. Amsterdam: Amsterdam University Press.

Mezzadri, M. G. 2009. Interview carried out at the conference "Museums and Intercultural Dialogue," Madrid.

Museums as Places for Intercultural Dialogue. 2008. *Progetti Pilota. Scheda descrittivo e di auto-valutazione del progetto (Pilot Projects. Descriptive and Self-evaluation Scheme).* Unpublished document. Parma.

Museums as Places for Intercultural Dialogue. 2009. *Museums as Places for Intercultural Dialogue: Selected Practices from Europe.* [S.I.], Selected Practices from Europe. Dublin: MAP for ID Group.

Museums as Places for Intercultural Dialogue. 2009. *Presentazione del progetto "Animali in cielo e in terra."* Unpublished document. Parma.

Musterd, S. and W. Osterdorf. 1998. *Urban Segregation and the Welfare State: Inequalities and Exclusion in the Western Cities.* London and New York: Routledge.

Parati, G. 2005. *Migration Italy: The Art of Talking Back in a Destination Culture.* Toronto: University of Toronto Press.

Sandell, R., ed. 2002. *Museum, Society, Inequality.* London: Routledge.

Sandell, R. 2004. "Engaging with Diversity and Equality: The Role of Museums." Paper delivered at the international symposium "When Culture Makes the Difference: The Heritage, Arts and Media in Multicultural Society," Genoa.

UNESCO. 2002. *Universal Declaration on Cultural Diversity.* Paris: UNESCO. Available at: www.unesco.org/culture.

UNESCO. 2005. *Convention on the Protection and Promotion of the Diversity of Cultural Expressions.* Paris: UNESCO.

UNESCO. 2009. UNESCO *World Report: Investing in Cultural Diversity and Intercultural Dialogue.* Paris: UNESCO.

Watson, S. 2007. *Museums and their Communities.* New York: Routledge.

Witcomb, A. 2003. *Re-imagining the Museum: Beyond the Mausoleum.* London: Routledge.

Yuval-Davis, N., F. Anthias, and E. Kofman. 2005. "Secure Borders and Safe Haven and the Gendered Politics of Belonging: Beyond Social Cohesion." *Ethnic and Racial Studies* 28 (3): 513–535.

–8–

Community Consultation and the Redevelopment of Manchester Museum's Ancient Egypt Galleries

Karen Exell

The Manchester Museum, a UK university museum, opened in October 2012 the new Ancient World galleries, after a four year redevelopment of the two ancient Egypt galleries and the Mediterranean archaeology gallery. The Museum carried out extensive community consultation during the first year of the project (2008). This chapter discusses the context for the gallery redevelopment, with an outline of the consultation program and a detailed focus on the often polarized views associated with the presentation and interpretation of ancient Egypt. These views encompass those of amateur enthusiasts and academic Egyptologists, refracted through the interpretation of Egypt as an African culture. These diverse viewpoints represent just some of the many groups that feel a passionate sense of ownership of the culture of ancient Egypt.

The Manchester Museum opened in 1890 in a purpose-built building on Oxford Road designed by Alfred Waterhouse (Alberti 2009: 23, fig. 1.5). The first keeper, William Boyd Dawkins, was a geologist and prehistorian, and he displayed the collections, the majority of which came from the Manchester Natural History Society, according to an evolutionary sequence designed to aid teaching within the University, with material organized in the following groups: mineralogy, paleontology, archaeology, zoology, and botany. The museum housed little in the way of cultural or archaeological material, and that which was present, including the mummy of Asru with her coffins, dating to circa 650 BCE, and still on display, was kept separate in the new Museum (Alberti 2009: 66). During the early years of the Museum, a local cotton merchant, Jesse Haworth, began to support the archaeological work of William Matthew Flinders Petrie in Egypt, and as a result received a share of the finds, initially from sites in the Fayyum such as Illahun (Kahun), Gurob, and Hawara (David 1996; Petrie 1890, 1891). Haworth loaned the material to the Manchester Museum, where it was displayed in a room of its own. In 1905, Haworth offered the collection to the Museum, but the Museum Committee refused it on the grounds that the material did not support scientific teaching within the University, the Museum's raison d'être. In a move that many financially struggling museums today can only envy, Haworth countered the refusal by pledging substantial funding for the building of an extension, which opened in 1912, to display archaeological material from

Egypt and elsewhere (Alberti 2009: 69). More recently, the ancient Egypt galleries were designed and installed in the same space in 1986 by the Keeper of Egyptology, Rosalie David, and the gallery on the Mediterranean World in 1993 by the Keeper of Archaeology, John Prag. These are the spaces which have become the Ancient World's galleries.

Over the last several years, the Manchester Museum has actively utilized community consultative practice in its work, creating outreach posts including a curator of community exhibitions; working closely with community groups in the creation of collaborative exhibitions both outside and within the museum; developing Museum Comes to You object boxes for outreach sessions; and running a project called Collective Conversations, where community representatives discuss objects, sharing their own understanding of the objects with curators on camera, after which the films are uploaded to the Manchester Museum's YouTube channel. Consultative practice in the United Kingdom in relation to the interpretation and display of ancient Egyptian material culture was pioneered by the Petrie Museum of Archaeology, UCL, in 1999–2000, with the aim of engaging current and potential visitors and representing diverse views of the past. These efforts culminated in a touring exhibition, Ancient Egypt: Digging for Dreams (Montserrat 2000); a related conference, Encounters with Egypt (UCL Institute of Archaeology, December 16–18, 2000), which, as the conference information explains, "examined the ways in which the cultures of Egypt—predynastic, dynastic, Hellenistic, Roman, late-antique, Islamic, colonial—have perpetually been re-configured in response to changing ideologies and strategies for appropriating the past"[1]; and a series of eight books entitled *Encounters with Ancient Egypt* (UCL Press) that contextualize ancient Egypt within archaeological theory, African, and cultural studies. The consultation work, which explored multiple viewpoints and popular (mis-)conceptions in relation to ancient Egypt, has been published in a sequence of articles (MacDonald 2005; MacDonald and Shaw 2004). From the consultation it emerged that the dominant white Western stereotype of ancient Egypt saw it as a place with no fixed geographical location within which were located icons such as pharaohs, pyramids, slaves, tombs, and Cleopatra, in no fixed temporal relation to each other (MacDonald and Shaw 2004: 118–120).

The Ancient Worlds Gallery Redevelopment at the Manchester Museum

The Ancient Worlds gallery redevelopment project marks the centenary of the opening of the 1912 building where the Egypt galleries were located. There are a number of factors behind the decision to redevelop the galleries in addition to the centenary. The Egypt galleries were heavily used by school groups and the general public, and were beginning to show a high degree of wear and tear. The layout of the galleries themselves was not suitable for large groups, with cramped and fairly dark areas making movement difficult. Since the galleries were installed, developments in technology have progressed enough to allow fragile painted and organic

materials to be displayed with greater visibility and a more readily controlled environment. Alongside these practical issues are the intellectual and curatorial developments that have taken place in museums and in the subject of Egyptology since the 1980s.

The two Egypt galleries presented a binary approach to ancient Egypt, dividing the ancient culture into the traditional Egyptological categories of Daily Life and Death and the Afterlife. The Mediterranean Archaeology gallery presented the material culture of the Near East and Europe from the second millennium BCE to the fifth century CE. Despite the numerous parallels in the material displayed in the Egypt and Mediterranean Archaeology galleries, and the fact that ancient Egypt is in part an ancient Mediterranean culture, there was no overt link between the spaces. The galleries were physically as well as culturally divided, with Mediterranean Archaeology inhabiting the mezzanine space above Death and the Afterlife, and visitors intuitively moved from Death and the Afterlife to the building housing the natural science collections, rather than up the stairs and back to the Mediterranean gallery. In addition, the Egypt galleries made little reference to the geographical location of Egypt in northeast Africa or to its deep cultural and ethnic associations with African cultures and peoples. In their approach, the galleries were typical of the single-author curatorial practice characteristic of the time of their creation, the mid-1980s to early 1990s. The galleries were developed by the subject specialist curators for Archaeology and for ancient Egypt, and to a large extent represent individual research interests. The Archaeology Keeper, John Prag, was a Hellenic specialist with a particular interest in facial reconstruction. The gallery he designed reflected his specialties with a space dedicated to his ground-breaking facial reconstruction work that took place at Manchester University from the 1970s (Prag and Neave 1997). Rosalie David, the Egyptology keeper, has focused her research on the scientific analysis of ancient Egyptian human remains (David 1979). In addition to mortuary artifacts such as canopic jars, amulets, and funerary stelae, the Death and the Afterlife gallery displayed eleven bodies—nine embalmed bodies and two skeletons—with labels describing the scientific work carried out on the bodies and the information gleaned in relation to their health, lifestyle, and environment. The gallery had twin foci in the form of the display of the Twelfth Dynasty (1985–1795 BCE) tomb group known as "The Two Brothers" and the embalmed body of the temple singer, Asru.

The frequent division in museums of ancient Egypt from the rest of the ancient world reflects a historical academic disciplinary divide alongside the more practical issue of the overwhelming wealth of material from ancient Egypt. This division reinforces the popular understanding of ancient Egypt as having existed in isolation and in no real geographical location. Since the development of Egyptology as an academic discipline—whose beginnings in the United Kingdom can be traced to the late nineteenth century and the appointment of William Matthew Flinders Petrie to the Chair of Egyptian Archaeology and Philology at UCL in 1892—the study of ancient Egypt has come to be regarded as separate from the study of the archaeology of the rest of the contemporary ancient world (Exell 2012). The material culture of ancient Egypt is often regarded as so peculiar to the culture that it cannot be compared to the contemporary material culture from other parts of the world.

The isolation of Egyptian archaeology has been compounded by the intense academic focus on the Egyptian language, a specialism that exists parallel to the study of the material culture.

Ancient Egypt: Popular, Academic, African

The idea of ancient Egypt's exotic difference that such a divisive approach promulgates has found a parallel expression in popular conceptions of ancient Egypt outside of academia. This can be traced historically to early displays of material from Egypt in the United Kingdom, as has been demonstrated by Stephanie Moser in her analysis of the acquisition, display, and reception of Egyptian artifacts at the British Museum from 1759 to the 1880s (Moser 2006). During this period, predating the establishment of Egyptology as an academic subject, and therefore with no subject specialist on the British Museum staff, the Egyptian objects that arrived as war booty or purchases of private collections were evaluated for their aesthetic merit and displayed in picturesque arrangements, or, for the smaller pieces, crowded into cases like sixteenth-century cabinets of curiosity (Moser 2006: 159). In contrast to the Classical material, which was generally regarded as intellectually owned by an educated elite, visitors considered the ancient Egyptian artifacts accessible to all; as a result they were regarded as sources of amusement and entertainment, and as quick and easy to consume, even as a sideshow, particularly in relation to exhibits such as the mummies (Moser 2006: 92). As Moser observes, with no requirement to study the ancient culture in order to access the Egyptian material, ancient Egypt became popular for what it represented, rather than what it actually was. Moser's study of the early displays of ancient Egyptian material highlights the influential nature of museum displays on popular conceptions of the subject, either as an introduction to that culture or, as is more often the case these days, as a reinforcement of preconceived ideas drawn from other sources such as films, television, and other cultural media.

Popular interest in ancient Egypt is huge, and the public audience for ancient Egypt is a broad church indeed, with ancient Egypt acting as a vehicle for multiple and varied views often entirely at odds with current academic research and findings. In addition, the differing mainstream views of Egypt are frequently at odds with each other. This presents a particular and complex challenge for a museum preparing a new set of galleries featuring ancient Egypt in the current climate of consultation and collaboration, of giving the audience(s) a voice in the interpretation. Rather than dealing with an indigenous community or a single community group, the Manchester Museum consultation program for the Ancient World galleries dealt with a myriad of groups, communities, and views. In addition, as a subject specialist curator, I brought my own understanding of the material culture, had my own personal research interests, and, to a certain extent, represented the academic orthodoxy. The ultimate aim of the Ancient World galleries is to allow visitors to experience the past and to give them an understanding of ancient lives that is as accurate as we can make it based on the current understanding of the material culture and textual sources. The challenge is whether specialist understanding would, or should,

carry any authority if audience expectation and understanding were very different from such specialist interpretation. Whose Egypt should we display?

The majority of the consultation work at the Manchester Museum was carried out in 2008 and included discussion with a wide variety of individuals and groups, from Afrocentrists to Eurocentrists, pagans to Christians, schoolchildren to specialist interest groups, and the discussions were often heated and illuminating. The consultation at the Manchester Museum developed some of the ideas used by the Petrie Museum outlined at the start of this chapter, and initiated some new approaches. Thirteen events took place in 2008, with some overspill into 2009. The participants included primary schoolteachers, adult visitors, family visitors, primary schoolchildren, members of the Sudanese community, teenagers aged fourteen to sixteen, and year seven gifted pupils in a summer school as well as representatives of various interest groups such as local specialist societies, pagans, and general interest visitors who attended the public consultation days that took place on March 29 and April 19, 2008. A simple questionnaire was given to all participants across the consultation events in order to establish general areas of interest across broad themes relating to ancient Egypt (Exell 2008: 9–12). Each consultation event took a slightly different form, depending on the participants, their interests, and the numbers attending, but all participants answered the questionnaires, and many of them addressed broader thematic issues the Museum felt were relevant to a contemporary approach to ancient Egypt: ethnicity and identity/Egypt in Africa, connections between modern and ancient Egypt, diverse voices (i.e., multiple viewpoints rather than a single orthodoxy), human remains (issues of ethics and display in museums), colonial archaeology (and cultural responsibility), and modern stories (process and techniques of archaeology and current research).[2]

One thing of particular relevance to this discussion that emerged from the public consultation events is that, when discussing the option of diverse viewpoints and multiple interpretations of objects, the majority of participants felt it was essential for the authors of any museum interpretation to have some kind of relevant expertise (for example, a carpenter talking about ancient woodworking), that the various authors acknowledged their professional identities, and that the process behind the interpretation be stated, that is, there was a desire for absolute transparency in the interpretation process. Interpretation by individuals with no relevant expertise or authority was not popular. Such a conclusion indicates that authority in interpretation is deemed necessary, and this should be paid attention to in a climate where museums perhaps feel that any expression of authority will be regarded as elitist (see Jenkins 2011). Put simply, people still come to museums to learn, and this should not be seen to be at odds with offering an engaging experience to the visitor.

Rather than discuss the full consultation in detail here, I would like to focus on one area that emerged that relates most directly to the tensions that can exist between community engagement and curatorial authority, and between different audiences, and for which the Manchester Museum carried out further consultation work in 2009: Egypt as an African culture. This subject covers material culture, ethnicity, language, and contemporary issues of black history and ancestry. The discussion of Egypt as an African culture from the 2008 consultation is summarized as follows in the consultation report:

The discussion on the [public] consultation day focused on ethnicity and colour, and the location of Egypt in Africa. This was recognized as a sensitive and complex issue, and one that was of more concern to certain ethnic minority groups—the participants in the public consultation day discussions and the MHM focus group were primarily White. Some participants said they had not considered this to be an issue, and also did not consciously think of Egypt being in Africa. The Sudanese community representatives felt the [current] galleries were too European in their approach, and suggested that the Mediterranean as a place of dynamic cultural exchange should be presented. The following themes and ideas were discussed:

- How did the ancient Egyptians present themselves and their ethnicity? What kind of social and artistic conventions may have controlled self-presentation in certain contexts?
- Modern definitions of ethnicity may be different to ancient ones, and modern ideas about ancient ethnicity may be influenced by Eurocentric media representations of ancient Egypt (e.g. Elizabeth Taylor as Cleopatra);
- The effect of a Eurocentric approach to ancient Egypt should be acknowledged, as well as the traditional lack of emphasis on Egypt's geographical location in Africa and cultural connections to other African cultures;
- It was suggested that the issues might be best dealt with in workshops and seminars rather than in the gallery, to allow for diverse views and discussion. (p. 18)

From this brief summary it is clear that the perception exists that discussing the subject of Egypt as an African culture relates primarily to issues of race and ethnicity and that the subject is far more important for some groups than for others with a lack of interest by ethnically white enthusiasts. In addition, the feeling by ethnic minority groups is that approaches to Egypt in museums are overly Eurocentric. For my own part, as a curator, I was interested in the African cultural aspects of ancient Egyptian material culture and society, from pottery forms to storytelling, concepts of magic to Egyptian kingship; I was also aware that many curators and academics working in the discipline in the United Kingdom do not want to engage with the subject of Egypt as an African culture through fear of association with extreme Afrocentrism. According to this latter view, all ancient Egyptians were black, a view that has come from American Afrocentrism, which has drawn many of its current arguments from the heavily critiqued work of Martin Bernal (1987, 1991).

In response to the interest expressed in the subject by participants in the consultation, as well as a small number of complaints by general visitors to the Museum that the presentation of ancient Egypt was overly Eurocentric, I organized a two-day symposium at the Manchester Museum called "Egypt in its African Context" in October 2009,[3] partly funded by the African Studies Society of the UK and the Heritage Lottery Fund (as part of the Stage 1 development money for the gallery redevelopment), and in association with colleagues from the Petrie Museum of Egyptian Archaeology, UCL, and the Fitzwilliam Museum, Cambridge. The conference aimed to discuss the African elements of ancient Egyptian culture and its physical location in Africa, and to address the prejudice that exists against suggestions that Egyptian culture can be situated within an African cultural context, counterbalancing the extreme Afrocentric views within which such a debate is often contextualized. The conference also addressed the subject of ancient

Egypt as part of black history and how ancient Egyptian material culture is perceived and interpreted in the West, issues that have only recently begun to receive attention in the United Kingdom.

Egypt as an African culture has a longer history of discussion in the United States; in the United Kingdom, it has recently been explored through a series of workshops hosted by the Fitzwilliam Museum, Cambridge in 2007 and 2008,[4] which relate to the work of one of the curators at the Fitzwilliam Museum, Dr. Sally-Ann Ashton. Dr. Ashton taught for ancient Egypt as part of black history in prisons in the United Kingdom for six years, and her approach to ancient Egypt as part of black history is reflected in the Africa-centered Egypt section of the Fitzwilliam Museum's website.[5] Outside of this work, few resources in the United Kingdom offer such an approach to Egypt. Related to this was a further aim of the Egypt in its African Context event, to showcase the work of scholars working on African-centered Egyptology, the majority of whom are not based in traditional Egyptology departments, but may be found in, for example, African studies or adult education departments. The academic work of the majority of these scholars has not been incorporated into the orthodox canon of Egyptological literature.

The papers at the Manchester symposium included discussions of the development of early iconography and language, African perspectives on Egypt, and interpretations of Egypt in museum displays and textbooks,[6] and there is a published conference proceedings (Exell 2011). The footage of some of the key speakers is available on the Manchester Museum's YouTube channel. The symposium attracted speakers and delegates from the United States, from African countries including Nigeria, very few people from the United Kingdom, and fewer still who were ethnically white. The demographic of the conference participants could not have provided a starker contrast to the more mainstream academic Egyptology conferences, and local Egyptology society meetings, for that matter, where there are almost no non-ethnically white people in attendance. In the lead up to the conference, a number of Egyptological colleagues questioned the point of hosting such an event, assuming that it was an Afrocentric event and therefore to be ignored. Such an attitude of non-engagement perpetuates the polarized positions of the Academy (academic Egyptology) and Afrocentrists (who may simply be black historians), excluding the possibility of dialogue and the exchange of ideas. The suggestion that the subject of Egypt as an African culture is worth exploring, and that the viewpoint of those who feel passionately that ancient Egypt is part of their heritage is worth acknowledging, is often dismissed by traditional academic Egyptologists. Western academic Egyptology is notoriously conservative and does not easily incorporate viewpoints and approaches to the ancient culture that divert from the accepted orthodoxy; ancient Egypt as black history is considered one such unorthodox approach (Exell 2012).

The gallery redevelopment consultation in 2008 and the Egypt in its African Context symposium in October 2009 revealed the existence of a strong interest in Egypt as part of black history and Egypt as an African culture, alongside a perception that museums in the United Kingdom have traditionally presented a version of ancient Egypt from which many people feel excluded. Egypt as an African culture is clearly of enormous relevance to certain demographic and ethnic groups, and therefore should be taken into

account in the current climate of consultation and public accountability; in the case of UK university museums, engagement with the subject relates to the HEFCE Widening Participation agenda.[7] As a subject specialist curator, with my own views on the subject of Egypt in Africa, my interpretations of ancient Egypt mapped to a certain extent onto the views expressed in the consultation events and at the Egypt in its African Context event, but they did not agree in their entirety.

Ancient Egypt as black history is one interpretation amongst many. It stands alongside a large demographic group with a general interest in ancient Egypt, from individuals who have visited on holiday to amateur enthusiasts who study and publish on the subject. Around forty-five local societies dedicated to ancient Egypt exist in the United Kingdom, a phenomenon of which other minority academic disciplines cannot boast.[8] Ancient Egypt's perceived accessibility, a perception in existence since the early displays of Egyptian artifacts at the British Museum, has been continuously maintained: sensational archaeological finds such as the discovery and carefully orchestrated media dissemination of the tomb of Tutankhamun in the Valley of the Kings by Howard Carter in 1922 (Carter and Mace 1977; Frayling 1992), The Treasures of Tutankhamen exhibition at the British Museum (1972) that attracted 1.7 million visitors, and the 2008 exhibition held at the O2 Arena in London on a similar theme have conceptually established Egypt as a land of treasure. Increasingly cheap travel allows people to enjoy a sunshine holiday with a superficially cultural background provided by the major Egyptian monuments such as the Valley of the Kings and the Giza pyramids, and fictional versions of ancient Egypt in novels, film, and computer games present it as a land of mystery and adventure.[9] Almost none of these versions of ancient Egypt can be said to be representative of the ancient culture; they focus rather on awe-inspiring, atypical examples of elite and mortuary aspects of the culture and locate Egypt within Western cultural conceptions, exoticized but accessible. However, such conceptions do have an internal consistency and logic, which has given rise to an almost impregnable version of Egypt that exists within the media and popular imagination (Exell 2013). Even documentaries that purport to disseminate current research on ancient Egypt and feature established academics and researchers fall back on familiar stereotypes. For example, a 2008 documentary series, *Secrets of Egypt,* featured programs on the Sphinx, the Valley of the Kings, Ramses II (the "Great"), and the lost tomb of Alexander, all iconic aspects of ancient Egypt that may feature in, but certainly do not dominate, the research of academic Egyptologists.

Since Flinders Petrie's appointment to the Chair of Egyptian Archaeology in 1892, academic Egyptology has flourished at a small number of universities in the United Kingdom and is now principally taught at Oxford, Cambridge, UCL, Swansea, and Liverpool, with individual modules in the subject available through Archaeology, Classics, and Oriental Studies departments at other universities. It is tremendously popular as an undergraduate subject. The subject has traditionally been divided into language and archaeology, though this division is now breaking down with many degree programs, such as that at Liverpool University, offering courses in both. Archaeological fieldwork in Egypt today focuses on the Egyptian Delta in the north of the country, due to restrictions imposed by then Egyptian Supreme Council of Antiquities (now the Ministry of

Antiquities) on excavation in the Nile Valley, with survey and epigraphic work continuing in the Nile Valley. Fieldwork has also developed in recent years in northern Sudan (ancient Nubia), due to the need for salvage archaeology in advance of the recent construction of the Merowe Dam near the fourth cataract of the Nile (Kleinitz and Näser 2011). This work has fed an increasing interest in the African kingdoms to the south of Egypt and a reinterpretation of their relationship with their northern neighbor. In research in general, there is an increasing emphasis on investigating the lives of the non-elite, the application of theoretical models to the existing data (see, for example, Dann and Exell 2013; Meskell 1999), reappraisals of earlier interpretations of ancient Egyptian society and history, and a more reflexive approach to the discipline itself.[10] The popular conception that there is nothing left to discover in Egypt and that the Giza pyramids and the Valley of the Kings tell us all we need to know about that ancient society could not be further from the truth. Academic research must be meticulous and rigorous in method and transparent in process and there can be no creative leaps of the imagination that cannot be substantiated by data and robust models of interpretation. The avenues of research and the form of dissemination (in journals in various languages and at conferences) are largely inaccessible to the general public—not due to active exclusion, but to the extremely specialized nature of each piece of work, which can be difficult to map onto a broader understanding of ancient Egypt. However, there is a perceived exclusivity, with some amateur enthusiasts feeling that, because they do not have institutional affiliation or a PhD in the subject, they do not have a voice. The biannual British Egyptology Conference overtly invites nonprofessional Egyptologists to participate, in recognition of the value of their contribution to the subject and in an attempt to counteract this perceived exclusivity. Academic elitism can, to a certain extent, be forgiven if one bears in mind the years of study and research necessary to gain a post in an extremely competitive field. An individual can describe himself or herself as an Egyptologist with no formal credentials, only a passionate interest and membership in a local or national society, and be published or present on television; this would be acceptable in few other disciplines.

Conclusion: Bridging the Divide(s)

Egypt in the popular imagination and academic Egyptology are just two out of the many approaches a university museum working on the redisplay of its Egyptian collection must take into consideration. The brief overview offered here skims the surface of the agendas of the groups and the differences and tensions that exist between their views. The case study of Egypt as an African culture draws into the discussion additional viewpoints, that of black historians and individuals who feel that Egypt is part of their heritage and who can feel excluded from mainstream representations of the subject by museums and popular media. The challenge for the Manchester Museum, with its commitment to consultative practice, is to bridge the divide between the different groups: to offer displays on ancient Egypt that do not compromise on accuracy, as far as this is possible, but are inclusive or accessible to a wide variety of views and interpretations.

Part of the solution to bridging the divide between the institution of the museum and its various audiences exists in the practice of the consultative process itself. The act of discussing people's views and attempting to create a dialogue between the museum and its current and potential audience, as well as between the diverse and often entrenched and differing viewpoints, is the first step to altering people's perceptions of a museum and how it works. Many people do not know how museum displays are created and how the information and objects presented are chosen and the interpretations given arrived at. The lack of transparency can generate suspicion and foster feelings of exclusion. By spending a year talking to people, acknowledging their viewpoints, and suggesting other interpretations and ideas, the process of decision-making, and the complexity of this process in relation to a subject as contested as ancient Egypt, has at least been made transparent to many of those who participated. The year of consultation and the associated events did not result in a single, harmonious view—events such as the Egypt in its African Context symposium with the dearth of attendance by white Western academics served to illustrate just how polarized some positions are—but served as a starting point for an ongoing dialogue with many groups and views and the development of a set of relationships that can inform decisions that the Manchester museum makes in relation to its display of Egyptian collections.

In relation to the consultation process in general at the Manchester Museum, a number of issues were raised by the ancient Egypt consultation process, such as who would make the final decision on gallery content and whether relationships with groups and individuals beyond the implementation of a project would be maintained. These two issues are subject to ongoing discussion and work. A focus group, drawing on participants in the original consultation process, was created to continue to assess design and content plans for the new galleries. In terms of content, whole sections of the Egypt gallery are based on themes and ideas drawn from the consultation process, at either primary or secondary levels of interpretation. For example, the entrance to the new Egypt gallery takes the visitor to Africa, *not* to Egypt, and explores the early development of the ancient Egyptian culture from the natural environment of northeast Africa and of the pool of African cultures located to the south and west of modern-day Egypt. That Egypt is located in Africa, and culturally of Africa, is stressed, and this theme continues in various ways throughout the gallery.

The consultation process for the ancient Egypt content of the Ancient Worlds galleries was for me an enlightening learning process. In discussion with staff members at the Petrie Museum on how they might have done things differently in their own consultation work, they reached the same conclusion I had: we would have done almost all of it differently! One of the central recommendations the Petrie Museum staff had in retrospect was that community groups will only really feel part of a project if they see themselves as integral to the institution—that is, if a member of the community works at the museum and is involved in the consultation from the inside. It will still be some time before many museums in the United Kingdom can offer this.

Returning to the issue of authority, toward the beginning of this chapter I noted that some of the feedback from the consultation events made it clear that people prefer to

have a clear and stated level of expertise in the gallery interpretation: they want to feel they can trust the information they are given. The role of a museum as a place of learning has not changed; however, the way a museum educates has evolved, with a move away from exclusion and unchallenged authority to inclusion and an acknowledgment that there is more than one truth, one history, one story. How is such an understanding put into practice? Central to any museum display are the objects. These are the museum's unique selling point, and they are, at least in the case of ancient Egypt, the reason people visit the galleries, over and above any interpretation in which they may be embedded. The objects alone inspire wonder, as was the case as far back as the eighteenth century with the very first displays of Egyptian artifacts at the British Museum, when there was almost no interpretation at all. Discussions with visitors, through the consultation period and at other times, reveal that, at a basic level, visitors want to know the following about objects on display: the age of something, what it is made of, its understood function, and where exactly in Egypt it came from. Further interpretation, which can place artifacts within a social context, or broader narratives of state and politics, archaeological investigation and related ethical concerns, and historical changes in understanding the past, can be provided by a secondary level of interpretation. It is at this second level that the museum can offer multiple views and opinions, and must be both creative and transparent in how it does this. The existence of extensive multimedia options within a gallery, and additional Web-based interpretation, offer enormous flexibility and range in the interpretation(s), and can even incorporate contributions from visitors, as has been done in the new ancient Egypt gallery at the Bristol City Museum and Art Gallery, where visitor comments on objects are regularly uploaded to the gallery-based PCs. This is not the place to discuss the variety of options available for interpretation in museums today, but simply to note the creative possibilities available and the uses to which they can be put. Such a multilevel approach to interpretation maintains curatorial and academic expertise and accuracy and simultaneously acknowledges the existence of, and gives voice to, the multiple interpretations of ancient Egypt. As Stephanie Moser notes in her discussion of the early displays of ancient Egyptian artifacts at the British Museum, "[t]he real 'magic' of ancient Egypt lies in its ability to tolerate these alternate identities" (2006: 217).

Notes

I am now a lecturer in museum studies at University College London (UCL) Qatar, Doha. At the time of writing and throughout the consultation process described, I was Curator, Egypt and Sudan, The Manchester Museum, University of Manchester, UK.

1. www.ucl.ac.uk/archaeology/events/conferences/enco/index.htm
2. The report on the consultation and its findings can be found here: http://egyptmanchester. files.wordpress.com/2009/03/archaeology-and-egyptology-gallery-redevelopment-consultation-report-december-2008.pdf
3. www.museum.manchester.ac.uk/collection/ancientegypt/conference/

4. At the time of writing, available online at: http://www.fitzmuseum.cam.ac.uk/dept/
 ant/egypt/outreach/kemet/resources/index.html0
5. www.fitzmuseum.cam.ac.uk/dept/ant/egypt/outreach/kemet/index.html
6. The complete list of papers can be found at: www.museum.manchester.ac.uk/
 medialibrary/documents/egypt_in_its_african_context_programme.pdf (available
 at the time of writing).
7. www.hefce.ac.uk/widen/
8. A list of the majority of the societies can be found at: www.maesweb.org.uk/other_
 societies.htm.
9. The www.egyptomania.org website has a fiction list of over 1,500 novels in seven-
 teen languages. The www.wepwawet.nl/films/ website lists over 650 films.
10. See, for example, the conference "Disciplinary Measures? Histories of Egyptol-
 ogy in Multi-Disciplinary Context," hosted by The Egypt Exploration Society
 (EES), The School of Oriental and African Studies (SOAS)-Centre for Cultural,
 Literary and Postcolonial Studies, University College London (UCL), and the
 Institute of Archaeology-Heritage Studies Research Group, held in London in
 June 2010.

References

Alberti, S.J.M.M. 2009. *Nature and Culture: Objects, Disciplines and the Manchester Museum.* Manchester: Manchester University Press.

Bernal, M. 1987. *Afroasiatic Roots of Classical Civilization, Volume I: The Fabrication of Ancient Greece 1785–1985.* Rutgers, NJ: Rutgers University Press.

Bernal, M. 1991. *Afroasiatic Roots of Classical Civilization, Volume II: The Archaeological and Documentary Evidence.* Rutgers, NJ: Rutgers University Press.

Carter, H. and A.C. Mace. 1977. *The Discovery of the Tomb of Tutankhamun.* Mineola: Dover Publications.

Dann, R.J. and K. Exell, eds. 2013. *Egypt: Ancient Histories and Modern Archaeologies.* New York: Cambria Press.

David, R., ed. 1979. *The Manchester Museum Mummy Project: Multidisciplinary Research on Ancient Egyptian Mummified Remains.* Manchester: Manchester University Press.

David, R. 1996. *The Pyramid Builders of Ancient Egypt: A Modern Investigation of Pharaoh's Workforce.* London and New York: Routledge.

Exell, K. 2008. "Egypt and Archaeology Gallery Redevelopment at The Manchester Museum." Unpublished consultation report. Available at: http://egyptmanchester.files.wordpress.com/2009/03/archaeology-and-egyptology-gallery-redevelopment-consultation-report-december-2008.pdf.

Exell, K., ed. 2011. *Egypt in its African Context: Proceedings of the Conference held at The Manchester Museum, University of Manchester, October 2009.* Oxford: Archaeopress.

Exell, K. 2012. "Egyptology." In *The Oxford Companion to Archaeology*, ed. N. Asher Siberman. New York: Oxford University Press.

Exell, K. 2013. "Domination and Desire: The Paradox of Egyptian Human Remains in Museums." In *Objects and Materials: A Routledge Companion,* ed. P. Harvey. London, Routledge.

Frayling, C. 1992. *The Face of Tutankhamun.* London: Faber & Faber.

Jenkins, T. 2011. *Contesting Human Remains in Museums: The Crisis of Cultural Authority.* London: Routledge.

Kleinitz, C. and C. Näser. 2011. "The Loss of Innocence: Political and Ethical Dimensions of the Merowe Dam Archaeological Salvage Project at the Fourth Nile Cataract (Sudan)." *Conservation and Management of Archaeological Sites* 13 (2–3): 253–280.

MacDonald, S. 2005. "Stolen or Shared: Ancient Egypt at the Petrie Museum." In *Edges of Empire: Orientalism and Visual Culture,* eds. J. Hackforth-Jones and M. Roberts, 162–180. Malden, MA and Oxford, UK: Blackwell Publishing.

MacDonald, S. and C. Shaw. 2004. "Uncovering Ancient Egypt. The Petrie Museum and its Public." In *Public Archaeology,* ed. N. Merriman, 109–131. London: Routledge.

Meskell, L. 1999. *Archaeologies of Social Life: Age, Sex, Class et cetera in Ancient Egypt.* Oxford: Blackwell Publishing.

Montserrat, D. 2000. *Digging for Dreams: Treasures from the Petrie Museum of Egyptian Archaeology.* Glasgow: Glasgow City Council.

Moser, S. 2006. *Wondrous Curiosities: Ancient Egypt at the British Museum.* Chicago: University of Chicago Press.

Petrie, W.M.F. 1890. *Kahun, Gurob and Hawara.* London: Kegan Paul, Trench, Trübner and Co.

Petrie, W.M.F. 1891. *Illahun, Kahun and Gurob. 1889–90.* London: David Nutt.

Prag, J. and R. Neave. 1997. *Making Faces: Using Forensic and Archaeological Evidence.* London: British Museum Press.

–9–

"Shared Authority"
Collaboration, Curatorial Voice, and Exhibition Design in Canberra, Australia

Mary Hutchison

Michael Frisch describes the relationship between public historians and those who contribute to historical understanding through their lived experience and knowledge as one of "shared authority" (1990). In this chapter, I use shared authority as a platform for discussing the whys and hows of embedding collaboration between museum curators and participants from outside the museum in exhibition making. My interest in such a practical application of shared authority is grounded in a desire to create exhibitions that include and open up conversations across socially and culturally diverse positions. I argue that sharing authority in practice requires attention to the agency of curatorial voices as well as those of participants. I also argue for making the agency of the collaborators and their interaction visible in outcomes of collaborative work. In particular, I suggest that agency and egalitarian interaction should be of central concern in developing and selecting material and in managing elements of design such as graphics, audio, and fabrication form.

My premise and contention is that working with and demonstrating an egalitarian conversation between differently located authorities, from the development of an exhibition into its fabric, plays a crucial role in creating an open, dialogue-inviting exhibition, encouraging audiences to respond from their own experience and knowledge. An inherent problem in this position is that individual experience is framed by wider discourses, including stereotypical views of "others." The approaches I discuss address this issue in several ways. First, they demonstrate sharing authority in exhibitions as an "alongside" conversational relationship between different experiences and knowledges, thus providing a model for audience engagement against hierarchical stereotypes. Second, they use individual experiences, rather than framing experiences as those of particular social groups, to invite responses related to one's own life and history rather than abstract generalizations about others. Third, in relation to this potential response, they present personal experience as both historical/social/cultural *and* as a distinct, embodied configuration of these dimensions. This third approach particularly connects with the use of

interpretive strategies that invite an intimate and imaginative relationship with exhibition material.

My thinking about shared authority as I discuss it in practice here is informed by experience both in and out of the museum context, and is particularly influenced by my work as a writer and public historian with community groups and individuals who wish to make their experiences of and perspectives on social life, history, and place visible. Through this work, I have become keenly aware of the power of individual renderings of personal experience to engage the imagination of readers and invite them, as bell hooks argues for the power of critical fiction, into an empathetic relationship with experience that is not their own (hooks 1991: 57–58). An ongoing focus in my academic work and in my work as a social history curator has been the capacity of personal experience, and the distinct expression of that experience, to create connections between diverse positions and histories (Hutchison 1999, 2009).

My discussion draws on material from a research project called Migration Memories, which tried out ideas for collaborative approaches to exhibiting Australian migration history by making exhibitions with community participants.[1] The exhibitions *were* the research rather than its outcome, and I use examples from them to show methods of sharing authority in content, process, and form. My intention in doing this is to support my argument and to suggest possibilities for future exploration raised by this initial experiment.

First my chapter provides the theoretical and practical context, including my understanding of Frisch's "shared authority," the background to and description of the exhibitions, and the broad outline of the Migration Memories approach to creating an inclusive, dialogic migration exhibition. Some additional theoretical background to Migration Memories practice is provided in the second part in relation to my description of the methods of working with agency and collaboration explored in the content and design of the exhibitions. This second part of the chapter also identifies some of the issues that emerged through the exploration. I then offer some reflections on the Migration Memories collaborations with participants and discussions with audience members. In conclusion I highlight relevant learning from the research and areas for possible further exploration.

Theoretical and Practical Background

Museum Studies Context

Theoretically, my interest in shared authority is based on the understanding that museums, as cultural institutions, are social agents. In their collection and display of cultural and historical material, they express and promote certain understandings of national culture and cultures. Sheila Watson highlights the role of 1960s radical politics in encouraging critical awareness of the museum's social role and the emergence of the

new museology movement in response (2007: 13). *New museology* is one way of describing a body of practical and theoretical museum work that takes account of the way museums position cultures and social identities in their collections and exhibitions and of the way they interact with their publics. One major area of discussion has been Western museums' management of colonial collections (e.g., Clifford 1997; Peers and Brown 2003). Another concerns the museum's role in and relationship with the increasingly diverse multicultural societies in which it operates. In 1997, the International Council of Museums (ICOM) produced a policy statement on museums and cultural diversity, with a view to "eradicat[ing] past and present inequalities in cultural representation of diverse peoples" (1997: 3). More recently, the Council of Europe has identified museums and heritage sites as spaces not just for recognition of one identity or another, but also for intercultural dialogue (2008: 33). Typically, the new museology's interest in democratic and inclusive practice involves developing collaborative relationships with diverse groups and individuals and engaging diverse audiences. As Watson characterizes it, the new museology is "community focussed" (2007: 13).

My own position is that inclusivity is not achieved by the display of "other" communities, but rather by exhibitions that encourage interaction across different positions—including those regarded as mainstream. The appeal of shared authority here is that it considers the specific agencies of the players involved and their interaction. It turns to personal complexity and what that reveals in contrast to representative simplicity and what that obscures.

Shared Authority

Michael Frisch's use of the term *shared authority* in reference to both interpretive authority and authorship was taken up by oral historians in the 1990s, and continues to resonate in oral history discussion. What shared authority does so usefully is acknowledge what Frisch describes as both scholarly authority and the authority of "culture and experience" (1990: xxii). It highlights the agency of both positions and identifies the relationship between them as an egalitarian exchange between *distinct* kinds of expertise. As Frisch discusses it, this exchange may take place between historian and informant participant or between a public presentation of history and its audience. He suggests that dialogue between scholarly and experiential knowledge taken into the "method" of public presentation may "more deeply characterise the experience of finished products themselves" and as a result "promote a more democratised and widely shared historical consciousness" (1990: xxii).

Shared authority as exchange or dialogue between distinct expertises takes us right away from a dualistic either-or relationship between "community" and "scholarship." But it also demands the presence of both as effective interacting players. Caring for the agency of community participants also means caring for our own. The typical absence of the scholarly voice in interviews with "informants" is highlighted in a 1993 article by

Mary Stuart, "And how was it for you Mary?" As an oral historian concerned with the impact of her presence on the interview, Stuart researched interviewee experiences of the interview. One narrator, taking this research as a two-way affair, asked, "and how was it for you?" For me, this is a critical aspect of honoring shared authority—we aren't caring for the agency of the participant if we don't respond as well as initiate, and are even more careless if we edit out our presence in the exchange. In the exhibition context, the absence of the curatorial voice as a particular and knowledgeable voice does not enable the agency of participants or audiences. It dishonors the intention of sharing authority by allowing museum knowledge to take up its usual and often oppressive omnipresent position.

Shared authority also opens the way for seeing the agency of participants in a complex and specific way. Those speaking from the position of experience of historical events or of particular cultural frameworks bring multiple perspectives to bear on the subject at hand. In Migration Memories, I was particularly concerned not to reduce the migration history of participants to ethnicity. Obviously ethnicity was a component of the partici-pants' experiences and perspectives, but I sought them out as *individuals* whose stories connected with local periods and types of migration—and I only made connections with ethnic organizations if individuals led me there.

Migration Memories: The Exhibitions

The Migration Memories exhibitions were made in two regional locations. They were exhibited in their own localities and then shown together at the National Museum of Australia. The localities were Lightning Ridge—an opal mining town in northern New South Wales—and Robinvale, a horticultural town on the River Murray in northwest Victoria. Both have rich migration histories and populations of around seven thousand. A strong reason for the selection of these places was the enthusiasm shown by community organizations for participating in something they saw could be of value to them.[2]

Resources for any activity in Lightning Ridge and Robinvale are modest. The exhibition shown in Lightning Ridge was housed in a 1914 weatherboard cottage owned by the Historical Society and used as its permanent gallery space. The venue in Robin-vale was a room set aside for child care in a very new leisure center. The exhibition in Lightning Ridge included objects in museum cases. In Robinvale, images of objects were predominantly used.

Migration Memories: The Research

In the context of critiques of the Australian multicultural migration exhibition, Migra-tion Memories was one of a growing number of initiatives seeking alternatives to the static display of difference in celebration of the contribution of "other"—non-British, overseas—cultures to the Australian way of life (Hutchison 2009; McShane 2001; Witcomb 2009). Specifically, the research explored ways of making an exhibition in

which the voices of the participants who contributed material, the curator, and members of the audience could be part of a balanced conversation that included a variety of experiences and points of view concerning Australian migration history. The focus on place as a shared experience was one way of framing this conversation. Another was to take migration as a historical theme rather than primarily as a cultural experience. In this way, Australian migration history could be seen as something that resonates in the lives of all Australians and could include descendants of British colonizers and indigenous people who have suffered the consequences of colonization, particularly through displacement and forced migrations. The exhibitions included indigenous perspectives on migration, as well as those that showed a variety of experiences of coming to Australia from the colonial period (first settlement 1788) to the present. In further support of the focus on migration history as an alternative to easily stereotyped migrant cultures, individuals chose artifacts used in the exhibition for their meaning to them, whatever their material culture dimensions.

Necessarily, the project took place on a small scale—even a small exhibition takes time, and my methods of working were designed to develop and investigate relationships, not simply produce outcomes. So in each location I identified six major migration periods from the colonization period to the present and looked for people interested in developing a story for display, whether it was a story of an ancestor or their own experience. The indigenous perspective featured in seven stories in each exhibition.

Within this framework, my aim was to show each individual migration experience as the storyteller understood it and in its historical context. This was researched as the storylines of the personal story became clear. In the exhibitions, the curatorial voice and the voice of experience were presented alongside each other, implicitly and sometimes explicitly in dialogue.

Inevitably, wider discourses of settlement, migration, and colonization spoke through the personal perspectives, but they spoke in particular ways. For instance, one storyteller saw the colonial history of her pastoral property in terms of more contemporary discourses about migration and focused on the connections between indigenous, Chinese, and British cultures rather than the more popular "pioneering" discourse of the heroic settlement of the land. On the other hand, the teller of a story of an Italian migrant who arrived in the 1920s used the term *pioneering* to express his father's experience as the first one to go to Australia from his village in Sicily.

The development process with the storytellers was one of quite intense collaboration. Decisions were made with them on all details of content—their own and the curatorial panel text, images, captions, objects, and object labels or descriptions—and on the broad design approach. Participants signed off on a mockup of the display of their stories.

For the realization of each exhibition, I also worked collaboratively with a designer, a photographer, and a sound artist. Sound was a very important component of the exhibitions, and like the main exhibition material was created with local participants. In Lightning Ridge, I worked with designer Iona Walsh and photographer Jenni Brammall; in Robinvale I collaborated with Paula McKindlay and Jo Sheldrick. Lea Collins served as the sound artist in both locations (Hutchison and Collins 2009).

Methods of Embedding Shared Authority
in Exhibition Content and Design

Migration Memories worked with agency and collaboration in the process of develop-
ing the exhibitions, in selection of content, and in the choice of interpretive strategies
and design forms. The research premise was that shared authority could not be honored
in one without the other. This section of the chapter focuses on content and design with
some reference to the development process.

Developing Content and Design as a Collaborative,
Evolving Process

Embedding shared authority in the exhibition involved the development of content and
design in relation to each other as an evolving and collaborative process. The exhibition
designers did not work with a cut and dried design brief. They were invited to respond
to the individual stories as they took shape and were involved in various ways in discus-
sion with participants. They worked closely with me on the translation of the research's
democratic intentions into the fabrication and graphics of the exhibitions. For instance,
in designing Migration Memories: Lighting Ridge, Iona Walsh saw the importance of
creating an exhibition that did not exceed person height so that audience and material
were on a similar scale. She also wanted to open up the relationship between viewer and
material in other ways. Her design invited audiences to walk around panels and look into
cases from varying angles, thus marking the difference between displays as a visceral
experience through bodily movement.

This evolving approach also meant that we could respond to opportunities that
emerged through the work in each locality. As it turned out, each exhibition included an
unplanned additional element of display that drew in other local residents apart from the
main storytellers.

Embedding Agency and Shared Authority
in the Subject of the Exhibition

The individual migration stories, as a combination of personal and historical perspec-
tives, were the subject and main substance of the exhibition. They were not illustrations
of history and culture nor used as a device to make the real information more personal
or engaging. By the same token, the historical text was written and placed so that it did
not frame the personal or suggest itself as more important. The use of personal images
as well as official images mirrored the approach to the text. In the event, while I was at
pains to show the seams, my experience was that visitors tended to read the story seam-
lessly and always identified the story by its teller—"the chap who thought he was going
to Argentina."[3] This identification was supported by creating each story as a stand-alone

display which, as far as possible, had a distinct form within the overall design—so as to be recognizable as, say, Lovelyn's story or Tory's story.

The introductions to the local exhibitions established the subject and fitted into the structure of the rest of the exhibition, which was based on distinction rather than hierarchy. They had the same design form and dimensions as the story panels. They did not frame the stories with an overall view, but simply provided information about the location and its migration history, the research, and the people involved. Most important, they sought to do this from the position of the collaborative making of the exhibitions.

> *Migration Memories: Lightning Ridge* is part of a research project about Australian migration histories and ways of creating exhibitions with a personal focus. It tells the stories of seven individuals from Lightning Ridge. The storytellers have worked with researcher and curator Mary Hutchison and designer Iona Walsh to develop their stories for display . . .
>
> As well as the storytellers, many other Lightning Ridge individuals and organisations have been involved with *Migration Memories*. They welcome you and invite you to enjoy the exhibition.[4]

It is worth noting that a visitor to the Lightning Ridge exhibition who had experience as a museum volunteer found the nonhierarchical approach very confusing. As she saw it, the exhibition was "muddled." She couldn't work out where it began or what belonged with what story.[5] This concern was an exception, but it suggests the tradition of museum exhibition that relies on what Freire called the "banking" system of education in which knowledgeable teachers make "deposits" into the heads of relatively ignorant learners (1972: 45–59). My experience of watching audiences at the local venues was that those who were not schooled in this tradition engaged freely with the material—usually heading first to a story they knew something of and then seeking others as they wished.

Presenting Historical Context alongside the Personal Story

As indicated, Migration Memories was grounded in the intention to show the relationship between personal experience and historical/social context. In addition, the presentation of this through two sets of authored text showed these as two forms of knowledge in side-by-side dialogue. My position is that this demonstration of dialogue between curatorial/historical authority and the authority of experience in the embodied form of two characters—Mary and, say, Jennifer—may create a nonthreatening *and* nonpatronizing invitation to audiences to enter the conversation from the point of view of their own experience. However, this doesn't work by device only—it requires attention to the development of content. To achieve a balance between forms of knowledge that might ordinarily be seen in a hierarchical relationship, historical context was developed in *response* to the individuals' stories and what was important to them. And just as the personal story was told through images, objects, and text, historical information was provided in the form of archival images and documents as well as text. For instance in Dusan Malinovic's story

of escaping from military service in the former Yugoslavia in the 1960s, a strong personal memory was the basis for providing information about Australia's immigration publicity machine of the time.

> In the refugee camp in Austria they showed us films about Australia. It's the nicest country on earth—green, all rivers, no deserts, beautiful. The place is full of fruit trees and people speaking many European languages.[6]

A typical beach paradise publicity image featuring a smiling young couple running hand in hand along the shoreline resourced from Immigration Department files in the National Archives accompanied these words. In combination they raised many smiles.

An example from Sothea Thea's story of escaping the civil war in Cambodia in a leaking fishing boat shows the use of text to describe an event from both personal and historical angles. In this case, it is the event of arrival in Australia in 1990.

Sothea

Navy take us to Darwin port. Immigration send us to camp in the bush. Volunteers come to visit. They give us clothes and teach us English. Then Immigration send us to Port Hedland. We don't know where we are or how long we have to stay there. Just waiting.

Mary

Between 1989 and 1991 several groups of Cambodians arrived by boat on the northern shore of Australia. Their applications for asylum were the catalyst for the Labor Government's 1992 immigration legislation which established mandatory detention for people arriving without authorisation.[7]

Using Democratic Interpretive Strategies

While my research and discussion are based on the understanding that individual knowledge and experience is framed by and expressed through the language of wider discourses, I also use the idea that neither individuals nor discourses are fixed or singular and that the human capacity to imagine and empathize, as bell hooks argues, may move individuals into less familiar territory (1991: 57–58). In taking the theory of the "dialogic" exhibition (Bennett 2006: 63) into practice, Migration Memories used interpretive strategies that took their inspiration from techniques writers use to engage readers in the world of story. In this I followed hooks's discussion of critical fiction and Mikhail Bakhtin's theorizing of the novel as a dialogic and essentially democratic form that invites readers to engage "on the same plane" as its narrator and characters (Vice 1997: 112). Migration Memories experimented with creating the exhibitions as open dialogic "texts" by attending to techniques such as precise description, metaphor and image, distinct characters, direct speech, and clearly defined points of view within a narrative

structure. These devices create a world a reader may enter as an equal and intimate participant because it is embodied and material. It can be heard, seen, smelled, tasted, and touched and, through the senses, felt emotionally. The story of this world unfolds through the relationship between its elements; through interaction and reaction (Hutchison 2009: 78–80).

Each story, including the selection of material to tell it, was based on its particular circumstances and the feelings and meanings it held for the teller. Images, objects, and text were juxtaposed to show rather than tell the story and its wider history. Although there were explanatory aspects within the material, it was arranged to make sense through connection and association rather than through exposition. This open method of putting material together creates the space necessary for audiences to imagine and feel the experience. For instance, an image of the clothes the Cambodian asylum seeker, Sothea, wore on his terrifying twenty-eight-day sea journey to Australia was integrated into the panel design with the following text:

> Seventy nine people on the boat including men, women and children. From memory the boat was about 20 metres long and 4 metres wide. I am alone so I stay in front where no-one else goes. At night the water comes over but I find a small space I can lie down in. I pull the sleeves of my jacket down over my hands to keep warm and turn my back on the water.[8]

The same sort of space was created by allowing tensions and questions, loss and hope, vulnerability and strength to be part of each story. A particular example is provided in the story of Jennifer Colless's grandparents. In 1913, Jennifer's Irish grandmother, Catherine, who had arrived in Australia in the 1880s, went to America, leaving her German husband and their two small boys in Lightning Ridge. She never returned. The panel dealing with this migration included images of the Christmas cards Catherine sent to her grandchildren in Lightning Ridge in the 1940s and 1950s. They were accompanied by Jennifer's memory of having to write back to her grandmother because her father didn't want to do it himself. Another feature of this section of the story was a 1912 photo of Catherine with her two young sons in the Sydney Botanic Gardens. Jennifer's text here read:

> I used to wonder why Dad always took us to the Botanic Gardens, but I think it might have been because that's where his mother used to take him and Uncle Bill when they went to Sydney.

My own text raised possible reasons for the situation on the basis of wider issues such as World War I and the decline of Germany's role in the opal trade.[9]

Events and experiences within the stories were specified through details of memory, sensation, and feelings of the moment. For instance, the second generation of the Tongan family in Australia, Joseph, Christopher, and Mele, remembered their trip to Robinvale in this way:

It was a 10 or 12 hour trip from Wollongong to Robinvale in Dad's 1984 Chrysler Valiant. The old brown Valiant. All of us jam-packed in there with blankets and clothes. The back seat made into a bed for us three kids.[10]

In Joan Treweeke's story of the three different cultures that came together on her pastoral property in the colonial period, three objects found on the station provided the abstract concept of culture with solid and distinct material shapes: a grinding stone, a piece of pottery marked with a Chinese character, and a cattle branding iron.

The exhibitions also sought to give the viewer a sense of each locality as a particular migration destination by using key material qualities of place in the exhibition design. For instance, in Robinvale, Paula McKindlay used a curved panel shape as a reference to the River Murray and a detail from a map of the river as a graphic panel motif. Another example of locating migration was the use of graphic maps created by the designers to specify the places and distances of each individual migration in the context of contemporary population movements. These proved a consistent point of interest for audiences, who traced the lines of movement on the map and then looked for other places known to them, often because of association with someone they knew.

Shared Authority in Exhibition Text, Graphics, Images, and Objects

This section of the chapter looks at how the exhibitions sought to use democratic interpretive strategies in the display of text, graphics, images, and objects and discusses issues arising from this exploration. The sound installations were a particular experiment in this regard and are the subject of a separate publication (Hutchison and Collins 2009).

Text and Graphics

The graphic representation of text, as well as the text itself, was seen as relevant to presenting curatorial and personal text as different but equal dimensions of historical experience. The title of each story located it in time and place and showed its joint authorship—for example: "From Italy 1925 to Robinvale 1936. Tory Pisasale in conversation with Mary Hutchison." The distinct pieces of text were headed by our first names—Tory or Mary—and given a graphic treatment that distinguished the text but gave it equal status. Despite my desire not to use italics for the personal text, it was presented in a very light form of italic that was larger than the sans serif curatorial text. Shading and color further identified the particular perspective, creating "zones" for each.

The shared making of the story across personal and historical interests was also shown through direct references to the dialogue between curator and storyteller. In Gabor (known as Gabo) Nagy's story, authored by him and his daughter Sheila, a vital official

document was the medical examination form that showed the photo of him taken at the displaced persons' camp in Naples in 1947. His children had never seen a photo of him as a young man, so it had great emotional importance as well as referring to immigration processes of the time. Sheila's text read:

> We didn't know much about Dad's life before he came here. Finding the documents was really exciting, quite emotional—finding out things you never knew.[11]

Another panel from Gabor's story concerned his journey from postwar Debrecen to Naples. The journey was rendered graphically alongside his fragments of memory. Sheila's words introduced the story: "When Mary asked Dad questions little things came back to him."[12] These examples show the storyteller's experience of making the story as well as the collaboration to make it. As well as showing process, this demonstrated that the story did not have a fixed or prior existence.

Several stories involved more than one storyteller or author—as with Gabor's story. In Robinvale, the involvement of the parents and three children in a Tongan family (the subject of a previous example) created the possibility of showing both first- and second-generation experiences. In telling Kay Grose's story of the colonial period in Robinvale, we sought advice from Aboriginal elders and included some of their perspectives alongside what she and I had to say. The designer created another text zone for these voices with circles interspersed at intervals through the panel.

The examples I have used of the words of the storytellers show that storyteller text reflected individuals' particular rhythms of speech and turns of phrase. It was essentially what they said and how they spoke, but it was not a simple, transparent selection of material. What became the storyteller text was drawn from digitally recorded conversations as well as my notes of conversations, and edited and reworked as necessary with the relevant storytellers. The process was that I made initial selections to go with the shape and content of the story as it had been agreed on. Then, as with all exhibition text, it was a matter of cutting and cutting. Many decisions with participants revolved around what areas of content to keep, what to delete, and what to prune. Cutting some bits then affected the content and expression of the bits that were left. Generally, we made broad decisions together; I then refined the text in response—always drawing on their words—and took the result back. From this it can be seen that the specific wording of text was an ongoing work in progress. The initial selections were generally composites of lightly edited verbatim material—often we had gone over the same thing several times and it had been recorded in various ways and expressed verbally several times. In going over these pieces of text to check them or make decisions about keeping or cutting, I read them aloud, which enabled quick clarifications and refinements. But there was also the opportunity to read and think over the inclusions. My own interest was always in retaining how people said things in a way that would make sense to a stranger, convey the distinct character of the speaker, and honor the telling. As an example, John Katis's text with his sketch from memory of the landscape of the Greek village he had left as a child read:

You look at the mountains there, they're totally different. The heritage you left behind, it just seems to be inside you, it just draws me, it's like a bloody magnet.[13]

I was always struck by the way he talked about his village, and I collected various ways in which he had expressed his sense of place. My memory is that this piece of text didn't come together until I read back something a bit like it to him one day and he said, "Yeah, it's like a bloody magnet." He was happy for it to be finalized in that way.

Perhaps not surprising, shaping my own text as the distinct historian-curator character, Mary, was more problematic. In Lightning Ridge, I used the first person at least once in each story. In Robinvale, I relied on the use of my name with my text. On reflection, the use of the first person seems stronger—it shows that the professional position is as active and experiencing as that of the participant.

What really struck me in Dusan's story was the connection between his work and Australia's really big construction schemes. The labour of new migrants was essential to Australia's industrial development in the 1950s, 60s and 70s.[14]

Images

Official and personal photographs and documents played a vital role in specifying place, experience, and historical context. The major question I had in relation to images and participant agency concerned the use of images of the participants themselves. In the Migration Memories exhibitions, I was determined to show the storytellers in their environments and in action—whether working with me or doing something else—not gazing at the camera as an illustration of themselves. This caused some controversy—some viewers felt that each story should headline a contemporary portrait of the storyteller, and the National Museum introduction to the exhibitions used one of the very few smiling to camera images that existed. Alternatively, there are a number of examples of lively, agentic images produced through collaboration between individuals being photographed and photographers. The portraits of artists created for the Docklands Museum Sugar and Slavery exhibition are one such instance.

Objects

As indicated, the objects displayed in the exhibition were chosen by the storytellers because they had important meaning for their story rather than wider cultural meaning. Text information about the objects using participants' own words was used to convey this personal meaning and provide some basic cultural and historical details—but this potential dialogue was not explored to the same extent as the personal story or the wider history. The use of objects and the presentation of their varying meanings in display form was one of the most challenging and least resolved aspects of the research. Each of the exhibitions tried a different approach.

In Lightning Ridge, objects were displayed in standard museum cases co-located with the panels. We experimented rather tentatively with large vinyl lettering on the cases to capture personal meaning, for instance, with Lovelyn's old vinyl handbag from her flight to Australia from the Philippines: "My uncle said to me, take only your handbag, don't look back, whatever you have in the cupboard, forget it."[15] We were aiming for a sense of the object as agent. Vinyl lettering was similarly used with Jennifer Colless's grandfather's opal cutting machine: "Dad'd say, now Jen, I want half the thickness of a cigarette paper off that stone."[16] The more label-like text with the opal cutter concerned its use by three generations of the family in accord with Jennifer's sense that it stood for their survival in Lightning Ridge "through thick and thin." But the opal cutter also had wider stories to tell. Research by the National Museum revealed that its frame had been manufactured in America in the late nineteenth century. More recent modifications to it were typical of opal fields invention. My own research suggested that Jennifer's grandfather had saved it from a fire at White Cliffs opal fields and brought it with him to Lightning Ridge. For me, an important finding of the Migration Memories experiment with privileging personal experience and historical context as an alternative to cultural stereotypes was that it opened up a way of reconnecting with the larger story of material culture. It was not possible to try this out within the frame of the research, but the potential for exhibiting objects in a way that included material culture and historical and personal perspectives alongside each other seemed strong.

In Robinvale, the research highlighted objects as embodiments of personal meaning by using images of those selected within the panel design. Small objects that could be integrated into the panels were displayed in their material form. A photographer was employed to take photographs of objects and encouraged to use her sensibility as portrait photographer rather than strive for images that provided a clinical description of the object. The photographer and exhibition designer then worked together on the panel design. The image of Sothea's clothes discussed earlier is an example of this approach.

Another issue that added to the complexity of experimenting with the agentic display of objects was that, as might be expected, not all storytellers actually had a personal migration object. Sometimes the quest led to items that would not usually be thought of as objects. In Robinvale, sounds had particular meaning for several of the storytellers: Italian opera, certain lines of the Greek national anthem, Tongan church choirs, the theme music of the television soap opera *Neighbours*. They were rather awkwardly incorporated into the sound installation, as we did not have the resources to create sound with the individual displays. Similarly, in Lovelyn's Lightning Ridge story, I always felt that the most striking and expressive objects she offered were things people had said to her. The handbag was a fortuitous discovery rather than the thing itself.

There were also occasions when it was appropriate to invite storytellers to create an object that expressed something central to their experience. These, vested with the person's making, were often seen as the most touching objects in the exhibitions. Aunty

Rose's feather flowers are one such example. By the early twentieth century, flowers made of feathers had become a craft object that Aboriginal people made to sell. They were a combination of traditional decorative use of feathers and European ideas of house decoration.[17] Aunty Rose's mother was a maker of feather flowers, and Rose had watched her make them. When I met Rose, she had recently tried her hand at the art and found that the skill came to her in the process. As an object that showed cultural adaptation in response to an oppressive new culture and the way Rose had carried the knowledge of their making in her hands, the feather flowers were vital. They were also powerful beyond the exhibitions. Since their display in Migration Memories: Robinvale, Rose has made feather flowers for the National Museum collection and for local display. People bring her bags of feathers and her making has become increasingly confident and adventurous.

Collaborations

Each collaboration with the storytellers was different, but all involved decisions and issues that had to be carefully considered. For example, Lovelyn Miglietta migrated to Lightning Ridge from the Philippines as the wife of an Australian resident—himself originally from Italy—in 1994. There has been much publicity about the problems of such marriages and the women are often described in a derogatory way as mail-order brides. While Lovelyn's marriage and her wedding memorabilia were in many ways central to her story, we were both hesitant about locating them at the heart of the display. Instead, we developed it as a story of *pakikipagsapalaran*, "finding my destiny," with her marriage as one step in this.[18] We tried a number of storylines before we arrived at *pakikipagsapalaran*, and with more time we could have made this stronger. It was one of those stories where new elements, issues, and objects kept coming to the surface. We did a lot of reworking from the mockup stage. Lovelyn checked everything extremely carefully for its possible impact on her husband or other members of her family. We also made a change as a result of her husband's response to the exhibition in Lighting Ridge. This was immensely important and he was really pleased to come to the Canberra opening.

The collaborative process was intimate but defined by the distinct positions of story-teller and professional researcher and curator. The individuals concerned understood that, although they told me much about themselves, it was related to the topic of migration and was for a specific purpose. In turn, I often sought their advice on how the community worked and what might be appropriate in a given situation. They were the experts on their history and place. I was the expert on history and making an exhibition.

As part of the research, I interviewed the participants about their experience of the process at three different stages of our work together. These interviews were not intended to evaluate the conduct of the process, but to document decisions we had arrived at, the negotiation of particular issues, and the development of our collaboration. One of the things I found through the interviews was that across various motivations for getting

involved—including doing something to benefit the community—storytellers often recorded a similar experience.

Len: When I went into it I roughly knew the direction but I didn't really know which—whether we were going to go down the middle or right, left or centre or where, but I can see where we've been now. [laughter]
Mary: So taking that kind of stab doesn't really worry you?
Len: No, not at all—on the contrary probably enjoy going that track rather than "yes Mary, no Mary."[19]

When professional expertise holds the status of the authority, developing a relationship based on shared authority and requiring joint decisions may seem aimless and time consuming. Like Len Arnott, Aunty June Barker recorded some time of confusion, but did so with a sense of her own agency.

> I couldn't see what was in it, but I thought, now I'll hang in there with this one [laughing] because I knew . . . that what we were talking about would come altogether.[20]

My first understanding of responses like these was that the people who agreed to be storytellers shared a preparedness for giving things a go and seeing them through over ups and downs. On closer scrutiny, and with the knowledge of enjoyment of the process, I think that, despite some confusion, insistence on sharing authority was a better "track . . . than 'yes Mary, no Mary.'"

The shared authority of the collaborative process is highlighted on the Migration Memories website, where both the storytellers' and my experience of the process are shown. My experience concerns the issues of developing the story from my position as a professional.

We focused on Tory's father in the exhibition. His mother was an equally strong character, but her experience was that of a woman, and while sensitive to it, Tory was not so connected with it. When I talked with Tory's sisters, Nella and Grace, at the exhibition, I also became aware of how different their experience as second-generation women was from Tory's. If I had worked with one of them, the story would have taken quite a different direction.[21]

But there was another more personal level of exchange and change from my point of view. For instance, I was nervous about how Dusan and I would get on. He was represented to me as something of a hard man, given to action rather than words, but to my amazement, and probably his, he stretched out into reflection with me. Even though at times we made little sense to each other, there was a strong feeling of the pleasure we were both taking in thinking about the meaning of things.

Collaboration between professionals and participants is often concerned with maintaining the status quo rather than allowing the inevitable impact of interaction. For Dusan, Migration Memories opened up the possibility to look back over his life. For Aunty June and Uncle Roy Barker, the invitation to think about the indigenous

experience in the context of migration history was also an important experience. When I attended a paper given by Roy on the theme of indigenous mobility and migration at an indigenous studies conference,[22] he made a point of saying that he hadn't considered migration as an issue for indigenous people until he and June had worked with me on Migration Memories.

Sothea's story provides an example of how the Migration Memories website has offered a next chapter in the making of participants' stories—and a new chapter in their authority. The website uses the image of Sothea's clothes with his text "These my only clothes I had to wear on the boat, I keep them to remember my journey."[23] Sothea has put this image and a link to the website on his Facebook page. One of the comments he has received is "Cool jacket and jeans from 90s I guess." He has responded by filling the writer in on the origins of the jacket and its family connections.[24]

The collaboration with individual participants, as well as with the community organizations that supported the project, was based on the idea of exchange—of a relationship based on mutual interest but not necessarily the same outcomes. For me, the exhibitions were a research process; for Robinvale Neighbourhood Centre they were an opportunity to do something for Robinvale; for Tory Pisasale it was an opportunity to continue a reflection he had already begun. Lovelyn's participation was part of her determination to contend with popular conceptions about her migration experience. Her growth in confidence during the process was a growth in capacity to do this. When I e-mailed her about discussing her story in this chapter, she wrote back: "By all means you can talk about my migration story . . . I'm so proud working with you Mary, my self-confidence was built up since I worked with you . . . [my husband] and the rest of my family will be happy for sure for you to discuss my migration story."[25]

My own response to the experience of the collaborations has the same satisfying memory of swimming well in unchartered waters; of developing relationships with people I would not normally meet, and of making something together that documents our exchange.

Audience

In seeking audience responses to the exhibitions, I wanted to set up a method of collecting them in which researcher and visitors were in an egalitarian relationship; not the satisfied/dissatisfied customer position vis-à-vis professional success or failure, nor the "have your say" or "tell us your story" approaches, which are both essentially patronizing. Alternatively, I wanted to know what the exhibitions made people feel and think *about* rather than what they thought *of* them in evaluative terms. This approach also met my interest in finding out whether visitors connected with the material in the dialogic way intended.

An ambitious intention that the research was not able to take up was to incorporate audience feelings, thoughts, and memories into the fabric of the exhibition. The idea here was for audience members to collaborate in an ongoing making through their knowledge

and experience. Instead, collecting visitor responses was based on a more literal exten-sion of the exhibition conversation.

Capturing audience experiences at the local exhibitions included observation and listening in to conversations (Leinhardt and Knutson 2004) between visitors, but was largely focused on notes of conversations between research personnel and visitors. At the National Museum, a questionnaire was the main form of response gathering. An additional experiment there was setting up informal conversations with two or three visi-tors together.

Visitor responses at local venues showed the greatest potential for democratizing his-torical understanding by taking shared authority into the method of public presentation, as Frisch suggests. In both locations, particularly at Robinvale, where interest in commu-nity is more widespread than in Lightning Ridge, there was strong interest in filling out the history of local people and of the locality. Across both localities, some local visitors saw the exhibition as an opportunity to relearn their community.

> It's like I think you have walked into a huge living room and there are all these people who have all known each other and who thought they knew each other. But you [exhibition cu-rator] actually connected some of them more to each other by reintroducing them to each other . . . Even though one has known them, but never actually known what their connection to something else—to the bigger picture—was.[26]

The local exhibition contexts had a relaxed, familiar territory feel conducive to lingering and chatting. Visitors often knew each other and would spend a moment to catch up, with the exhibition often providing an initial talking point. As I have mentioned, preconceptions about exhibitions were few and far between. By contrast, the exhibition at the National Museum was in a small space within large open spaces whose exhibits interpreted broad themes of Australian social life. A number of responses to the questionnaire indicated that it had been seen as one asking for responses about the museum more generally. Others reflected the difficulty of viewing a specifically located exhibition in this context and one that was not primarily a collection of objects. By contrast, the *conversations* with visitors at the museum, as at the regional venues, reflected the complexity of audi-ence response. The frame of mind of the moment—"is there somewhere to eat around here?"—as well as existing ways of seeing, are always part of the mix, but conversations also showed the capacity of talk around an exhibition to extend the material on display through audience members' own experiences and their varied responses to those of oth-ers. This is not to suggest that some conversations did not revolve around stereotypes, but sometimes there was a struggle to make them fit. A number of responses used the phrase *you just don't realize.*

Conclusion

The Migration Memories exploration of shared authority methodology, in the use of character and narrative and collaborations between museums and creative arts practice,

shares features made visible in other exhibitions, notably Mason et al. in this volume. I shall highlight some key characteristics and questions raised in the application of the theory-driven shared authority approach.

A central issue for the collaborative activity was the tension between scholarly authority—embodied by myself as the curator—and the individual storytellers. Despite detailed decision making, most storytellers could not envisage the final exhibition and so shared authority was limited, but participants had agency and saw their role as an exciting and meaningful aspect of skills and knowledge exchange. In hindsight, making the interaction between scholarly and personal voices visible in the exhibition could have been used more extensively, to cross generation and gender, perhaps. Collaboration with designers also warrants further concern for the participants as "clients."

The National Museum's outreach support for community collaboration may be extended through partnership and guest exhibitions rather than through organizational change. Place offered a frame for bringing different experiences and perspectives into relationship with each other, but a stronger sense of differences and connections could have been achieved; for example, design and personal objects might show the local in the national context not as a "special effect," but representing different knowledges and the many places that inhere in one place.

Finally, Frisch's "shared authority," based on the intimate interaction between oral history interviewer and narrator, offers a space that has not been colonized by "community engagement," which can resemble a marketing strategy more than a democratic process. It rather engages across difference; skills, knowledges, cultures, viewpoints; making connections and reacting to these. To use Elspeth Probyn's metaphor for contact between self and other as surface contacts "on the skin" (1996: 3–15), collaboration may be rough and smooth; it creates movement and change and the product reflects particular exchanges.

Notes

1. I carried out the research, which included developing the exhibitions, through an Australian Research Council Linkage Project based at the Research School of Humanities at the Australian National University and in partnership with the National Museum of Australia.

2. A mark of the community's sense of ownership of the Robinvale exhibition was the Neighbourhood Centre's decision to enter it in the annual Victorian Community History awards. They won the award in the category of best exhibition—and won the recognition they wanted as a community keen to explore opportunities.

3. In talking with visitors about things that stood out for them about the exhibition, I usually had to ask directly what they thought about the authored text.

4. Introduction, panel 1, Migration Memories: Lighting Ridge, 2006.

5. Visitor responses, Migration Memories: Lightning Ridge, August 26, 2006, conversation 8.

6. Dusan Malinovic, panel 2, Migration Memories: Lightning Ridge, 2006.
7. Sothea Thea, panel 2, Migration Memories: Robinvale, 2007.
8. Sothea Thea, panel 1, Migration Memories: Robinvale, 2007.
9. Jennifer Colless, panel 5, Migration Memories: Lightning Ridge, 2006.
10. Maamaloa-Fine family, panel 2, Migration Memories: Robinvale, 2007.
11. Gabor and Sheila Nagy, panel 1, Migration Memories: Lightning Ridge, 2006.
12. Gabor and Sheila Nagy, panel 2, Migration Memories: Lightning Ridge, 2006.
13. John Katis, panel 3, Migration Memories: Robinvale, 2007.
14. Dusan Malinovic, panel 3, Migration Memories: Lightning Ridge, 2006.
15. Lovelyn Miglietta, vinyl text, Migration Memories: Lightning Ridge, 2006.
16. Jennifer Colless, case text, Migration Memories: Lightning Ridge, 2006.
17. Michael Pickering, curator, National Museum of Australia, personal communication, September 2007.
18. I am grateful to Aileen Paguntalan for providing me with information about the role that *pakikipagsapalaran* plays in Filipino women's migration stories.
19. Len Arnott, interview 2, Migration Memories: Robinvale.
20. Aunty June Barker, interview 2, Migration Memories: Lightning Ridge.
21. See the discussion of Tory Pisasale's story on the Migration Memories website: http://rsh.anu.edu.au/migrationmemories/html/robinvale/pisasale2.htm.
22. Australian Institute of Aboriginal and Torres Strait Islander Studies (AIATSIS), National Indigenous Studies Conference, Canberra, September 29–October 1, 2009.
23. http://rsh.anu.edu.au/migrationmemories/html/robinvale/thea1.htm.
24. Available at: www.facebook.com/posted.php?id=742806531&share_id=156686289 581&frag#!/profile.php?id=742806531. Accessed October 20, 2009.
25. Personal communication, November 12, 2009.
26. Nezaket Schulz, visitor response interview, Migration Memories: Lightning Ridge, September 4, 2006.

References

Bennett, T. 2006. "Exhibition, Difference and the Logic of Culture." In *Museum Frictions: Public Cultures/Global Transformations,* eds. I. Karp, C. A. Kratz, L. Szwaja, and T. Ybarra-Frausto, 46–69. Durham, NC: Duke University Press.

Clifford, J. 1997. *Routes: Travel and Translation in the Late Twentieth Century.* Cambridge, MA: Harvard University Press.

Council of Europe. 2008. "Living Together as Equals in Dignity." White Paper on Intercultural Dialogue. In Council of Europe/ERICarts, *Compendium of Cultural Policies and Trends in Europe,* 10th ed. Available at: http://www.culturalpolicies.net/wev/intercultural-dialogue.php. Accessed January 7 2010.

Freire, P. 1972. *Pedagogy of the Oppressed.* London: Penguin.

Frisch, M. 1990. *A Shared Authority: Essays on the Craft and Meaning of Oral and Public History.* Albany: State University of New York Press.

hooks, b. 1991. "Narratives of Struggle." In *Critical Fictions: The Politics of Imaginative Writing,* ed. P. Mariani, 53–61. Seattle, WA: Bay Press.

Hutchison, M. 1999. "I Am the Amazon who Dances on the Backs of Turtles: The Poetics and Politics of Writing Self and Community." PhD thesis, University of New England.

Hutchison, M. 2009. "Dimensions for a Folding Exhibition: Exhibiting Diversity in Theory and Practice in the *Migration Memories* Exhibitions." *Humanities Research* 15 (2): 67–92.

Hutchison, M. and L. Collins. 2009. "Translations: Experiments in Dialogic Representation of Cultural Diversity in Three Museum Sound Installations." *Museum and Society* 7 (2): 92–109.

International Council of Museums. 1997. "Museums and Cultural Diversity: Policy Statement." Available at: http://icom.museum/diversity.html. Accessed January 26, 2010.

Leinhardt, G. and K. Knutson. 2004. *Listening in on Museum Conversations.* Walnut Creek, CA: AltaMira Press.

McShane, I. 2001. "Challenging or Conventional?: Migration History in Australian Museums." In *National Museums: Negotiating Histories Conference Proceedings,* eds. D. McIntyre and K. Wehner. Canberra: National Museum of Australia.

Peers, L. and A. Brown, eds. 2003. *Museums and Source Communities.* London and New York: Routledge.

Probyn, E. 1996. *Outside Belongings.* New York and London: Routledge.

Stuart, M. 1993. "'And How Was It for You Mary?' Self, Identity and Meaning for Oral Historians." *Oral History* 21 (2): 80–83.

Vice, S. 1997. *Introducing Bakhtin.* Manchester: Manchester University Press.

Watson, S. 2007. "Museums and Their Communities." In *Museums and Their Communities,* ed. S. Watson, 1–23. London and New York: Routledge.

Witcomb, A. 2009. "Migration, Social Cohesion and Cultural Diversity: Can Museums Move beyond Pluralism?" *Humanities Research* 15 (2): 49–68.

–10–

One Voice to Many Voices?
Displaying Polyvocality in an Art Gallery

Rhiannon Mason, Christopher Whitehead,
and Helen Graham

Voice has emerged as a crucial issue in the design of exhibitions. . . . How can museums make space for the voices of indigenous experts, members of communities represented in exhibitions and artists? . . . How can the widely varying voices of museum visitors be heard by exhibition makers and reflected in their designs? Can an exhibition contain more than one voice, or can a voice exhibit more than one message? (Lavine 1991: 151)

Since the 1990s, there has been increasing discussion about community involvement and participation in museums and, to a lesser extent, art galleries, giving rise to terms such as *consultation, outreach, inclusion, engagement, inreach, co-curation,* and *co-production* (Black 2010; Crooke 2010; Fouseki 2010; Karp and Lavine 1991; Lang, Reeve, and Woollard 2006; Lynch 2011; Lynch and Alberti 2010; Sandell 2002; Watson 2007). Each of these terms has different connotations and politics in terms of how much control is retained, ceded, or shared by institutions and individuals. This reframing of the relationships between museums, galleries, and their publics has raised many issues. It calls into question the traditional roles of curators and—from one perspective—the museum's ability and responsibility to maintain quality, expertise, and professional standards. Viewed from the other side, this reframing problematizes what counts as quality and accepted standards of museum practice and whose purposes they serve. It raises questions about different types of knowledge and how they come to be valued and validated within the public museum or gallery. This gives new impetus to the long-standing question within new museology of how to deal with conflicting perspectives, competing agendas, issues of control, and who has the authority to speak on behalf of others.

At the same time, the principle of greater public involvement and ownership of what happens in museums and galleries has been criticized as sometimes falling into the trap of tokenism when translated into actual practice (Fouseki 2010; Lynch 2011) and producing oversimplified, reified notions of representativeness, identity, public, and community. More trenchant critiques suggest that certain tenets of new museology have been premised on either an overly optimistic and unrealizable view of the museum as a place inflected with inequalities yet also capable of being "redeemed" (Dibley 2005), or an

overly negative and simplified reading of museum history and practice prior to the advent of new museology (McCarthy 2007).

One way of thinking about community engagement and participation concerns the idea of voice. As we have discussed elsewhere, new museology has problematized the impersonal, authorial, and institutional voice of the museum and gallery and highlighted how voice and authorship are intimately connected to knowledge and authority (Mason, Whitehead, and Graham 2011). Writers have questioned whether the museum's voice might be more clearly authored and if and how the mode of address might be changed from monologic to dialogic and from a monovocal to a polyvocal mode of address (Bennett 1995; Black 2010; Butler 2000; Hutchison and Collins 2009; Lavine 1991; Lynch and Alberti 2010; Vogel 1991). In this scenario, museums are encouraged to give up some of their control and their authorial voice to allow the public or specific communities to speak for themselves and be heard in a public space. This corresponds with the broader shift in understanding of the museum less as temple and more as forum (Cameron 1971).

Viewed in this light, the museum is sometimes recast as a space capable of engendering and facilitating public debate and conversation or even a new public formation (Black 2010; Simon and Ashley 2010). The intention is laudable and can often be politically and ethically important for communities seeking to win specific battles. However, those who study postcolonialism, feminism, and ethnicity have long cautioned that the concept of voice, the notion of speaking for oneself and the possibility of being heard by others, is complicated and bound up with power inequalities and historical legacies (Spivak 1988). Similarly, those who write about communities and "the public" caution us against assuming their homogeneity and essentializing them (Crooke 2010). Lynch and Alberti also warn against the museum or gallery's institutional predisposition to avoid conflict. Instead, they promote the idea of "discensus" to draw visitors into "further dialogue" (2010: 16). A clear example of the incorporation of ideas of polyvocality and cross-cultural dialogue can be seen in the British Library's online interactive about sacred texts, which explicitly invites the user to explore contrasting points of view, such as those of the atheist philosopher versus the faith leader.[1]

This chapter contributes to these debates by exploring a real-life example of how we, as researchers, set out to work through these issues in practice and by examining some of the challenges and successes we encountered along the way. Specifically, we discuss how we used participatory methods, digital media, and the concept of place with members of the public to coproduce audiovisual exhibits for inclusion in a new permanent art display. We will explain how we worked with the idea of place as a means of creating room for new voices without assuming that the basis of authority to speak was anchored in predetermined categories of identity.

This chapter pursues the concepts of voice and polyvocality specifically within the context of the museum-as-institution and within the museum display design process. We argue that discussions about coproduction within museums and galleries need to pay particular attention to the negotiations that take place when different kinds of knowledge and expertise come into relation with each other. We also argue that it is important to reflect upon

the opportunities for coproduction and participation made possible (or not) by particular genres and forms of media. Moreover, our experience of the design process suggests that more attention needs to be given to the way assumptions and practices inherent in museum and gallery design frame the possibilities for voice and polyvocality. This may foreclose the possibility for visitors to hear multiple voices even if they are physically present.

Rather than the issue of coproduction being understood as a transfer (or a resisting of that transfer) of power between two distinct and discrete players—museum and community—we conclude that there are a complex series of negotiations and adjustments, which are not always predictable or static. These depend on a much greater number of factors including design, media, and the exhibition-making process than may be commonly acknowledged. In the same way that writers have pointed to the need to avoid oversimplifying and homogenizing the idea of community, we argue that equally the museum or gallery needs to be understood in all its complexities and as situated in its own institutional set of relationships with all the attendant constraints and opportunities this brings.

About the Project: Theory and Aspirations

Our project ran from November 2008 to November 2010 and was a collaboration between the International Centre for Cultural and Heritage Studies, Newcastle University and the Laing Art Gallery.[2] The Laing Art Gallery is the main city art gallery in Newcastle and part of Tyne and Wear Archives and Museums (TWAM). Founded in 1901, it has a traditional collection dominated by oil paintings and watercolors as well as decorative arts, engravings, and books. The project was concentrated on the ground floor gallery and involved collaborating with curatorial, learning, outreach staff, and senior managers from TWAM as well as external design consultants, audiovisual software designers, and a hardware company. Previously, the area housed a display called Art on Tyneside, which was redeveloped into a new display titled Northern Spirit: 300 Years of Art in the North-East that opened on October 22, 2010. As researchers, we were funded by the Arts and Humanities Research Council (AHRC). The overall project also involved funding from other sources within the UK museum sector; the Heritage Lottery Fund (HLF) and the Woolfson Foundation, which provides funds for improvement to the quality of displays and public spaces. The overall budget was £1.1 million.

We became involved as researchers in order to explore the relationships between art, identity, and place and to develop research-informed content coproduced with members of the public in various media, both for display and research purposes. Accordingly, this content, and insights derived from the research, have been integrated within the new display at the Laing Art Gallery. Our contribution focused on one component of the overall redisplay; that of the audiovisual materials. The overall design, interpretation, and organization of the larger display of paintings and decorative arts was managed by the curatorial and learning staff in conjunction with the external design team. Although there were different areas of responsibility, as researchers, we liaised closely throughout the exhibition design process by sharing joint planning meetings and contributing ideas

to the overall project where appropriate. Similarly, the curatorial team gave feedback on the development of the audiovisual exhibits.

The following research questions were developed through discussion with the curatorial team and senior managers:

1. How is the relationship between people's identities and sense of place performed, produced, and negotiated through, or in response to, art (with specific reference to the Laing's collection)?
2. How is sense of place represented and constructed in a display like Art on Tyneside and what role can audience perspectives play within this process?
3. How can the polyvocality of audience perspectives be represented in a coherent and engaging display?
4. Can the use of digital technology within the redeveloped display fulfill the Laing's objective to work toward the "democratisation of curation"?

As these questions show, our project was influenced by many of the new museological concerns discussed previously. We approached the project attentive to issues of power but also optimistically with a view to seeing if different perspectives could be brought into some kind of dialogue with each other and with the collection. At the same time we also acknowledged what was different about the context for our project. The literature on issues of voice and representation in museums is understandably dominated by discussions of colonial contexts and colonial museum histories. By contrast, the Laing Art Gallery is a regional art gallery, and many of the local participants with whom we were working had a strong sense of positive identification with the region and ownership over the gallery's collection. There were, of course, still some tensions arising from power asymmetries, but these were along lines of age, professional background, socioeconomics, educational background, length of residency in the region, and art historical knowledge rather than primarily ethnicity. They were not because of concerns over historical provenance of collections.

With the ideas of polyvocality in mind, we designed the project to place different voices alongside each other in the audiovisual elements of the display. Ideally, we aimed to create a dialogue between different perspectives by connecting them through their shared engagement with both a) the collection and b) the idea of place and its visual representations. We hoped that the audiovisual components of the overall display would offer an opportunity to juxtapose and make visible different types of knowledge usually held apart intellectually and physically in museums and galleries. We aimed to test if the audiovisual aspect of the display could question conventional boundaries between categories like art/geography/social history; amateur/expert; scholarly/vernacular; and public/personal.

At the same time, we aspired to contribute to a display that people would want to visit and that could speak to multiple audiences. We wanted the audiovisual aspect of the display to offer something to the first-time visitor, the repeat visitor, the local, the tourist, the art expert, the art novice, adults, young people, lone visitors, and groups. We hoped to

do this through building multiple perspectives into the actual audiovisual materials. The use of digital media technology was intended to enable visitors to actively select different interpretive routes throughout the display according to their preferences, expertise, experience, and motivations.

Much of the discussion around participation in museums focuses on museums' engagement with communities. However, it is essential to recognize, as Nina Simon points out, that: "Participatory projects aren't just about empowering visitors. Every participatory project has three core stakeholders: the institution, participants, and the audience" (Simon 2009). Simon identifies how a participatory approach fundamentally changes the nature of exhibition production:

> The chief difference between traditional and participatory design techniques is the way that information flows between institutions and users. In traditional exhibits and programs, the institution provides content for visitors to consume. Designers focus on making the content consistent and high quality, so that every visitor, regardless of her background or interests, receives a reliably good experience.
>
> In contrast, in participatory projects, the institution supports multi-directional content experiences. The institution serves as a "platform" that connects different users who act as content creators, distributors, consumers, critics, and collaborators. This means the institution cannot guarantee the consistency of visitor experiences. Instead, the institution provides opportunities for diverse visitor co-produced experiences. (Simon 2009)

Our approach to producing what Simon calls "diverse co-produced experiences" combined participatory research methods and standard UK practices in community engagement as pioneered by Glasgow's Open Museum. By the end of the process we had worked with sixty-seven participants (both individual members of the public and preexisting groups) and brought them to the gallery to hear about the plans for the new gallery from curators, to visit the picture stores, and to work with a creative facilitator to make something for inclusion in the new display. The choices of what people could make included: 1) photographs, 2) a digital story, 3) a short film, and 4) a sound piece.

All of the resulting exhibits feature in the gallery. These are now accessible via touch screens, sound cones, a digital projection, a sound bench, and an interactive touch table. The six stand-alone touch screens are located throughout three of the four rooms of the ground floor gallery. In the final design the other media—the projection, sound bench, and touch table—came to be located together in a fourth and final space at the end or beginning of the display, depending on how visitors enter the gallery (i.e., from the shop or the café). In each of the different platforms, we designed the conceptual architecture of the digital media to make different knowledges resonate against one another, to disrupt conventional boundaries between types of material culture, and to problematize the traditional hierarchies that underpin assumptions about different kinds of visual culture and representations of place.

To put it another way, we aimed to recontextualize what is traditionally classed as art history within a broader concept of visual culture. For example, the cityscape paintings in

the display have a secure place in art historical discourse and in the canon. Placing them alongside and in relation with people's alternative visions of the city upturns the convention whereby curators traditionally construct, consecrate, and reproduce art historical knowledge for visitor consumption. It complicates the account of the region the display provides. Alongside representations of place in paintings, or artistic products made in place, are visual, film, and audio representations of contemporary people's situated experience of living in place.

This approach was intended to bring into play new mnemonic, affective, sensory, intellectual, and personal dimensions and to spotlight other places not shown in the fine art collection. Equally, we hoped to show how the same places have been perceived differently by people. We also hoped this would challenge the conventional and often unquestioned separation of art from life, lived experience, and broader forms of visual culture. Our objective was to find a new way to think about relationships between visual art, the city and region in which the art was made and collected, and its inhabitants.

At this point it is useful to explain why we as researchers chose place as a framing device for the audiovisual exhibits. On one level, it was in keeping with the curatorial strategy for displaying and interpreting their collection of art from the northeast region. Another reason was that we predicted the concept of place would engage a range of visitors, especially those without a prior art background. If people did not have art history-based cultural capital, they could still draw on their knowledge of the northeast. If they did have art historical knowledge, they could do either or both. If they were not familiar with the northeast, they could relate it to places they knew. In other words we used place as a common frame of reference to provide different points of entry into the display for a range of visitors as we have discussed elsewhere (Mason, Whitehead, and Graham 2011).

Practice and Constraints

Having outlined the principles underpinning our project, we now turn to the discussion of what happened in practice and the implications of this for museological debates in this area. We highlight five areas in particular: (1) the initial project design, (2) the process by which we engaged participants, (3) producing the audiovisual exhibits, (4) valuing knowledge and expertise, and (5) design and display.

The Initial Project Design

As indicated, certain aspects of the project were predefined from the outset. These included the preliminary design options, which had been sketched out by the curators at the planning stage as part of their application to the Heritage Lottery Fund (HLF). In order to judge whether to fund a project or not, the HLF requires an extensive application detailing intended audiences, target groups, visitor numbers, identification of stakeholders, a preliminary display proposal, a rationale for the exhibition, and letters of support for the

proposal. As researchers applying to the AHRC, we carried out a similar process, outlining our rationale and quantifying in detail the various project outputs and costs. We also identified what AHRC terms "the beneficiaries"—academic, practitioner, and public—and mapped our plans against the specific criteria for that particular funding scheme.

The initial project design was based on issues of cost, floor and wall space, physical restrictions relating to environmental controls for the collection, accessibility considerations (physical and intellectual), lighting, heating, and air conditioning. Other practicalities concerned access to electrical power sources (especially important for our audiovisual equipment), building regulations, safety issues such as fire exits, and listed building consent. The design had to take into account how to highlight historic architectural features, and any specific requirements of the collection—for example, where watercolors requiring a lux level of 50–100 could be suitably sited or where to fit a case large enough to contain all of the silverware together.

Overlaid onto these practicalities were the display and interpretation issues. How best could the collection be organized to foreground themes in a form visitors could appreciate? How to organize the display so visitors could start at either end—café or shop? What kind of ambience to aim for? Which sight lines would create the best opportunity to view large paintings or how best to encourage visitors to inspect the intricate detail of the woodcuts? Which levels and kinds of interpretation to aim for? How to create spaces for social interaction between visitors, especially families and children? How to create room for groups of schoolchildren to use the gallery at the same time? How best to encourage visitors to linger in the space and offer other sensory engagement, for example, through touch?

As researchers, curators, learning staff, and designers, we all brought our own understandings of visitor behavior in galleries and how we hoped people would use the gallery and audiovisual materials. In addition, the curators had a clear sense of how this ground floor display fitted within the overall venue, how it would work with the strengths and weaknesses of the collection they had inherited, and how this would compare with other contemporary regional and national art gallery displays. As in every museum and gallery a plethora of institutional, sectoral, and material factors were in play before the conceptualization of a permanent display began. As always, these factors framed both the museum's voice and any possibilities for expanding it.

The Process of Engaging Participants

Our key objective was to understand more about people's sense of place. We wanted to know how it might shape and be shaped both by visual representations of places and people's experiences of living in those places. We elected not to start by predefining people's identities nor by privileging one particular aspect of someone's identity above all others. Instead, we were interested in tracing the ways and moments in which people make identifications with places and visual representations and what this might tell us about how they perform their own identities on a number of fronts. In this aspect we were

inspired by the ideas of mobilities and flows as developed with the cultural geography literature, particularly in relation to ideas of urbanism (Urry 2006).

At the same time, we recognized that places are always closely bound up with identities because of their histories, housing stock, and socioeconomic profile (Massey 1991). With this in mind, we chose a range of areas with different socioeconomic characteristics in the northeast. The locations were also cross-referenced with a mapping exercise we carried out on the paintings and decorative objects selected for display by the curatorial team. Here we identified place-based associations represented in the art or decorative arts. This approach revealed what was on or off the visual map in terms of the art that would appear in the display.

It is important at this point to say that our rationale was not to provide a corrective to the weighting of representations that have arisen through collecting and artistic practices. In our view, it is an illusion to imagine that it is possible to fully represent all of society in any museum display. Displays are always selective and partial and art collections are not assembled with any intention to be representative of a place or population. However, we did seek to provide points of identification through the coproduced material where visitors could see how these same places resonate differently for different people. In this sense we hoped that the audiovisual exhibits might bridge the traditional disciplinary distinction between taking a social history or an art history approach to understanding and presenting visual culture in a regional context.

The mapping exercise revealed that the collection featured certain areas heavily such as: the coast (Tynemouth and Cullercoats), the river, the quayside, and the city centre markets, and featured certain trades more than others—like coal mining and seafaring. The industrial suburbs that grew up outside the city from the late nineteenth century tend not to be represented in the fine art collections, perhaps because they do not conform to more picturesque tastes of patrons, although products from local factories, such as Maling Pottery, are featured in the display.

These industrialized areas do feature heavily within the visual iconography of the northeast and elsewhere in the Tyne and Wear Archives and Museums, but through the media of film and photography—neither of which feature greatly in the Laing's collection because traditionally it has focused on paintings and decorative arts. By contrast, the film and photographic representations of the northeast tend to focus on its twentieth-century deindustrialization. In this sense, the history of collecting practices within an Edwardian art gallery like the Laing, where most of the collection was acquired in the first half of the twentieth century, produces a particular kind of visual lexicon that sets parameters for what it is possible to represent today. It is important to be attentive to the implications and politics of this inherent selectiveness.

Having identified four areas, we looked for highly visible public spaces through which people tend to flow and mingle—for example markets, train stations, and community centers. We set up stalls with reproductions of a selection of paintings from the planned display and talked to people who were attracted to the pictures about the project, the artworks, and their memories and experiences of living in that place. Our initial round of stalls generated considerable interest, but also some significant omissions in terms of

age, disability, and ethnicity, and did not tend to attract people newer to the region. People tended to be older (50+), and were often attracted to the paintings precisely because of their familiarity with the locale and their family history in the region. This revealed distinct asymmetries in terms of which demographics were using which public spaces in the city or felt sufficiently inclined to approach us.

We therefore used more targeted approaches to reflect the diversity of the northeast and worked with some preconstituted groups. These included refugees and asylum seekers, family groups, young people through a youth project, blind and partially sighted older adults, adults with learning difficulties, and women involved in First Step, which describes itself as a multiracial project. We also identified two other target groups defined by a common specialist interest—the friends of the Laing group (FLAG) and members from the art community in the northeast. Finally, we expanded our range of potential contributors by running a Flickr photography competition alongside the exhibition development. A selection of Flickr images would be incorporated within the interactive map and digital wall projection alongside photographs taken by our participants, professional photographers, artists, and unknown photographers whose images have tended to be directed not into art galleries but into local picture and library archives.

Through this and subsequent discussions with the participants over many months we identified particular stories, memories, or associations that seemed particularly resonant with the broad topic—"How does the northeast look to you?" We introduced the people who had agreed to participate in the project to the art gallery, the curators, the existing display, the art collections, the stores, and the plans for the new display. Subsequently, we introduced creative professionals into the mix and they, implicitly and explicitly, introduced some of the generic conventions of each medium along with aspects of their own professional practice.

We estimate we spoke to around 200 people via this method, and by the end of the project we had worked with 67 participants to coproduce the final audiovisual exhibits. Using place instead of other traditional demographically based identity categories enabled us to avoid reproducing an image of society seen through the lens of cultural policy drivers, although it was not without its challenges. By starting the process outside of the gallery in other less culturally weighted public spaces—such as markets—we managed to draw people in who told us they never visit art galleries. The result is that the final group of participants encompassed a real range in terms of people's familiarity with art, educational background, and familiarity with the art gallery and its collection.

However, in practice this diversity proved challenging when we finally brought these same people together in the space of the art gallery. When we required different people to occupy the same space it became apparent that distinctions and anxieties around conventional markers of identities—namely class, education, cultural capital, disability, and accent came into play. We also observed a palpable "threshold anxiety" from infrequent or new visitors to the art gallery. Fortunately, as we had hoped, the effect of meeting people in advance of the first visit to the gallery, the common referent of place, and a shared interest of the region's visual history seemed to bridge the gaps and form new bases for discussion over the course of several months of workshops and activities.

Producing the Audiovisual Materials

As indicated earlier, participants could choose one of four ways of coproducing their audiovisual exhibits for inclusion in the new gallery. From a production point of view, photography, digital storytelling, film, and sound appear comparable, but it quickly became apparent that they create subtle but different participatory dynamics, for example in terms of whether they require more or less interaction, technical skill, and personal or collective investment. The filmmaking strand, for example, developed as a collaborative effort requiring negotiation between the group members who were in this case teenagers aged thirteen to fourteen, us as researchers, and the filmmaker. It also required an investment of interest and commitment to be sustained over time from one session to the next. The sound strands, by contrast, provided more scope for individual activity and autonomy. We observed that photography, in particular, provided a much more immediate type of involvement in short, discrete, and self-contained bursts.

Unlike photography, both sound and film are time-based media that conventionally employ a narrative structure. Contributions using these media necessitated greater emphasis on selection, emplotment, and editing. Narrative structure for time-based media was also circumscribed to an extent because in order to work from a visitor's perspective we decided that these exhibits would, in most cases, be limited to a maximum length of three minutes.

Many of these issues relate to technical considerations and how they resulted in dynamics of social interaction. However, genre was also significant. We observed that participants, creative professionals, and curators all brought their own understanding of the generic conventions of different media; for example, what makes a good photograph or a strong narrative hook in an audio piece. In one workshop, participants' different beliefs about what constituted good photography, its purpose, and what kind of photograph was appropriate for display in an art gallery produced strong disagreement and a lively debate.

As the process unfolded, it became apparent that some of the exhibits produced were hybrid in nature and not easily classifiable in terms of authorship. This was particularly clear with the audio exhibits, which involved a sound engineer, a local sound archive, a producer, and a recording studio. The process resulted in sound pieces that were neither entirely participant created nor fully commissioned. To increase dwell time in the gallery and where sound pieces required visualization for explanation, we also took the decision to supplement some of the sound with photography.

We decided jointly with the gallery team to provide subtitling to make the all the audiovisual exhibits accessible to visitors who are deaf or hearing impaired and to commission an introductory BSL welcome to the gallery page for the touch screens. Where relevant, participants were consulted about whether they wished their subtitles to be presented with local dialect spelling or a standardized spelling. Participants were involved in the process of writing the equivalent of a label for their audiovisual contribution and everyone who chose to was identified by name; everyone did bar one person.

As this creative process with participants unfolded over the course of a year and alongside the curatorial team, we developed our plans for the best medium with which to present the audiovisual exhibits. We decided on touch screens, projections, sound cones, and an interactive map. Each decision over a delivery method further refined the parameters for the audiovisual exhibits and fed back into the processes of their production. Discussions with the audiovisual designers and gallery staff determined some of the limits of what we were able to imagine as well as inspiring us to new possibilities. In this way, the relationship between participatory approaches and display production worked in an iterative way.

Valuing Knowledge and Expertise

During our project, it became clear that the way a museum or gallery might foster participant involvement depends on the kind of knowledges the museum or gallery wishes to present. Asking someone to share and present knowledge about their own lived experiences in a social history display is different from asking them to participate in a display that features specialist knowledge like art. It is different because of sociohistorical conditions: social history practice—like oral history—confers expertise on people by recognizing and valorizing their involvement in, or experience of, historical contexts or events. By contrast, familiarity with art history discourse is still seen by many as a form of cultural capital only to be accessed through one's elite social position and/or educational privilege. For the former (social history) participants are seen to be the expert on the subject of their own lives and, accordingly, this gives them a sense of authority over their story. In the latter (art history), our experience suggested participants were far less likely to be viewed or themselves feel authorized or empowered by the invitation to participate.

The important point here is that coproduction does not have to be read as an either-or equation. Far from meaning handing over responsibility for the production of displays as might be imagined in more skeptical approaches, "co" precisely signals the interaction between different individuals and their knowledges and skills. Curatorial expertise is not made redundant by the introduction of new types of knowledge. We found that participants expected gallery staff and the researchers to facilitate their contribution by lending their gallery-based expertise to the process, resulting in what Simon refers to as "scaffolding participation" (2009). At the same time, we also found that participants drew on a whole range of personal and professional expertise, which contradicts the simple dichotomy of participant-amateur and museum professional-expert. For example, a number of the participants drew on their own professional expertise around housing, architecture, engineering, and seafaring in their involvement in the project. In this respect, our experience chimes with Michael Frisch's comments about the value of recognizing and bringing together different kinds of expertise:

> [S]cholars and designers need better to respect, understand, invoke, and involve the very real authority their audiences bring to a museum exhibit. . . . Although grounded in culture and

experience rather than academic expertise, this authority can become central to an exhibit's capacity to provide a meaningful engagement with history—to what should be not only a distribution of knowledge from those who have it to those who do not, but a more profound sharing of knowledges, an implicit and sometimes explicit dialogue from very different vantages about the shape, meaning, and implications of history. (1990: xxii)

Design and Display

Underlying the design process were complex sets of assumptions about the value of different media, materials, experiences, and knowledges within gallery displays. For example, should materials produced by participants count as exhibits in their own right or be presented as a form of interpretation? If classified as interpretation how would this new material sit alongside the museum or gallery's own interpretation and how would visitors differentiate between the different voices, if at all? Would the final display imply an unspoken hierarchy either in terms of the way the audiovisual exhibits were presented or the spatial arrangement, which therefore might do little to alter the museum's institutional voice and authority?

In principle, our goal was not to produce a commentary on the gallery and its contents, nor to generate ancillary interpretation. Neither did we want to employ a stimulus-response model—in other words to cast participants' contributions only in response to the collection as is often the way with community contributions. Instead, we aimed to facilitate the creation of new audiovisual exhibits that would be integrated within the display and brought into relation with the collection. The aim was that these new media exhibits would set up a conceptual relay for visitors between the city, visual representations of it, and its inhabitants, both past and present.

We designed the architecture for the touch screens mindful of how implicit hierarchies of knowledge confer or deny status. For example, we made it possible for visitors to navigate from objects in the collection to contributions from the public (photographs, films, or stories), which would be the conventional stimulus-response way. At the same time, we constructed paths leading in the other direction from publicly produced digital materials to the collection and sometimes from one audiovisual exhibit to another. We did this to avoid centering the art and rendering the other material as secondary interpretation; instead we aimed to treat it as an object on a par with the collection. However, this intellectual principle was not easy to maintain in practice. The wider exhibition process tended to gravitate toward an audiovisual design organized around the collection and conventional categories of material culture (e.g. decorative arts and paintings) because it was expected by the audiovisual designers that this would be the easiest way to orientate visitors and help them to navigate their way through the levels of audiovisual materials.

The sense of the object being the primary reference point for visitors partly came about because of the issue of physical space. Ultimately, the audiovisual materials are layered upon each other and packed into slimline pedestal touch screens so they take up a fraction of the physical space of the tangible materials. In one sense this means it feels like they command less representational space. In the final outcome, the six stand-alone

touch screens are located throughout three rooms of the gallery. For various reasons, primarily to do with electrical power sources and environmental controls, all of the other media—the projection, sound bench, and touch table—came to be located together in a fourth and final space at the end or beginning of the display depending on how visitors enter the gallery (i.e., from the shop or the café). For environmental control, this space is separated from the other three galleries by a sliding glass door.

This does give rise to a sense of separateness and this is an obvious potential criticism of the end result of the project. Visitors may be visually cued to read the audiovisual materials on the café side of the glass as not really in the gallery despite the fact that there is also a large painting and a case of important ceramics in this space. However, preliminary visitor observations reveal that a high proportion of visitors spend a long time in this area sitting on and using the story bench while watching the slideshow projection. Contrary to our assumption that visitors would spend a few seconds in front of the projection, people are stopping to watch the whole slideshow of sixty images and actively using it as a means of reminiscing with other visitors. Moreover, when the slideshow has not been playing some visitors have commented on the absence of contemporary images in the main areas, indicating that the projection is seen, by some at least, as contributing this perspective to the overall display. Therefore although the spatial organization of some of the audiovisual materials might lead one to judge it to have less representational weight than the main collection, the visitors' responses tell a different story.

All of this illustrates the complexities involved in producing and making visible the contributions and voices of different constituents in the gallery and assessing visitors' responses to them. It raises important issues about how the techniques and practicalities of display and design processes interact with objects, both tangible and digital, and physical space. It begins to question what exactly we mean when we speak about introducing new voices into the gallery space and the challenges of realizing it.

Conclusions

Looking back over the process, our aspiration to turn the theory of polyvocality into practice involved creating a conceptual space within the processes of building a new display for people's own ideas, responses, and priorities to emerge. This meant that it was not possible or desirable to determine all aspects of what would happen in advance. Whereas a traditional design process starts out by specifying which themes will relate to which objects, we worked by creating and holding open conceptual spaces to be filled as the project progressed. We also used these emerging ideas to help shape our part in the design process.

Digital media—if used in a flexible way—offers the possibility to do this; for example, we can plan to use a projector without knowing what all the images will be at the outset. If galleries are keen to move toward more participatory and responsive displays, they will have to find ways of incorporating more uncertainty in the design process. Digital media does offer a practical way to convey polyvocality. It can provide flexibility, choice, and a degree of openness within the display. On the other hand, digital media in museum and

gallery displays is not attractive to every visitor or participant. Crucially, it brings institutional requirements in terms of set-up cost, staffing, and maintenance. More important, if it is the only way in which the participants' voices are heard, then the coproduced element may well become invisible if it breaks down or if visitors choose not to engage with it because they perceive it as lower status than more traditional materials. In other words, its flexibility could also lead to its marginalization. Ideally, coproduced material would be integrated across a whole range of exhibition media to guard against such a possibility.

We did introduce new voices into the display through the use of audiovisual materials, and in many cases the perspectives they articulated were different from and in contrast with each other. Taken together they do provide a more multifaceted view on "how the northeast looks to people who live and work in the region" and reveal some real disparities and diversity of experience and opinion. Whether we succeeded in putting these voices into dialogue rather than simply alongside each other is a more difficult question to answer. As Simon and Ashley note: "Stories and storytelling does not turn into the 'in-between' of public connectedness just by being on display" (Bauman 1999 cited in Simon and Ashley 2010: 248). The extent to which those new voices—and the potential dialogues between them, the city, region, and the collection—are fully audible to the visiting public is something that cannot be tested without talking to visitors and exploring their responses. This is our next task.

Notes

We acknowledge the support of the Arts and Humanities Research Council (AHRC), our partners Tyne and Wear Archives and Museums and the Laing Art Gallery, and all of the participants and creative practitioners. This project would not be possible without them.

1. http://www.bl.uk/learning/cult/sacred/understanding/
2. Aspects of the project have previously been published in Mason, Whitehead, and Graham (2011).

References

Bennett, T. 1995. *The Birth of the Museum.* London and New York: Routledge.

Black, G. 2010. *The Engaging Museum.* London: Routledge

Butler, S.R. 2000. "The Politics of Exhibiting Culture: Legacies and Possibilities." *Museum Anthropology* 23 (3): 74–92

Cameron, D. 1971. "The Museum, a Temple or the Forum." *Curator: The Museum Journal* 14 (1): 11–24.

Crooke, E. 2010. "The Politics of Community Heritage: Motivations, Authority and Control." *International Journal of Heritage Studies* 16 (1): 16–29.

Dibley, B. 2005. "The Museum's Redemption: Contact Zones, Government and the Limits of Reform." *International Journal of Cultural Studies* 8 (1): 5–27.

Fouseki, K. 2010. "Community Voices, Curatorial Choices: Community Consultation for the *1807* Exhibitions." *Museum and Society* 8 (3): 180–192.

Frisch. M. 1990. *A Shared Authority: Essays on the Craft and Meaning of Oral and Public History.* Albany: State University of New York Press.

Hutchison, M. and L. Collins. 2009. "Translations: Experiments in Dialogic Representation of Cultural Diversity in Three Museum Sound Installations." *Museum and Society* 7 (2): 92–109. Available at: http://www2.le.ac.uk/departments/museumstudies/museumsociety/documents/volumes/hutchisoncollins.pdf. Accessed October 14, 2012.

Karp, I. and S. Lavine. 1991. *Exhibiting Cultures The Poetics and Politics of Museum Display.* Washington DC: The Smithsonian Institution.

Lang, C., J. Reeve, and V. Woollard. 2006. *The Responsive Museum: Working with Audiences in the Twenty-First Century.* Aldershot: Ashgate.

Lavine, S. 1991. "Museum Practices." In *Exhibiting Cultures: The Poetics and Politics of Museum Display,* eds. I. Karp, and S. D. Lavine, 151–158. Washington, DC: Smithsonian Institution Press.

Lynch, B. 2011. *Whose Cake Is It Anyway?: A Collaborative Investigation Into Engagement and Participation in 12 Museums and Galleries in the UK.* Summary Report. London: Paul Hamlyn Foundation.

Lynch, B. and S. Alberti. 2010. "Legacies of Prejudice: History, Race and Co-production in the Museum." *Museum Management and Curatorship* 25: 13–35.

Massey, D. 1991. "A Global Sense of Place." *Marxism Today* (June): 24–29.

Mason, R., C. Whitehead, and H. Graham. 2011. "The Place of Art in the Public Art Gallery: A Visual Sense of Place." In *Making Sense of Place,* eds. P. Davis, G Corsane, and I. Convery. Woodbridge: Boydell & Brewer.

McCarthy, C. 2007. "Before 'Te Maori': A Revolution Deconstructed." In *Museums Revolutions: How Museums Change and Are Changed,* eds. S. Knell, S. MacLeod, and S. Watson, 117–133. London and New York: Routledge.

Sandell, R., ed. 2002. *Museums, Society, Inequality.* London and New York: Routledge.

Simon, N. 2009. *The Participatory Museum.* Available at: www.participatorymuseum.org/chapter1/. Accessed March 15, 2010.

Simon, R. and S. Ashley. 2010. "Heritage and Practices of Public Formation." *International Journal of Heritage Studies* 16 (4): 247–254.

Spivak, G. 1988. "Can the Subaltern Speak?" In *Marxism and the Interpretation of Culture,* eds. C. Nelson and L. Grossberg, 271–316. Basingstoke: Macmillan Education.

Urry, J. 2006. *Mobilities, Geographies, Networks.* Aldershot: Ashgate.

Vogel, S. 1991. "Always True to the Object, in Our Fashion." In *Exhibiting Cultures: The Poetics and Politics of Museum Display,* eds. I. Karp and S. D. Lavine, 191–204. Washington, DC: Smithsonian Institution Press.

Watson, S., ed. 2007. *Museums and Their Communities.* London and New York: Routledge.

Whitehead, C. 2009. "Locating Art: The Display and Construction of Place Identity in Art Galleries." In *Heritage and Identity: Engagement and Demission in the Contemporary World,* eds. E. Peralta and M. Anico, 29–46. Abingdon: Routledge.

–11–

A Question of Trust
Addressing Historical Injustices
with Romani People

Åshild Andrea Brekke

This chapter is narrated from my point of view as an employee of the Norwegian state, and my objective is to show the importance of competent flexibility in the implementation of political decisions, especially concerning groups marginalized in society. This chapter then, is not a sociological or anthropological case study and analysis.[1]

The Norwegian Romani have been marginalized to the point of invisibility and/or near extinction, and have only recently received the recognition and space that rightfully belongs to them. Theirs is the story of a people that for centuries was hounded to the degree that the government implemented measures to extinguish its culture.

Most of the research into Romani culture has been conducted by historians who have also documented the history of the systematic repression and assimilation on the part of the Norwegian state. The Romani still have, quite understandably, great difficulty in trusting outsiders such as researchers, and the issue of their identity and ethnicity remains a sensitive topic. Moreover, there is still a widespread lack of knowledge and quite a bit of prejudice in Norwegian society.[2]

The story of the Norwegian Romani is an important one, not least because of the shocking recentness of the Norwegian government's invasive and abusive state policies. Important steps have been taken to rectify past wrongdoings and avoid future ones. The role of adequate political tools, dedicated individuals, and open-minded museums can unquestionably be instrumental in this effort, as this chapter attempts to show. In time, it will hopefully be possible to further strengthen and widen the scope of research and raise the level of public knowledge about this part of Norwegian culture and history. Ignorance creates the risk of committing further injustice.

A little known but particularly grim side of Norwegian history concerns the brutal repression and forced assimilation of the Romani/Tater[3] people of Norway, a Traveller community whose presence in the country has been recorded as far back as the early 1500s. Lobotomy, sterilization, and forced adoptions were just some of the tools used by Norwegian authorities in their endeavor to assimilate this minority during the last century. In 1999, the Romani were finally recognized as a national minority with special rights to protection and the preservation of their culture.

In collaboration with a traditional folk museum, the Norwegian Archive, Library and Museum Authority (ABM-utvikling)[4] started the long and demanding process of establishing and facilitating dialogue and participation with the Romani/Tater. This particular national minority had all but disappeared from the public consciousness due to severe and systematic assimilation measures implemented by the Norwegian state over many years. The Romanis' voice had remained absent in the public and political arenas for a long time. Thus, the main aim of this particular project was to ensure the Romanis' right to safeguard their cultural heritage. More concretely, one important initial objective was to establish a center for documentation and create a permanent exhibition of Romani/ Tater culture in order to communicate a more nuanced history of Norwegian culture and to increase public awareness and understanding of the Romani minority.

The biggest stumbling block in the process was the complete (and historically well-founded) lack of trust from the Tater community. Moreover, the Romani were afraid that the prejudices targeted at them, which still exist in Norwegian society, would harm them should more focus be placed on their group and situation. At the same time, they feared their culture would be completely forgotten.

The main focus of the process has been, and still is, developing and maintaining a relationship of trust with the Romani minority through extensive and long-term contact and active participation in developing the exhibition. This process is still ongoing, and the Glomdal Museum has actively embedded the principles of participation in its long-term mission documents. Several factors are key to the success of this process:

1. Sufficient time and resources to establish and maintain trust between the different stakeholders;
2. Ensuring active participation from the Romani in all phases;
3. Keeping focus on process rather than end results, not knowing where it may end; and
4. Allowing the process to continue.

The result of this painstaking and sometimes painful process is astounding: today, the Romani people have a strong sense of ownership of the Glomdal Museum and pride in the exhibition about their culture that opened in 2006.

The following text is roughly organized around three different periods in the history of the Romani in Norway. The first section describes the historical background of the Norwegian Travellers and their close but mutually uneasy relationship with the sedentary population before and after the Protestant Reformation. It also briefly examines culture and cultural heritage specific to the Norwegian Romani. The second section gives a short outline of how and why their situation rapidly became increasingly precarious as the development of the Norwegian national identity gained momentum in the wake of Norway's secession from Denmark and Sweden, a period that roughly covers 1814–1905. It also outlines the subsequent government policy of forced assimilation of the Romani. These two sections provide the necessary context for the third and main section. This section highlights the growing awareness and recognition from the 1990s onward of the immense injustice suffered by the Romani and how Norwegian museum authorities

started the slow and uncertain process toward ensuring one of Norway's forgotten national minorities their right to their own culture.

A Mythical Origin

The Romani, or Tater, are a branch of the Romani peoples in Norway and Sweden. Their presence in Scandinavia was first recorded in the 1500s. Originally, they presented themselves as pilgrims from Egypt, which is why in many places they were described as "gypsies." Some theories claim the gypsies/Rom people and the Tater/Romani peoples originate from the first group, which arrived in Scandinavia in the 1500s. However, this does not mean that they constitute the same ethnic group today. Over the centuries, the Norwegian Romani have developed their own particular culture and language, adapted to life in Norway.

Their language has Indo-Aryan (Sanskrit) roots, but the Tater community has picked up elements from other cultural areas through years of traveling. Today, the Tater are recognized as one of five national minorities in Norway: the Romani/Tater, the Rom,[5] the Jews, the Kvens, and the Forest Finns.

A primary trait in Romani culture is the Romanis' itinerant way of life. Traveling has been central both to their economic adaptability as well as to their fundamental sense of identity. Today, most Tater have a permanent residence, but in the summer they often take to the open road. Historically, freedom was an important thing for the Romani people,[6] and they usually traveled during spring and summer. Many would travel by horse and buggy, even using sleighs in the winter. Strapped to the back of the buggy would be a coffee chest and a leather bag containing bed linen and clothes. The coffee chest would contain a coffeepot, coffee and sugar, and dried food, as well as cutlery. After 1951, when the Romanis' use of horses was legally prohibited, the horse was replaced by hand-drawn buggies, bicycles, and cars. In the 1920s, it became more usual for the Romani to use tents during the summer season. During the 1960s, camper cars became more widely used. In other parts of the country, Romani families used boats along the coast, mainly making a living from trading, not fishing. In the coastal districts in the west and south of Norway, the Romani would use different kinds of fishing boats (*skøyte*). The boat had multiple functions: mode of transport, workplace, and living quarters. Most of the Tater boats disappeared during the 1950s.

On the road, different Traveller groups would communicate with each other through signs. During the summer, a *patrijal* (sign), a combination of twigs and stones, was often used at crossroads to indicate which path other Romani had taken. In the winter, the Romani would leave marks in the snow to indicate the composition of a particular group of Romani and the direction it had taken. Regardless of the mode of transportation, the Romani were a visible and familiar, if not always welcome, part of the landscape through the various seasons.

Five Centuries of Repression

It is a common joke that people without mailboxes are dangerous—being without a permanent address has always been seen as a threat by the Norwegian majority society,

which until recent generations for the most part consisted of sedentary farmers and fishermen. This sedentary, agrarian society eyed any itinerant groups with skepticism, a skepticism reflected in the history of government policies vis-à-vis the Romani—a history of almost 500 years of repression. One factor that came into play regarding the repression of the Tater people was the Protestant Reformation, which came to Norway during the first half of the 1500s. In its wake, the old Catholic tolerance of pilgrims gradually disappeared and the Romani were told to leave the country. Before long, they were subject to complete banishment. Another factor that affected the Tater people's situation adversely were periods of war, pestilence, poverty, or epidemic (i.e., the recurring outbreaks of bubonic plague), which created social upheaval when many otherwise sedentary people were forced to leave their homes and grounds. The added numbers of beggars and socially deprived individuals thus did nothing to improve the perception of Tater people as a threat to the order of things—quite the opposite.[7]

A Royal License to Kill

The Reformation entailed a stricter perception of the concepts of clean/unclean and normal/deviating, and in 1536, King Christian III issued the first banishment order. Over the years, more laws were passed: in 1589 the king issued a royal license to kill, which meant anybody could kill a Romani without punishment. In 1643, all people traveling were required to have an official passport, another stumbling block for the Romani as the church refused to baptize them. In order to obtain a passport, a person had to be officially baptized.

During this period, the Tater were regarded as unclean mainly for two reasons: they took jobs nobody else wanted, jobs including various tasks of urban renovation (removal of garbage and carcasses, emptying of latrines, etc.). The second reason was that their itinerant form of life kept them out of reach of the government and thus out of reach of the official tax collectors. The government perceived the Romani as a group living on the fringes of society that represented a challenging poverty problem.

Deviation from the majority norms was no longer tolerated, and deviators had to be forced back into "normality," often by expulsion or internment.[8] One might even say that the position of the Romani people became even more precarious as people living on the fringes of society were increasingly perceived as a threat to the established order. The attitude of society at large was that people at the margins were unreliable, unteachable, and had all the wrong social attitudes.[9]

Nevertheless, many examples exist of mutually friendly and fruitful meetings between people. The relationship with the majority was not altogether negative, and there was a clear aspect of mutual benefit. The Romani traded goods in demand by the sedentary population, which led to regular contact between the Romani and the majority. Their specialties included trading in pocket watches, knives, and horses. Moreover, news and gossip from other regions would always be welcome in a country where a relatively sparse population was spread over a large geographical area mostly consisting of mountains.

This serves to illustrate the duality in the Romani-Buro relationship.[10] On one hand, the itinerant lifestyle of the Romani was perceived both as a threat and a secret object of envy for the sedentary majority. The fact that they did not hold steady jobs or own property could make the farmers perceive them as untrustworthy and irresponsible. On the other hand, the Romani brought new cultural impulses, skills, news, products, and trade, all of which were useful to the farmers.

Lifelong Friendships

Some farmers would develop lifelong friendships with the Romani. One old woman recalls how her parents always opened to their home to passing Travellers and that they never had any trouble at all: "they were friends who received help and who gave help in return." She also recalls how the bonds grew particularly strong during the winter of 1935–1936, when one of their Romani friends, a father of eight, caught double-sided pneumonia and almost died. While he was slowly nursed back to health at the farm of her parents, the children played together: "my mother played the piano and we sang and danced in the evening, forgetting the tough times for a little while. From then on we belonged together."

Traces of Lost Heritage

As already mentioned, the Romani people made a living by selling goods and services in great demand among the farming population. Thus there were many and varied occasions when the Romani and the farmers met and interacted, and the Tater were colorful participants in local marketplaces all over the country. Trading was done on a door-to-door basis, as well as at various local and regional marketplaces. The Romani produced and sold various types of handicraft (often produced by crocheting, sewing, knitting, weaving, and embroidery), and many were highly competent horse dealers and gelders, cobblers, metalworkers, watchmakers, knife makers, and musicians. They adapted their craft, skills, and products to the changing market demands over the years. In this way, their economic adaptability fitted well with a traveling lifestyle.

Today one cannot find many tangible material traces of the Tater community, although there are more clues than is apparent to the eye—if one only knows where to look. Different objects and artifacts crafted by the Romani are still around, although they are not necessarily recognized as such by younger generations. Shawls, silver pocket watches, embroidered tablecloths, handcrafted kitchen utensils, pewter candleholders, and knives are just some of the objects that can still be found in older kitchens, attics, and thrift shops. After the law that prohibited the Romani from keeping horses came into effect in 1951, many of the Romani disappeared from the markets, although watches and Romani knives can still be bought in local markets in some areas.

Traces can also be found in the more intangible heritage, especially music, as well as in the names of places where Romani used to camp. The Tater were popular musicians

and extremely competent fiddlers, and they promoted and influenced Norwegian folk music across the country, picking up and disseminating new impulses. It is thought that this is one of the reasons the flat or common fiddle remained a popular instrument, giving the traditional Norwegian Hardanger fiddle serious and lasting competition.

The Romani are a people who lived in a reciprocal, albeit uneasy, relationship with the Norwegian peasant society for hundreds of years. And then they seemingly disappeared almost completely in the space of the last century. What happened?

The Building of the Norwegian National Identity

As we have seen, the Reformation brought about a change in attitude that was not particularly positive toward the Romani and their traveling ways. Moreover, this negative development subsequently coincided with the larger process of the building of the Norwegian nation in the 1800s. Norway had been a part of the Danish kingdom from the 1300s until 1814, when the country established its own parliament and enjoyed a brief period of independence. However, since Denmark had supported the "wrong" side in the Napoleonic wars, it had to hand Norway over to Sweden in a somewhat looser union lasting until 1905. During this period, Norway began a systematic selection of cultural elements that would serve as defining elements of this new national, purely Norwegian, identity. One might, for example, point out that coastal culture fell outside the criteria of cultural purity, as people in these coastal regions were regarded as having too much contact with the world outside. Viewed in this context it is not surprising that the somewhat exotic Romani people would be regarded with irritation and suspicion: they did not fit into the expected national romantic stereotype of "Norwegianness."

Moreover, there was also during this period a general development in anthropological and psychological theories and methods. In the early 1900s, Scandinavia became a leading force in the science of racial hygiene. This had tragic ramifications for the Romani. Based on the scientific arguments of the day, they were seen as degenerate and of lesser human value, and a governmental program was developed to rid the budding nation of undesirable elements. This program included, among other things, forced sterilizations, forced lobotomies, forced placement of children in foster homes, and a general criminalization of the Tater way of life.

In 1896, a child care law was passed allowing the government to remove children from families deemed unfit and place them in foster care. In 1900, another law was passed that prohibited loitering, which in reality meant that the whole itinerant way of life was deemed criminal. Furthermore, in 1924 traditional Romani trading became illegal and in 1951 another law made it illegal for the Romani to own horses, which dealt a severe blow to their traveling culture. Many switched to using cars to get around, but many others were effectively deprived of their preferred mode of transportation. In this way the brutal assimilation of the Romani was legally sanctioned in a most efficient and comprehensive manner.

The State Mission for the Homeless

From 1897, the government handed the responsibility for the Tater over to the Norwegian Mission for the Homeless (the Mission), an organization that subsequently became its operative and executive arm. It also had legal rights to remove children from their families so they would not be contaminated by the so-called evils of traveling. Around 1,500 children were removed and placed in foster care. The mission ran a number of orphanages, schools, and even labor colonies around the country. In the latter, the Romani would be taught a sedentary way of life, including farming, housework, and social skills: Romani women would, for example, learn how to hold a coffee cup in the proper manner. The aim of these government initiatives was to "remove the Traveller gene," as one contemporary newspaper described it.

Moreover, it was strictly forbidden to speak Romani in these institutions, and failure to comply with these rules often led to forcible removal of children and their placement in foster homes. The most famous of these labor institutions, Svanviken Arbeidskoloni, received its last government grant in 1989, the same year the Mission was formally disbanded. It was also in 1989 that the Data Inspectorate[11] decided that the practice of automatically entering babies born to Romani families in the register for the criminally insane was unethical and in violation of the right to privacy. The history of the forced assimilation of the Romani is shockingly recent.

The Council of Europe Plays a Part

These increasingly systematic governmental politics of repression proved a most effective tool, both physically and psychologically. Many people of Romani origin are still very much afraid to make their identity public. Trusting the government has always been fraught with dangers and risks for them. Only in the 1990s did the stories of the abuse trickle into the public sphere, thanks to the tireless awareness-raising efforts of different individuals and nongovernmental organizations (including the Tater's own organization).[12]

In 1996, the issue was formally raised in the Norwegian parliament (Stortinget) by a highly dedicated member,[13] resulting in discussions on how the government should attempt to improve the situation for the Norwegian Romani. Questions of legal changes, an eventual collective economic compensation, and the establishment of a cultural center and museum for the documentation and promotion of Tater culture were all placed on the agenda.

As a consequence of these painstaking efforts, Norway finally signed the Framework Convention for the protection of national minorities of the Council of Europe in 1995, ratifying it three years later. This is the first legally binding multilateral agreement on the protection of these minorities, and became active on February 1, 1998.[14]

As already mentioned, the issue of openly claiming a Romani identity has been, and to a certain degree still is, extremely shameful and taboo, not least internally in the Tater

community. For those of us belonging to the majority community, the silence about this national minority and its history and culture has been absolute until recently. And it is only recently that we are beginning to see more research into this area. This presents in itself several ethical and methodological challenges. On one hand, the Romani still have a deep distrust of outsiders, including researchers, and consequently refuse to be interviewed or studied. On the other hand, paradoxically, only researchers have had access to certain restricted institutional archives containing the dossiers of Romani subjected to the medical and social service systems in charge of lobotomy, sterilization, and foster care.

National Minority

In Norway, the definition of a national minority encompasses ethnic, religious, or linguistic minorities with long-standing ties to the country. The group must be able to show ties to the country spanning at least a century. Norway's population includes five such national minorities: the Romani/Tater, the Rom, the Jews, the Kvens, and the Forest Finns.[15] The Framework Convention emphasizes the importance of respecting the ethnic, cultural, linguistic, and religious identities of the national minorities, as well as ensuring that these minorities can actively express, sustain, and develop their own identity. It also underlines the right of the national minorities to actively participate in society, particularly in decision-making processes pertaining to them.

From Red Tape to White Papers

The first official apology to the Romani came from the Norwegian government in 2000. The same year, the government issued several white papers outlining the principles that would form the basis for the state's subsequent policy concerning the national minorities.[16] In these position papers, the role of museums, archives, and libraries was underlined. These institutions had historically mostly represented the majority society, whereas information, services, and artifacts concerning the national minorities are underrepresented or not present at all. The white papers thus concluded that there was a special need for action concerning these issues, especially concerning museums, archives, and libraries.

The Idea of a Common, National Cultural Heritage

The white papers recognized that traditional ideas of Norwegian and national identity were changing, constituting a major challenge to central premises of official government cultural policies and programs.

Many archives, libraries, and museums were established during the nation-building era, and their raison d'être based on the idea of one, common national culture. As such, they have always been power-wielding institutions—having the power to define whose

history is legitimate, power to include or exclude. Through processes of selection, these institutions have excluded among other things the cultures and histories of the minorities and thus contributed to a marginalization of other cultural groups that have been a part of Norway for several hundred years. This selection can be seen in the light of the brutal politics of assimilation to which these minorities were subjected, consequently leaving a huge gap in the historical consciousness of the majority society.

The government white papers on the national minorities state in a very clear and unambiguous manner that as democratic institutions of knowledge and competence museums, archives, and libraries have a duty to spread awareness and knowledge about human rights and minority rights in particular. A deeper knowledge and understanding of the history of the national and other minorities is not an issue exclusive to the minorities themselves and a few researchers, but concerns in a very direct way how minorities are perceived and treated in society as such.

In 1997, Norsk Museumsutvikling, the predecessor of ABM-utvikling (the Norwegian MLA, now part of the Arts Council Norway), started work aimed at following up the political intentions regarding the preservation of Romani culture. The first step in this process was to build on the formal foundation the government had laid down, starting with the ratification of the Framework convention. Following the commitment expressed in the Framework convention and the white papers, the government finally granted the necessary funding to establish a center for documentation and communication of the Tater culture at the Glomdal Museum, situated a couple of hours north of Oslo.

The Glomdal Museum is a traditional open-air museum in a geographical area where there traditionally have been many Tater families. The museum recognized that the cultural history of Norway wouldn't be complete without the perspective and history of this ethnic group. One of the main objectives of the Romani exhibition has been to show the public that Norway has been multicultural for hundreds of years and to spread knowledge and raise awareness about the Romani community.

A Question of Trust—The Importance of Informal Processes

The biggest stumbling block in the process turned out to be the complete and historically well-founded lack of trust from the Romani community toward anyone representing the majority society, not least representatives of the government. This was understandable considering that it was a government body (ABM-utvikling) inviting them to a dialogue. Another difficult issue concerned representativeness; considerable internal disagreement existed within the group as to whether one should talk to the government at all, why Romani would want a museum ("museums had never done anything for them," "we don't belong in a museum—we're not dead yet!"), who was to represent the group, and so on. The Tater community as such is not a homogeneous group, not least when it comes to regional cultural differences.

Moreover, the Romani were afraid that prejudice would harm them should there be more focus on their group and situation. At the same time, they were interested in the initiative as they worried their culture would otherwise be completely forgotten.

Fragile and Human Process

The informal aspect of this process turned out to be a pivotal factor in building trust. As Hilde Holmesland, a member of the ABM-utviklings staff responsible for the process, sometimes quips: "it took a lot of shared coffee and cigarettes."[17] This illustrates how important this informal side was, alongside the formal meetings. It also took a lot of personal courage and generosity of spirit to stay the course, representing the government and the Norwegian community at large, in the formal meetings where deep-rooted anger and sometimes aggressive recriminations would surface. A mutually negotiated recognition that conflict can be fruitful if properly handled also contributed to driving the process forward: all stakeholders had to give some ground in order to keep the dialogue open. Also, they had to recognize and deal with (real or perceived) cultural differences in the way the interaction was handled. A quote from one of the participants when tempers flared during the discussions serves to illustrate this point: "ok, if we're to continue these discussions, either we're all Tater or we're all Buro." Everybody realizing the fairness in this, the dialogue would get back on track and continue much less aggressively.

Another key issue regarding the relative success of this process was the fact that it was initiated, funded, and sustained without anyone knowing quite where, if anywhere, it would lead. Fortunately, the Ministry of Culture recognized the need for considerable slack both financially and with regard to time: it did not interfere in the process and did not demand quick results that might jeopardize the effort.

The first and crucial stepping stone in the process toward a real and lasting improvement of the situation for the Romani community was thus developing and maintaining a relationship of trust with the Romani, through extensive and long-term contact on both a formal and an informal level. Furthermore, active participation by the Tater community was a necessary principle through all phases of the project.

Strong Principle of Participation

Later, when sufficient trust had been established, the Glomdal Museum and the Romani community could get on with discussing the permanent exhibition to be developed and curated at the museum. All collaboration was based on a principle of active participation from the community. The museum even changed its overall strategic goals to make sure the cooperation with national and other minorities was robustly and permanently anchored in the whole institution and all its work.

A reference group that discussed and approved form, content, and theme for the exhibition was established, and things started to take shape. The Tater participated in all phases; developing the vision and overall goals for the exhibition (cf. Figure 11.1.), collecting objects, designing the exhibition, and communicating with museum visitors. One of the employees at the museum is also of Romani origin. Other members of the Romani community have also participated in a digital storytelling project, where they have made short digital films about their culture published on the Internet. Today the museum and the Romani have a mutually constructive relationship and have found different ways of collaborating.

"Abuse was Part of Your Culture, not Ours"

The Romani people themselves prefer to focus on the positive side of their culture. In time, they may add more of the darker stories about the years of repression and abuse, but this is still controversial within the group and discussions are still ongoing. The main thing is that they refuse to be pigeonholed as victims. For now, they are concerned with communicating the importance of freedom and the joys of traveling, the craft and trading skills, the music and the good stories, the resilience and the unbreakable will to

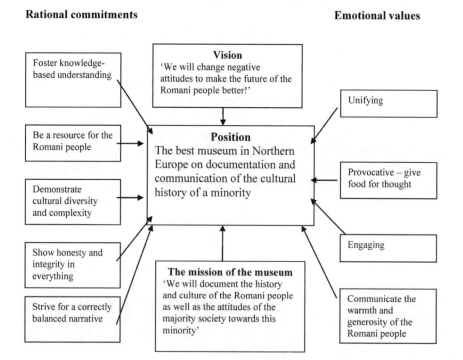

Figure 11.1 Diagram showing the vision and mission of the Romani exhibition at the Glomdal Museum

survive. As such, the exhibition shows different aspects of their culture (marriage, traveling, handicrafts, horsemanship, etc.) in the manner of traditional ethnographic curatorship. Claims that it has become too traditional tend in my opinion to overlook the fact that the underlying process of building and maintaining trust with the community has been and is still a much more important goal than any end product in the form of spectacular new ways of exhibiting objects. Put very simply, the process is more important than the resulting displays, part of which can be seen in Plates 11.1 and 11.2.

Key Elements to Success

The permanent Romani exhibition has come about through a long, tough process of establishing and maintaining trust in close dialogue with the Tater themselves. This approach to museum work has turned out to be extremely demanding, but also extremely fruitful. The key elements that proved important for the success of the process can be summed up in the following points:

1. The first and crucial part of the dialogue consisted in *developing and maintaining trust through formal and informal contact* with the Romani community.
2. The different stakeholders in the process were *allowed the time and resources required to establish and maintain trust.*
3. Throughout the whole process, the Romani *community was ensured active participation in all phases.*
4. The *focus was kept on the process itself rather than the end result.*
5. The *process has been allowed to continue.*

The result of this painstaking and sometimes painful process is astounding: the exhibition officially opened in 2006, and today the Romani people have a strong sense of ownership of the Glomdal Museum and pride in the exhibition about their culture. The museum has become a true intercultural meeting place, as well as a place where the Romani people feel at home.

Agents for Social Change and the Road Ahead

The right to access and participation, not least concerning cultural heritage, are fundamental rights which have been set down in several international conventions ratified by the Norwegian state: the UN convention on human rights, the UN convention on the rights of the child, the UNESCO convention on the protection of intangible cultural heritage, and the Framework convention on the protection of national minorities. This makes it imperative, not only for all government bodies, but also for museums, to shoulder their responsibility when it comes to fulfilling these rights. Given enough time and resources, museums have an exciting potential as empowering and critically thinking agents for social justice and positive change.

Notes

1. As the process of building trust is fragile and still ongoing, the Romani community small, and the majority society still largely in ignorance, any description needs to be extremely discerning. For example, a use of the term *subculture* would be offensive to the Romani—they see themselves as a culturally and ethnically independent group. And because their status in Norwegian society has been stigmatized to the point where they went underground and disappeared from the public eye, their culture did not explicitly influence majority culture, like youth culture—no one would want to be associated with the Romani. Today, there are still people of Romani origin who refuse to be "outed." However, this seems to be changing with younger generations, not least because young Romani musicians currently are finding their way into mainstream popular music.

2. In 2009, the Glomdal Museum, in collaboration with the Romani community, developed an exhibition project for primary and secondary schools. The school project was effectively stopped by concerned parents who didn't want their kids exposed to this sort of subject.

3. In this chapter, I refer to *Romani* and *Tater*, two names for the same ethnic group. *Traveller* is another term used. I specifically use the Norwegian spelling for Romani, with an "i" at the end, in an attempt to underline that this is a particular ethnic group in Norway, distinct from other Romany or Rom peoples in Europe.

4. ABM-utvikling was created in 2003 following the fusion of Norsk Museumsutvikling (Norwegian Museum Development) and two library and archive organizations. NMU originally started this process. After January 1, 2011, ABM-utvikling became part of the new Arts Council Norway.

5. In Norway, the gypsies are called *Rom* and speak *romanès*. Despite a possible common ancestry, today the Norwegian Rom are ethnically and linguistically different from the Romani/Tater, who speak Norwegian *romani*.

6. Today the Romani maintain that "the sense of freedom" is still the single most important factor motivating their traveling in the spring and summer seasons (Dyrlid and Bjerkan 1999).

7. Bastrup and Sivertsen 1996.

8. Ibid.

9. Douglas 1996: 98.

10. *Buro* is the Romani word for non-Romani or peasant.

11. An independent administrative body under The Ministry of Government Administration and Reform was set up in 1980 to ensure enforcement of the Data Register Act of 1978, now superseded by the commencement of the Personal Data Act of 2000. The purpose of this Act is to protect persons from violation of their right to privacy through the processing of personal data. The Act will help to ensure that personal data are processed in accordance with fundamental respect for the right to privacy, including the need to protect personal integrity and private life, and ensure that personal data are of adequate quality.

12. The first Tater organization, Taternes Landsforening, was founded in 1995; the second, Landsorganisasjonen for Romanifolket, in 2000.

13. Incidentally, the MP who formally raised the issue has a professional background in the archive sector. The archives have been essential in documenting the government's systematic abuse of the Romani people. Some archives apparently contain still unopened Christmas presents for Romani children, presents which were confiscated by the orphanages.

14. The Council of Europe's Framework convention on the protection of national minorities. Available at: http://www.regjeringen.no/en/dep/ud/Documents/Proposi tions-and-reports/Propositions-to-the-Storting/19971998/stprp-nr-80–1997–98-/9. html?id = 202022.

15. It is difficult to get exact numbers for these groups, as their status is still very much a sensitive political issue. Some minorities even have a dual identity, that is, they are both Sami (indigenous) and Kven, and some haven't yet discovered or claimed their minority identity (Holmesland, pers. com.).

16. www.regjeringen.no/nn/dep/krd/Dokument/proposisjonar-og-meldingar/storting-smeldingar/20002001/stmeld-nr-15–2000–2001-.html?id=585195.

17. H. Holmesland, senior advisor on national minorities at the Norwegian Archive, Museum and Library Authority/Arts Council Norway, personal communication.

References

Aftenposten. 2009. "Omstreiferens etterkommer." April 6; updated November 15, 2011. Available at: http://www.aftenposten.no/amagasinet/Omstreiferens-etterkommer-5568738.html.

Bastrup, E., R. Olav, and A. G. Sivertsen. 1996. *En landevei mot undergangen.* Oslo: Universitetsforlaget.

Douglas, M. 1996. *Purity and Danger: An Analysis of the Concepts of Pollution and Taboo.* London and New York: Routledge.

Dyrlid, L. and L. Bjerkan. 1999. "Om likhet, likeverd—og annerledeshet. Et antropolo-gisk blikk på taternes livshistorier." Rapport fra delprosjekt nr. 112955/510. Sosial-antropologisk intitutt. NTNU, Trandheim.

Gotaas, T. 2000. *Taterne—livskampen og eventyret.* Oslo: Andresen og Butenschøn.

Holmesland, H. 2006. *Arkivene, bibliotekene, museene og de nasjonale minoritetene.* ABM skrift #61. ABM-utvikling (The Norwegian Archive, Library and Museum Authority).

Møystad, M. Østhaug, ed. 2009. *Latjo drom—Romanifolkets/taternes kultur og historie.* Elverum: Glomdalsmuseet.

Web pages

The Glomdal Museum web pages: www.glomdal.museum.no.

Web-version of Romani exhibition at the Glomdal Museum: www.latjodrom.no

Taternes Landsforening (A national organization of the Tater): www.taterne.com.

Landsforeningen for Romanifolket (A national organization of the Romani): www.lor.no.

Political Documents

The Council of Europe's Framework convention on the protection of national minorities. Available at: www.regjeringen.no/en/dep/ud/Documents/Propositions-and-reports/ Propositions-to-the-Storting/19971998/stprp-nr-80–1997–98-/9.html?id=202022.

Stortingsmelding 15 2000–2001. Available at: www.regjeringen.no/en/dep/krd/docu ments/white/Propositions/20002001/stmeld-nr-15–2000–2001-.html?id=585195.

Stortingsproposisjon 80 1997–1998. Available at: www.regjeringen.no/en/dep/ud/ Documents/Propositions-and-reports/Propositions-to-the-Storting/19971998/stprp- nr-80–1997–98-.html?id=202013.

Part III
Audiences and Diversity

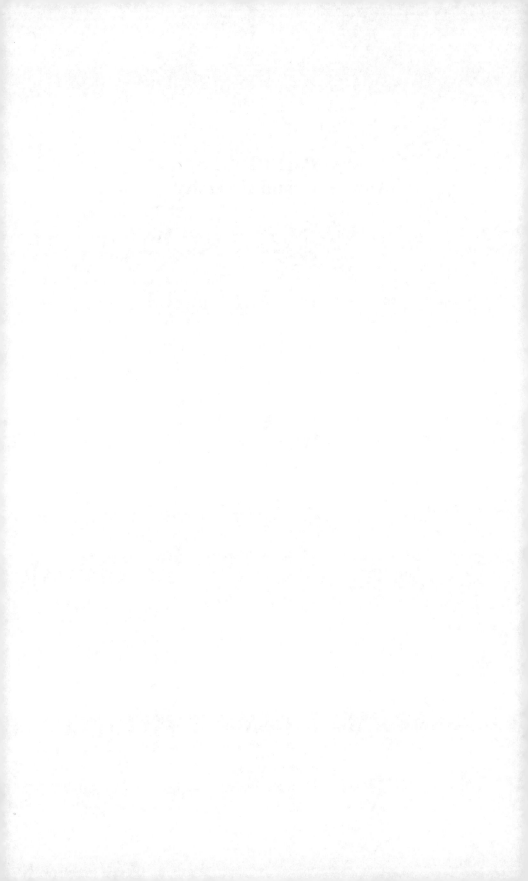

–12–

Creolizing the Museum
Humor, Art, and Young Audiences

Viv Golding

When Édouard Glissant speaks of creolization he notes:

> It is not merely an encounter; a shock (in Segalen's sense), a metissage, but a new and original dimension allowing each person to be there and elsewhere, rooted and open, lost in the mountains and free beneath the sea, in harmony and in errantry. (1997: 34)

What is important to emphasize here for the present-day museum context is the way Creole perspectives challenge the views of some cultures as "bounded," "pure," "homogenous," and "timeless" that philosophically have contributed to the traditional museum space and exhibition. As I have discussed elsewhere this divides, for example, Western high art and the lower artifacts of other cultures (Golding 2009: 27–33, 46). For museums aiming to present a more welcoming and inclusive stance, especially to youth and popular cultures, Creole standpoints are helpful, since they highlight complexity, overlaps, and inventiveness, as well as the possibility of forging alliances in extremely asymmetric power relations. Creolizing the museum requires inventiveness and reflexivity. It vitally includes critical attention to diasporic histories and the negative legacies of dominant cultures, as well as imaginative borrowing and transformation of hegemonic institutions such as the museum in the creation of something new (Hannerz 1996: 66).

In this chapter, I draw together ideas from humor studies with the notion of creolization. I argue that humor, like creolization, calls for a politically revolutionary stance, disruptive of the status quo that maintains hierarchies of privilege. Drawing on specific exhibitions, artist's practice, and responses from young people, I explore how hierarchies of traditional curatorial power can be productively disrupted in museums, enabling the development of "moral activism" (Sandell 2007: x), and how these disruptions can act as agents of social change in the progression of social justice and human rights (Sandell and Dodd 2010). To examine these issues, my focus is on humorous public art, specifically the performance work of James Luna (Luiseño), the ironic signs of Hock E Aye IV Edgar Heap of Birds (Cheyenne Arapahoe), and the graffiti work of JR (Tunisian Eastern European) and Banksy (UK). These artists are selected for their politically motivated

work with histories of colonialism and contemporary oppression that dismantles the wounding stereotype.

First, I provide an outline of how the key concept of creolization may be employed along with some points of reference from humor studies. Then, I outline world art practice that is challenging the museums' traditional role. Following this, I examine the practical application of creolizing museums with humor, noting demographic details and cultural characteristics of Watershed, a youth group from Leicester, UK, to an exhibition that highlights the creolizing viewpoint.[1] Finally, some tentative recommendations are made for future work outside of the United Kingdom case study site.

Creole and Creolization: Metaphorical Understandings and Culture Building

Starting with a brief view of language and drawing on Stuart Hall, we note the origins of the term *creole* has strong connections with the Spanish word *criollo*, which has resonance in the French Caribbean. Hall observes the French-derived vocabulary and syntax with African structures of speech that arise from Norman sailors' associations with "native" women and the construction of an "abjected" language (2004: 28–29). This history—free and forced, of poetics and politics—determines *creole* as a powerfully charged and slippery signifier that denotes cultural, social, sexual, and linguistic *mixing,* to threaten ideas of *purity.*[2]

My political stance on creolization is reinforced by Toni Morrison when she speaks of the "postmodern," which Caribbean peoples understood from the times of enslavement, when in the face of absolute "loss" there was "the need to reconstruct certain kinds of stability" through "[c]ertain kinds of madness"; she notes people were "deliberately going mad" to keep their sanity in insane situations (1994: 178). Morrison highlights the necessity of looking back and acknowledging historical injustice, however painful that memory work is, but in hopeful ways that point to future possibility, not abandoning people in a horrific state of fixity and inertia.

While creolization is rooted in Caribbean history, Édouard Glissant remarks that "the whole world is becoming creolized," and I want to ponder Stuart Hall's question, "what can such a statement mean and what are its conceptual implications?" for the museum (Hall 2004: 27). Hall and Ulf Hannerz consider a metaphorical use of the term *creolization*, which depends on extending a spatial and temporarily specific concept to another historico-cultural situation. Hall proposes using creolization as a master metaphor for approaching the complex histories and experiences of societies in the contemporary world of mass migration, tourism, and cultural globalization. Similarly, Hannerz speaks of creolization as a "root metaphor offering an alternative to the linear analytical processes of colonial mixing in a contemporary global context" (Hannerz 2010: 381). As Robin Cohen and Paola Toninato contend, it captures the increasing fluidity of world systems that result in greater complexity than the terms "acculturation" or "survivals" suggest (Cohen and Toninato 2010: 12).[3] The appeal and value for the contemporary museum lies

in Glissant's foregrounding of the special creativity in the *Poetics of Relation* (1990), the rejection of essentialist notions and fixity that limit translation and change, and hinder intercultural understanding.

However, we need to acknowledge here at the outset the dangers of mapping across a number of conceptual frontiers. Mimi Sheller cautions against "theoretical piracy" here (2003: 288), and we are reminded of Barbara Smith's warning to white scholars engaging in "academic tourism of the exotic" or "cultural imperialism" of black thought (1993: 172). Primarily, we risk losing the original historico-political complexity, notably the horrors of the relationship to plantation enslavement during colonial times (displacement and dehumanisation), as well as the imperialist legacy (discrimination and stereotype) that persists today. In the museum context, these remarks point to the need for curatorial collaboration to raise the voices of communities historically erased or silenced within the museum space. Most important is the need to be mindful that in the original Caribbean context, *creolization* denoted *"culture building"* rather than simple "mixing" (Mintz 1998: 119).

Mindful of this qualification, if this new metaphor can recognize the agency and influence of peoples and their cultures previously thought of as subordinated and marginalized, perhaps it can stand as testament to the resilience and creativity of other people in extremis and by extension to the humanity of us all. Creolizing the museum might concern the creation of new forms of communication and ways of being together inside and beyond its walls. In other words, an optimistic analysis would privilege positive exchange and contact while recognizing the problem of glossing over the pernicious link between colonization and forced migration; the oppression and subordination that ensued from power relationships and the legacies of inequality that persist today in museums and in the wider social world.

I want to attempt in my discussion of creolization in the museum context to approach the complex problems of translation and to open an interrogative space around the processes of understanding. Working from creative practices and expressions, I shall explore to what extent creolization may offer a new theoretical model for coming to an understanding of wider processes of culture building in the contemporary global world. This work has resonance in ideas on the process of "transculturation," which produces a productive "third space" and new configurations, although it is questionable to what extent hierarchical elements are permanently "translated" through temporary exhibition strategies (Bhabha 1995; Hall 1994).

Nevertheless, as Hannerz observes, the asymmetrical relations of dominance and subordination are always a "two way struggle" characterized by reciprocity and mutually constituted systems. Perhaps we have mistakenly seen the museum discourse as "totally dominant" and impervious to the agency and work of communities at the periphery (Hannerz 2010: 386), whereas those on the margins have impacted on curators at the center of museums in the first part of the twenty-first century (Sandell and Dodd 2010: 7). Hall's emphasis on the need to keep contradictory tendencies together rather than single out certain celebratory aspects is helpful here. He speaks of the need to adequately describe the creative vibrancy of the Caribbean, which results from a colonial history of

enforced voyage, unrequited trauma, appropriation, and expropriation. We might usefully apply these notions to the field of museums and their visitors today. For example, Sandell and Dodd observe contemporary museums widening museum interpretation and representation teams to engage visitors on "rights-related issues" that promote social justice for disabled people (Sandell and Dodd 2010: 12–13). This involves museums taking a more complex and nuanced "moral standpoint" on "often contentious" topics (Sandell and Dodd 2010: 20).

Humor

Just as creolization points to our common humanity without eliding differences, so humor is seen as an essential part of being human for all cultures around the world. I have argued elsewhere that museums of different sorts work with narrative, telling stories of the person in a sociocultural world (Golding 2007a, 2007b, 2007c, 2009). Here I want to examine the place of the humorous story in creolizing the museum and to draw on anthropologist Mahadev Abte's helpful outline of the importance of humor in ritual and in trickster tales across the globe that have the positive effect of reducing tension (1983: 206).

While we have observed the positive aspects of humor, two caveats need noting. There is no one particular reward of humor per se, and people all over the globe find vastly different things funny. Humor is both a universal feature and subject to specific local variants; different types of humor appeal to different audiences and serve different reward purposes, as Michael Billig's work on racist jokes websites demonstrates (2001: 267–289). The field of humor studies is vast, and this chapter can do little more than approach the theme, which has been somewhat neglected by museum studies. In my analysis I shall employ a probing attitude of suspicion akin to Freudian psychoanalysis to counter the rather simplistic, celebratory tone of some exhibitions (Höller 2006).

Historical Outline

Three theories seem useful to any analysis of how humor works in the museum: Superiority, Relief, and Incongruity/Resolution, which I shall outline in turn. Historically, humor has been disparaged since Plato's Superiority Theory, so called because it involves the "nasty business" of ridicule and denigration, which makes it ethically suspect (Morreal 1983: 3–4). In brief, Plato considered the loss of rational control and the maliciousness of comedy childish, morally dangerous, and harmful to the state, since it permits the "worst citizens" to enjoy the lower emotions—"buffooneries"—mocking those in "authority"; it requires discipline and censorship to prevent rebellion (*Republic* 1976: 336–338 [Chapter 36 x. 602–c.605]).

Closer to our time, Freud also observed humor as "a rebellion against" and a "liberation" from the pressure of "authority" ([1905] 1976: 149) through analysis of jokes

passing by word of mouth amongst ordinary people, in what is regarded as the Relief theory of humor (Morreal 1983: 20–37). Freud distinguishes between jokes, the comic, and humor to account for laughter as resulting from the discharge of surplus psychic energy normally expended in suppressing forbidden thoughts and feelings (Morreal 1983: 29). Briefly, it is the operation of condensation and substitution, which permits the adult "joke work" to slip unconscious repressed desires through the taboos of social censorship, in similar ways to dream work (Freud [1905] 1976: 51, 238).

More important than the mechanics of "relief" for this chapter is the view of humor as a playful, social activity, which Freud traces to the early word play of children when they engage in nontendentious "jesting," or putting ideas and words together in silly ways, to tendentious "joking" proper that involves complex motives of a sexual or aggressive nature ([1905] 1976: 183). When he states "a joke is developed play," Freud emphasizes the social communicative aspects of humor as playful activity ([1905] 1976: 238). Freud also connects humor to the lifting of taboos during carnival and "festivals in general" ([1905] 1976: 140), times that are vital to creolization when we mock authority figures, overturn established "rules," and ignore social conventions (Freud [1921] 1985: 163–164). The value of humor here seems to lie in permitting the voicing of that which is usually silent, and by means of playful joking opening a brief space of social freedom and "sources of pleasure" (Freud [1905] 1976: 147).

The notions of play and social freedom recur in the Incongruity/Resolution theory, which accounts for amusement when our experience of the orderly world is subject to some surprise. According to this theory, humorous activity, exemplified in Magritte and Dali, for example, draws us into a play with our sense of reality, calling into question ordinary distinctions between, for example, liquid and solid, animate and inanimate, real and fake. Freud observes such incongruity marking an attack on "the certainty of our knowledge itself, one of our speculative possessions" (Freud [1905] 1976: 238). Here it is a "non-serious use of reason," not the abandonment of reason, that operates, as the case of very young children, whose underdeveloped rationality leads them to react with frustration to incongruity, demonstrates. Adults, teenagers especially, can enjoy a violation of expectations and revel in the freedom of the humorous space.

Nina Simon regards humor as a design tool that can offer connection points to those who are unfamiliar, uncomfortable, or wary of visiting museums (Simon 2010). Simon notes humor challenges "traditional models of museum-going" and appeals by "releasing the pressure valve on uncertainty" about entering. She contends:

> As more museums seek to diversify beyond the intellectual experience of objects and ideas, humor should sit alongside emotion, spirituality, expression, and other newfound palettes for experience design. (Simon 2007)

Simon cautions boundaries and I also recognize the dangers of humor; laughing at others can alienate, and certain topics are simply not funny. However, humor can also expand the limits of the permissible, as we can see by examining the "unfunny" colonial history of the United States.

Humor in Indigenous American Art

Here I want to explore ironic humor as a mechanism to address historical injustice—as part of the creolizing museums project. First, we will look at the art practice of two Indigenous Americans who powerfully address the history and negative effect of colonialism on their communities.

Almost thirty years ago, "the receptiveness of a single curator," as Paul Chaat Smith notes (2009a: 98), facilitated Luiseño artist James Luna's performance of Artifact Piece (1985–1987) amongst the collection of Kumeyaay material culture on display at the Museum of Man San Diego. Playing with notions of display fraught with histories of objectification, genocide, loss, and trauma for Indigenous Americans, the piece involved Luna exhibiting himself as an object. Dressed in a loin cloth, he lay motionless for hours in a glass vitrine of sand with labels around his body. These referenced a harshness to his humor, noting "emotional scars," his "fears of giving, communicating and mistrust" arising from "alcoholic family backgrounds" and his own "excessive drinking" (Chaat Smith 2009a: 94). This piece, which included other cases containing Luna's personal and ceremonial objects, presented "an Indian viewpoint," that used ironic humor to reclaim subjectivity for Indigenous community members who were objectified and silenced in the historical museum's framing of knowledge (Luna 1985). Here visitors were startled to see a living, breathing man listening to them and returning their voyeuristic gazes.

The development of Luna's work highlights the power of humorous activism. In his collaborative 1993 piece, The Shameman meets El Mexican't at the Smithsonian Hotel and Country Club, Luna shared "a diorama space" or "ethnographic prison cell" at the Smithsonian's Natural History Museum with fellow artist Guillermo Gómez-Peña. Luna's persona moved from "Indian shoe-shiner" through "diabetic Indian" shooting insulin directly into his stomach to "janitor of color" (Chaat Smith 2009a: 95–96). On his website Luna explains these works: "Performance and installation offers an opportunity like no other for native people to express themselves," which is evident in his complex photo, video, installation, and performance pieces for the 2005 Venice Biennale (Luna 1985). In Venice, Luna employed his body and voice to dismantle the tired stereotypes of "natives," donning hides and feathers, by wielding a whip and drinking cappuccino. Luna's work is grounded in his own experience and thorough research, such as his Biennale installation Chapel for Pablo Tac, which paid homage to the twelve-year-old Luiseño boy who journeyed to train as a missionary in the Vatican in 1834. Pablo Tac wrote of his home and language before he died in Rome aged nineteen, and Luna's piece resonates in his own twentieth-century journey to Venice.

The theme of giving voice to the ancestor echoes in the 2007 Venice Biennale, where Hock E Aye IV Edgar Heap of Birds (Cheyenne Arapahoe) represented the United States with a multi-sited public art piece, Most Serene Republics (Heap of Birds 2007). In this piece Heap of Birds reflected on aggressive colonial policies destroying "Indigenous Republics" and the "double displacement" of forced removal from homelands by war and treaty to exile and exhibition, including 1880s Venice, when warrior chiefs representing the Sioux Nations were subjugated performers—a ridiculed human

spectacle—entertaining large audiences in William "Buffalo Bill" Cody's Wild West Shows (Heap of Birds 2007).

At the 2007 Biennale Heap of Birds saw audiences as forming a contemporary spectacle in terms of entertainment and commerce, and he connected them to colonial history by means of "ironic assessment" with four site-specific enamel sign panels and signs placed at transit routes throughout Venice—the airport and vaporetto. Each sign aimed to activate healing of the damage caused to Indigenous people, for example in repetition of the number four, which holds symbolic ceremonial significance amongst the Cheyenne. The largest site located sixteen enamel sign panels (24" by 36") along the colonnade connecting the Biennale Pavilions and Arsenale, with multilingual (Italian, English, and Cheyenne) memorial messages stating the words HONOR MORTE (honor the dead), RAMMENTARE (remember or rethink),[4] and the name of a "show Indian" subject to ridicule in nineteenth-century Venice but previously a warrior chief (Ash-Milby and Lowe 2009).

Heap of Birds's Biennale pieces make pertinent reference to diverse histories in ways that bring silenced and shamed ancestors into a newly dignified space for contemporary global audiences. Additionally, he engages the younger members of his community in projects tracing the ancestors and revaluing the contemporary relevance of Native American heritage. Part of his youth work is directly concerned with making respectful site visits to places of historic suffering for the ancestors. Some youth projects involve reciting the ancestors' real names, which facilitates a deeper richer understanding and renewed pride in Cheyenne people today. Such work aids what is prized in creolization, community building. To summarize, Heap of Birds's art operates through ironic humor and collaboratively with youth and other communities, recalling oppressive colonial histories and inserting Cheyenne voices at sites where they have been erased, to demonstrate like Luna the creative power of creolization to world audiences.

These Indigenous American artists work with irony, which involves not just an interpretation of the bizarre but act as "a kind of fixer" of it, as a "way to make sense in an empire of the senseless" (Chaat Smith 2009b: 146–147). This works because "situated knowledge" is part of the artist's heritage (Harraway 1991; Hill-Collins 1991). It is different for curators who lack proximity and ironically cite missionary comment on African "Others," as Jean Canizzo did in the Heart of Darkness exhibition, although as I argue elsewhere more rigorous collaborative engagement at the outset and throughout her project may have avoided community anger and criticism (Golding 2009: 33–34). I contend here that no subaltern can speak for a whole community, and I would like to unpack these ideas of distance and proximity, who can speak for whom, by examining the extent to which European artists may address world politics and issues outside of their own heritage.

Humor in European Graffiti Art: JR and Banksy

JR, who calls himself a "photograffeur," is a Parisian photographer and public artist of Tunisian-Eastern European heritage. His work involves pasting huge, fine-grained, black-and-white photographic canvases in surprising public locations. The images

often feature portraits of people in the most economically impoverished areas of the globe and JR, by means of close-up and fish-eye lens, gives them a personal human face. He offers audiences a different perspective to those whom the wide-angle media lens distances and demonizes. For example, in the first stage of his 28 Millimètres project on the walls of the Marais in Paris, he showed the young residents of the *banlieues,* who protested their hopeless lot during riots on the streets of Paris in 2004, pulling funny faces. In the second stage, he appropriated a border wall area of disputed territory between Israel and Palestine, pasting giant images of a rabbi, a priest, and an imam with deliberately comic expressions. In these works he makes use of humor and pays respect to those portrayed, which dismantles divisive ideas of "us" against "them," or, as JR notes: "[I]t's about breaking down barriers" and "[w]ith humour, there is life" (Day 2010).

JR is an activist, and his art is socially conscious at a number of levels. First, he carefully selects materials, such as the Women Are Heroes photographs that were vinyl printed onto their rooftops in Kibera, Kenya to waterproof their homes, and the sheets of corrugated iron used in another part of the shantytown that were distributed to participants after the project for waterproofing. Second, he uses the money from sales of work to make a difference; for example, by establishing a cultural center in Morro da Providencia the oldest and most perilous *favela* in Rio de Janeiro, where a 2009 piece pasted images of the female residents on the sides of their houses. In this work, the gaze of the women, looking with dignity into the *favela*, where their children had died in gun and drug-related crimes, drew attention to the grinding poverty on the doorstep of a rich cosmopolitan city. JR notes the importance of "eye contact" prior to starting work and states, "You have to go straight to the point. There's this person in front of you and there's no fucking around. That's how I test my projects: if they get it, it's going to work" (Day 2010). The results of his working practices are subjects that have agency. They return his gaze and meet our eyes directly as we view the photographs in museums. High up on the external wall of Tate Modern (2009) and inside the Modern Art Gallery at the Shanghai Biennale (2010), we saw visitors coming into eye contact with JR's public art images. At the Biennale, nearly every visitor's eye was behind a mobile camera lens taking photographs of JR's photographic public pastings and sometimes putting their friends into pictures, to take away their memories of a social occasion and maybe further reflect on the museum event where diverse cultures were able to meet.

To summarize, JR's activist work restores agency and individuality to people living on the margins of mainstream society. I would argue that this graffiti art creolizes—it observes Edward Said's call to forge allegiances to challenge injustice (1993). Creolizing graffiti is political and distinct from the more simplistic tagging of names on empty walls and train carriages. Naming is interesting in this work. JR, like Banksy who I will discuss next, and all trickster characters from humorous tales hide their identity. This is because graffiti is produced by outsiders; it is found in deprived urban environments beyond the prestigious museums containing the masterpieces of "our" artists; it marks "otherness" and is a criminal act. In his book *Wall and Piece*, Banksy makes a stoutly political defense of graffiti art, stating:

The people who truly deface our neighbourhoods are the companies that scrawl giant slogans across buildings and buses trying to make us feel inadequate unless we buy their stuff. They expect to be able to shout their message in your face from every available surface but you're never allowed to *answer back.* (Banksy 2005: 8) [my emphasis]

These words resonate in the potential of the contemporary art museum experience to engage active audiences, to facilitate "answering back" in critical conversations, and to progress their social role. My concern in the rest of this chapter will be with audiences targeted as "difficult" or "hard to reach" in the United Kingdom—people aged fourteen to twenty-five—whose culture[5] can be regarded as marginalized in the context of high art spaces, where economic privilege has been dominant, but where I contend the status quo may be unsettled through creative collaboration. I will draw on Banksy's art that I saw working so well inserted into the context and fabric of one traditional museum, which holds colonial traces, objects, and narratives of loss and trauma from the wider world. Specifically I want to reflect on the exhibition Banksy Versus Bristol (2009) at Bristol Museum and Art Gallery (BMAG) that I visited with the Watershed youth group from Leicester[6] in the summer of 2009. This exhibition, in pointing to global movement and change, resonated with the Watershed group, whose family positioning in colonial and more recent histories of exile include Ugandan Asian, African Caribbean, and Romany heritages.[7]

Pre-visit Preparation to Banksy Versus Bristol (2009)

Preparation for the museum trip included booking with the BMAG education team to avoid the queues of visitors good-humoredly snaking around the building for up to five hours, extensive group discussion of Banksy's book *Wall and Piece,* and art workshops. In the opening section of his book, Banksy considers the nature of graffiti art and makes a stout defense of the form. He notes the absence of "elitism and hype," the importance of public locations "on the best walls in town," and the free "price of admission," which removes economic barriers. Banksy counters the charge of graffiti as "the lowest form of art . . . frightening . . . and symbolic of the decline in society," when he highlights the overriding connection of art with profit in the art market and points to a graffiti artist's desire "to make the world a better *looking* place" (Banksy 2005: 8) [original emphasis].

The Watershed group admired Banksy's public art and were impressed that he infiltrated his pieces into museums around the world. Wall Art East London, an ancient wall fragment depicting a "primitive" graffiti artist complete with supermarket shopping trolley, remained in the British Museum for eight months and was a favorite piece in the book. This piece with its spoof label giving the date "from the Post-Catatonic era" and the author as "Banksymus Maximus," appeared in the Bristol show and influenced the young people's follow-up artwork after the museum visit (Banksy 2005: 185).

I would like to employ notions of time and sequencing, key to humor, narrative, and a positive museum visit, as a structuring device to investigate the teenagers'

responses at BMAG. I have found the "beginning, middle and end" structure of storytelling helpful to my educational work and I shall employ it here to guide readers through a complex theoretical terrain.

Timing: The Beginning

In transforming the serious museum space into a play zone at BMAG, Banksy works with the temporal features of humor. He times a shift from the serious everyday world to a playful space at the outset of his Bristol exhibition, with the clown figure of Ronald McDonald sitting atop the entrance. Ronald sits between the Corinthian columns, his legs dangling as he stares down from this homage to the Greek temple structure, which he transforms by taking physical ownership in ways that echo the graffiti artist's climbing skills. Here we observe creolization at work: like Rastafarians who employ a textual strategy of inversion—reading the Bible backward—Banksy immediately writes and invites us to read "against the grain" of the traditional museum, where visitors usually enter to have establishment knowledge confirmed. Once inside we see how he transforms the stuffy museum into a "scene" of violence and conquest at the entrance lobby with his apocalyptic burnt out porta-toilet dolman, positioned like ancient standing stones and covered with graffiti. Straightaway it seems we visitors enter a "site" of tabooed desire, a distinctive third space of unsettledness and conquest, which echoes the *dis*placement of *diaspora*.

Starting to journey through this museum exhibition may be seen to echo the narrative movement—*routes*—that transform. Creolization as vital routes challenges the logic, essentialism, and false purity inherent in the notion having a single root and nation. The notion of routes points to the complexity of identity and the impossibility of returning to one imagined root. Our museum routes can creatively move us towards the future. Creolization can also counter the problem of "traveling" theory privileging elite holidays that bell hooks highlights by the necessary movement in alliance with others, through fear to "confront terror" (hooks 1992: 174). Alliance was vital for the Watershed youth, who were not regular museum goers and avoided such institutional spaces where the codes of behavior were thought of as "not for the likes of us."

Banksy's introductory features bear visual resemblance to the call—"let's play"— we remember from our childhood. They also seem to visually mark a preface, immediately inviting us into an imaginative space (Billig 2005: 182). On entering the building the playful mood is enhanced when we see the burned out porta-toilets, covered in the sort of "nasty" rapidly scrawled graffiti that too often defaces the most economically disadvantaged community spaces. In *Wall and Piece,* Banksy comments on this with reference to Wilson and Kelling's "Broken Window Theory," which contends that when broken windows in run-down neighborhoods are not repaired, vandalism and other crimes exacerbate as a result of the public perception that "no-one cares" (Banksy 2005: 130). These ideas echo in the nearby Welcome to the Museum sign with pink graffiti lettering that admonishes the visitor to "now wash your hands," which made

some of our group think of Pontius Pilate washing his hands of what was to follow—the crucifixion of Jesus Christ—to be equated with the death of the old museum. The museum voice echoes this washing of hands in a sign at the entrance to the special exhibition stating:

> The museum does not support or condone any form of illegal activity, regardless of its artistic merit. . . . Museum staff have had no form of contact with the artist. The views expressed by Banksy in this room and throughout the museum do not necessarily represent those held by the museum, its staff, the trustees or funding partners.
>
> Please be aware that some of the historic relics now on display throughout the museum are fakes. (BMAG 2009 sign)

The flyer for Banksy's show counters this disclaimer, stating "Bristol Museum and Art Gallery is proud to present a unique collaboration between the city's foremost cultural institution and one of the region's most overrated artists," which shows Banksy employing ironic self-depreciation (flyer 2009; Charney 1978: 13). Charney is helpful in understanding the group feeling here when he observes, "irony is more a mood than a metaphysical assumption," since Banksy as a "comic hero" creolizes; he sets the stage for us as visitors to "be alert, ready for the unexpected, skilful, versatile, spontaneous, ingenious and able to improvise" (Charney 1978: 11).

The fact that museums necessarily operate within the law and with funding partners accounts for their hand-washing and equivocation over collaboration; they are fortresses of value as decreed by the global art market while graffiti is a criminal activity, although Watershed observed Banksy regarding graffiti as an offense to private property and viewing capitalists as the real criminal culprits. Entering the museum as visitors aware of these issues and familiar with the body of Banksy's work, and having some experience of legal graffiti art projects, we were excited to tread Banksy's playful pathway toward what we hoped may be the birth of a new museum.

The BMAG education team warmly ushered us inside to the foyer for an introductory talk on the dos and don'ts of the visit. Then, once inside the first large hall, normal rules were clearly waived or ignored, and our group happily clicked cameras and mobile phones with the rest. Sharon Heal notes in the exhibition's first months of opening more than twenty thousand Banksy versus Bristol Museum visits appeared on Flickr, the photo-sharing website much used by "hard to reach" teen-aged visitors (Heal 2009: 4). From a creolizing perspective, I agree with her contention that it is the museum's willingness to relinquish some curatorial control, to move away from the purity of a single positioning and engage in "mash-up" or complex mixture, which accounts for such a phenomenal appeal to the younger generations. The burnt out and graffitied ice-cream van reception desk (Plate 12.1) fuels this idea. The giant ice-cream cone seemingly spilt on top visually illustrates the creolization process—turning the world upside down—and promising some overturning of the established museum order.

In line with humor theory, then, Banksy made a pronouncement at the outset, a startling proposition that jerked us out of the complacency of the everyday and called us

to pay attention to the creolizing event. As an audience, we shared characteristics with theatergoers and cinemagoers—high and low cultures—agreeing to a "willing suspension of disbelief" at the beginning of the exhibition that plunged us directly into a humorous world (Charney 1978).

Banksy's art, like all humor, purges initial anxieties to relieve us of tensions and fears for the purposeful work of play. At BMAG it provided a vital way of mastering the apprehensions of the young people about entering the uncertain and mysterious museum space, which they had avoided because its unknown social codes were assumed to be at odds with their own; feelings, desires, and interests. Banksy enabled Watershed to cross the threshold of fear, which as I argued with reference to bell hooks's and Nina Simon's observations earlier, is vital for the museum concerned to engage its social role; to progress the sort of embodied knowledge and intercultural understanding between and within groups that the creolizing museum strives towards (Silverman 2010). However, as Simon notes, it is only by punctuating the "oppressively" serious tone with humor that museums can *keep* audiences engaged (Simon 2007). Humorous interest needs to be maintained during the show or the humor will flop. I turn to this point next.

Middle Passage: Visual Thinking and the Play of Difference

Pre-visit preparation facilitated positive journeying through galleries at the museum, engaging in Banksy's game, a "play of difference," not only exploring the space between self and other but between animate and inanimate, as the animatronic bunny putting on makeup (Plate 12.2) illustrates (Young 1990). Another popular animatronic was a caged monkey artist, complete with easel, brushes, palette, canvas, and paint, as well as the stereotypical beret. There was much amusing monkeying around (monkeys debating in the House of Commons and monkey queen portraits) in ways that resonate with Henry Louis Gates's thought on the "signifyin'" monkey (Gates 1988), which pointed to creolizing methods such as the devious ways voices of the subjugated express ideas through—detour, evasion, mimicry—subversion from below of the culturally dominant group, by appropriation, translation, and expropriation (Hall 2004: 32).

At Bristol, in the special exhibit gallery and throughout the museum intervention, Banksy developed the comic device of repetition (Charney 1978: 82–83). Repetition provides a secure point in an otherwise dislocated world and maintains positive feelings initiated at the outset of the humorous event, which enabled Watershed to delight in Banksy's use of incongruity, humorous juxtapositions, and deliberate mislabeling that denoted a realm of humorous possibilities swirling beneath rational discourse. As an audience, we enjoyed sharing the visual and linguistic jokes, the myriad of imaginative ways Banksy confounds and affronts the sign systems of logical, rational language, visual and written that resonates with creolization theory.

Framing, Modification, and Mockery

In creolizing museums for young people, it seems especially helpful to emphasize an area of human agency—imaginative engagement—that demands from audiences active critical thought, not the absence of thought. To take one example, Banksy works with the picture space in several ways. First, he notes the importance of framing when he writes, "The key to making great art is all in the composition" over a framed piece of the museum wallpaper. Second, he plays with historical compositions, copying and modifying famous paintings and pieces of sculpture in subtle and more dramatic ways. These modified pieces playfully present an incongruity, confusing the viewer before the joyful resolution and feeling of amusement when the joke is seen and shared. A favorite piece with us antiracists was the image of a Ku Klux Klan (KKK) member subject to the lynching inflicted on so many black people in the United States. This tiny KKK figure, taking no more than five percent of the picture plane, hangs limply in the center of a small nineteenth-century pastoral landscape painting, making a quiet commentary on the horrors of racial prejudice. During our visit it prompted much debate on violence, whether it is ever necessary to take up an armed struggle against the injustice that creolization histories note.

Other paintings poignantly mock advertising within modified historical pieces. One nineteenth-century spoof work referencing the battles between Indigenous Americans and the colonial invaders depicts four dead horses and three soldiers making a ring filling the picture plane; one soldier holds a placard reading "Luxury Loft Complex coming soon," which makes an ironic statement on ownership and the brutal seizure of Indigenous lands that creolizing perspectives highlight. In the center of another modified Claudian landscape, a billboard advertisement for easyJet is pasted, making another ironic play with art history and pointing to the problems cheap travel causes to the environment, which is a key concern of Glissant (1997).

Working together in small groups discussing the art, we became alerted to our location in history and the need to work for future cohesion. This resonates in Glissant's term "Relation" (1997) that emphasizes the alliance central to community building in creolization, and highlights the artist who "articulates this threatened reality but also explores the often hidden workings of this fragmenting process" (1999: 235). Talking about our reactions and relation to Banksy's work, we decided he plays seriously. Like Glissant, he asks us to muse on tragic histories that affect our present—politics and hierarchical subject positionings—while pointing to the vital agency of the arts to effect positive change. Banksy seems to suggest that change may be violent. In the main galleries, he ruptures the picture plane. He cuts into his fake canvas and figures physically emerge from the pictured world into the viewer's space. Here Banksy's poetics startle us into an awareness of our location as viewing subjects in the twenty-first century, just as the cinquecento painters did when their depiction of saint's toes appeared to emerge from the painting.[8]

In some works, the cutting device interrupts the pastoral mood of established art history with political messages. For example, in a famous Millet painting, *The Gleaners,*

a Creole woman, a farm worker, sits with ears of corn (Plate 12.3). She rests her left hand on the edge of the picture frame, gazing into the viewer's space in the far distance over our right shoulder and holding a cigarette in her right hand. Her body, leaning toward the other two French peasant women picking the corn, is outlined as a gaping hole cut into the fake canvas on the wall, revealing the museum wallpaper through the painting. Such art practice draws attention to the framing of knowledge in a painting and in the museum space, which are key ideas the creolizing museum concerns itself with.

Questioning Authenticity, Bodies, and Capital

Notions of revealing and concealing are evident in graffiti, since the artists need to cover their faces during illegal art work, and in Banksy's "modified" art works. For example, the outside of the museum flyer shows a traditional portrait of a woman "taken" from the New York Metropolitan Museum and "modified" with large prosthetic nose, glasses, spectacular eyebrows, and moustache (Banksy 2005: 175). Inside the flyer, "modified" examples include: Banksy's famous rat (a clever anagram for art that he pretended to "know all along" (Banksy 2005: 104) grafitting out part of a Damian Hirst spot painting; a classical sculpture modified with a suicide bomber's belt; a pixilated portrait of the artist and a painting of a Muslim woman wearing a full burkha with a plastic apron on top giving an illusion of black bra, knickers, stockings and suspender belt, which makes visible the references to underwear and sexuality normally forbidden in the social group.

Pieces such as these comment on the notion of the authentic and the fake, which is so vital to the art market that Banksy mocks. The laboring body in a capitalist global economy was another recurring theme of the BMAG show. A series of large paintings shown in the special exhibition space highlights the problem of child labor. In one painting of two small children scavenging in a rubbish dump, one child wears a raggedy T-shirt with a logo stating "I hate Mondays." The adjacent painting shows a tiny child looking out at us as he pulls a rickshaw with two very overweight tourists inside. A parasol protects the red and fleshy pair from the sun while they take a photograph of themselves on their mobile phones. Affluence and a cause of the excess of flesh is referenced in a nearby piece depicting an armored car with a giant, pink-iced doughnut fastened on top and protected by an armored guard of four policemen on motorcycles. These paintings seemed to ask the political questions pertinent to the creolizing museum, whether "capital must be protected" and "children of the Third World must be sacrificed at the altar of cheap labor."

Political messages rang in our ears as we moved through the long gallery, past examples of disguises and consciousness-raising activism: the call "Workers of the world unite" in graffiti style painted on a wall, a painting of a sitting at the House of Commons "modified" with debating monkeys, and a reconstruction of the artist's studio at the far end. Here we saw how Banksy constructs his pieces from the exquisite drawing

stage through the highly intricate stencil cutting process to the final rapid spraying technique that enables the escaping human body to evade capture and curtailment by the law enforcement officers who are the subject of perpetual ridicule.

Our group, having overcome the threat of social embarrassment and losing face in the unfamiliar museum setting, remained shy and bashful at certain points in front of strangers. For example, at the large painting on board with two life-sized classical figures, naked, with two cut-out heads and one cut-out penis in the manner of seaside humor sites. A standing platform behind the painting clearly invited visitors to fill the cut out sections by putting bodies in the gaps, to photograph a body transformed. Yet the docile visiting public during our visit rarely took the opportunity to engage in this humorous activity, inserting a fist, finger, or nose where the penis should be until authorized by our example and assurance "yes you are allowed." According to Billig, this may exemplify Erving Goffman's rule of self-respect and considerateness, where others attempt to remedy a gaffe made, reacting with care and concern rather than "superior" laughter mocking the individual, who is seen as part of a human social group (Billig 2005: 226).

Social Functions of Humor

While humor may have hundreds of different social functions, two seem to be of significance for the museum: promoting intergroup cohesion and provoking intergroup-intragroup conflict. I shall examine intergroup cohesion with reference to Gestalt theory and well-being research. According to Gestalt psychology, humor occurs in an embodied field. The phenomenal experience of persons is characterized by an outward bodily movement that the clichés "crack up," "burst out," or "split my sides laughing" capture, while the expressions "hold on," "hold tight," and "control yourself" further highlight bodies in specific situations, times, and societies (Pollio 1983: 215). Here humor is seen as breaking the person—intellect and emotion, mind and body—to free a new individual from wider social constraints and unite subgroups, which is also how I see creolization working in museums.[9]

Similarly, "Aha!" moments of pleasurable discovery unify groups in joking. First there is a perception of dissonance and incongruity, then we follow our curiosity and the urge toward reason and explanation, before the burst of insight—"Yes, I see the joke and am part of the group" (Hurley, Dennett, and Adams 2011: 78). For example, in both Banksy and in the trickster storytelling sessions of the creolizing museum, false or incongruous realities are set up, which require the visitor's careful thought to unravel. Such creolizing often foregrounds the physical potential of the body; Banksy's Ronald McDonald, for example, mirrors the graffiti climber's strength and agility as does Anansi, the spider-man trickster character of African Caribbean tales. From a creolizing perspective, Anansi tales and Banksy's Ronald also point to the power of imagination for people of all ages and physical abilities, which can promote feelings of well being (Golding 1997).

Laughter and humor have been seen since the 1970s to progress mental health by reducing stress and enhancing communication (Billig 2005: 22). At BMAG we also observed humorous communication holding "sociopositive" potential, with "Humour / Playfulness" promoting group cohesion during the Banksy work (Billig 2005: 23).[10] The Watershed experience of well-being strengthened their group connection by "playing" and sharing jokes at BMAG, which in turn progressed "Relational and Civic Strengths" subsequently during follow-up art work at the Youth Centre (Billig 2005: 27; Seligman 2002b; Seligman and Csikzentmihalyi 2000).

In other words, Banksy's art, working like jokes with "surprise" and "incongruity," seemed to act as an emotional amplifier that the group leaders intentionally used to "boost positive emotions," which are so vital for young people whose future life chances depend on finding socially supportive spaces of enjoyment that might aid the management of intense feelings (Hurley et al. 2011: 39, 253). Our BMAG experiences support the proverb that "laughter is the best medicine," which is reinforced by the physiological evidence observing beneficial effects on students hearing good jokes. It seems that joking releases an endogenous opiate (nature's painkiller) without suffering real pain that needs to be neutralized (Amada 1993: 158; Hurley et al. 2011: 253).[11] Play theorists also suggest nonaggressive play and humor is important in facilitating group cohesion from the earliest years of childhood. Children play and play at; being doctor one minute and dog the next, they learn acting is funny and fun. At BMAG we saw our young people creolizing, engaging their imaginations in positive play, which brought feelings of liberation and a perception of new pathways, as I shall explain.

Ending/Continuing—Afterward

Our humorous Banksy event ended in typical fashion with feasting in the park after our "Exit through the Gift Shop" (Charney 1978: 88).[12] The Banksy work showed humor is part of liberatory practice, and sharing it in a social group is good work vital to democratic conversations. We talked throughout for amusement, connection, and communication, but creolizing museum practice does not stop at the museum doors, and it was at Watershed that ideas and issues were extended. A large display covering one wall of the reception area with images taken at the museum served as a reminder and reference point for art, drama, and health sessions. For example, images of animatronic chicken nuggets "pecking" their own dipping sauce and fish fingers "swimming" in their bowl contributed to dialogical work on diet and healthy eating, providing a humorous entrance to these serious issues. Most notably, Banksy's shopping trolley (seen in "Rock art" and the reconstructed studio) inspired Leicester Carnival 2009 work, which won first prize.[13]

Conclusion

This chapter has begun to discuss the value of bringing a breadth of theory from creolization and humor studies to museology. It pointed to humor as a key feature of

our common humanity and a way of creolizing the museum space. However, I want to emphasize that while humor is found in all societies it is crucially subject to local variation, having universal and particular, social and antisocial features; it can provide a binding cohesive force that draws people together and it can serve exclusionary purposes.[14] To highlight this complexity I outlined art practices that humorously revealed colonial histories of oppression and contemporary pretensions to respectability by gently mocking museum hierarchies and the art world. In summary the chapter illustrated humor creolizing museums by vitally opening spaces to fresh interpretations and presenting possibilities for inserting new identities. Notably my Watershed work critiqued the values of an acquisitive society and the traditional museum, where things are perpetually sought, pursued, hunted, bargained for, or stolen before being fixed in categories, whereas creolizing takes delight in rule breaking—turning the proper upside down—to celebrate the possibilities of finding new ways of ordering and valuing our world and each other.

For museums the chapter shows how curators collaborating with artists, seriously addressing colonial histories and laughing at our museums, can transform them into a "Home Sweet Home," as Plate 12.4 states, which may offer an untapped area to encourage "difficult" youth audiences through the doors. Humor challenges James Boon's point in his important essay that regards museums as "beautiful tombs" from which we must turn in an effort to resist pessimism and the overwhelming feeling of sadness. Yet, even Boon, speaking of fragments, the results of pillage, humorously reflects on the compulsion to collect and to pass on for prosperity disparate items such as "my rat's testicles," bequeathed to a "learned and worthy friend Dr. Johannes Elscirckius in the novel . . . which may mark 'the other side of sadness' satiety, museumy melancholy, mirth" (Boon 1991: 257, 258). It is this other side, pointing to a more positive way of seeing for economically disadvantaged youth, which I have started to explore in this chapter.

The art I discussed creolizes museums in working with the political, moral, and aesthetic dimensions of humor. I should note here that while some humorous acts appear rebellious, daring, challenging to the status quo, transgressive of polite and established behavioral codes, like all humor the consequences may be disciplinary rather than rebellious. In other words, what we experience as humor may have a disciplinary function. We may question whether, if at all, the Banksy exhibit transformed the traditional hierarchies of power and control in the museum. To what extent has this intervention transformed future exhibitionary practice? Does humor really call us to our senses, do we laugh our politicians out of office or change the nature of the serious museum?[15]

I recognize that humor may not subvert the established order, and that positions of power remain intact, yet at the moment of humor we do feel—creolization—a sense of freedom. I speak in an optimistic tone. Creolizing the museum with humor points to difficulties as fortuitous and temporary. I argue that while the positive value of humor is time bound, and everyday rules are only suspended temporarily and continue to apply outside of the humorous museum event, the triumph of witty ingenuity points to wider possibilities for individuals and new ways of organizing society; it civilizes.

Notes

I would like to acknowledge the Arts and Humanities Research Council (AHRC) for their support of this project. It was at the AHRC-funded "Behind the Looking Glass 'Other' Cultures within Translating Cultures" network meetings where I first discussed these ideas.

1. Watershed Youth Centre (opened in 1991) is situated in central Leicester, in Bede Island, Upperton Road, Leicester, UK. The group I consider is composed of fourteen young people aged fifteen to twenty-five years old (six of whom were NEET or Not in Employment, Education or Training), together with five of their key workers and four volunteers (including myself). This cohesive group, reflecting the ethnic diversity of the Leicester population, made a study visit to the Banksy versus Bristol exhibition at the Bristol Museum and Art Gallery on July 31, 2009.

2. The term *Creole* refers to Europeans who moved to colonies during imperialism, their white descendants living in the postcolonial world, those of African heritage and mixed peoples who were enslaved.

3. This point has resonance in the term *survivance* employed at the NMAI noted in Chapter 1 of this book.

4. Lucy Lipard observes *Rammentare* is translated as *remember* in Italian but literally means *rethink* (Lippard 2009: 31).

5. See Chapter 1 in this volume.

6. The 2011 census records the population of Leicester at 279,921 and for England and Wales at 52,041,916 (www.leicester.gov.uk/your-council-services/council-and-democracy/city-statistics/demographic-and-cultural/). Leicester has areas of wealth as well as areas of extreme and multiple deprivation, and is ranked the twentieth most deprived local authority region (out of 354), according to the Index of Multiple Deprivation (available at http://data.gov.uk/dataset/index-of-multiple-deprivation, accessed on December 12, 2009). Nearly half the population live in areas classified as the fifth most deprived in the country.

7. In 2007 the schools recorded the ethnically white population at 44 percent and it is predicted that in 2016 Leicester may become the first English city with a majority population (up to 60 percent) from a minority or religious background. In Leicester, the majority of ethnic groups are spread across the city rather than isolated in pockets, and the largest minority ethnic community, until recently Hindu and Gujarati speakers, migrated with an entrepreneurial spirit, having been expelled from Uganda in the period from 1965 to 1967 and Uganda and Kenya on August 4, 1972 (available at www.researchasylum.org.uk/?lid=1304, accessed February 16, 2011). The 2011 Census recorded the largest single minority ethnic community group in the city to be of Indian origin at 25.7 percent (72,000), ranking Leicester with the largest Indian population of any local authority area in England and Wales. Subsequent migrations from the Indian subcontinent include Sikhs from Kashmir and Muslims from Bangladesh (ibid.: pdf 136465).

8. In another work, a man rows a boat with a rather tubby woman holding a parasol. Their boat sits precariously on a wave tipping right over the framed edge of a painted river and mountain landscape. The man's gaze is directed back toward the painted scene while the woman looks out at us and brazenly holds our gaze in a manner reminiscent of Manet's *Odelesque*.

9. The thoughtful emotional body is often a focal point of humor. In Banksy, we smile at the large false nose because it is identified with another person, not my self and not my body; at that moment we experience freedom and feel "superior"; contrariwise, humorous smiles and laughter may mark an empathetic response, a reaching out in sympathy for the "victim," and a human request for relationship with others we identify with (Pollio 1983: 225).

 In this sense perhaps the emotional body in the humorous event resonates in Aristotle's notion of catharsis, which follows the arousal of human emotions such as 'pity and fear' in the safe space of dramatic tragedy.

10. We should note here that there are types of humor with "socionegative" features that can progress division.

11. Furthermore, evidence from evolutionary theorists reinforces the positive value of humorous play, suggesting one purpose of play is to sharpen the mind's physical, cognitive, and emotional skills, which would reduce the real risk of getting caught by predators.

12. *Exit Through the Gift Shop* is Banksy's "mockumentary/documentary" film, which premiered at the 2010 Sundance Film festival. The film was also nominated for the Academy Award for Best Documentary Feature at the Eighty-Third Academy Awards.

13. I should point out here that the timed museum trip is limited. Like all humorous events, a strong entry point and good pacing during the visit was vital. Conversations flowed in the exhibition, sparked by the humorous work, but it was later, at moments of reflexivity, that deeper questions could be considered. For example, questions were raised at the Centre about when humor and laughter might be inappropriate. Sharing humor in a group, individuals come to realize they are in the same situation and this has been seen to indirectly build confidence in extreme circumstances such as Nazi death camps. However, while the gallows humor of condemned prisoners and the jokes told by Jews in Auschwitz have been seen as ways to ease tensions in the face of unbearable reality, joking by outsiders at times of major misfortunes may be hurtful. The racist jokes following the 2009 flood in India and Bangladesh were widely agreed to be not "just a joke" but morally incorrect responses by this mixed group with personal heritage or friendship connections; concern and practical care were shown through cake and white elephant sales (Billig 2001).

14. The youth workers encouraged the positive features of humor to unite and further group cohesion, but also discussed the bounds between positive and negative humor that is divisive and hurtful.

15. Most worrying, at the time of writing Watershed is threatened with a severe cutback of funding that may close the Centre.

References

Abte, M. L. 1983. "Humour Research, Methodology and Theory in Anthropology." In *Handbook of Humour Research,* eds. P. E. McGhee and J. H. Goldstein, 183–212. New York: Springer-Verlag.

Amada, G. 1993. "The Role of Humour in a College Mental Health Program." In *Advances in Humour and Psychotherapy,* eds. W. E. Fry and W. A. Salameh, 157–183. Sarasota, FL: Professional Resource Press.

Ash-Milby, K. and T. T. Lowe, eds. 2009. *Most Serene Republics Edgar Heap of Birds.* Washington, DC: Smithsonian Institution.

Banksy. 2005. *Wall and Piece.* London: Random House.

Bhabha, H. 1995. *The Location of Culture.* London: Routledge.

Billig, M. 2001. "Humour and Hatred: The Racist Jokes of the Ku Klux Klan." *Discourse and Society* 12: 267–289.

Billig, M. 2005. *Laughter and Ridicule Towards a Social Critique of Humour.* London: Sage Publications.

Boon, J. 1991. "Why Museums Make Me Sad." In *Exhibiting Cultures*, eds. I. Karp and S. Lavine, 255–277. Washington, DC: Smithsonian Institution.

Bristol Museum and Art Gallery (BMAG). 2010. Available at: www.bristol.gov.uk/page/bristol-museum-and-art-gallery. Accessed on December 29, 2010.

Chaat Smith, P. 2009a. "Luna Remembers." In *Everything You Know about Indians Is Wrong,* 88–102. Minneapolis: University of Minnesota Press.

Chaat Smith, P. 2009b. "A Place Called Irony." In *Everything You Know about Indians Is Wrong,* 145–150. Minneapolis: University of Minnesota Press.

Charney, M. 1978. *Comedy High and Low: An Introduction to the Experience of Comedy.* Oxford: Oxford University Press.

Cohen, R. and P. Toninato, eds. 2010. *The Creolisation Reader: Studies in Mixed Identities and Cultures.* London: Routledge.

Day, E. 2010. "The Street Art of JR." *The Observer* (March 7). Available at: www.guardian.co.uk/artanddesign/2010/mar/07/street-art-jr-photography. Accessed March 5, 2011.

Freud, S. [1905] 1976. *Jokes and their Relation to the Unconscious,* vol. 6. Harmondsworth: Penguin.

Freud, S. [1913] 1972. *Totem and Taboo,* trans J. Strachey. London: Routledge & Kegan Paul, Ltd.

Freud, S. [1921] 1985. "Group Psychology and the Analysis of the Ego." In *Civilization, Society and Religion,* vol 12. Harmondsworth: Penguin.

Gates, H. L. 1988. *The Signifying Monkey: A Theory of African-American Literary Criticism.* New York: Oxford University Press.

Glissant, E. [1990] 1997. *Poetics of Relation,* trans. B. Wing. Ann Arbor: University of Michigan Press.

Glissant, E. [1989] 1999. *Caribbean Discourses,* trans. M. Dash). Charlottesville: University of Virginia.

Golding, V. 1997. "Meaning and Truth in Multicultural Education." In *Cultural Diversity: Developing Museum Audiences in Britain*, ed. E. Hooper-Greenhill, 203–225. Leicester: Leicester University Press.

Golding, V. 2007a. "Challenging Racism and Sexism at the Museum Forum." In *I am Black, White and Yellow An Introduction to the Black Body in Europe*, eds. J. Anim-Addo and S. Scafe, 148–166. London: Mango Publishing.

Golding, V. 2007b. "Learning at the Museum Frontiers: Democracy, Identity and Difference." In *Museum Revolutions*, eds. S. Knell, S. MacLeod, and S. Watson, 315–329. London: Routledge.

Golding, V. 2007c. "Using Tangible and Intangible Heritage to Promote Social Inclusion for Students with Disabilities: 'Inspiration Africa!'" In *Museums and their Communities*, ed. S. Watson, 358–378. London: Routledge.

Golding, V. 2009. *Learning at the Museum Frontiers: Identity Race and Power.* Surrey: Ashgate.

Hall, S. 1994. "New Ethnicities." In *Race, Culture and Difference*, eds. J. Donald and A. Rattansi, 252–259. London: Sage.

Hall. S. 2004. "Creolite and the Process of Creolization." In *Creolite and Creolization*, eds. O. Enwezor, C. Basualdo, and U. M. Bauer, 27–41. Kassel: Hatje Cantz Publishers.

Hannerz, U. 1996. *Transnational Connections.* London: Routledge.

Hannerz, U. [1986] 2010. "The World in Creolization." In *The Creolisation Reader: Studies in Mixed Identities and Cultures*, eds. R. Cohen and P. Toninato, 376–388. London: Routledge.

Haraway, D. 1991. "Situated Knowledges: The Science Question in Feminism the Privilege of Partial Perspectives." In *Simians, Cybourgs and Women: The Reinvention of Nature*, 183–201. London: London Free Association.

Heal, S. 2009. "Editorial: Making an Exhibition of Yourself Pays Off." *Museums Journal* (September): 4.

Heap of Birds, E. 2007. Most Serene Republics. Available at: www.nmai.si.edu/exhibitions/msr/MostSereneRepublics.html.

Hill-Collins, P. 1991. *Black Feminist Thought Knowledge, Consciousness and the Politics of Empowerment.* London: Routledge.

Höller, C. 2006. Test Site. Available at: http://www.tate.org.uk/whats-on/tate-modern/exhibition/unilever-series-carsten-holler-test-site/carsten-holler-interview), Accessed 16 February 2012.

hooks, b. 1992. *Black Looks, Race and Representation.* Boston: South End.

Hurley, M. M., D. C. Dennett, and R. B. Adams. 2011. *Inside Jokes. Using Humor to Reverse Engineer the Mind.* Cambridge, MA: The MIT Press.

JR. 2012. Available at: www.fatcap.com/artist/jr.html; http://www.tedprize.org/jr-2011-ted-prize-winner/.Accessed February 16, 2012.

Lippard, L. 2009. "Signs of Unrest Activist Art by Edgar Heap of Birds." In *Most Serene Republics Edgar Heap of Birds*, eds. K. Ash-Milby and T. T. Lowe, 17–33. Washington, DC: Smithsonian Institution.

Luna, J. 1985. Artifact Piece. Available at: www.jamesluna.com/oldsite. Accessed March 5, 2012.

Mintz, S. 1998. "The Localization of Anthropological Practice: From Area Studies to Transnationalism." *Critique of Anthropology* 18: 117–133.

Morreal, J. 1983. *Taking Laughter Seriously.* Albany: State University of New York Press.

Morrison, T. 1994. "Living Memory: A Meeting with Toni Morrison." In *Small Acts: Thoughts on the Politics of Black Cultures,* ed. P. Gilroy, 173–182. London: Serpents Tail.

Plato. 1974. *The Republic of Plato,* trans. F. MacDonald and F. Cornford. London: Oxford University Press.

Pollio, H. R. 1983. "Notes Towards a Field Theory of Humour." In *Handbook of Humour Research,* eds. P. E. McGhee and J. H. Goldstein, 213–230. New York: Springer-Verlag.

Said, E. 1993. *Culture and Imperialism.* London: Chatto and Windus.

Sandell, R. 2007. *Museums, Prejudice and the Reframing of Difference.* London: Routledge.

Sandell, R. and J. Dodd. 2010. "Activism Practice." In *Re-Presenting Disability: Activism and Agency in the Museum,* eds. R. Sandell, J. Dodd, and R. Garland-Thompson, 3–22. London: Routledge.

Seligman, M.E.P. 2002. "Positive Clinical Psychology." In *A Psychology of Human Strengths,* eds. L. G. Aspinwall and U. M. Staudinger, 3–12. Washington DC: American Psychological Association.

Seligman, M.E.P. and M. Csikzentmihalyi. 2000. "Positive Psychology: An Introduction." *American Psychologist* 55: 5–14.

Sheller, M. 2003. "Creolization in Discourses of Global Culture." In *Uprootings / Regroundings: Questions of Home and Migration,* eds. S. Ahmed, C. Castaneda, A. M Fortier, and M. Sheller, 273–294. Oxford: Berg.

Silverman, L. 2010. *The Social Work of Museums.* London: Routledge.

Simon, N. 2007. "What's So Funny: Humor in Museums." museumtwo.blogspot.co.uk (August 16). Available at: http://museumtwo.blogspot.co.uk/2007/08/whats-so-funny-humor-in-museums.html. Accessed March 2, 2012.

Simon, N. 2010. *The Participatory Museum.* Museum 2.0, Santa Cruz, California. Available at: http://www.participatorymuseum.org/read. Accessed December 1, 2012.

Smith, B. 1993. "Towards a Black Feminist Criticism." In *The New Feminist Criticism,* ed. E. Showalter, 168–185. London: Virago.

Young, I. 1990. *Justice and the Politics of Difference.* Princeton, NJ: Princeton University Press.

–13–

Museums and Civic Engagement
Children Making a Difference

Elizabeth Wood

Dramatic shifts in museum practice over the last thirty years suggest that, despite the snail's pace, change is possible (Janes 2009; Weil 1995, 1999). From the growth of children's museums and science centers, the de-emphasis of collections, and the rise of community-curated exhibitions, museums are focusing more on the needs of the audience (Falk and Dierking 2000; Hooper-Greenhill 1999; Weil 1999). However, across these many "new" museums and even in the older, venerated institutions, exhibition content and delivery remain relatively conservative in their choices to portray difficult topics. In particular, exhibitions focused on racism, prejudice, and intolerance seem to be relegated to the "niche" museums—those that focus specifically on a special topic or specific audience. Of the more notable examples are District 6 Museum in South Africa, the Japanese National American Museum in the United States, the Terezin Memorial in the Czech Republic, and other member organizations of the International Coalition of Sites of Conscience (2010). While there are many other small-scale examples in numerous museums across the globe, the stark reality is that many comprehensive collecting museums do not consider their purview to include core issues of social justice—racism, sexism, colonialism, classism, and so forth.

Although it is not uncommon for general interest museum exhibitions to address racism, prejudice, and intolerance, these presentations are frequently restrained (Bunch 2007; Teslow 2007). The process of engaging in dialogue on, taking ownership of, and taking a more pointed stand on issues of racism or prejudice may be more frequently viewed as the role of niche museums, where community or issue-specific themes provide the foundation for critical examination (Gurian 2006). Few general interest and even fewer family-oriented museums take on such topics with the specific intention to explore social justice or civic engagement. As Teslow notes, "the existence of small, personal exhibitionary projects and to some extent the proliferation of 'ethnic' museums, speaks to the reluctance of some larger, better-funded and more visible institutions to present painful pasts" (2007: 24). The risks for larger museums can be significant, but they can also be rewarding.

The challenge for these institutions is in navigating the social implications and recognizing the influence of dominant cultural values within the museums' own communities.

While the museum exhibition itself is simply a medium for communication and interpretation, this *interpretation* is shaped by the dominant culture carried by many museum workers and museumgoers alike (Weil 1995). The notion that such contentious topics as racism can be portrayed objectively is perhaps a remnant of the "old ways": "opinions about whether museums have a responsibility to represent contentious topics are grounded in the belief that museums are apolitical" (Cameron 2008: 331). A museum's ability to navigate the interpretations of controversial topics relies heavily on the approaches taken by its staff to effectively and appropriately convey exhibit information.

Mounting exhibitions that focus on civic engagement and social justice issues cannot be the realm of the niche museum, nor should these topics become the primary objective for every museum (Sandell 2002). Instead, museums might take advantage of their role as social institutions where difficult topics can be dealt with appropriately, as Janes (2009) suggests.

In 2007, The Children's Museum of Indianapolis opened a permanent exhibition entitled The Power of Children: Making a Difference. The interactive exhibition provides families the opportunity to explore racism, prejudice, and intolerance through the stories of three historically significant children. The exhibit aims to support the development of empathy and commitment in children and adults in order to create positive change within their communities. The experiences and messages in the exhibition demonstrate the commitment to take on this topic in a museum more popularly known for dinosaurs and carousel rides (The Children's Museum 2010).

This chapter explores the conceptual design and development of The Power of Children exhibit and examines the influences of critical pedagogy and the ongoing efforts to promote dialogue around issues of intolerance with families. This chapter outlines a proposed framework for critical museum pedagogy that demonstrates that not only niche museums can provide a broad-level effort to bring issues of civic engagement and social justice to the forefront (Wood 2008).

Critical Museum Pedagogy

Critical pedagogy, following the basic principles set forth by Freire (1989) and expanded on by many others (see, for example, Giroux 1988; McLaren 1989; Shor 1997; Wink 1997), at its fundamental level represents a wide range of educational approaches that highlight the influence of political, social, economic, and cultural contexts on human lives. It is an approach that recognizes the significance of power, language, morals, values, and social and cultural relationships in all aspects of learning. The potential for museums to undertake transformative, liberatory teaching and learning is at once appealing and daunting. As Hooper-Greenhill suggests:

> To perceive the educational role of the museum as a form of critical pedagogy entails understanding the museum within a context of cultural politics; it means acknowledging the constructivist approach to knowledge and to learning; and it means recognizing the fact that museums have the potential to negotiate cultural borderlands, and create new contact zones where identities, collections, people and objects can discover new possibilities for personal and social life and, through this, for democracy. (1999: 24)

While museum education and exhibition development is expanding beyond traditional, didactic approaches in favor of more constructivist approaches (see Hein 1998), moving toward a critical pedagogy in museums is much more challenging (Lindauer 2007). At the heart of this work is the recognition that museums must work toward creating conditions where visitors can connect with the meaning of an exhibition and connect this to the ongoing struggle for power and change (Golding 2009; Hooper-Greenhill 1999; Lindauer 2007). It poses a dramatic challenge to the traditional hegemonic structure of museums where dominant cultural values are preserved and celebrated. The notion of employing critical pedagogy in museum exhibitions requires an orientation to museum work that unites an exhibition or program's *context, content,* and *methods* (Wood 2008) around the idea of transformation and emancipation. Within each of these three areas the principles and practices of critical pedagogy play a particular role and function in the development and ultimate implementation of ideas.

Context

For critical museum pedagogy, the exhibition context reflects the museum's physical location, a neighborhood or community, as well as its role as a shared cultural resource for the public at large. Simply *re*placing the museum into its local context can help focus the purpose and process of the exhibition itself. The museum becomes a setting for the shared transformation of all those who come together to experience the exhibitions and programs. Within this context the inspiration for the exhibition evolves from shared discourse drawn from local needs and interests, and builds on collective ownership and knowledge. In these situations, the community's knowledge and expertise blends with that of the museum, its resources, and collections. This practice can lead to greater connection between communities and museums and reiterates the range of knowledge that contributes to visitors' understanding of exhibition content.

Visitor understanding stems from a motivation by visitor and staff alike to explore new perspectives and differing viewpoints and to question the conditions that create problems such as racism and intolerance. When community members and visitors are asked to take part in the shaping of the content along with the museum staff, the shared discourse builds the potential for new ways of knowing and inspiration for change (Abram 2005; Archibald 2004; Janes 2009; Wood 2009). In short, the idea of a localized context helps to remove the expectation that this work can only be done in niche museums: the local focus becomes the museum's own niche.

Content

The context of the exhibit, as a localized and shared space for discourse, is balanced by the selection, interpretation, and representation of exhibition content. This includes the recognition of objects as polysemic (Hooper-Greenhill 2000) and as vehicles for varied meanings and interactions for visitors (Wood and Latham 2009). Equally important in

decision making for exhibition content is the inclusion of local needs, issues, and contexts. The collections material and local context thus inform, rather than dictate, each other on content choices.

The interpretation of museum content from a critical pedagogy perspective will focus on highlighting the range of potential ways of knowing objects and concepts (Wood and Latham 2009), questioning the use and emphasis of particular cultural artifacts and symbols, and reinterpretations of thematic organization of artifacts. The potential for stimulating questions and challenges to the existing cultural notions of content can be expanded; notwithstanding, of course, the potential for visitors to be riled at the task. A notable example of such a reinterpretation of content is Fred Wilson's 1992 exhibit, Mining the Museum, at the Maryland Historical Society. Artistic representations such as these clearly and fluently articulate new meaning and interpretations. Too frequently curatorial practices fail to find this level of enlightenment (McLean 2007).

Method

The methods and practices typically utilized in exhibition development draw heavily on the content backgrounds of curators and exhibit developers, creating an interdisciplinary milieu for understanding and interpreting themes and collections. Coupled with this orientation are the museum's own developmental processes (and culture), audience foci, and overall approach to exhibitry. Thus, expectations for the method of devising an exhibition in an art museum vary quite dramatically from those in a hands-on or interactive museum. The research and development for these exhibits, as well as their assumptions, are inherent in an institutional orientation. Following a critical pedagogy approach, such assumptions about content, type of museum, and audience needs can be reengineered to focus on using themes and collections as cultural products that can reveal constructed reality and meaning (Hooper-Greenhill 2000). Exhibit elements can be formed with an emphasis on more probative behaviors that support interaction between visitor and object or between visitors.

Emphasis on dialogic interactions, questioning strategies, and different orientations to the museum's "texts" (the artifacts, the labels, the visual media, etc.) can aid the visitor in deciphering multiple meanings. The critical orientation of decoding allows visitors the opportunity to expand their perspectives on particular topics and observe the subjective ways in which meanings are made and the potentials for acting on those meanings. The promotion of new horizons for change is equally valuable as a method. Imagining new possibilities allows for the transformation and liberation of existing struggles. Possibility helps to create agency and ability to question the status quo. Greene suggests, "it is a matter of awakening and empowering today's young people to name, to reflect, to imagine, and to act with more and more concrete responsibility in an increasing multifarious world" (1997: 7). Providing this level of action and reflection gives new meaning and focus to the important work that museums can have not only for young people, but for all visitors.

From Theory to Practice: A Case Study of The Power of Children: Making a Difference

The orientation to critical pedagogy in the museum outlined previously suggests that there is much more to this process than meets the eye, but using this approach is not an impossible task. The interconnected natures of context, content, and method provide a formidable undertaking that impels museum staff toward a diligent and focused process of exhibit development. This section provides an in-depth case study of The Power of Children: Making a Difference in its attempt to provide more than just a historical review of its content. Rather, the exhibition pursues a more significant investigation of the conditions and situations that often lead to racism, prejudice, and intolerance.

Exhibit Background and Overview

The Power of Children: Making a Difference is a 10,000 square-foot (930 m²) permanent exhibition at The Children's Museum of Indianapolis that opened in the fall of 2007.[1] One of the museum's ten permanent exhibit spaces, this exhibition deals with the most serious topics of racism, prejudice, and intolerance. However, this orientation is somewhat underplayed in the museum's official marketing materials:

> The Power of Children Gallery at The Children's Museum of Indianapolis takes visitors on a journey through the lives of three children who faced profound trials and emerged as heroes of the 20th century. The stories of Anne Frank, Ruby Bridges, and Ryan White exemplify for children and adults how every individual can make a difference. (The Children's Museum 2010)

Included in the exhibition are four primary pathways visitors can follow to investigate and experience the lives of Anne, Ruby, and Ryan. Each child's pathway presents a section on the historical and social conditions leading up to their individual experiences, an immersive space that explores in-depth aspects of each child's life, and an area that provides more information, context, and background on the focus child as well as others who faced similar treatment. A fourth pathway presents the visitor with an opportunity to "make a promise" to take action on social issues.

Although Anne Frank's life is familiar to millions of people worldwide, most museum visitors do not know the stories of Ruby Bridges and Ryan White. The inclusion of Anne's story in this exhibit helps create the overarching theme not only of making a difference—ostensibly through the writing of her diary—but also an arc of late-twentieth-century history that unites multiple generations of visitors.

Ruby Bridges, perhaps most notably recognized as the child in Norman Rockwell's 1964 painting, *The Problem We All Live With*,[2] was among the first African American children to integrate New Orleans public schools in 1960. As a six-year-old, she endured

endless violent protests, largely by adults, and ridicule as she went to school each day. As a representation of the struggles of racism and integration in the United States during the civil rights era, her story reflects her first year integrating William Franz Elementary School. White parents removed their children from her class and she spent the year alone with her teacher.

Ryan White's story represents a local connection for Indiana. In the early 1980s, Ryan, then a resident of Kokomo, Indiana, was diagnosed with pediatric HIV/AIDS, the result of a complication from treatments for hemophilia. At the time, HIV/AIDS was an emerging disease and the causes of the illness were simply unknown. The local reaction to Ryan's contraction of AIDS included limitations on his access to school and use of public facilities. Ultimately, the community barred Ryan from school altogether. Despite his youth, he mounted a very public campaign to educate others on the devastating effects of the disease, and, most important, to change public perceptions, stereotypes, and misconceptions.

The Take Action area of the exhibit encourages families to work together to identify local issues and problems and consider how to bring about change. In addition to this orientation toward action, visitors have opportunities to create action plans, identify volunteer opportunities, and make promises. A major component of this area is the Tree of Promise, modeled after the great chestnut tree that inspired Anne Frank. In this area, visitors make public commitments to bring about change, using a computer-based system to track their efforts or purchasing a silver leaf engraved with their message.

Exhibit Experiences

The Children's Museum of Indianapolis is a collecting institution, housing over 110,000 artifacts from natural history, cultural history, and American popular culture. It also features highly immersive, recreated environments and hands-on interactive elements to support children's learning. The Power of Children is no exception and houses a number of authentic and replicated artifacts, including the entire contents of Ryan White's bedroom, Nazi uniforms and symbols, a replica of Anne Frank's diary, civil rights-era documents, and an array of artifacts from each topic child's era to provide greater cultural context for multigenerational visitors.

In each area, a combination of artifacts, exhibit interactives, and label text provides visitors with thought-provoking experiences to drive discussion and contemplation. A series of multimedia productions offers short interpretations of each child's story. These presentations emphasize images, sounds, and narration, and draw on specialized lighting to highlight different artifacts in each of the areas. In addition to these multimedia selections, professional actors present live theatrical presentations on regular basis. Within each section of the exhibition, visitors may see performances that further elaborate on the story of each child: they might watch a monologue by Miep Gies describing the challenges of living in the secret annex; an account by a federal marshal who escorted Ruby to school each day; or an actor portraying Ryan White as

he prepares for his testimony in front of the United States Senate. These museum theater presentations provide another level of connection for visitors to the deeply felt emotional experiences of these children.

Finally, the label framework designed for the exhibition incorporates a variety of strategies to promote discussion and dialogue. These include asking key questions related to artifacts and their relationship in the story of making a difference and promoting further investigation of historic events, suggestions for taking action, and overall collaboration and discussion (The Children's Museum 2007).

Analysis of Critical Pedagogy Approaches

The initial aims of The Power of Children exhibition positioned the issues of racism, prejudice, and intolerance in a framework of historical storytelling. The opportunity to showcase the stories of Anne, Ruby, and Ryan was driven more by an effort to demonstrate history and philanthropy. While these orientations remain, the final iteration marks a notable attempt by the curatorial team in using elements of critical pedagogy for the development of an exhibition. Following is an analysis of the exhibit using the areas of critical museum pedagogy described earlier. As the analysis shows, a children's museum context along with the content of racism, prejudice, and intolerance proves to be a challenging blend, and the result is somewhat timid. However, despite difficulties along these lines, The Children's Museum of Indianapolis's attempt to mount an exhibition of this type in a children's museum is laudable and important (American Association of State and Local History 2009; Wood and Cole 2007). While the success of the exhibit is construed across multiple factors, the stature of a museum of this size and focus reiterates the value of positioning social justice and civic engagement topics in more than just niche museums.

Context

A major consideration of the exhibition context is its intended age range. While the target audience for the exhibit is eight to ten years old and older, the majority of museum visitors fall under that range. According to the exhibition evaluation, in 2008 and 2009, nearly half of all the visitors to the exhibition were under the target age (Wolf 2009). Though potentially a frustrating experience for visitor and exhibit developer alike—the composition of family visitors creates a unique situation for critical pedagogy in museums—such approaches are not out of the question for this age group (see, for example, Kilderry 2004). Another contextual consideration is the fact that the exhibition itself competes internally with similarly sized exhibitions focused on dinosaurs, a working carousel, hands-on science experiments, and any number of other temporary exhibitions with popular culture themes. The Power of Children is certainly not what many visitors expect to encounter, and when they do they must quickly determine their level of

attention and engagement with the content. This dissonance can sometimes result in visitors actively avoiding the exhibition or making plans to return at a later date. Those who do choose to visit find the experience meaningful and emotionally potent.

Elements of The Power of Children draw on localized knowledge, most specifically in the Ryan White and Ruby Bridges sections. Ryan White, as a resident from central Indiana, carries the greatest localized connection in the exhibit. Multiple references and connections to local schools, hospitals, and locations are portrayed in the Ryan White story to which visitors can relate. In addition, the exhibition development team worked closely with those close to Ryan, and their contributions informed various aspects of the story as it unfolded. In the Ruby Bridges section, two different artifact cases highlight the specific experiences of racism in Indiana during the civil rights era. The team interviewed Ruby Bridges as well as members of the local Indianapolis community to build on the experiences portrayed in the exhibition. Similar, though far less overt, is a small element of the Anne Frank section that highlights artifacts from local Holocaust survivors. In each of these instances, the exhibit elements clearly portray the voices and knowledge of others (outside that of the curatorial voice). These localized depictions reiterate the shared connections between the primary story and personal associations that humanize the experience.

Shared discourse and interaction with new points of view stem from various interactive elements, many of which invite visitor responses and hope to inspire dialogue between visitors. In particular, several graphic and text panels prompt visitors to respond via sticky notes within each area of the exhibition. These include questions such as "What would you want to change?" or "Why is it hard to speak up when we see something wrong?" (The Children's Museum 2008). However, in most instances to date, there is no evidence that visitors are responding to other visitor comments; rather they are more likely responding directly to the exhibit prompt (Wolf 2009). Gallery programming through the museum theater also has potential to elicit shared discourse. While a more rigorous strategy for post-performance discussion is in development, the majority of deep interactions are made between visitors—though these are often unintentional benefits of the visitation. For example, many adult visitors are willing to share their own experiences with racism and prejudice during the civil rights era, as are others who experienced the effects of World War II either as Holocaust survivors or soldiers (Wolf 2009).

Overall, the contextual effect of the exhibit highlights local connections to the exhibit themes. While most of these experiences have potential for shared discourse and dialogue, the contextual features do not appear to promote the underlying connections. Many aspects of the exhibit context promote the involvement of local community members in the development of these ideas, yet these contributors are not fully recognized in all instances. While there was a concerted effort to involve members of the community and those whose lives were affected by or intersected with the primary subjects, greater demonstration of their role would help to promote the overall breadth of knowledge shared for the preparation of the exhibit.

Plate 9.1 Aunty Rose, panel with feather flowers, Migration Memories exhibition in Robinvale (2007). Photograph © Jo Sheldrick

Plate 9.2 Tory Pisasale's family at the Migration Memories exhibition in Robinvale (2007). Photograph © Mary Hutchison

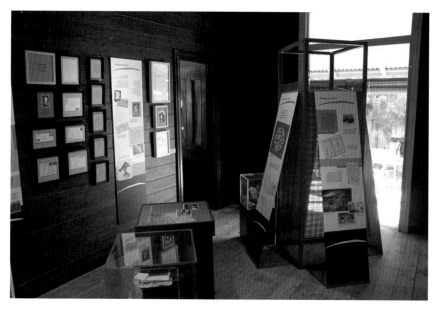

Plate 9.3 A view of Migration Memories displays in the main room of the Lightning Ridge Historical Society gallery. Photograph © Ursula Frederick

Plate 10.1 Audiovisual touch screen in the Northern Spirit gallery. Photograph © Nicola Maxwell

Plate 10.2 Digital projection in the Northern Spirit gallery. Photograph © Nicola Maxwell

Plate 10.3 Sound bench in the Northern Spirit gallery. Photograph © Nicola Maxwell

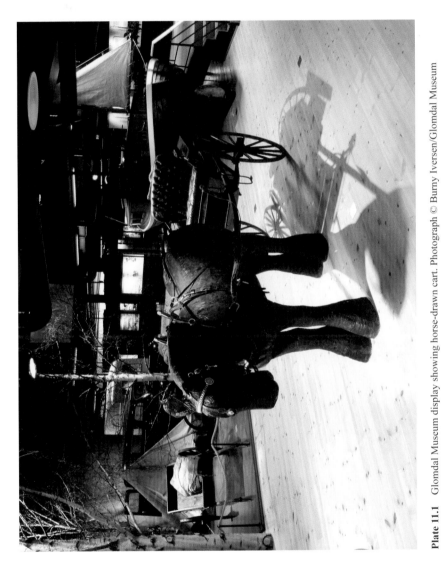

Plate 11.1 Glomdal Museum display showing horse-drawn cart. Photograph © Burny Iversen/Glomdal Museum

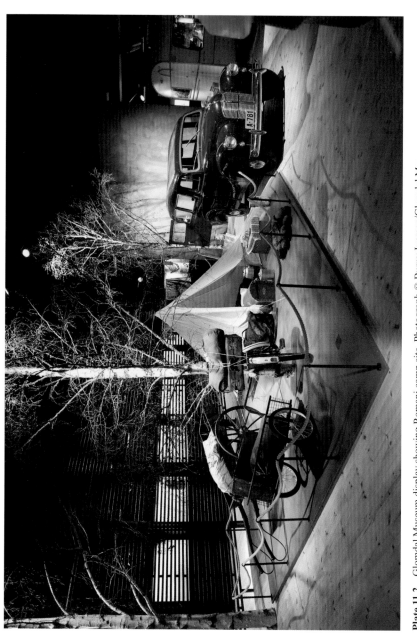

Plate 11.2 Glomdal Museum display showing Romani camp site. Photograph © Burny Iversen/Glomdal Museum

Plate 12.1 Ice cream van reception desk. Photograph © Viv Golding

Plate 12.2 Animatronic bunny. Photograph © *South West News* [SWNS]/Jon Mills

Plate 12.3 Caribbean woman emerging from Millet's *The Gleaners*. Photograph © *South West News* [SWNS]/John Mills

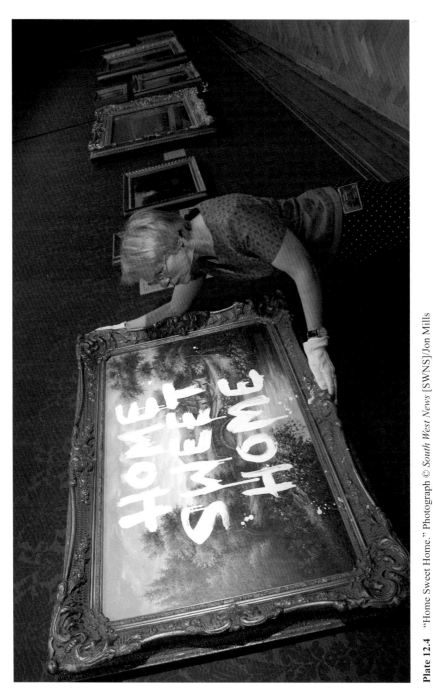

Plate 12.4 "Home Sweet Home." Photograph © *South West News* [SWNS]/Jon Mills

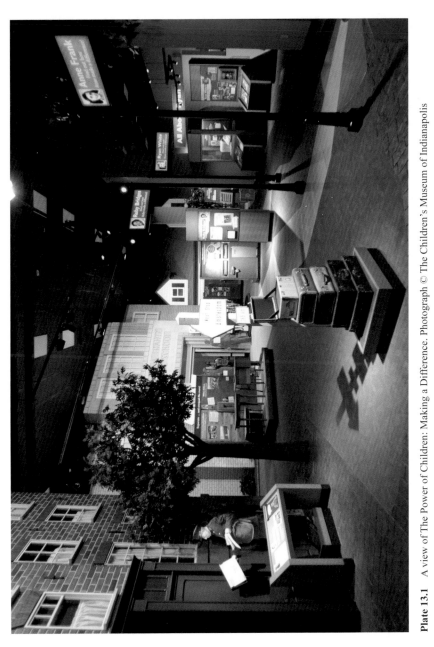

Plate 13.1 A view of The Power of Children: Making a Difference. Photograph © The Children's Museum of Indianapolis

Plate 13.2 Recreation of Ryan White's bedroom. Photograph © The Children's Museum of Indianapolis

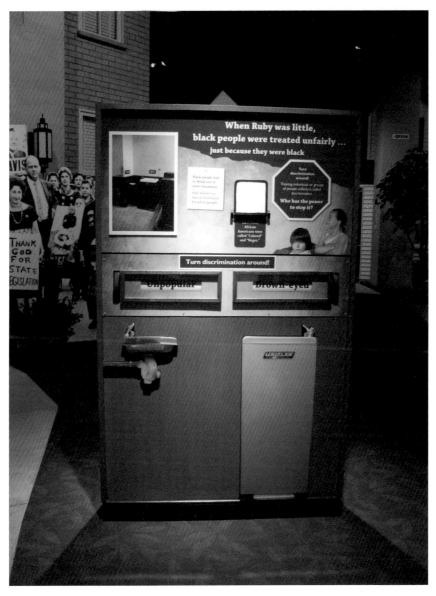

Plate 13.3 Drinking fountain interactive. Photograph © The Children's Museum of Indianapolis

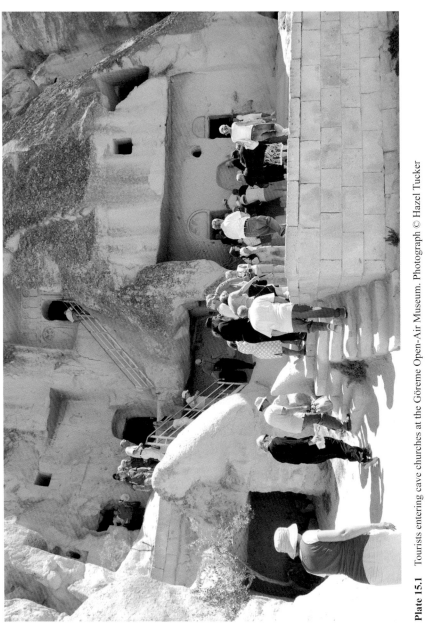

Plate 15.1 Tourists entering cave churches at the Göreme Open-Air Museum. Photograph © Hazel Tucker

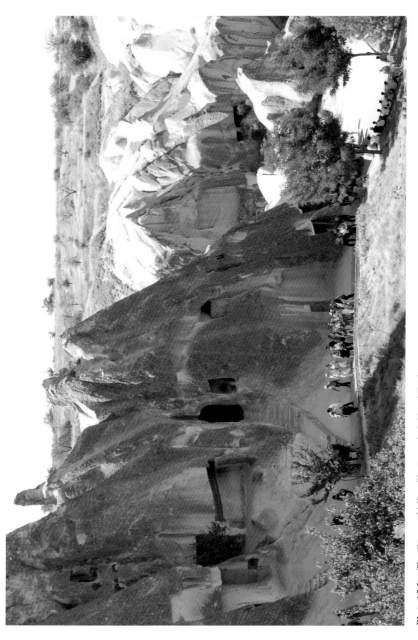

Plate 15.2 The Göreme Valley. Photograph © Hazel Tucker

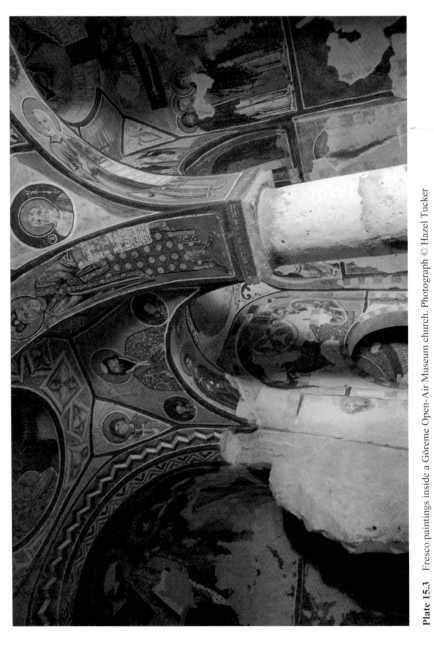

Plate 15.3 Fresco paintings inside a Göreme Open-Air Museum church. Photograph © Hazel Tucker

Content

As described previously, presenting the topical mix of racism, prejudice, and intolerance told through stories of the Holocaust, the civil rights era in the United States, and the emergence of the AIDS epidemic is a challenging process for any museum, let alone a children's museum. The development of content in this exhibit focused primarily on the historical perspectives of the conditions that led to each child's story. This is achieved most specifically through strategic use of objects and label prompts that support the decoding of artifacts in more thoughtful and valued ways. For example, a drinking fountain labeled "whites" helps illustrate the story of Jim Crow laws in the U.S. South. Drinking fountains and many other public amenities were labeled according to those who were allowed to use them. A related interactive experience adjacent to this artifact allows visitors to compare the labeling schemes to better understand their meanings. Replicas of a lower quality, less appealing drinking fountain and a nicer drinking fountain have changeable labels. Visitors select various labels and consider the reality of not being able to drink from the fancy fountain because you were, for example, "popular" or "blue eyed."

Other areas of the exhibition have less explicit connections to the underlying causes and conditions for prejudice. An example of this is in the Ryan White section of the exhibit. While the exhibit itself does not mention AIDS outside of the pediatric version contracted by Ryan, at the time of his diagnosis the majority of those who contracted AIDS were gay men or intravenous drug users. This led to irrational assumptions, fear, and extensive misinformation by many in Ryan's community. One example of this was graffiti written on his school locker. Among others, "fag" was prominently displayed. The locker is presented as an interactive element—as the visitor opens the locker door, they hear whispers of children saying "don't let him touch you"—but the graffiti is highly modified and does not include the word *fag*. As such, though it is important to recognize that his treatment by others was fueled by extensive misinformation and fear, the power of Ryan White's story is somewhat diminished. An unfortunate implication of not providing all the information is that the museum runs the risk of miseducating visitors, or worse, reinforcing previously held inaccuracies. Despite this potential flaw in the exhibit element, it remains one of the most visited aspects of the exhibition.

Method

The label framework for this exhibition has multiple goals that support the overall implementation of critical pedagogy in the exhibit. Many labels connected to artifacts and visual images highlight challenges and questions to help visitors take a closer look at the content or challenge what they see. While this is not prevalent throughout, key areas help visitors connect to simple and powerful ideas (Rand 2010; Serrell 1996). These labels frequently depict young children and "thought bubbles" that focus on the inner dialogue or questions that may be going on for visitors.

Outside of the specific label strategies, which invite visitors to think differently about the artifacts, the majority of the exhibit design and presentation follows a very traditional "case and label" format. The orientation and focus of these cases within the exhibit itself do not necessarily deliver on more probative behaviors. For each child's story, the primary focal point is a key to each child's room—Anne's annex, Ruby's classroom, Ryan's bedroom. Each of these areas features an immersive design, making the visitor physically present in the space. These are also the locations for the live theater presentations and the multimedia shows. Though each area is distinct to the story told, these spaces, as immersive environments, are more likely to reinforce the overall feeling of the story rather than to challenge the perspectives presented. Multiple perspectives are thus less common across all spaces and the potential for recognizing change or new possibilities is pushed to the Take Action section of the exhibition.

Within the Take Action area, visitors may elect to "make a promise" through a computer interactive or simply through writing their promise on a sticky note and placing it on a branch of the Tree of Promise. Visitors may select pregenerated promises or compose their own. In both instances, visitor promises reflect rather far-ranging responses, with the most prevalent being "help family," "accept others," and "care for the environment" (Wolf 2009). Overall, the relationship between the promises made and the messages in the exhibit are not particularly aligned, although it is hopeful to note that about 15 percent of the total promises made do reflect issues of equality and acceptance of others (Wolf 2009).

Strengths

The Power of Children exhibit illustrates a number of positive efforts toward incorporating critical pedagogy practices. The overall content of the exhibit presents a natural opportunity for discourse and examination of the issues related to racism, prejudice, and intolerance. The label framework, the selection of artifacts, and live theater presentations all contribute to the high level of shared discourse and connection to local issues and events. The content strategies employed and methods enacted support more critical reflection and thought by visitors. This approach is reinforced by evaluation data that reflect the types of questions and experiences reported by visitors. During their visit to the exhibition, visitors reported their children asking questions such as "Why did people, especially the Nazis, hate the Jews?" "Why was Ruby segregated at school?" and "Why [wasn't] Ryan allowed to attend school?" Nearly 70 percent of the families who visited the exhibition had a follow-up discussion with their children about the artifacts in the exhibition and 94 percent of the families with children in the target age group had some discussion about the exhibition messages and content, most notably about discrimination (Wolf 2009).

In sum, the museum's efforts in mounting this exhibition are generally well received, though limited. Of those families who visited the exhibit there is recognition of the

value of the experience for the adults as well as for children (despite the age differences for many visitors). Visitors appreciate the approach to the content and the relationship it has to them locally.

Limitations

In contrast to the overall approach to the exhibition content, the umbrella theme of racism, prejudice, and intolerance is not as provocative as one might hope. Perhaps this is in part based on the contextual challenges, but in general the exhibition does not fully achieve its goals in focusing on the potential for transformative and liberatory practice. The exhibit shows a fairly confident approach to presenting the historical details with questions to support further interrogation, but the connection between visitors and the collective struggle for power and meaning is less developed. As described previously, this clearly reflects the original aims of the exhibition in presenting history and the concerted effort by the curatorial team to bring in a more critical voice. Programming opportunities offer a connection to the struggle for power and meaning to some extent, but even at the level of presentation, the performances stop short of a fully critical approach. In particular, more focused questions relating to the meaning and purpose of the exhibition would be useful. Why is this the position of the museum? How is it that these children and their stories are important in today's world? Despite the effort to make this discussion a permanent one for the museum, the dedication of the topic is contained within an exhibition rather than distributed throughout the museum's galleries and content. As such, the exhibition feels more like a social justice add-on than a fully developed orientation.

Overwhelmingly, the visitor's cognitive understanding of the exhibit reflects the light touch on the topic. Visitors were more likely to describe the exhibition's main messages around equality and acceptance and ending discrimination; further prompting reveals a sense of treating everyone equally and modeling socially positive behaviors (Wolf 2009). However, many children were not able to make connections between the children depicted in the exhibit and their own agency. This is an unfortunate disconnect for children and the examination of possibility and change. Furthermore, visitors' ability to recognize the kinds of differences made by Anne, Ruby, and Ryan were low, and the circumstances of their lives and experiences, as described in the exhibition, were fairly general.

One interesting challenge, which may in fact be evidence of its strength as a critical approach to museum work, is the recognition by a few visitors of the exhibit's political nature. The comments made include: "Seemed much more political than historical"; "We oppose the politicization of children. I want my kids to know these historic episodes . . . but I do not want them to become prematurely politicized by the knowledge" (Wolf 2009). Equally common among the negative responses was the lack of a positive feeling about the exhibit. Many visitors felt the topics of racism, prejudice, and intolerance were too depressing to deal with or should not be discussed with children. To an extent,

these responses reflect the degree that the exhibition addresses the inequalities but does not fully present challenges and change to the system, thus resulting in visitors feeling conflicted about the issue (Lindauer 2007).

New Possibilities and Concluding Thoughts

The Power of Children presents an important case study on the ways in which critical pedagogy approaches can be successfully used in many types of museums. It also illuminates the challenging prospects for any museum undertaking such an initiative. The efforts made in The Power of Children exhibition reflect a concerted effort to go beyond a simple history exhibit and move into territory not common to more general interest or family-oriented museums. The inclusion of a *permanent exhibition* with a social justice emphasis goes beyond a simple add-on approach. However, in making such a commitment, there must be ongoing effort to infuse multiple experiences across the museum with this message. By attempting to employ key strategies such as localized knowledge, shared discourse, and dialogue, the museum staff provides a larger context to address the issues of racism and intolerance. Equally important are the strategies focused on delivering the content through multiple representations of artifacts, supporting different ways of knowing, and providing a range of objects to promote greater consideration. Furthermore, the methods employed, while potentially limited in this particular example, including questioning, and presenting potential for change and action, demonstrate that there is a way for museums to address these social issues effectively.

Those involved in museum education and social change have long seen the benefits from including more critical approaches in museum work. Sandell writes:

> Within the museum context, social responsibility requires an acknowledgement not only of the potential impact on social inequality, but also of the organization's obligation to deploy their social agency and cultural authority in a way that is aligned and consistent with the values of contemporary society. (2002: 18)

This obligation exists for all museums, whether they serve a particular audience or niche topic, or whether they present large comprehensive collections to the larger public. A commitment to present contemporary topics from a critical perspective reiterates the vast array of information present across multiple convictions, belief systems, and ways of knowing. It can broaden the perspective on collections and reveal significance of objects in ways other than that held by the dominant culture. In doing so, museums stand to gain a far richer and wider audience than in previous times.

The risk of mounting exhibitions with a critical pedagogy orientation certainly stems from perceptions of the museum as an apolitical, neutral space (Cameron 2008; Sandell 2002; Weil 1995). Rather, it is important to provide visitors with transformative and liberatory experiences that open the possibilities of change and renewal. Such experiences are valid and valued ends by which museums can bring about social change. Reliance on specialized or niche museums to convey such important messages and opportunities

for reflection not only diminishes the value and purpose of those museums, but it also denies the larger visiting public opportunity to take on the kinds of challenges and issues that help us shape democracy. Rather than assume the niche museum as one that takes on tough issues, we should look to all museums to find their niches within tough issues. For The Power of Children, that meant presenting material appropriate for children and families following a critical pedagogy mode. Museums can take advantage of the wealth of knowledge both inside their walls and inside their communities to build significant experiences that support visitor understanding, perspective, and ways of knowing. This is the niche all museums can fulfill.

Notes

1. A virtual walkthrough of the gallery is available at The Children's Museum of Indianapolis website: www.childrensmuseum.org/themuseum/powerofchildren/html/index.html.
2. The image can be viewed online at the Norman Rockwell Museum's website: www.nrm.org.

References

Abram, R. J. 2005. "History is as History Does: The Evolution of a Mission-driven Museum." In *Looking Reality in the Eye: Museums and Social Responsibility,* eds. R. Janes and G. T. Conaty, 19–42. Alberta: University of Calgary.

Archibald, R. 2004. *The New Town Square: Museums and Communities in Transition.* Walnut Creek, CA: AltaMira.

American Association of State and Local History. 2009. *Leadership in History Award Winners 2009.* Nashville, TN: Author.

Bunch, L. 2007. "Embracing Ambiguity: The Struggle to Interpret Race in American Museums." *Museums and Social Issues* 2 (1): 45–56.

Cameron, F. 2008. "Moral Lessons and Reforming Agendas: History Museums, Science Museums, Contentious Topics and Contemporary Societies." In *Museum Revolutions: How Museums Change and are Changed,* eds. S. J. Knell, S. MacLeod, and S. Watson, 330–342. London: Routledge.

Falk, J. H. and L. D. Dierking. 2000. *Learning from Museums: Visitors and the Making of Meaning.* Walnut Creek, CA: AltaMira.

Freire, P. 1989. *Pedagogy of the Oppressed,* trans. M. Ramos. New York: Continuum.

Giroux, H. 1992. *Border Crossings: Cultural Workers and the Politics of Education.* London: Routledge.

Golding, V. 2009. *Learning at the Museum Frontiers: Identity, Race and Power.* Farnham, England: Ashgate.

Greene, M. 1997. "Teaching as Possibility: A Light in Dark Times." *Journal of Pedagogy, Pluralism, and Practice* 1 (1). Available at: www.lesley.edu/journals/jppp/1/jp3iil.html.

Gurian, E. H. 2006. "Choosing among the Options: An Opinion about Museum Definitions." In *Civilizing the Museum: The Collected Writings of Elaine Heumann Gurian,* ed. E. H. Gurian, 48–56. New York: Routledge.

Hein, G. E. 1998. *Learning in the Museum.* New York: Routledge.

Hooper-Greenhill, E. 1999. "Education, Communication and Interpretation: Towards a Critical Pedagogy in Museums." In *The Educational Role of the Museum*, ed. E. Hooper-Greenhill, 3–27. 2nd ed. London: Routledge.

Hooper-Greenhill, E. 2000. *Museums and the Interpretation of Visual Culture.* London: Routledge.

International Coalition of Sites of Conscience. 2010. *About Us.* Available at: www.sitesofconscience.org/about-us/en/.

Janes, R. 2009. *Museums in a Troubled World: Renewal, Irrelevance, or Collapse?* London: Routledge.

Kilderry, A. 2004. "Critical Pedagogy: A Useful Framework for Thinking about Early Childhood Curriculum." *Australian Journal of Childhood* 29 (4): 33–37.

Lindauer, M. A. 2007. "Critical Museum Pedagogy and Exhibition Development: A Conceptual First Step." In *Museum Revolutions: How Museums Change and are Changed,* eds. S. J. Knell, S. MacLeod, and S. Watson, 303–314. London: Routledge.

McLaren, P. 1989. *Life in Schools.* New York: Longman.

McLean, K. 2007. "Do Museum Exhibitions Have a Future?" *Curator: The Museum Journal* 50 (1): 109–121.

Rand, J. 2010. "Write and Design with the Family in Mind." In *Connecting Kids to History with Museum Exhibitions,* eds. D. L. McRainey and J. Russick, 257–284. Walnut Creek, CA: Left Coast Press.

Sandell, R. 2002. "Museums and the Combating of Social Inequality: Roles, Responsibilities, Resistance." In *Museums, Society, Inequality,* ed. R. Sandell, 3–23. London: Routledge.

Serrell, B. 1996. *Exhibit Labels: An Interpretive Approach.* Walnut Creek, CA: AltaMira.

Shor, I. 1997. "What is Critical Literacy?" *Journal for Pedagogy, Pluralism, & Practice* 4 (1). Available at: www.lesley.edu/journals/jppp/4/shor.html. Accessed November 14, 2006.

Teslow, T. 2007. "A Troubled Legacy: Making and Unmaking Race in the Museum." *Museums and Social Issues* 2 (1): 11–44.

The Children's Museum of Indianapolis. 2007. *The Power of Children: Making a Difference* [Exhibit concept document]. Indianapolis, IN: Author.

The Children's Museum of Indianapolis. 2008. *The Power of Children: Making a Difference* [Museum exhibition]. Indianapolis, IN.

The Children's Museum of Indianapolis. 2010. *Current Exhibits.* Available at: http://www.childrensmuseum.org/.

Weil, S. E. 1995. *Cabinet of Curiosities: Inquiries into Museums and their Prospects.* Washington, DC: Smithsonian Institution Press.

Weil, S. E. 1999. "From Being about Something to Being for Somebody: The Ongoing Transformation of the American Museum." *Daedalus* 128 (3): 229–258.

Wilson, F. 1992. *Mining the Museum: An Installation by Fred Wilson* [museum exhibit]. The Contemporary and Maryland Historical Society, April 4, 1992–February 28, 1993, Baltimore.

Wink, J. 1997. *Critical Pedagogy: Notes from the Real World.* White Plains, NY: Addison Wesley Longman Publishers.

Wolf, B. 2009. *The Power of Children: Making a Difference: In-depth Exhibit Report.* Indianapolis, IN: The Children's Museum of Indianapolis.

Wood, E. 2008. "Critical Approaches to Museum Education and Civic Engagement." Paper presented at the annual meeting of the American Educational Research Association, New York, March.

Wood, E. 2009. "Rules for the (R)evolution of Museums." In *Inspiring Action: Museums and Social Change,* 22–38. London: MuseumsEtc.

Wood, E. and S. Cole. 2007. "Can You Do That in a Children's Museum? A Look at the Power of Children." *Museums and Social Issues* 2 (2): 195–202.

Wood, E. and K. F. Latham. 2009. "Object Knowledge: Using Phenomenology in Object Research and Museum Experiences." *Reconstruction* 9 (1). Available at: http://reconstruction.eserver.org/091/wood&latham.shtml.

–14–

Community Consultation in the Museum
The 2007 Bicentenary of Britain's Abolition of the Slave Trade

Kalliopi Fouseki and Laurajane Smith

Community consultation has become a dominant theme in museological debates and is often an integral part of attempts to broaden museum audiences and address social exclusion issues. In 2007, museums were presented with an opportunity to engage African-Caribbean communities, often counted among the traditionally excluded audiences, in the development of exhibitions marking the bicentenary of Britain's 1807 act to abolish the slave trade. However, as public debate about the bicentenary grew, museums found themselves caught in a dilemma. On one hand, they faced governmental calls for a bicentenary that would celebrate the act of abolition and the so-called moral leadership of Britain. On the other hand, African-Caribbean community groups argued that the importance of the bicentenary lay in the opportunity to acknowledge obscured and hidden histories and legacies. For some, this recognition, it was hoped, would lead to an apology from the government. In this chapter, drawing on interview data with museum staff and community representatives, we explore some of the tensions and issues that arose during 2007 between community groups and museums. Museums were often faced with the dilemma of presenting a balanced exhibition while juggling the competing demands of communities and funding bodies with governmental and wider public expectations about the bicentenary, which made community consultation in this context confronting and challenging. For their part, many of the community representatives we interviewed expressed feelings of frustration with both the consultation process and its outcomes.

Methodology

During 2007 and 2008, interviews were undertaken with curatorial staff, outreach officers, and community representatives as part of a wider study entitled 1807 Commemorated[1] carried out at the University of York between 2007 and 2009. In total, twenty-four semi-structured interviews were conducted with community representatives who had worked with five museums. Staff members from these museums were also interviewed,

as were staff members from a further three museums. Eighty-eight museum staff members were interviewed using semi-structured interviews. In addition, a workshop was held at the Museum of London Docklands with individuals involved in community consultations at a number of museums. The workshop was an open-ended discussion of community consultation issues and experiences with eleven participants. Approximately 100 invitations were sent by e-mail and post to organizations and individuals involved in consultations to participate in this workshop, eleven of whom were able to participate. It is important to note that follow-up telephone calls and e-mails were made to invited participants, with many still declining to attend. The reasons given, or impressions formed, during these communications were that many felt too disillusioned with the consultation processes they had engaged in and/or considered that spending more time on the issue was too difficult or likely to be counterproductive.

Consultation Models Employed by Museum Partners

Four consultative models were employed by the museums involved in this study. The most common was the development of small consultative or advisory groups, often consisting of four or five people from community groups, sometimes alongside academics and other advisors. Discussions with those interviewed revealed that community members of these groups often expressed a strong or shared sense of ownership of the exhibition being developed. However, they also expressed concerns about the representativeness of such groups, noting that the diversity of community interests could not be canvassed or explored by small advisory or cultural groups. Moreover, these groups tended to be formed through existing museum networks. The tendency was to invite individuals who had previously worked with the museum on other topics or to get such people to make recommendations about who should be approached. While pragmatically a useful way of developing committees, it did limit the ability of the committee to represent the diversity of opinion in stakeholder communities. The well-documented tendency of museums to avoid conflict and controversy will also mean that such committees will more likely be populated with individuals with whom the museum will feel "safe" (see Lagerkvist 2006; Lynch and Aberti 2010: 3; Watson 2007: 2). Conversely, some museums will work with the most vocal and provocative community representatives in order to create a positive and public image of a museum "engaging with communities"; in this context, the substance and representative content of that engagement may be questionable.

A few museums worked with larger groups gleaned through open invitations advertised in local newspapers. The groups formed were often between thirty and forty individuals and were quite diverse. The utility of this second model was that it was perceived as more representative of community diversity, although many community representatives we interviewed, who had participated in such groups, noted a lack of a sense of "ownership" was often generated within large groups. This often caused people to drop out of the group, as did the tendency for vocal community voices to dominate. For

museum staff, this was often a harder group to interact with, especially given the diversity of opinions expressed. However, this diversity also made this group very useful for surveying wider community interests and concerns.

The third model adopted by some museums was to conduct individual interviews with a range of community representatives, as well as undertaking one-off focus group or workshop discussions. This model allowed individual voices to be expressed and enabled wider representation than the first model, while the focus groups and workshops provided forums for discussion and debate. Conversely, however, this model was often time consuming for museum staff, and did not lead to the sense of engagement or ownership of the exhibition processes that, as discussed later, was so important to many community representatives we interviewed.

The fourth model involved the development of specific subprojects, sometimes running alongside the main exhibition. Such projects included art installations and oral history projects, which communities organized with support from museums. Community members involved in such projects were very positive about both the projects and their relationship with the museums in question. Many commented that they felt actively engaged in the bicentenary process and that they gained a range of skills from their involvement. However, some expressed disappointment that their work was often peripheral to the main exhibition and that they had little or no input into the overall exhibition. Others noted that it was often a shame that their art or oral history project was only housed within the museum, and suggested that aspects of the exhibition and their projects would have been usefully displayed also in community centers (Workshop transcript: 9f). This was particularly stressed by the fact that many members of African-Caribbean communities, particularly younger people, were traditionally among those groups who felt excluded from museum visiting. The fact that many of these projects were additional to the main exhibition, and were seen by the museums as the focus of community consultation rather than the main exhibition, highlighted for some a sense of exclusion. For instance, one community leader noted:

> [O]ne of the young people said why is it always white people always talking about slavery and it is (laughs), if you look around and you can see it's white people being employed to talk about slavery, it took a young person to point that out. (07ComC25 2007)[2]

Although the art project was designed to give the community some voice in the exhibition, its peripheral relationship to the main exhibition highlighted for this young person the sense to which dominant versions of the history of enslavement were still promulgated. This impression was reinforced when, as some museums acknowledged doing, community voices were used as a means to fill up empty gallery spaces. The lack of objects that related to the history of enslavement and its legacy constituted a major concern for the majority of curators we interviewed: ". . . that was frustrating because we just did not have the objects. How do you create an exhibition without any objects?" (07comM3 2007). For some curators, the production of artwork and oral history displays by the

communities themselves was reckoned an effective way of "contemporary collecting." As one museum curator stated:

> I mean from our point of view the consultative group is really the core of the whole project . . . because we knew from the outset as a museum that we had a couple of big problems; the first one is that we had virtually no slavery collection at all . . . [communities were important] to actually help us assemble a collection around which to build the story of the gallery we were going to tell. (07comM90 2007)

While the incorporation of community voices into exhibitions can be very affective how and why that is done will also send messages, however unintended, to museum audiences and communities.

Despite the issues identified here, it is important to note that community interviewees stressed the inclusion of what they often referred to as "authentic," "real," or "unique" people voices in exhibitions. As one museum professional noted:

> Oral history for them is very important, that we sit down and talk, that's the way history and stories are told. Rather than the written word. (07comM3 2007)

For some, listening to and integrating alternative and diverse voices into the gallery space did challenge the authoritative nature of museum institutions as conveyors of absolute and accurate scientific truths. As one museum professional observed:

> If it [the exhibition] was to have any meaning at all it was about finding a way to enable those voices [voices of underrepresented groups] to be heard, to be able to challenge so called authoritative histories which are the preserve of museums. (07comM48 2007)

Each model had its utility and limitations—and indeed it is not possible, or perhaps even desirable, to nominate which model was the most useful. Consultation is, or at least should be, about dialogue, and each situation will necessitate different strategies for developing dialogue (Lagerkvist 2006: 60). Notable about each of these models is that no one we spoke to considered that dialogue had been well facilitated in the consultation practices with which they had been engaged. Also notable is that, in each case, meetings, focus groups, interviews, and so forth were held *at* the museum. This tendency, at least for one participant, reinforced the sense that the museums were in control of the process:

> And yet, when I look at a museum and they say what a consultation is, they mean they invite people in and give them a cup of tea and a biscuit. That to me I find, going into somebody else's territory, I find it discombobulating. I don't find it comfortable. I found very few museums that went out to community centres, art centres, places, health centres, went out to where the people are and talked to them there, on the territory that the people felt comfortable. (Workshop transcript: 5)

At issue here was not so much the specific model of consultation used, but the different expectations and understandings of consultation held by museum staff on one hand and community representatives on the other. Significantly, *how* consultation was done only reinforced this disjuncture for many community representatives and undermined the stated philosophical commitments of museum staff to the idea of inclusive consultation.

Community Concerns and Expectations

What needs to be noted at the onset is that all of the museum staff members we spoke to were committed to community consultation and saw it as an important, if not vital, part of the exhibition process. Indeed, many community representatives themselves recognized the commitment of staff, and appreciated the difficulties some staff faced in undertaking consultation. This included their own inexperience in consultations, the confronting nature of consultation and the topic at hand, and the criticisms some staff faced from other staff about what they were doing and why (for fuller discussion see Smith and Fouseki 2011). As one person noted:

> It was a very difficult process because the curators and the museum staff were terrified. It's a very difficult history, but they took grace from actually engaging with people directly. (Workshop transcript: 6)

Given this commitment, why did community representatives overwhelmingly report feelings of significant frustration? Fouseki (2010) has identified the object-centric concerns of museums as one of the key issues at work here. Community representatives focused much more on how the exhibition as a whole was going to impact both community and wider public perceptions of African and Caribbean culture and history, and what, in turn, that would mean to contemporary public attitudes to African-Caribbean British people and their communities. As Prior notes, the history of enslavement and the consequences it had for Africa, the Caribbean, and Britain had not been adequately acknowledged by museums in the past, and thus a lot of expectation was riding on the exhibitions to mark the bicentenary (2007: 202). As we have argued elsewhere, political recognition and all the material and symbolic consequences of this for communities was at stake here (Smith and Fouseki 2011). In developing our argument, we drew on the work of Nancy Fraser (2000) to illustrate how museums become implicated in struggles for social justice through the politics of recognition. They become implicated due to the power and authority of museums to represent and define histories and cultures (Bennett 1995; Witcomb 2003). This authority has been well recognized in the museum literature and within policy debates and social inclusion and other diversity policies, which may be seen as attempts to address these issues. As Lagerkvist notes, the politics of difference, in which the unique identity of groups and their distinctiveness from other groups is recognized, can be identified in the diversity policies of museums (2006: 55–56). Despite these debates and policy initiatives,

much of the stress and frustration over consultations during 2007 was created by the two very different aims of communities and museums. Communities were often concerned to see the exhibitions as opportunities for the recognition of the consequences for contemporary Britain of the history of enslavement and the exploitation of Africa. Museums attempting to present a balanced exhibition wanted to simply canvass and collect community views (Smith and Fouseki 2011). The extent to which diversity or social inclusion policies were driving the consultative process does not seem to have been adequately realized (see Smith and Fouseki 2011). For communities, consultation was about *working through* what was at stake for them, what they needed the exhibitions to say and acknowledge, while also working through the difficult emotional affect of engaging with this history and its continuing legacies for individuals and their communities:

> Only Friday, Thursday sorry, I found out about my great, great grandfather; who owned him as a slave, and that only came out of the slave records, which were released last year . . . so I'm still on an emotional rollercoaster right now . . . That's part of what I wanted to say. Just to say we need justice not necessarily anything else . . . (07comC114 2008)

> When I was younger, when you mentioned slavery . . . we didn't want to acknowledge it, we didn't want to think about it, we didn't want to feel it, because we . . . have this image in our head of being inferior people. (07ComC101 2008)

> Because people do tend to bring their own personal baggage to this history and it's unresolved, and it's impossible to deal with this history without actually addressing some kind of pain and harm that's in there. So time is needed. (Workshop transcript: 6)

For the museums, it was ultimately about getting an exhibition together. It may also have been about listening to consultative groups and representatives, but the final product of consultation was, pragmatically, the development of an exhibition, a professional product, within a defined timetable. The political ramifications of such exhibitions, while of concern to museum staff members, would never touch them in the way it would and did communities. As one representative noted:

> I want people to be aware that there is some fantastic history of queens and kings [of Africa] of the time . . . and when an English person sees you next time is not just seeing a black colour, they are seeing a person who . . . played a part in developing the world. (07comC74 2007)

We have argued that this disjuncture, and the failure of museums to understand the wider political contexts and ramifications of exhibitions, was at the heart of the tensions and frustrations felt by both staff and community representatives (Smith and Fouseki 2011). However, in this chapter, we want to explore some of the practical issues that helped to facilitate and underline this disjuncture. One of these was the issue of time. Many of the exhibitions were developed over relatively short timeframes due to the

restricted period created between the securing of funding and the need to develop an exhibition that met a commemorative date:

> It wasn't enough consultation because if you know you have the money in August you can only . . . you can only have five consultations at the most, once a month . . . (07ComC74 2007)

Thus, the community priority to *debate,* and not simply to *display,* was further undermined by time limitations. As one community representative noted, time was needed to not only discuss and debate issues in meetings with museum staff, but to take these issues back to communities so that the communities themselves could debate and discuss the issues raised in consultation meetings:

> When I came on [to the consultative group] as an individual I said these things are too big for me I have to share with the members of my community. (Workshop transcript: 20).

Adding to this problem was the degree to which museums and their staff assumed community representatives could and did speak for entire communities. Communities are, of course, diverse and may not have a united view on any given topic, let alone dissonant and contested ones. Representatives at the workshop voiced concern about the stress placed on them to represent diverse community views, an issue made all the more problematic by the lack of time available for representatives to go back to communities and get feedback themselves.

A great deal has been written in the literature on museum consultation about the need to develop long-term relationships with communities (for example, Crooke 2005, 2007; Kelly 2004; Kelly and Gordon 2002). However, this is not a relationship with a homogeneous hermetically sealed unit—communities are diverse, divisive, and changeable—and thus any relationships, of necessity, will need time to adjust and develop as the needs and concerns of communities change and develop (Smith and Waterton 2009; Waterton and Smith 2010). Obviously, such relationships need time, and that was not made available in this context due to a range of constraints not always controlled by museums. However, the lack of available time sent, or reinforced, the message that communities were not being listened to. Many communities desired to develop long-term relationships with museums, a desire often shared by museum staff, but which was inevitably not realized due to time constraints, but also because consultation was seen to have been achieved and completed once the exhibition was put in place. Some of those interviewed expressed regret that consultation had finished once the exhibit opened, as one community representative observed about the attitude of the museum they worked with: "it's kind of been we've done the work and we're moving onto different groups" (07ComC25 2007). The lack of debate, negotiation, and possibility of long-term commitment in the consultation process helps explain frustrations, despite the attempt of many museum staff members to ensure critical issues and debates were addressed in the gallery space.

At issue is not so much what the exhibitions displayed finally (although of course it was an issue), but community representatives' overall experience in the consultation process. The ability to have active involvement in the exhibition development was for participants as much a gesture of honest recognition and social justice as the actual exhibition outcome and content. An exhibition product without honest engagement with the African-Caribbean community was defined as simply a tokenistic, box-ticking exercise that aimed to fulfill the quantitative DCMS (Department for Culture Media and Sport) Performance Indicators or the funding criteria of nongovernmental funding bodies:

> What became clear to a lot of delegates, a lot of the people participating, even though the people working with us didn't view it that way, it was a rubber stamping exercise . . . we've already chosen the pieces, and we're only working with the artefacts in our collection. (07comC107 2008)

> I felt that the museum was doing it was like a requirement for them to do those meetings . . . it was like ticking a box. (07ComC102 2008)

> Whenever you do a consultation, it really does feel like you're just talking. There is no political will to change. (Workshop transcript: 11)

The lack of ownership of the consultative and exhibition development process was a theme that emerged again and again in interviews with community representatives, for instance:

> I can't honestly [see how] people who were engaged in this programme could say that they owned this project because they were not allowed to own it, they were not allowed to own it. (07ComC77 2007)

This concern over a lack of ownership, or of feeling that they played an active role, was not only reinforced by the limitations of time, but by the *timing* of when community consultation commenced in the exhibition development processes. Community participants expected to be consulted at *all* exhibition stages *before* any firm decisions were made about the aims, scope, nature, or content of the exhibition. Indeed, some argued that the very decision to have an exhibition in the first place on the topic of enslavement should have been part of consultations (Workshop transcript; 07ComC101 2008):

> Consultation should have started from the moment they had the idea of designing the gallery, they should have brought people on board from the very very beginning ok? They should have been open and prepared to take on the views and I know this is a very difficult thing . . . they should have brought them on board from the very beginning, they should have been involved in looking at the objects, they should have been involved in looking at the material and telling them what they see, what they think and what they understand and that should be part of it. (07ComC77 2007)

[Community officers were often] an afterthought or you are thought about in the beginning and then you are marginalized, or you are pushed aside or you are dropped kind of thing and that has happened [here]. (07comC105 2008)

While many people stressed the importance of being involved at the beginning of an exhibition, they also stressed the importance of being involved at the very end. As one curator noted, the final design of an exhibition can differ markedly from how it was envisaged during development and consultations, and thus one of the things she learned from the consultation process was that she would:

put the designers on board far earlier, everyone needs to be part of that process and everyone needs to be signed up to that process and I think . . . one thing I can learn from that process that everyone needs to be on board and from as early as possible. (07ComM103 2007)

Time has been a significant constraint in the consultation experiences of both museum staff and community representatives. Further constraints added to the frustrations and tensions reported to us. One of these was the lack of understanding of diversity issues, and many community representatives commented that further diversity training was needed in museums to increase understanding of equity, multicultural issues, and the continuing political and social experiences of minority community groups. This was also highlighted against the observation of the relative lack of employment of African or Caribbean British staff at curatorial levels within museums. As one person noted, the lack of success of community consultation occurred because:

I think it was the lack of understanding of black people and black experience and it was a lack of understanding by the white people in positions and jobs. (07comC102 2008)

Conversely, the lack of understanding on the part of communities about how museums work was another significant issue. Discussion at the workshop noted that communities often needed training, or briefings at the start of the consultation processes, about the management structure of museums and the overall exhibition development process. Providing information about how the museum works, in particular its management structures, funding pressures, time pressures, and other logistical and professional limitations on staff, was felt by many community representatives as something that would help prevent misunderstandings between museums and communities. It could, it was hoped, also foster a sense of community ownership of the consultation process and its potential outcomes for communities.

Of concern to members of the workshop was the lack of accountability of museums in the consultation process. This arises from a combination of issues, including the amount of time given to the consultation process, the impressions and beliefs by many that decisions were made prior to consultations commencing, and the degree to which many felt they were not listened to. These factors again tended to undermine the sincerity of the stated motivations of institutions for consultations, and a strong perception arose that

museums were paying lip service to the social inclusion requirements of DCMS and the Labour government:

> This exercise? Tick, tick, tick. On to something new. So the real test of all this, the kite-mark aspect, is how are these organisations looking at their permanent exhibitions because that's the real test I think of whether any of these consultations mattered or made a difference. Because the whole story of these museums should now be altered in some way. (Workshop transcript: 18)

Moving from Consultation to Negotiation

Community consultation is by nature fraught and difficult. What makes for "good" consultation will also be hard to measure, as so much is usually at stake for community groups, and indeed for museums themselves, and there is such a diversity of opinion about any given topic that it is not possible to satisfy everyone. The simple observation that community consultation is difficult and confronting is an important one to make and acknowledge. Such an acknowledgment is vital for the possibility of the development of long-term dialogue. As Lagerkvist notes, there are no short cuts to community inclusion in museums:

> The task is essentially to keep the dialogue alive, to negotiate and renegotiate and thereby to find a balance and move positions forward in each separate case of community involvement. (2006: 60)

The point here is that community consultation is a continuous dialogue, and creating the attitudes and cultures within museums and the wider cultural sector that will allow and facilitate this is what is ultimately important. Moreover, consultation is all about *negotiation*. It is not about telling or about simply listening to viewpoints, it is about engaging in debate and negotiation. *Community engagement* or *community negotiation* are perhaps better terms to use than *consultation,* which all too often invokes a sense of simply telling and informing (Clarke 2002; Greer et al. 2002).

However, systemic and institutional issues prevent dialogue and negotiation either from occurring or from being effective. Institutional racism, as Lynch and Aberti (2010) note, is still alive and well, and the call by community representatives for diversity training of museum staff is not an insignificant observation. The assumptions embedded in the heritage sector about whose history and heritage matter are well documented (Littler and Naidoo 2004, 2005). The dominant and pervasive assumptions about heritage, defined as they are by the authorized heritage discourse, are that heritage is comfortable, familiar, good, and "white" (Smith 2006, 2010; Smith and Waterton 2011). As Stuart Hall observes:

> The "peculiarity" of Afro-Caribbeans—that they are simultaneously deeply familiar, because they have lived with the British for so long, and ineradicably different because they are

black—is regarded by most of the British (who have never been asked by their "Heritage" to spare it a thought) as culturally inexplicable. (2005: 34)

Without continuing debate within the heritage and museum sector about cultural diversity issues, consultation practices will all too often continue to be tokenistic. More pragmatic, but nonetheless vital in the development of negotiation and dialogue, is the provision of sufficient time. It is perhaps a somewhat obvious suggestion that museum exhibition practices need to build into them sufficient lead up time for consultation. However, it is an observation that cuts to the core of perceptions that communities were not listened to or valued—the more time and investment given to communities the more investment communities will have in museums and their activities. Moreover, this is not just a museum issue; the bodies that fund exhibition development also need to understand these issues as they influence timetabling through the way they disperse finds and the conditions they set.

Community consultation, as well as being about dialogue and negotiation, is also about learning about and recognizing each other. Representatives reported on the need for training about museum practices and operations. Just as museum staff members need to learn about the histories and the experiences of communities with which they work, so do communities engaged in work with museums need to be given access to knowledge about exhibition development. Some of the community representatives interviewed noted they only gradually learned about some of the constraints placed on staff, and on what exhibitions could or could not achieve. Thus, they considered that an honest assessment and discussion of what constraints staff faced at the start of the consultative process would help alleviate some misunderstandings and frustrations.

Conclusion

What was significant about the results of the interviews is how similar the tensions and issues are to those experienced and documented in other consultative contexts. The international literature on community consultation, particularly that with Indigenous communities, documents many of the issues we have identified here—in particular the need for honest communication about the possibilities and constraints of what can and cannot be done in exhibitions, the development of trust and long-term relationships, and the miscommunication that occurs over the value and meanings of objects (see, for instance, Greer 2010; Greer et al. 2002; Hemming and Rigney 2010; Perkin 2010; Smith and Wobst 2005; Zimmerman 2005). At the crux of the issues, both in the United Kingdom and internationally, is a disjuncture over the needs and aspirations of community groups—this may seem obvious, but a failure by museum staff to understand how exhibitions feed into the wider political and emotional needs of communities underlines the failures and frustrations of community consultation. A very real sense emerges out of the interviews we did with community groups that the exhibitions were a moment that would represent something big—that they would be an opportunity for political and historical recognition. This does not imply there was a naïve perception in communities

that exhibitions would immediately bring about social justice, or access to resources to improve equity; rather they were perceived as a crucial step in the struggles for recognition and the social justice claims that flow from this. Understanding the way museums as cultural authorities can be and are used in any struggle for recognition and social justice is crucial in understanding and implementing community consultation. Successful community consultation requires not only reflections upon the specific issues we have raised here, but a deeper philosophical and contextual understanding of both the power differentials that exist between curatorial staff and communities, and the power of museums to *be* a legitimizing resource in social and cultural conflicts.

Notes

1. The 1807 Commemorated Project was funded by an Arts and Humanities Research Council Knowledge Transfer Fellowship (2007–2009) when both authors were based at the University of York, UK. Further details about the project and its outcomes can be found at the project's main website: www.history.ac.uk/1807commemorated/. A second website, funded by the Museum, Libraries and Archives Council (MLA), can be found at www.york.ac.uk/1807commemorated/index.html. Toolkits developed from the project's findings may be found at this site, together with a toolkit for community consultation at www.york.ac.uk/1807commemorated/commun.html. The authors wish to acknowledge our colleagues on the project, Geoffrey Cubitt and Ross Wilson, and to thank all those who allowed us to interview them for this project.
2. Interviews cited in this chapter have been given reference numbers to maintain the anonymity of the individuals interviewed. The referencing system for interviews is as follows: "07Com" refers to the overall 1807 Commemorated project from which this study derives; the use of a following M or C refers to either museum staff or community representative; the following number is the sequential number of the interview out of a total of 128; while the final number refers to the year in which the interview was undertaken.

References

Bennett T. 1995. *The Birth of the Museum: History, Theory, Politics.* London: Routledge.

Clarke, A. 2002. "The Ideal and the Real: Cultural and Personal Transformations of Archaeological Research on Groote Eylandt, Northern Australia." *World Archaeology* 34 (2): 249–264.

Crooke, E. 2005. "Museums, Communities and the Politics of Heritage in Northern Ireland." In *The Politics of Heritage: The Legacies of "Race,"* eds. J. Littler and R. Naidoo, 69–81. London: Routledge.

Crooke, E. 2007. *Museums and Community: Ideas, Issues and Challenges.* London: Routledge.

Fouseki, K. 2010. "'Community Voices, Curatorial Choices': Community Consultation for the *1807* Exhibitions." *Museum and Society* 8 (3): 180–192.

Fraser, N. 2000. "Rethinking Recognition." *New Left Review* 3 (May/June): 107–120.

Greer, S. 2010. "Heritage and Empowerment: Community-based Indigenous Cultural Heritage in Northern Australia." *International Journal of Heritage Studies* 16 (1–2): 45–58.

Greer, S., R. Harrison, and S. McIntyre-Tamwoy. 2002. "Community-based Archaeology in Australia." *World Archaeology* 34 (2): 265–287.

Hall, S. 2005. "Whose Heritage? Un-settling 'the Heritage,' Re-imagining the Post-nation." In *The Politics of Heritage: The Legacies of "Race,"* eds. J. Littler and R. Naidoo, 23–35. London: Routledge.

Hemming, S. and D. Rigney. 2010. "Decentring the New Protectors: Transforming Aboriginal Heritage in South Australia." *International Journal of Heritage Studies* 16 (1–2): 90–106.

Kelly, L. 2004. "Evaluation, Research and Communities of Practice: Program Evaluation in Museums." *Archival Science* 4: 45–69.

Kelly, L. and P. Gordon. 2002. "Developing a Community of Practice: Museums and Reconciliation in Australia." In *Museums, Society, Inequality,* ed. R. Sandell, 153–174. London: Routledge.

Lagerkvist, C. 2006. "Empowerment and Anger: Learning to Share Ownership of the Museum." *Museum and Society* 4 (2): 52–68.

Littler, J. and R. Naidoo. 2004. "White Past, Multicultural Present: Heritage and National Stories." In *History, Nationhood and the Question of Britain,* eds. H. Brocklehurst and R. Phillips, 330–341. Basingstoke: Palgrave Macmillan.

Littler, J. and R. Naidoo, eds. 2005. *The Politics of Heritage: The Legacies of "Race."* London: Routledge.

Lynch, B. and S.J.M.M. Aberti. 2010. "Legacies of Prejudice: Racism, Co-Production and Radical Trust in the Museum." *Museum Management and Curatorship* 25 (1): 13–35.

Perkin, C. 2010. "Beyond the Rhetoric: Negotiating the Politics and Realising the Potential of Community-driven Heritage Engagement." *International Journal of Heritage Studies* 16 (1–2): 107–122.

Prior, K. 2007. "Commemorating Slavery 2007: A Personal View from Inside the Museums." *History Workshop Journal* 64: 200–211.

Smith, C. and H. M. Wobst, eds. 2005. *Indigenous Archaeologies: Decolonising Theory and Practice.* London: Routledge.

Smith, L. 2006. *Uses of Heritage.* London: Routledge.

Smith, L. 2010. "'Man's Inhumanity to Man' and Other Platitudes of Avoidance and Misrecognition: An Analysis of Visitor Responses to Exhibitions Marking the 1807 Bicentenary." *Museum and Society* 8 (3): 193–214.

Smith, L. and K. Fouseki. 2011. "The Role of Museums as 'Places of Social Justice': Community Consultation and the 1807 Bicentenary." In *Representing Enslavement*

and Abolition in Museums, eds. L. Smith, C. Cubitt, R. Wilson, and F. Fouseki, 97–115. New York: Routledge.

Smith, L. and E. Waterton. 2011. "Constrained by Common Sense: The Authorized Heritage Discourse in Contemporary Debates." In *The Oxford Handbook of Public Archaeology,* eds. J. Carman, R. Skeats, and C. McDavid, 153–171. Oxford: Oxford University Press.

Smith, L. and E. Waterton. 2009. *Heritage, Communities and Archaeology.* London: Duckworth.

Watson, S. 2007. "Museums and their Communities." In *Museums and their Communities,* ed. S. Watson, 1–23. London: Routledge.

Witcomb, A. 2003. *Re-Imagining the Museum: Beyond the Mausoleum.* London: Routledge.

Waterton, E. and L. Smith. 2010. "The Recognition and Misrecognition of Community Heritage." *International Journal of Heritage Studies* 16 (1–2): 4–10.

Zimmerman, L. J. 2005. "First, be Humble: Working with Indigenous Peoples and other Descendant Communities." In *Indigenous Archaeologies: Decolonizing Theory and Practice,* eds. C. Smith and H. M. Wobst, 301–314. London: Routledge.

Interpreting the Shared Past within the World Heritage Site of Göreme, Cappadocia, Turkey

Elizabeth Carnegie and Hazel Tucker

> One of the most pressing problems in the world is the need to develop and promote universal normative values which protect individuals and communities from oppression, enabling them to realize as much of their potential as possible, while at the same time respecting particular cultural traditions. (O'Neill 2004: 199)

This chapter provides a case study of the World Heritage Site (WHS) of Göreme Open-Air Museum, within the Cappadocia region of Turkey, which achieved UNESCO World Heritage Site designation in 1985. It highlights the tensions inherent within the various faith communities as well as between the demands of the global and the values of local communities. In particular, it explores the implications of the reclaimed and reemphasized Byzantine Christian material made dominant within the museum. Based on fieldwork carried out in November 2008 and September 2009, and drawing on Tucker's longitudinal study of the region, we discuss the way the site is formally interpreted as both a World Heritage Site and as a museum of Byzantine Christian heritage, while located within an Islamic region. We examine the site as a meeting ground (MacCannell 1992) of tourists and locals, of Christians and Muslims, and as a place where past and present meet and merge within the "constructed, artificial nature of cultural accounts" (Clifford 1984: 2).

We initially explore the ways in which tourists engage with heritage spaces and how World Heritage Sites as global spaces are inevitably shaped and interpreted for international visitors. We then discuss the case study of Göreme to determine how privileging of particular narratives for the purposes of a global audience creates tensions between global and local communities. We focus our discussion particularly around purposeful damage to Byzantine frescos at the site, which we consider a material manifestation of these tensions. Ultimately, we argue for a more inclusive form of interpretation that allows for multiple viewpoints and the construction of an interpretation that includes local communities, past and present, to be represented.

Fieldwork

As noted, this chapter draws on Tucker's longitudinal study of the area, with particular relevance to the relationship of tourists and locals to the WHS space. Our fieldwork for this

study included participant observation, interviews with international and formally trained national and local tour guides; museum staff, from civil servants to site security; and visitors (including local and international tourists representing a number of religions and cultures). During our site observation, we noted particular stress points where conflict was evident and ongoing—most notably in the graffiti and damage to the frescos, which we saw as evidence of religious tensions inherent in the differences between the non-iconic faith of Islam and Byzantine Christianity, and of tensions within a local space shaped for tourist purposes. These tensions formed the central focus of the interviews conducted at the site.

During our site visits, we also considered how the past and present history and religious identity(s) of the site were interpreted formally in signage and the tour guides' repertoire. To this end, we shadowed groups within the site and thereafter asked selected individuals to relay to us how the disfigurement and damage to the frescos was explained to them. Additionally, we asked tour guides to tell us how they interpreted the fresco damage and how this related to their own culture, sense of history, and belonging. The "shoulder months" of the year—September to February—are the busiest times for this site, which is otherwise punitively hot, and thus our fieldwork was timed for when the site was at its busiest. This enabled us to also witness tensions between rival tour guides as they sought to gain access to the church interiors amidst bottlenecks caused by waiting groups. We noted that guards were deployed at busy churches as much for crowd management as for artifact protection. Guards were largely supportive of our fieldwork and would alert us to the presence of large English-speaking groups as they were preparing to enter the major caves. The fieldwork was carried out in English with tourists and English and Turkish (Tucker) with local guides and guards.

Thus, our chapter considers these tensions from multiple viewpoints, including Islamic perspectives (locals and tour guides) and those of tourists (cultural tourists and pilgrims mostly from Europe), and explores the interpretation, management, and social issues that impact the experience and long-term care and development of the site. Through exploring attitudes to, and knowledge of, the Christian scenes depicted within the cave structures and the time frame explored within the representational framework, our study details the religious tensions within the interpretation and management of the site for tourist purposes. We discuss whether problems of interpretation may in turn further fuel religious tensions depending on the religious or cultural expectations of visitors. We also consider who might be the relevant community(s) here, drawing on Aas et al.'s (2005: 30) definition of community in tourism studies: "in terms of geographical area, or a group of people with shared origins or interests." To this we might add shared religious or cultural values.

Tourism and the Shaping of the Heritagized Past

The relationship between the tourist imaginary and the way tourist spaces are shaped is a complex and interdependent one (Salazar 2010). Kerstetter and Cho (2004) determine that tourists depend more on their own internal sources when making decisions about which destinations to visit. Additionally, this "internal knowledge" creates expectations

destinations must respond to by creating and providing the best experience possible, which theoretically leads to satisfaction. Inevitably, this selective process creates a particular shaped and carefully constructed heritagized past, or "worldmaking" (Hollinshead 2004), and the privileging of interpretations, which in turn become accepted narratives. As Poria et al. (2006: 54) argue, "the crucial issue is that it is the perception of the site attributes rather than site attributes per se that are important."

Tilden notes that representations must "connect with visitors' personality or experience" (1977: 9), while Moscardo argues that if tourists share the values of the site they will seek to safeguard it (1996). It seems, then, that the dominant narratives must have resonance with the dominant visitor group in order to ensure they value the site. The formal narrative of Göreme presents it as a Byzantine Christian site, and this narrative is dominant within guidebooks, brochures, and tour itineraries, rendering these key shapers of tourist expectations. This is particularly the case for visitors traveling for religious purposes or with religious intent. Uzzell and Ballantyne argue that issues that "involve personal values, beliefs, interest and memories will excite a degree of emotional arousal which needs to be recognised and addressed in interpretation" (1998: 1). They go on to posit that "it would be strange if heritage did not have an effect on us. This is surely the point about heritage—it is value-laden" (1998: 2).

Although many World Heritage Sites represent and symbolize the country in which they are located, thus reflecting that country to an international gaze, many such sites are constructed and shaped by global values (Kirshenblatt-Gimblett 2006). Museum visiting also reflects social aspirations (Carnegie 2010), and Göreme, as a World Heritage Site, is both a shrine to history and a contested space that may or may not inspire religions feelings in contemporary visitors. This of course creates potential tensions at Göreme, since communities living in the area around the site today do not necessarily share these values. World Heritage status thus adds an additional layer of meaning and complexity to an already complex space, made more so by the tensions inherent in the seductions of place in both secular and religious terms.

The question then follows: Whose values are represented and interpreted and for whom within Göreme? How does this contradict or jar with the religious values of the contemporary surrounding population? As discussed later, the religious and cultural tensions inherent in the Göreme museum impact local communities' relationship with the site and indeed with their own sense of history and present. In this chapter, we determine that "hot interpretation" "should present perspectives on the world which encourage visitors to question and explore different understanding, values and viewpoints" (Uzzell and Ballantyne 1998: 11). We share Moscardo's belief that effective interpretation can support the development of "mindful" visitors (1996: 377) and that the past can be experienced through the "endless possibilities of interpretation" (Nuryanti 1996: 250).

Museums, World Heritage, and Global Value

Kirshenblatt-Gimblett highlights the problems of World Heritage sites which, as global spaces, are deemed to have international significance and appeal (2006). Being structured

round the concept of "universal value," such sites are generally interpreted for a largely international audience—indeed WHS status is attractive to many countries because of the potential for increased tourism that may result as a consequence of inscription and the concomitant recognition of global significance of the space. Thus, as museums with a global remit, they may seek to benefit localities. However, the "universal themes" can be problematic by contradicting or even proving offensive to local communities whose needs will be subjugated to the demands of the global.

Several museums theorists argue that there is evidence of, or a need for, a local turn within such supposedly global sites. Emery argues that museums have the potential "to make a difference" within society "in the face of a rapidly growing need to examine environmental, cultural and socio-economic problems, people are turning to institutions or sources that will address global problems at local levels." Society, he argues, "must be a part of a museum's organisation" (2001: 70).

Bennett maintains that "many display sites today are less globally ambitious then their nineteenth-century counterparts" since they are "less monolithic than in the past" (2006: 48). Museums accorded WHS may not be self-representative in the same way as national museums, yet Steiner maintains that the ordering of the material cultural and built environment "can serve to legitimate or 'naturalise' any given configuration or political authority" (1995: 4). Therefore, nation states may support WHS values in order to reflect their own changing culture, values, and above all, attitudes toward other cultural values. As Matarasso notes, "Turkey has proved, over 80 years, a steadfast commitment to acquiring the cultural values and capital of its European neighbours" (2004: 4). Tourism provides a showcase and opportunity to evidence this. Hampton argues:

> tourism, in addition to its economic contributions to wealth creation, investment and employment, also plays a significant role in the construction of many countries' national identities, and particularly how a country wishes to be perceived by others. (2004: 736)

Kearney suggests that rapid cultural change is linked to secular movements, resulting in "deterritorialisation," as "consumption, communities and identities become detached from local places" and lead to the creation of hyperspaces (1995: 553). Tucker and Emge argue that "global socio-environmentalist movements such as World Heritage Sites, and the associated tourism, are hegemonic in themselves in that they promote these values as global *needs* and in turn are blatantly neglectful of local voices" (2010). In Göreme, this has resulted in the more recent Islamic settlement in the region becoming in turn de-emphasized (Tucker 2000), as inevitably stories change with the telling, retelling, and the audience. As the demands of tourism prioritize the Byzantine Christian past, inevitably this has resulted in not just a "loss of memory" (Tucker 2000), but a disengagement with place beyond the tourist sphere.

Göreme provides a potential meeting point of seemingly opposing faiths and is subject to the impacts of historical, political, and cultural change and diasporic "remembering." Rather than diffusing tension, however, World Heritage status actually compounds the potential tensions inherent within the site as a religious or geographical bound museum space. As we discuss later, our research shows that failure to develop mutual respect and

understanding between the local community(s) and tourists/visitors results in negative valuing and the necessity for attempts to release tension by guides telling potentially rogue stories to tourists within the site.

Introduction to the Site and Locality

The Cappadocia region is set amongst a landscape of giant rock cones with historic Byzantine cave dwellings and churches alongside contemporary villages and townships. The remains of approximately 300 cave churches and monasteries dating back to between the ninth and the thirteenth centuries are scattered throughout the region's valleys. Amongst these, the Göreme Valley is a particularly concentrated area of monastic settlement, and was enclosed as the Göreme Open-Air Museum during the 1950s and designated a UNESCO WHS in 1985. There are also many rock-cut churches in and around the site of the current Göreme township (situated 1.5 kilometers from the museum site), which was originally resettled (after the earlier Byzantine settlement of Matiana) as a Turkish farming village named Maccan, and where the oldest mosque dates back to 1686.

According to much of the tourist literature on Cappadocia, the region was discovered by the West in the early twentieth century when Guillaume de Jerphanion, a French priest, published the results of his study of rock-cut churches in the Göreme Valley. Followed by other scholars, Jerphanion's work served to mark off the Byzantine churches in the Göreme Valley as having key significance to Christianity. Contemporary travel guidebooks and tourist brochures repeat this emphasis with descriptions and photographs of the frescos in the churches. These frescos are painted either directly onto the cave walls or onto a plaster base within the later churches, typically depicting the Holy Trinity, apostles, and disciples and reflecting scenes from the Old Testament, including miracles such as the raising of Lazarus, for example.

Since the mid-1980s, Göreme and the wider Cappadocia area have become a major focus of Turkey's cultural tourism development. The primary tourist attraction in the region is the Göreme Open-Air Museum. As mentioned earlier, having an explicitly Christian site such as Göreme under its protection allows Turkey to perform a secular state role of religious tolerance and openness. The formal narratives of the Göreme Open-Air Museum thus prioritize the site's Christian importance. While Islam is a non-iconographic faith barring representations, icons were an important element of Byzantine religious expression and worship (Frank 2000). The well-preserved Byzantine frescos within the caves of the Göreme Open-Air Museum result in a highly visualized and potentially religiously charged experience, which in turn inspires visitors to embody and experience their faith and/or culture through the visual.

The site attracts a steadily increasing number of international tourists and pilgrims, together with a small number of domestic tourists. The region plays host to some six hundred thousand visitors per annum, three-quarters of whom are international cultural tourists. By emphasizing this Byzantine past, the site interpretation and formally trained local guides, who are invariably drawn from other faith communities, highlight how cultural

memory and identity shaping can operate within tourism as a powerful discourse, silencing certain narratives about the past and privileging others. Moreover, discussions with local guides suggest there is an expectation that, as a Christian site, it will be experienced by tourists as a place of pilgrimage. The museum thus functions as a "cultural station" (Burns 2000) and as a site of pilgrimage for secular and/or religious visitors, with visitors able to determine the degree of secular or religious value they bring to the site.

Construction of Tourist Experience at Göreme

There has been a growth of interest in the potential of developing tourism at religious sites with debates about whether such visitors should share the religious values of these attractions (Carnegie 2006a, 2009; Devereux and Carnegie 2006; Shackley 2001). The World Heritage Site at Göreme presents a complex mixture of religious identities, constructed as it is as secular (WHS) space within a country with a secularized state but a predominantly Muslim population, yet it is strongly associated with the Byzantine Christian faith. Therefore it is both a secular space "religiousized" within the interpretation and a religious space officially secularized as a WHS. Thus Göreme, as a World Heritage Site, is interpreted in cultural value terms within the formal signage, albeit as a site of Byzantine Christian importance, but it is experienced as a contemporary space, with visitors bringing contemporary values, religious beliefs, and all the potential biases and prejudices associated with their own and other faiths.

Valk notes that the removal of religion from the public realm does not create a neutral space. Rather he argues that:

> The degree to which religion has been marginalized or removed has not, however, resulted in a "naked public square." Beliefs, values and principles still hold sway, even if they are not religious in the conventional sense. People and entities continue to be shaped if not driven by views that may contrast or oppose religious ones. These too must be accounted for, if not identified and described, as having great import in the public square. (2009: 1)

In the case of Göreme, although situated within a secularized country, the dominant faith of Islam remains key to local people's identity. Within the museum, however, there is no doubt that the physical landscape reflects the Byzantine Christian past—indeed Climo and Cattell note that powerful institutions such as the church "can replicate activities in several locations which in turn shapes the landscape in recognisable ways" (2002: 43). MacCannell argues that tourism also shapes environments and that it is "not just an aggregate of merely commercial activities; it is also an ideological framing of history, nature and tradition; a framing that has the power to reshape culture and nature to its own needs" (1976: 1). Thus the physical environment is a complex space shaped by the symbolic power and meanings attached to religious values, world heritage, and tourism. World Heritage Sites are thus spaces of encounter and indeed they become containers of global cultural ideas, with cultural products a "language" or "currency" of cultural exchange.

Formal Interpretation

The official narrative within the museum is limited to formal panels, which are large, billboard-type signs outside each of the main churches. These provide technical depictions of the noteworthy features of each church and the expected architectural features found in any church—that is to say the church features that have been cut into and imposed onto the natural landscape. Such signage offers nothing in the way of debate and avoids any controversy regarding the previous inhabitants of the space, or "hot interpretation," as Uzzell and Ballantyne (1998) call it. It also generates the need for tour guides to elaborate on these panels and include general comments about the geography, landscape, and history of the area during the Byzantine era. Unlike fixed narratives on signage, what Hermer and Hunt (1996) term the "official graffiti of the every day," tour guides can, and do, change their interpretation to suit the imagined expectations of the group they are guiding or to best reflect their own knowledge, beliefs, and, potentially, prejudices and partialities. An example of this more subversive interpretation was the idea that the monks and nuns of the Byzantine settlement had created secret underground passages so they could meet up, with the potential consequences if children were born. This tale told at the entrance of the site may well be intended as an ice breaker to the tour, but nonetheless serves to destabilize the visitor's belief in the piousness of those living under holy orders. It must also be borne in mind that many visitors come for religious reasons, often as part of the route of Saint Paul, and we witnessed several coach tours of priests and nuns during our fieldwork who could have been offended by these stories.

Guides therefore play a significant part in shaping the experience of the visitors and can contradict the fixed narratives or create other narratives, which cannot be refuted due to the paucity of the formal interpretation. Our research highlighted that these multilayered *verbal* interpretations, as the main sources of information offered within the site, contrasted sharply with the official billboard written accounts. Guides become the intermediaries on the visit and, as many are from other parts of Turkey and are nationally certified as guides, they cross the divide between locals and tourists. They either collude with or create other, sometimes subversive, narratives that, while not fixed, become the dominant narratives within the frame of the visit. Thus both visitors and guides bring to their experiences of the site their own and each other's cultural influences, prejudices, and ideologies, while in theory the site remains neutral and not implicated in the subversions. We now discuss these tensions and subjections and consider their implications for the physical environment of the museum site.

Tensions within the "Meeting Ground" at "Göreme": Damage to the Frescos

An increasing number of visitors to the site, often in large tour groups arriving together, means there is inevitably a cost to the site as a consequence of this ever-increasing footfall. Erosion caused by rain and wind is also ongoing, and some of the churches have been

concreted over to ensure their survival. Tourists tend to seek to gain access in groups, and often this means that large groups entirely fill the space within churches with the risk of accidental damage to the fragile frescos on the church walls. A key organizational and site management issue centers around restoration and maintenance of the iconic images within the many Byzantine churches.

Although there is some dispute about the actual age of many of these depictions, the earlier wall paintings do not reflect the human form and thus are less problematic to Islamic beliefs. Later cave paintings, depicting biblical scenes and key figures from the Bible, invariably have evidence of vandalism to figures, with one or both eyes usually obliterated and commonly the whole face destroyed. There is also graffiti scribed on many of the frescos. Given the holy nature of images of Christ and Jesus within these sacred spaces, such vandalism can be interpreted by Christians as evidence of a lack of respect for the Byzantine history of the site. Tour guides therefore are obliged to attempt to explain this damage to their tour groups, while a variety of explanations given maintain an air of mystery regarding the perpetrators and reasons for the damage. We sought to determine if there was a central narrative that explains the damaged icons, as this "mystery" appeared central to the site experience and to the relationships between local communities and tourists. We now discuss the varied accounts offered and question not only why the images, particularly the faces and eyes of the figures, are vandalized, but also how the damage is incorporated into the contemporary politics of place at the site.

Tourists hear narratives of the Byzantine Christian past, narratives of religious practice and of religious and cultural difference and cultural change. They also hear explanations for the graffiti and damage to the frescos. Many guides do not necessarily include this information as a part of their tour, but rather provide an explanation for the damage only when obliged to respond to questions from visitors. The explanations offered ranged from folkloric to xenophobic and covered the grand narratives of diasporas to the common prejudices of and about, particular, often local, ethnic groups.

There appears to be no single narrative that satisfactorily explains this vandalism, because explanations vary according to who is telling the story and to whom the story is being told. A common explanation offered by guides suggested that the damage was done by local children playing in the caves or by local herdsmen who used the caves for shelter. These narratives suggest both accidental or naive damage and deliberate vandalism, but with both carried out in ignorance of the site's contemporary value. Interestingly, this narrative implies that WHS status raised the profile of the area locally and, as a consequence, that local people learned to value the area. The implication is that local people now value the site and feel proud to "own" a site deemed of international significance, despite not sharing in the religious values the site reflects. However, this very act of valuing the value others give to it can compound the sense of "forgetting" of local memories and pride of Islamic past (and indeed present) (Tucker 2000). However, restored areas also show signs of recent vandalism and guides agreed that it is ongoing and therefore cannot be consigned as historical ignorance predating WHS designation.

Another explanation offered for the damage suggested that the Greeks took the faces with them during the post-1923 Greek-Turkish population exchange. Indeed, while this

explanation can seem offensive, it is interesting to note that Shackley (2001) points out that damage to religious sites is often carried out by those who most revere the site and who seek reliquaries and to take some of the potency of the site home with them. During our fieldwork, we were aware of groups of Greek visitors, traveling in the company of their priests, for whom such explanations, as in the case of references to monks and nuns earlier, could be problematic.

Another explanation offered by a local photographer, who earned his living taking pictures of tourists within the site, described a folk cure that involved grinding the scraping from the fresco eyes and making medicine from the powder. This form of sympathetic magic suggests that local peoples of other non-iconographic faiths attribute power to the frescos despite not sharing the religious values. There is no one truth explaining the damage to the frescos in the museum; all of these explanations are believed as factual by some, while other stories are offered perhaps more as entertainment. Importantly, all of the narratives allowed a distancing from the cause of the damage by the guide, allowing locals and guides to perform the role of host without being implicated in the vandalism. Kurkowska-Budzan notes that shaping collective memory is possible under some conditions, of which the main one is: "that the interpretations of the past produced by authorities or the spokespersons . . . not contradict the lived experience of individuals" (2006: 134). Indeed, the guides operating in the Göreme Open-Air Museum are shaping a collective guiding narrative linked to their own and each particular tour group's relationship with place.

The vast majority of visitors are international and have no connection with Göreme as a place apart from what it represents in terms of Byzantine religious values. However, as tends to be the case in tourist zones, local people service the site in terms of providing food and drink and selling souvenirs, mostly outside the formal boundary of the WHS. Souvenirs reflect local and Turkish culture; for example, evil eye charms again highlight the relationship to the damaged eyes within the site. Nearby activities offered to tourists such as camel riding also draw on tourists' expectations about Turkishness. Therefore, the Byzantine Christian past may well be the narrative within the site, but it is held, even trapped within, and surrounded by the present, where the local customs, faith, and values excluded from within hold sway.

Visitors on guided tours may also have the opportunity to visit local carpet shops and restaurants in order to experience something of the "real Turkey." Tucker (2010a) has elsewhere noted that hot air ballooning over the WHS, an increasingly popular tourist activity, allows visitors privileged, and it could be argued voyeuristic, access to local communities through an appropriation of the air, which has created tensions between the ballooning companies and the local communities whose lives are observed for tourist purposes. Inevitably, tourism provides much needed income and employment, and local communities often act as intermediaries within the locality, taking tours locally, and providing other services for tourists such as accommodation and dining. Tucker's longitudinal study (2010b) in the region has highlighted the complexities within the local communities as family and local allegiances and personal relationships impact on how tourists experience the locality.

Clearly it is hard to argue the existence of a coherent and cohesive community of either locals or tourists. Indeed at various times, and in different contexts, both categories overlap. Some local traders, for example, initially visited as tourists and stayed to become locals. Some tourists are diasporic locals seeking to remember. It may well be argued, though, that remembering is more acute amongst the diasporic, and that those expatriate locals are important in maintaining an international relationship with the Turkish past, embracing a different way of valuing the site.

Locals, who now live and work close to the heritagized space or are engaged in the business of tourism within or nearby the site, cannot be understood as one community any more than the visiting tourists can be viewed as a single group. However, the WHS promotes a particular form of inclusiveness to those whose beliefs, cultures, and values are contained within. Inevitably, this polarizes people, and by default excludes. The damage to the eyes, both historical and contemporary, physically scars the site, changes the landscape, and offers clear evidence of unacknowledged tensions. WHS values help to fix the narratives for the museum site, which does not address these tensions. We now conclude with some comments on the possibilities for a more inclusive interpretation.

Conclusion

In this chapter, we have argued that the Göreme Open-Air Museum site is constructed and interpreted differently for different audiences and that the dominant Byzantine Christian narratives are structured predominantly to meet the particular expectations of different international visitors. Meanwhile, the local communities have experienced layers of distancing: through the secularization of the state and the move toward Westernization; through the explicit and implicit values inherent in WHS status; through the gating of the area into a closed-off site rather than shared community space; and through the interpretation and promotion of the Byzantine Christian past. Urieli et al. (2002) uses the term *heritage proximity* in order to explain the attitude of local residents toward their heritage site. Indeed, regarding the Göreme Open-Air Museum, local people, despite the close physical proximity of the space, have ceased to focus on their own past relationship with the site and therefore reinforce the key messages of the WHS.

However, this need not be the case. Schmidt and Little (2007) suggest that people seek a deeper connection with others within their discretionary time and that leisure activities can draw people's attention to spiritual pursuits. There is also a growth in the number of pilgrims to historic sites (Devereux and Carnegie 2006; Diggance 2003) and evidence of what McLennan (2010) has termed a "post-secular" turn within society. It seems desirable that the site at Göreme be interpreted to allow for a broader understanding of spirituality and faith within all communities so that the shared past can be revisited in the present to create a sense of shared values (Carnegie 2009). In order to do this, the WHS management must reevaluate the site's role and recognize, as Emery (2001) suggests, that such museums could play a wider role in society. As O'Neill notes:

Attempts by museums to make histories of religion reflect a wider attempt to redefine their role in society. [. . .] They are struggling to deal with the realities of human life, the universal mysteries of birth and death, love and tragedy, individual freedom and belonging. (O'Neill 1996: 198)

To turn the quote by O'Neill around, all cultural institutions, whether localized or products of global markets, are struggling to make sense of their role as cultural spaces interpreting and responding to cultural change, even when not attempting to interpret religions. Uzzell and Ballanytne (1998) have argued that visitors are likely to experience some form of emotional arousal within such potent sites and it seems that the interpretation (or lack of it) is destined to ensure cool interpretation, which might minimize the risks involved in focusing on that which might foreground religious differences. However, we argue that the evidence of ongoing damage to the museum and the variable and often contentious interpretations offered by tour guides suggests that hot interpretation (Uzzell and Ballanytne 1998) might be more conducive to inclusiveness.

At present, the formal signage within the Open-Air Museum does little to help visitors, guides, and locals experience their own relationship to the locality in contemporary terms, or indeed with each other. This begs the question as to whether the WHS of Göreme could do more to embrace plurality and to offer interpretation that encourages a "mindful" (Moscardo 1996) connection with place and with peoples of all faiths. Matarasso maintains that those who do not recognize or accept a given interpretation are likely to be in a local minority, but he also argues that the "contested nature of heritage production could be seen as a positive space within democratic society, allowing different forces and interests legitimately to express values they hold important as well as to question accepted views of the past and its influence on the present" (2004: 6). He goes on to suggest that "far from being risky, this is arguably less dangerous than promoting exclusive interpretations under the guise of objectivity" (2004: 6). We are not contesting that the WHS at Göreme is based on a real relationship with a Byzantine Christian past, nor indeed would local people argue against this central truth. Rather we are saying there are other stories to be told, other heritages, other faiths, who equally have a right to share in the history of the site. We might also argue that the various interpretations of the damage to the eyes suggest that more could be done to encourage a greater understanding of the central values of each other's faiths. As Emery's study concluded, "communication is a necessary and important binding mechanism to allow guided conversations through any or all of the areas of expertise of the museum . . . the museum and the community need to work together in a conversation about the future" (2001: 79). We suggest that the problems encountered at Göreme are not helped by WHS notions of value without debate—which forces a globalized view.

Ultimately, we argue for greater reflection within the formal WHS signage to allow for a more multivocal interpretation which, while it might not transcend religious and cultural differences, can become a forum for the exploration of mutual respect and understanding. Heath and vom Lehn note that there is much to learn about how "the experience of exhibits in museums and galleries emerges in, and through, social interaction,

interaction between people," as "people, in collaboration with others, reflexively constitute the sense and significance of objects and artefacts" (2004: 44). This suggests that the meanings need not be fixed and the narratives can include other visions and versions of the shared past. A stronger visible curatorial presence is therefore required to mediate between the formal signage, the guides, and visitors to support the creation of shared meaning where differences are understood within a framework of promoting dignity and mutual respect and including local communities.

In this way, local communities can share in the values of the site and create new ways for remembering. Local people could become more involved in the guiding process, informing visitors of the more recent Islamic settlement in the area, enhancing visitors' engagement with nearby resident communities. This seems particularly important in the current global climate of perceived fears over the "religion of the other"; and would allow for a more informed and informing "meeting ground" (MacCannell 1992).

References

Aas, C., A. Ladkin, and J. Fletcher. 2005. "Stakeholder Collaboration and Heritage Management." *Annals of Tourism Research* 32 (1): 28–48.

Bennett, T. 2006. "Exhibition, Difference and the Logic of Culture." In *Museum Frictions: Public Culture/Global Transformations,* eds. I. Karp, C.A. Kratz, L. Szwaja, and T. Ybarra-Frausto, 46–70. Durham, NC: Duke University Press.

Burns, P. 2000. *An Introduction to Tourism and Anthropology.* Routledge: London.

Carnegie, E. 2006a. "Religion, Museums and the Modern World." *MARTOR, The Museum of the Romanian Peasant Anthropology Review* 11: 171–179.

Carnegie, E. 2006b. "'It wasn't all bad': Representations of Working Class Cultures within Social History Museums and their Impacts on Audiences." *Museum and Society* 4 (2): 69–83.

Carnegie, E. 2009. "Museums of Religion in a Pluralist Society, Special Edition." *Journal of Management, Spirituality and Religion,* eds. T. Selwyn, N. Graburn, and A. Ron, 6 (2): 157–169.

Carnegie, E. 2010. "Museums in Society or Society as a Museum? Museums, Culture and Consumption in the (Post) Modern World." In *Parcelling the Past: Selling Heritage in the Modern World: New Directions in Arts Marketing,* eds. F. Kerrigan and D. O'Reilly, 231–239. London: Taylor & Francis.

Clifford, J. 1984. "Introduction: Partial Truths." In *Writing Culture: The Poetics and Politics of Ethnography,* eds. J. Clifford and G. E. Marcus, 1–26. Berkeley: University of California Press.

Climo, J. and M. Cattell, eds. 2002. *Social Memory and History.* New York: AltaMira Press.

Da Silva, T. 1999. "The Poetics and Politics of Curriculum as Representation." *Pedagogy, Culture & Society* 7 (1): 7–33.

Devereux, C. and E. Carnegie. 2006. "Journeying Beyond Self." *Tourism Recreation Research* 31 (1): 47–56.

Diggance, J. 2003. "Pilgrimage at Contested Sites." *Annals of Tourism Research* 30 (1): 143–159.

Emery, A.R. 2001. "The Integrated Museum: A Meaningful Role in Society." *Curator* 44 (1): 69–82.

Frank, G. 2000. *The Memory of the Eyes.* Berkeley: University of California Press.

Hampton, M.P. 2004. "Heritage, Local Communities and Economic Development." *Annals of Tourism Research* 32 (3): 735–759.

Heath, C. and D. vom Lehn. 2004. "Configuring Reception: (Dis-)Regarding the 'Spectator' in Museums and Galleries." *Theory, Culture & Society* 21 (6): 43–65.

Hermer, J. and A. Hunt. 1996. "An official Graffiti of the everyday." *Law & Society Review* 30 (3): 455–480.

Hollinshead, K. 2004. "Tourism and the New Sense: Worldmaking and the Enunciative Value of Tourism." In *Tourism and Postcolonialism: Contested Discourses, Identities and Representations,* eds. M.C. Hall and H. Tucker, 25–42. London: Routledge.

Kearney, M. 1995. "The Local and the Global: The Anthropology of Globalisation and Transnationalism." *Annual Review of Anthropology* 24: 547–565.

Kerstetter, D. and M-Hea Cho. 2004. "Prior Knowledge, Credibility and Information Search." *Annals of Tourism Research* 31 (4): 961–985.

Kirschenblatt-Gimblett, B. 1998. *Destination Culture: Tourism, Museums and Heritage.* Berkeley: University of California Press.

Kirschenblatt-Gimblett, B. 2006. "Exhibitionary Complexes." In *Museum Frictions: Public Culture/Global Transformations,* eds. I Karp, C.A. Kratz, L. Szwaja, and T. Ybarra-Frausto, 35–46. Durham, NC: Duke University Press.

Kurkowska-Budzan, M. 2006. "The Warsaw Rising Museum: Polish Identity and Memory of World War II." *MARTOR, The Museum of the Romanian Peasant Anthropology Review* 11. Available at: http://martor.memoria.ro/?location=view_article&id=191&page=0.

MacCannell, D. 1976. *The Tourist: A New Theory of the Leisure Class.* New York: Schocken Books.

MacCannell, D. 1992. *Empty Meeting Grounds: The Tourist Papers.* London: Routledge.

McLennan, G. 2010. "The Postsecular Turn." *Theory Culture Society* 27 (4): 3–20.

Matarasso, F. 2004. "History Defaced: Heritage creation in contemporary Europe." Paper delivered at the international symposium "When Culture Makes the Difference: The Heritage, Arts and Media in a Multicultural Society," Genoa, November 19–21.

Moscardo, G. 1996. "Mindful Visitors: Heritage and Tourism." *Annals of Tourism Research* 23 (2): 376–397.

Nuryanti, W. 1996. "Heritage and Postmodern Tourism." *Annals of Tourism Research* 23 (2): 249–260.

O'Neill, M. 1996. "Making Histories of Religion." In *Making Histories in Museums,* ed. G. Kavanagh, 188–199. London: Leicester University Press.

O'Neill, M. 2004. "Enlightenment Museums: Universal or Merely Global?" *Museum and Society* 2 (3): 190–202.

Poria, Y., R. Butler, and D. Airey. 2006. "Tourist Perceptions of Heritage Exhibits: A Comparative Study from Israel." *Journal of Heritage Tourism* 1 (6): 51–72.

Salazar, N. B. 2010. *Envisioning Eden: Mobilizing Imaginaries in Tourism and Beyond.* Oxford: Berghahn Books

Shackley, M. 2001. *Managing Sacred Sites: Service Provision and Visitor Experience.* London: Continuum.

Schmidt, C. and D. E. Little. 2007. "Qualitative Insights into Leisure as a Spiritual Experience." *Journal of Leisure Research* 39 (2): 222–247.

Steiner, C. 1995. "Museums and the Politics of Nationalism." *Museum Anthropology* 19 (2): 3–6.

Tilden, F. 1977. *Interpreting our Heritage.* 3rd ed. Chapel Hill: University of North Carolina Press.

Tucker, H. 2000. "Tourism and the Loss of Memory in Zelve, Cappadocia." *Journal of the Oral History Society* 28 (2): 79–88.

Tucker, H. and A. Emge. 2010. "Managing a World Heritage Site: The case of Cappadocia." *Anatolia* 21 (1): 41–54.

Tucker, H. 2010a. "Appropriations in the Air." *iNtergraph Journal of Dialogic Anthropology* 3 (1).

Tucker, H. 2010b. "Peasant-entrepreneurs: A Longitudinal Ethnography." *Annals of Tourism Research* 37 (4): 927–946.

Urieli, N., A. A. Israeli, and A. Reichel. 2002. "Heritage Proximity and Resident Attitudes toward Tourism Development." *Annals of Tourism Research* 29 (3): 859–862.

Uzzell, D. and R. Ballantyne. 1998. *Contemporary Issues in Heritage and Environmental Interpretation.* London: The Stationery Office.

Valk, J. 2009. "Religion or Worldview: Enhancing Dialogue in the Public Square." *Marburg Journal of Religion* 14 (1): 1–16.

Testimony, Memory, and Art at the Jewish Holocaust Museum, Melbourne, Australia

Andrea Witcomb

In his book *The Texture of Memory: Holocaust Memorials and Meaning*, James Young (1994) argues that, for Holocaust survivors, the most important form of memorialization was that of the testimony. To testify to the existence of the Holocaust and its impact on Jews was to deny the perpetrators their victory by maintaining the memory of those killed and to speak their names. To forget was to let them win.

To testify in order not to forget has been one of the central pillars of the work of the Jewish Holocaust Museum and Research Centre in Melbourne.[1] Formed mainly by Polish survivors in 1984, this Centre has striven to tell the story of the Holocaust in order to prevent anti-Semitism from developing in Australia and to counter those who claim the Holocaust never happened. To this end, the Centre, which until recently was run by volunteers with a minimal number of paid staff members, developed a photographic exhibition on the Holocaust and established an archive, a library, and a program of ongoing video testimonies. Here I want to explore the possibilities opened up by their use of a small number of artworks as an adjunct to their photographic displays in the task of testifying, remembering, and memorializing those who lost their lives during the Holocaust.[2] I focus on the work of two sculptors—Sarah Saaroni, who was a teenager during the Holocaust, and Charles Aisen, who migrated to Australia before the Holocaust but who returned to Poland in 1965 only to discover the total destruction of the community in which he had once lived.

I want to argue that in the context of the desire to provide testimonies, here understood as a wider phenomenon than the recording of oral and video testimony, the use of artworks provides a more complex set of meanings than the more usual form of documentary heritage such as photographs. Until the end of 2009, when the exhibition that provides the examples for this chapter was taken down, the story of the Holocaust was told almost entirely through photographs. Survivor guides augmented the narrative for school groups and interested visitors by using the photographs on display to anchor their narrative about the events of the Holocaust and their own experiences within it. Nearly all the photographs on display were copies of photographs taken either by the perpetrators or by the liberators, found through established archives such as those at Yad Vashem in Israel, or in books. The only exception was one panel of photographs at the beginning of the exhibition. This panel

included photographs depicting the families of a number of survivors at the Centre. These images represented the only material traces of the world they had lost.

In this context, the use of a small number of artworks—sculpture and paintings—to extend the display is of interest. None of the artworks on display was produced during the Holocaust. They did not, therefore, have the status of being a document from the time itself such as the artworks produced by residents at Theresienstadt—those of Otto Ungar, Bedrich Fritta, Karel Fleischmann, and Leo Hass, for example (Blatter and Milton 1982). Nor, with a few exceptions, were they produced by professional Jewish artists engaged with Holocaust themes. Instead, most of the artworks were produced by survivors who came to art making as a form of therapy, usually much later in life. In some cases they were also produced by the second generation. They used their art making to deal with the trauma they experienced. Because of this, these art objects are very different from the official photographs taken from the point of view of the perpetrators. In their intensely personal nature, the artworks begin to express, as Saba Feniger (1996)—the volunteer survivor curator who collected them for the Holocaust Museum suggests—"not only the horror but also how it felt being subjected to it." Furthermore, because they are based on memories, these artworks are also understood by the survivors as offering a form of testimony. For Feniger, "the artists share a history in what they have witnessed and remembered, their art providing a visual and concrete testimony for the future while we still have living witnesses to the human tragedy of the Holocaust" (1996). Interesting, the majority of the sculptures at the JHMRC were displayed in a section marked as "Memorials," indicating perhaps their double function of memorializing by testifying.

As Nanette Auerhahn and Dori Laub (1990) have argued, however, giving testimony is not a simple process. While it is true that the giving of a testimony, in public, is part of a desire to provide evidence, a number of complex psychological issues are also taking place. To begin with, there is the desire to overcome the absence of the dead by documenting their past presence in what becomes the creation of a historical document as well as a memorial. Second, the audience is a multifaceted one that includes the dead, other survivors, the perpetrators, and the bystanders, as well as present-day audiences. This means that as a device that addresses the dead, testimonies are intended to "reanimate, anthropomorphise, or make present the addressee" (Auerhahn and Laub 1990: 447). But as devices that address the perpetrators, the bystanders, and their descendants, they are intended to do much more than deny them victory. Testimonies are also intended to constitute the testifier as a whole person again by insisting on a dialogue with those who denied them their humanity. The rhetorical presence of the listener creates the hope of reconstituting the victim's sense of self as human again and thus overcome the trauma of losing their humanity by no longer being alone. Thus testimonies are predicated on the possibility of empathic listening. Given that the experience of the Holocaust for Jewish people represents the loss of faith in the possibility of empathy, the attempt is courageous and potentially dangerous, carrying the risk of not reaching the intended audience in the desired manner and thus of reliving the initial trauma over and over again (Auerhahn and Laub 1990: 448).

How, then, do survivor artworks work as a form of testimony? What do they testify to, to whom and what might they do for the maker of that testimony and the audience that receives it?

One way of approaching these questions is to explore these artworks as objects that embody different forms of memory and produce, as a consequence, different affective responses in the viewer. Particularly useful is the distinction between narrative and traumatic forms of memory. In narrative forms of memory, people tell stories about particular people, places, and experiences from their past. In doing so, they use the past tense, placing these memories within a temporal framework in which the past is clearly differentiated from the present. For those who have suffered trauma, however, memory can manifest itself in other ways. In a phenomenon poet Charlotte Delbo, a member of the French resistance and survivor of Auschwitz, called "sense" memory, the physical imprint of the experience lingers on, casting aside any understanding of memory as based on a temporal division between past and present (Bennett 2002, 2005). Furthermore, these physical imprints are remembered not through narrative, but viscerally, through what Delbo refers to as an "impervious skin of memory" that forms itself in the body of the survivor (in Bennett 2005: 25). While this "skin" is dormant most of the time, it nevertheless erupts into a survivor's present-day consciousness in a process in which victims relive the physical and emotional pain of the initial trauma. Experiencing such sense memories is literally to relive the past in the present by feeling it in the deepest recesses of one's body. In Freudian terms, victims can only act out their trauma, rather than work through it. When given expression through art making, the result is an art form that communicates the sensory experience of trauma in what Jill Bennett calls a "seeing truth" rather than a "thinking truth" (Bennett 2005: 25). Rather than attempting to represent the past, such artworks embody sense memories by "registering the pain of memory as it is directly experienced, and communicating a level of bodily affect" through the form of the work itself (Bennett 2005: 26). For Bennett, this sensory landscape has the power to affect the viewers, generating an empathic form of understanding that moves them beyond their existing knowledge, framed as it is by conventional historical knowledge and by common or narrative memory.

The other form of memory associated with trauma is what Jacob Climo (1995), discussing the experiences of children of survivors, calls "vicarious memory." This term refers to the ways in which the second generation or those who were not there remember the Holocaust through a cultural repertoire of images and embodied behaviors in what has become a collective memory. While Climo emphasizes the embodied nature of these memories, discussing their physical manifestation in a range of behaviors, Marianne Hirsch (2001), in her discussion of "post-memory," refers to a more generalized form of collective memory between survivors and their children as "experiences that they 'remember' only as the narratives and images with which they grew up, but that are so powerful, so monumental, as to constitute memories in their own right" (Hirsch 2001: 9). To have this kind of post-memory, for Hirsch, is to be involved in a retrospective adoption of trauma suffered by others into one's own life story.

In what follows, I want to explore the complex nature of the testimonies offered by Saaroni and Aisen by exploring the ways in which the testamentary nature of their

sculptures is reflected in the different ways in which they embody these different genres of memory. In the process, I want to ask what possibilities this form of documentation opens up for creating an affective space in which empathy is reestablished for the testifier through a rhetorical form of dialogue with the viewer, as well as to explore the experience for viewers.

In doing so, I also want to explore the implications of Jill Bennett's insistence that the development of empathic understanding is only possible through affective experiences that emerge in response to the form rather than the meaning of artworks. Like many other theorists of affect, Bennett (2005) argues that as sense memories are generated outside of language and representation, it is important to ask of artworks that embody such memories not what they mean but how they work. Bennett is interested in pursuing a visual analysis that focuses on the form of the work, on asking how its structure embodies and communicates sense memories that have their own affective or sensorial impact on the viewer. She is, however, rightly wary of suggesting that this impact creates its own trauma or that the viewer can somehow inhabit the victim's experience. Like Dominick La Capra (2001), in his critique of historians and documentary filmmakers that seek to inhabit the landscape of trauma in order to make the reader or viewer experience it, Bennett is critical of those who suggest that it is either possible or desirable to take on the victim's position. Both are concerned that a simple repetition of sense memories intended to act them out does not enable a future beyond the moment of trauma, beyond a culture of victimhood. Like La Capra, Bennett encourages a form of art making that uses sense memories and their affective powers to jolt viewers from complacency and lead them toward a form of empathic understanding La Capra calls "empathic unsettlement"—an experience more akin to working through than to acting out and which has recourse to language and therefore to the future.

For Bennett, trauma art can achieve this if it contains within it a point of entry for the viewer, one that connects to their narrative memory so that it may be possible to connect the victim back into common narrative memory and thus effectively recuperate them back into society. As she puts it, the aim of art concerned with trauma is to "constitute a language of subjective process (specifically, of affective and emotional process) to complement history and to work in a dialectical relationship with common memory" (2005: 26). However, for the artwork to work at the affective level, this point of entry must never reduce the artwork to a representation of the past.

Bennett's arguments are largely based on the work of professional artists who comment on social traumas from the point of view of either a vicarious memory or at a point where they have worked through their own sense memories of the original traumatic experience. That is, none of the artworks she discusses were done by artists at a point in time in which they were still acting out their trauma and thus without a perspective on their sense memories. What, then, are the implications for the display of artworks that do not possess this external point of view because their makers have not yet come through the other side of their sensory memories? If the entry point for the viewers is not in the form of the work because the artists themselves do not as yet possess the necessary distance from their sense memories, does the construction of this entry point become

the responsibility of the curator? If so, how much interpretation is necessary and how should it be provided? Does falling back into language, into representation, facilitate and enhance empathic unsettlement or does it prevent it? This point is an important one to consider in relation to the extent of interpretation that museums need to provide when displaying artworks that embody the trauma experienced by survivors, and it is one I hope to explore in the analysis that follows.

Sarah Saaroni's Memories and her Art

Sarah Saaroni was born in Lublin, Poland in 1926 to a merchant family. She was thirteen years old when war broke out. Within weeks, her father lost his shop, and by the middle of winter the family had been forced to move to the Lublin ghetto, where they shared two rooms with another family. In her autobiography, Saaroni recalls the ghetto thus:

> Conditions inside the Ghetto were appalling. We were so cramped; there were so many people around us, such crowds everywhere. People walked the streets listlessly, trying to figure a way out. And there were signs of poverty everywhere: people begging, dying, hungry children crying. But life had to go on. (1995: 9–10)

They managed to escape the first wave of deportations, but not before the young Sarah had witnessed the brutality of the Nazi forces. This is her description of the first round up for deportation in the ghetto after her father had come running to tell them to get up and get dressed early one morning as the Germans were coming:

> We had hardly finished dressing, when the Germans were in our room, shouting, "Out! Out you go, you cursed dirty Jews!" and they herded us outside, where hundreds of men, women and children were already gathered.
>
> There was such confusion: the soldiers were pushing, shouting, and beating people, without discrimination: they turned into savage animals, without any feelings whatsoever. Mothers were embracing their terrified children trying to quieten them down, and trying to protect them from the brutality of the Germans.
>
> . . . We were taken to a big square called Place Grodzki where thousands of people were already waiting. We put our packs down and sat on them. Every so often a group was selected and taken away, but still more people were coming and coming. (1995: 11)

They escaped deportation that day. After several attempts to escape the Gestapo, her parents decided to return to the Lublin ghetto, but not before organizing for Sarah to pass herself off as Polish and join a group of Polish youths as forced labor in Germany. With much reluctance, Sarah was persuaded to leave her parents, whom she never saw again. She did, however, manage to pass herself off as a non-Jewish Pole, working in Hamburg and later in the countryside around it. On her last night in Hamburg, Saaroni had a strange nightmare in which her mother's head, wrapped in a towel, appeared to her to say goodbye. Crying, Saaroni begged her not to leave her alone again to which her

mother replied: "I can't take you with me. . . You are too young and your life is still in front of you" (1995: 40). She then leaned over, kissed her on the forehead, and floated off. Saaroni, stretching her arms out, was unable to catch her, waking up in terror. The nightmare repeated itself for many nights afterward. Saaroni herself is not sure to this day whether this was a nightmare or whether her mother's presence really did come to her.

After the war, she went to Palestine where she joined two surviving brothers. She married and had two children, emigrating from Israel to Australia in 1953. She began to sculpt at the age of fifty-five during a period in her life when she had recurring nightmares about her experiences during the war. The nightmares made her feel fearful of sleeping, for as soon as she managed to fall back asleep they would return. She found she could not speak about them at all to anyone, not even her husband. Only in the 1980s, after she had done many sculptures, was she able to write her autobiography and gain "some measure of conscious control" (La Capra 2001: 90) over her past experiences.

As a body of work, Saaroni's sculptures tread a complex line between narrative, sense, and vicarious memories. At times, it seems her aim is to represent her experiences directly through visual narratives. Much of her work, for example, seeks to document and interpret life in the ghetto. Her sculptures read like a chronological narrative, documenting the increasing brutality and eventually the deportations. Even the titles reflect this: *In the beginning, The Ghetto I, The Ghetto II, The Ghetto III, Deportation I, Deportation II, Deportation III,* and *Deportation IV.* Like the titles, the works are descriptive. Done in a realist style, they depict little scenes, many of them the scenes she describes in her autobiography. The family group sitting on their luggage waiting in the town square not knowing whether or not they were about to be deported; a child being terrorized by a Nazi soldier at gun point.

While we might say that this chronological narrative reflects a narrative as opposed to a sense memory, Saaroni's own traumatic sense memories of the ghetto experience are expressed through the figures of others. Thus, while these sculptures represent a scene, they also communicate sensations. And they do so by their form as well as by their expressive content. The statues are small, almost diorama-like, associating them with the world of children. This is a world Saaroni had barely left at the time these events occurred. Such a creation of a miniature world however, does not carry the connotations of childhood, naivety, and nostalgia, qualities Susan Stewart (1984) identifies with this category of objects. On the contrary. They carry the weight of feelings such as fear, disorientation, and dread. And while about the same size as decorative ceramic figurines, both their content and their style are completely different. Saaroni's miniatures might be redolent with memory, but they are not nostalgic. They register and express trauma on the bodies of those depicted, focusing on their pain and fear. As the viewer, we are capable of feeling this pain through our own physical discomfort at witnessing the pain of others. However, this is not to say that the viewer experiences the original trauma or even that he or she can take on the trauma of the victim, for we know very well that it is not our trauma but someone else's. Nor is it even a form of secondary trauma. Instead, I would argue that our experience as a viewer sits within the domain La Capra (1998) called *empathic unsettlement*—the ability to feel empathy for another without appropriating

either their trauma or their victim position. Producing this ability is central to the peda-gogical aims of both trauma art and the mission of an institution such as the Holocaust Museum—to use visual arts to disturb complacence.

Saaroni's expression of a sense memory becomes more complicated in another theme she explores—that of the death camp. We know from her autobiography that she never experienced this herself, though it is unclear just how much she knew. In looking at her sculpture *The End,* which depicts a group of emaciated people looking straight at the viewer from the end of one of the bunks so that only their heads are visible, we are struck by the size of their eyes, which seem to bulge out of their heads. They look completely resigned, knowing that the end is near and yet their gaze never wavers. It is us who look away, unable to confront the knowledge of their end, not them. Are they accusing us? Are they asking us to pity them? Or simply to recognize and remember what happened, acknowledge it? Is this a lament or an accusation? Does their gaze implicate us in what happened to them? And if so, what is our response? The questions posed by those eyes are unsettling, especially as they look at us within the context of a memorial.

Empathic Unsettlement One

This feeling of unsettlement is an affective response to the form of the piece. But I want to argue that, if we explore what kind of memory is going on in this piece, this disquiet can be made stronger if Sarah's story is allowed to play a role in the production of affect. At first glance, it would seem that this sculpture and others like it, is, to some extent, an expression of vicarious memories, making use of a visual language with a long history of circulation in the images taken of emaciated people lying and sitting on their bunks at the point of liberation. Like many other conventional works on the Holocaust, this piece would seem aimed at generating pity for the victims. It is also possible however, to in-terpret this work as an expression of Saaroni's own sense memory. First, we have her ac-count of the dream in which her mother appeared to her presumably just before her death. We know from that account it was her head, wrapped in a shawl Saaroni remembers. Sec-ond, we know from excerpts of her oral testimony recorded onto a digital touch screen within the exhibition (located at the other end of the room from the sculptures) that she left her mother for what turned out to be the last time feeling angry with her for pushing her to leave. In hindsight, she knows her mother was trying to save her, but at the time she felt rejected. There is thus intense pain, sorrow, and guilt that she felt like this when it was her parents who died and she who survived. As for many other survivors, the ques-tion of survivor guilt hangs in the background. In this context, this sculpture can be un-derstood as an enactment of survivor guilt, itself a traumatic experience. With Saaroni's story in mind, the eyes of the people in the sculpture take on an added significance, for in the process of making those figures with her hands, Saaroni was reliving her trauma and looking into her parents' eyes, facing her guilt and sorrow directly. In making this sculpture, Saaroni was physically, and viscerally, through her own hands and her own

eye contact with the eyes she was creating, acting out the trauma of leaving her parents in these circumstances and living with the knowledge that she survived and they did not.

While to interpret the work in this way might be, in terms of Bennett's (2005) arguments, to turn it into a representation by asking what the object means rather than to focus on how it works affectively, I want to argue that doing so does not take away from its affective impact but rather that this impact is enhanced. For Bennett, affect is about sensations or feelings rather than meaning. Following Deleuze, who argues that "feeling is a catalyst for critical inquiry or deep thought" (Bennett 2005: 7) in ways which rational inquiry is not, Bennett argues that the political import of affect is communicated through the form rather than the content of the work of art. Crucial to this, she argues, is the ability of the artist not to render a "faithful translation of testimony" but rather to contribute to the politics of testimony by blurring the distinction between experience and art (Bennett 2005: 3). For Bennett, a productive form of empathy is produced not when we identify with the victim at an emotional level through a process of recognition, but when we experience a "direct engagement with sensation as it is registered in the work" (Bennett 2005: 7).

Applied to Saaroni's sculpture *The End,* for example, this argument would suggest that the visceral shock of the gaze that does not go away, leading the viewer to wonder whether the work is a lament, an accusation, or a memorial has more power that a reading that ties the work down to a personal lament on the part of Saaroni for her mother or an admission of survivor guilt. This is because the latter reading, in leading the viewer to identify with a character (Saaroni herself) is more likely to result in feeling pity, to lead the viewer to sympathize with the victim but not to question his or her own relationship to the events in question. Thus, while the tension within Saaroni herself between sensory, narrative, and vicarious memories may have led her to make this particular artwork, it is not necessary to know about them in order to feel the sensations that structure the work and lead one to respond affectively in what La Capra would call *empathic unsettlement.*

Bennett's arguments work well for the non-narrative, nonrepresentational art forms that form the bulk of her examples. However, the majority of the artworks at the Holocaust Museum, including Saaroni's sculptures, are firmly embedded within a realist tradition. This suggests that they embody a tension between different forms of memory, making it difficult to resist aligning them with actual experiences. Their power to produce *empathic unsettlement* appears to reside not simply in the form of the piece but in the relationship between their ability to produce sensations out of their form and the articulation of these sensations to the lived experiences of the artists that made them. In other words, in the case of sculptures like Saaroni's, affect resides not only in the sculptures themselves but also in the stories of their makers. In bringing the two together, the affective dimensions of both are enhanced. Story enhances affect rather than diminishes it, raising the question of how to present the two side by side in a way that does not reduce the story to a representation but that plays to its affective powers.

The answer to this quandary may lie in understanding the display of works like these as artworks in their own right that use the qualities of their form to create the necessary

entry audiences need in order to experience empathy as unsettlement rather than pity. My argument here rests on my own encounter with Saaroni's story, which was serendipitous in nature in that I found bits of information over time and in different places, allowing me time to put them together. The process of discovery, of a developing sense of awareness as to what was going on in these sculptures was more powerful by the work I had to do than if there had been an interpretative panel laying it all out before me and side by side with the sculptures in question. However, that only occurred because I was interested in these objects and did some homework outside of my visit to the exhibition. The way these artworks were displayed—in a cabinet in rows—outside of any narrative at all, created an experience of them that was underwhelming rather than overwhelming. This impression is supported by the way in which all the guides I observed ignored these objects in their tours of the display, possibly because they did not fit into a conventional historical narrative of the Holocaust. That is, they did not fit within the established chronology, and the work they did was of another order—one that cannot be articulated through narrative forms of memory. The question of their interpretation then becomes a question of the creation of a further artwork, an installation that creates the space in which narrative might be put together through the work of the viewer but that does not narrate the meaning of the artwork directly. This might allow for the unfolding of an affective experience in ways that do not prescribe identification with the victims and their trauma, but open up a path for *empathic unsettlement.*

Empathic Unsettlement Two: The Works of Charles Aisen

The question as to the nature of the testimony offered and its relationship to the form of memory expressed and its affective impact on the viewer is given a further twist in Charles Aisen's work. Aisen is unusual amongst the artists displayed at the Holocaust Museum in that his experience of the Holocaust is not direct; but neither is it vicarious in the sense of being purely a post-memory mediated by family stories or the now global images that have come to define the Holocaust.

Aisen was born in 1901 as Charles Ribaisen, in Chelm, Poland, into a family of tinsmiths.[3] He experienced various forms of anti-Semitism, particularly in relation to employment opportunities, an experience that seems to have pushed him toward socialism. He got an opportunity to leave Poland in 1926 through relatives living in Melbourne. There he took on various jobs, learned English, and made contact with other socialists who were soon meeting in his room at a boarding house in Carlton, which was then the center of the Yiddish Jewish community. After a short spell in Sydney, he returned to Melbourne where, despite the Depression, he got a job in a shoe factory as a shop steward and joined the union. He met his wife, Fay, there and their home became the usual meeting place for left-wing Jewish migrants. Eventually he began his own business with another partner.

He became disillusioned by communism when the Russians made a pact with Nazi Germany, and he joined the Jewish Council against Fascism and Anti-Semitism,

organized just before the outbreak of World War II. It was then that he made contact with and eventually joined the Labor Party. His home once again became the meeting place for the local branch.

After the war, he decided to give up business and concentrate on social work within and outside the Jewish community in Melbourne. In 1965 he went to Warsaw to the twenty-second anniversary of the Warsaw Ghetto Uprising as a representative of the Jewish Council. The seventeen days in Poland were, he said,

> memorable. I realised there the horror of the eleven million people gassed by the Nazis, amongst them six million Jews. I went to Chelm where once twenty thousand Jews lived. I found there only two Jewish families. I visited concentration camp sites. I have seen in Majdanek the table used to extract gold teeth from the gassed victims of this camp. All those things were well documented and open for everybody to see, yet the world kept silent! Those pictures stayed with me all along and I longed to preserve somehow the memory of those perished people.
>
> I tried clay, ceramics, enamel, attended art classes till I found the right medium to express myself—my old friend, tin. I actually combined three media: sheet metal to make the figures, paint to give it additional life and some wording as an additional form of expressing my feelings.
>
> I have been told that mine was primitive art, naïve art, but the name means little to me. It was the best method as far as I was concerned to say what I felt needed saying. (in Robe 1982: 9–10)

Aisen's response, to make art that spoke to his sense of shock at what the Holocaust had done to his homeland rather than to his experience of it, was an attempt to recover the past. Thus, a good proportion of his works offers a record of shtetl life based on his memories. For Stanley Robe, Aisen's purpose was "To help the castaways remember, to give them the foundations of the old traditions and old values on which to build their new lives" (Robe 1982: 11). In some ways, Aisen was an anthropologist, recording the folk traditions of his people, just like other ethnographers who had begun to document shtetl life before it disappeared. Indeed, as Roskies (1992), argues, the shtetl had already become subject to the anthropological gaze and represented in the museum well before the advent of the Holocaust. What makes Aisen's gaze different is, of course, the knowledge of the Holocaust and the physical and emotional realization of the extent of the absence. In the absence of any traces from the pre-Holocaust world, he set about creating them, attempting not only to deny the Nazi attempt to destroy the Jewish world but to reconnect himself with his own past. That he did so in sculptural form and through the miniature diorama is significant, for this reflects his attempt to embody this world, to make it "real." As an expression of his own trauma or sensory memory, Aisen's documentation of shtetl life could also be interpreted as providing one of the functions of testimony as described by Auerhahn and Laub—to reconnect with a time in which the distinction between I and you had not been severed, a time when Jewish people were not alone and the sense of community was strong. This is the same function that, within the exhibition, is produced by the "World we have lost" section mentioned at the beginning of the chapter.

These sculptures are quite unlike Aisen's attempt to memorialize the Holocaust itself, which, because he did not directly experience it, is not as literal in its representational form. Instead, like many other artists, he used stock images that have come to evoke the Holocaust such as candles on top of tin representations of the crematoria chimneys or images of well-known figures. One of his strategies is to tell well-known stories such as that of the Polish nun who saved Jewish children in her orphanage or of Janus Korczak who went to the gas ovens with the children in his care. These latter pieces in particular are commemorative pieces as opposed to sensory expressions of mourning.

In choosing the diorama for most of his work, Aisen was following a realist tradition that suited his socialist politics. It was his intention to speak to ordinary people in a style that Richter and Faine (2008) have referred to as that of the political cartoon. Interesting, while the impulse to render his feelings through sculpture arose out of his shock at realizing how extensive the genocide had been, his socialist outlook meant that he soon began to sculpt on any topic on which he felt he had something to say. Thus his support of the union movement came to the fore in a sculpture about Eureka, another one called *Equality for all/Everyone likes to be equal.* His sympathy for the position of Aboriginal people came out in a work called *The Endeavour, Botany Bay, La Perouse,* his critique of current global politics in *Fifty-Three Hostages in Iran. How could this happen?* while his desire to belong, to have a home, came out in works that documented his local environment of Carlton and Studley Park by the Yarra River in inner city Melbourne.

When taken with his position as someone who experienced the Holocaust vicariously but nevertheless with enormous emotional intensity, Aisen mixes all three forms of memory—narrative, sense, and vicarious, creating an interesting position for the audience as a result. This is a position Jill Bennett (2002) helps us to understand, as it comes closer to her examples of artists working within an empathic mode. In discussing artworks by Sandra Johnson and Doris Salcedo, both of whom deal with political or "bad" deaths, the former in Ireland, the latter in Columbia, Bennett suggests that these artists go beyond the issues normally within the purview of artists who work with sense memory. She argues that they do this by addressing the interrelationship between the artist and others in the ways they position themselves within the work. In "exploring ways in which the artist can act as a mediator for the trauma of others," Bennett argues, "they both give consideration to the ways in which secondary witnesses—and by extension, a spectator—is positioned in relation to that trauma and also to the way visual imagery might trigger an affective response" (2002: 335). Part of their strategy is their representation within the works of their own affinity with the "bad deaths" they represent. Thus, for example, Sandra Johnson uses her own body in confrontation with a mound of garbage to enact a cathartic engagement with grief, a performance that is shown alongside a series of slides depicting political funerals in which women are the chief mourners. Doris Salcedo uses domestic items belonging to people who disappeared in Columbia to generate artworks that articulate the pain of loss within their households rather than offering a memorial to them. The attention is drawn to those who live with survivor memories rather than those

who died, and thus to the ongoing impact of trauma. The artworks are about the present as much as about the past.

I would argue that Aisen does something similar—not in any individual work but across his work as a whole. Taken as a group installation, his works offer the viewer an understanding of how one man's grief can generate empathy for the plight of others. It is when his works are viewed as a totality that we get a sense of how Aisen's original trauma is acted out then worked through and finally made to do political work on behalf of others.

If we view Aisen's work from this perspective, a number of practical issues emerge when it comes to the display of his art. One finds that his artworks tend to be thematically spread across different kinds of institutions—Holocaust-related art at the Holocaust Museum, depictions of *shtetl* life at the Jewish Museum and Shalom College, and his Australian works at the Powerhouse Museum, the Art Gallery of Western Australian, and Ballarat Art Gallery. I would argue that this separation of his works prevents an understanding of his wider significance and the way he has used the Holocaust as a bridge to other forms of oppression. Instead of sensing his own empathic unsettlement as a productive force in his own life, it becomes all too easy to reduce his work on the Holocaust either to commemorative artworks or to nostalgic memorials to a past life. The recent retrospective of his work at the Jewish Museum in Melbourne (2008) is interesting in this regard. In bringing his work together, the political dimensions of his aims were far clearer, largely because the viewer could sense the impact of his trauma on the way he approached life. For non-Jewish visitors such as myself, this exhibition was more successful in establishing a link between Aisen and his Australian rather than specifically Jewish audience because, when seen alongside his other works dealing with relations of power more generally, his work could be interpreted within a universalist rather than a particularist tradition of interpreting the Holocaust. Aisen used his personal experience to empathize with the experiences of others in a way that generates empathic unsettlement in the viewer as well. As Avril Alba (2007) has argued, the point is an important one for Australian Holocaust museums as they seek to find a role for themselves beyond the survivor community.

This in itself raises the question as to how the wider community can be brought in so that the injunction to remember actually means something in the political sphere. The best argument I have yet come across is that of Roger Simon (2006), who argues that testimonies from survivors of state-sponsored violence represent more than the desire to document what occurred. He argues that they represent the desire to leave a legacy, a gift to future generations. The difficulty is that this legacy is a "terrible gift" that demands reciprocity on the part of those who receive it. In particular this demand is for political action in the present, action that works to defend democracy and prevent the Holocaust from happening again. This argument echoes Auerhahn and Laub's warning that the giving of testimonies runs the risk of reliving the severing of human relations experienced during the Holocaust by its victims, as well as the possibility of overcoming it. We can choose to listen and act or to block the testimony out. For Simon, this choice "opens up the possibility of learning anew how to live in the present with each

other, not only by opening up a question to what and to whom I must be accountable, but also by considering what attention, learning, and actions such accountability requires" (2006: 188).

While Aisen demonstrated this attention in the way in which he conducted his life and in his art making, both of which reflect his attempt to establish bridges between people, the framing of his work within exhibitions doesn't always facilitate an environment in which others can witness his testimony and act on it. The complexities of how to engage audiences in responding to the gift of the testimony can be illuminated by the range of comments left in a visitors' book to an early exhibition of Aisen's works at the Ballarat Art Gallery in November 1996[4] which suggest how difficult it is to move beyond sympathy toward an empathy that leads to action in the present. To begin with, a considerable number of visitors acknowledged the direct attempt to address them, indicating they were listening. For example, one visitor writes "I didn't know, Now I do—Thank you, I was moved," suggesting perhaps that the works generated some form of understanding and through that, some form of dialogue. Others point to the affective power of the works in statements such as "the pain is tangible" or "incredibly moving and powerful—made more so by the simplicity of his art." Others though, assumed Aisen had been a "prisoner of war to remember all the sadness" or hoped that in making the works Aisen had achieved some kind of resolution, recognizing their therapeutic function: "I hope by making these works it helped the artist with his memories. Very powerful images." While the audience for this exhibition was engaging, and so, at least taking on the part of listener, the last statement indicates that while sympathy is not difficult to elicit, a realization of what it means for the viewers and their responsibilities is another matter. Clearly the works about the Holocaust overrode any other messages Aisen might have wanted to communicate about its meanings in the present. These comments by visitors show confusion over the status of Aisen's memories and a lack of knowledge as to his actual experiences. While his pain was heard, the nature of his testimony was not. Either there wasn't enough interpretative context or the combination of works on display did not offer the opening that was necessary to recognize Aisen's universalist narrative. Displaying his works on the Holocaust in isolation prevents audiences from engaging with his wider political message and recognizing how his own trauma provided the impetus for his politics. The force of his testimony is not fully realized and so his own request for us to act is not heard. Not to display examples from across his oeuvre is to risk a limited form of understanding that remains caught within an emotional response without recognizing Aisen's own politics.

Relying only on the affective power of the form of the object is not enough in these contexts—the provision of a wider context through some form of storytelling is also necessary if the potential of the "gift" that Simon puts forward is to be realized. However, while it is obviously too much to suggest that statements such as those above indicate visitors to this kind of exhibition achieve a complex understanding of the nature of the trauma experienced by survivors of genocide, it is not too much to claim that many of them are willing to listen. This suggests, perhaps, that the risks associated with the giving

of testimony Auerhahn and Laub were pointing to are worth taking and therefore, that we must find ways to give such objects the interpretation they deserve.

Notes

1. The Jewish Holocaust Museum and Research Centre has been renamed the Jewish Holocaust Centre. I have used the name as it was during the period the exhibition discussed here was up.
2. The exhibition I discuss in this chapter was dismantled in December 2009. A new exhibition put together by professional staff now takes its place. The aim for the new exhibition is not to have to rely on survivor guides to explain it, given these are diminishing in number. A series of interactive touch screens have been developed that incorporate stories from survivors, including that of Sarah Saaroni, whose sculptures form one of the case studies in this article.
3. The following summary of Eisen's biography comes from two sources: Richter and Faine (2008) and Robe (1982).
4. Quotations from this visitor's book were found in a letter to Saba Feniger from the Ballarat Art Gallery thanking her for the loan of some of Eisen's works from the Jewish Holocaust Museum. The letter can be found in a curatorial folder with information on the artists in the museum's collection listed in alphabetical order in the museum's curatorial office. The exhibition, titled Émigré: Victor Litherland and Charles Eisen: Migrant Naïve Artists, was held in 1996.

References

Alba, A. 2007. "Displaying the Sacred: Australian Holocaust Memorials in Public Life." *Holocaust Studies: A Journal of Culture and History* 13 (2–3): 151–172.

Art of the Holocaust. n.d. [brochure]. Melbourne: Jewish Holocaust Centre.

Auerhan, N.C. and D. Laub. 1990. "Holocaust Testimony." *Holocaust and Genocide Studies* 5 (4): 447–462.

Bennett, J. 2002. "Art, Affect, and the 'Bad Death': Strategies for Communicating the Sense Memory of Loss." *Journal of Women in Culture and Society* 28 (1): 333–351.

Bennett, J. 2005. *Empathic Vision: Affect, Trauma, and Contemporary Art.* Stanford: Stanford University Press.

Blatter, J. and S. Milton. 1982. *Art of the Holocaust.* London: Pan Books.

Climo, J.J. 1995. "Prisoners of Silence: A Vicarious Holocaust Memory." In *The Labyrinth of Memory: Ethnographic Journeys,* eds. M.C. Teski and J.J. Climo, 175–184. Westport, CT: Bergin and Garvey.

Feniger, S. n.d. *Less is More, Museum Guide.* Melbourne: Jewish Holocaust Centre.

Feniger, S. 1996. "Catalogue Essay." In *Art and Remembrance: Addressing the Holocaust: An Exhibition Dedicated to the Preservation of Memory.* Melbourne: Jewish Museum of Australia.

Hirsch, M. 2001. "Surviving Images: Holocaust Photographs and the Work of Postmemory." *The Yale Journal of Criticism* 14 (1): 5–38.

LaCapra, D. 2001. *Writing History, Writing Trauma.* Baltimore: Johns Hopkins University Press.

Richter, A. and S. Faine. 2008. "Political Cartoons in Tin: Charles Aisen, Man of the Twentieth Century." *Jewish Museum of Australia Gandel Centre of Judaica Journal* 13 (3): 2–3.

Robe, S. 1982. *Charles Eisen: His Metal Sculptures.* Fitzroy: Globe Press.

Roskies, D. C. 1992. "S. Ansky and the Paradigm of Return." In *The Uses of Tradition: Jewish Continuity in the Modern Era,* ed. J. Wertheimer, 243–260. New York and Jerusalem: The Jewish Theological Seminary of America.

Saaroni, S. 1989. *Life Goes on Regardless.* Hawthorn: Hudson.

Simon, R. I. 2006. "The Terrible Gift: Museums and the Possibility of Hope Without Consolation." *Museum Management and Curatorship* 21: 187–204.

Stewart, S. 1984. *On Longing: Narratives of the Miniature, the Gigantic, the Souvenir, the Collection.* Baltimore: Johns Hopkins Press.

Young, J. E. 1994. *Texture of Memory: Holocaust Memorials and Meaning.* New Haven, CT: Yale University Press.

–17–

Afterword
A View from the Bridge in Conversation
with Susan Pearce

Kirstin James, Petrina Foti, and the Editors

**Viv Golding and Wayne Modest [Editors]: Our book is concerned with theoreti-
cally grounded museum practice, which we think operates at the borderlands
between divides: the mind/body, thought/feeling, subject disciplines. We are
thinking about putting ourselves into the museum as human beings, as visitors
with our minds and bodies, whereas Brian Doherty, for example, speaks of the
"white cube" art space where minds are welcome but bodies aren't (1999). Can
you give us your thoughts on this?**

Susan Pearce: Well, a lot of very interesting work is being done. One volume by David
Howes, *The Empire of the Senses*, speaks of multisensory experiences, the tactile,
visual, and auditory. I think particularly tactile experiences, when you move into a
particular place with a particular feel and a particular character, are crucial to the
way you experience museums. Now, if you take the view that I do, that we are not
creatures with souls, we are creatures that have bodies and that's it, but parts of our
bodies, notably our brains, are extremely complex and can manage all sorts of imagi-
native and intellectual processes. If you take that view, then everything that we un-
derstand aesthetically and intellectually has to have a physical process attached to it.
And that physical process can only be tactile visual and auditory since those are the
ways we come to terms with the world outside our own bodies. So I think the physical
experience—which is all we've got, as I've said—does sit in the middle of the divide
and is the fundamental way in which we constitute ourselves and our experience.

**Editors: Museums are sort of like that, aren't they? They've got objects that they
have put in cases over time together with text, and that's another sort of wonder-
ful complex mix of things.**

Pearce: You start experiencing physically before you even get so far as the objects don't
you, because you have to go through the front door and there's the steps, then there's
the shop. I mean museum people have done a lot of thinking over the architecture

of the museum and how it can be very difficult. People have worked hard at ways to make it a bit easier; sometimes with success, sometimes not. I was working in the British Library last week and this week. If you went into the place as an ordinary visitor, you'd hardly know that possibly the best library in the world is actually attached to this place. It's all the shop, the cafe, there are various Dickens [exhibitions] going on, pervasively interactive and everywhere. You know in a way, I'm not happy about this—partly because I think they [the British Library] are diverting far too much work and effort into their outreach program and partly because I think the public likes to know that this is possibly the greatest library in the world, which arguably it is. Same thing about the British Museum—and yet that message [the value of the content of the collections] tends to get a bit clouded. I mustn't mount hobby horses, but I do feel rather strongly about this.

Editors: We think that relates to a notion of proximity, how museums have been working with specific communities to understand and get useful information about particular objects, and also to return collections in digital terms such as the work of Pitt Rivers with Blackfoot People (Krmpotich and Peers 2011). It seems to us there can be a sort of curatorial practice that's academically rigorous and mindful of community needs. There are positive ways that curators, educators and community can work together.

Pearce: Yes, one of the ways, I suppose, Anna Catalani, one of my PhD students, worked on; her PhD was on how Yoruba in Britain feel about displays of Yoruba culture in Britain. She explored this with various groups of Yoruba in Britain. I think they came to the conclusion that probably the best way was to work in tandem, preferably if possible from someone who comes from the country, and the educationist and the curator, so what's written in the label actually brings in how the Yoruba person sees all this, and it turned out also that Yoruba people tended to see these things in rather unexpected ways (Catalani 2007).

Editors: That was interesting because the Yoruba people weren't one homogenous group, were they? The Yoruba people that Anna interviewed, some of them held deeply Christian beliefs, so they saw the traditional African beliefs that the objects held as embodiments of evil, nothing to do with them at all.

Pearce: Some of the Yoruba were uneasy about the display of pagan materials as they saw it, deeply because they saw this really as a presentation of what they had been, rather than what they were now, and they rejected the paganism of their ancestors in favor of a fairly fundamental Christianity, I think, whereas others liked the notions of their grandfathers' culture on display. Basically the best way is to try to display material culture through people who are actually of that culture. But don't expect it's going to be simple because what you will get will be a complex series of responses, not one easy ones you can place on a label.

Editors: **And recognize we can never get a complete picture, for example, of all Yoruba people over time. We like Anthony Shelton's point about offering "glimpses" of Africa at the Horniman (Shelton 2000).**

Pearce: No; there are huge numbers of them and they have had very different experiences. And anyway, it's difficult to pin down what difference being here in the United Kingdom makes to the way they see it. I think everybody—historians, ethnographers—has had to come to terms with the fact that all we ever show of anything are glimpses. Not an easy thing to take on board. I recall some sixth-century BCE correspondence found in Egypt from the man who may have been the Persian governor in Egypt. A detailed analysis of what these letters were and where they came from and how they survived subverts the twentieth-century view of how they could be used to construct a model of what the Persian empire was like. You can't actually do that with the odd bits of flotsam and jetsam that has drifted up from the past.

Editors: **The flotsam and jetsam can be the thing that really encourages audiences to cross that threshold. If they find the bits and pieces that reflect their culture, it can give the feeling that the museum is a home place where they can go in and be—have their identities confirmed. We guess this brings us back to the social role of the museum.**

Pearce: Yes, and trying to break down the wall between people and curators. Trying to dethrone the specialist. We've been talking about this for quite a long time now. Some specialists hate it still, though. They are not up for this.

Editors: **What about you, Sue, when you were working in the museum, were you willing to share your knowledge, your throne, with others?**

Pearce: I like to think that I was very willing to share my knowledge throne with others. I mean, for one thing, when you are in a regional museum like I was in Devon, local people have usually got all sorts of odd bits that are actually very handy and interesting—and that would be true in London too, I imagine, but basically you want to share enthusiasms. One of the things I'm interested in is that it doesn't matter what society you're looking at or what context, you're looking at the way professions make themselves. At UCL we were critiquing some cuneiform texts—I'm doing this course there—I mean, I can't read cuneiform but there are people there who can—and you get these incredibly elaborate texts, written by professional scribes, with very formal greetings, and very formally expressed letters all done in cuneiform tablet, then a very formal ending and at the bottom there'll be a bit saying: "I hope Brenda's feeling better"—and this is one scribe to another, and they both know that nobody else but scribes can read cuneiform, because only professionals could read it, so they were perfectly safe in doing this, and you can just see how the professional network was creating itself. Fascinating!

Editors: Visitors are really interested in human stories like that, aren't they? Not just facts and materials.

Pearce: Don't you sense that that's where the museum is moving? That whole museum narratives are moving toward individual statements of "how it was for me," basically, which can be in video or diary or novels or discussions or any of these less formal, more personal formats.

Editors: Speaking of personal narratives, it's a really interesting story of how you entered museums when you were a little girl.

Pearce: Shall I tell the story? Well, bear with me. When I was a child, about eight-ish, I collected fossils. We went on two family holidays in the Isle of Wight. Now these are what English people call "beach holidays," where you spend days huddled in rain-coats on inhospitable beaches, pretending to enjoy yourself. And this is what English people still did in the 1950s. We went to Sandown on the Isle of Wight (Barnes and Walklate 2012). Sandown had, and still has, a major geological museum because the Isle of Wight is a major focus for dinosaur fossils and all sorts of other fossils. We went there two years running, and I spent two fortnights solidly in the museum there. I went the first year and I was there and I spent the entire fortnight there, and then I went the second year and the curator remembered me—I should imagine I was the keenest visitor he'd had in some time! He took this little girl in hand, we went through all the museum drawers and all the back collections. At the end of the second fort-night, he gave me my heart's desire, which was an iguanodon vertebra. I came back absolutely fired with enthusiasm intending from the age of nine onward that I was going to go into museums. Eventually, sometime later, I did just that.

Editors: That couldn't happen nowadays with health and safety! And your life might have taken a completely different course!

Pearce: No! It couldn't! And can you imagine? He seemed to me incredibly ancient; he was probably about forty, but I mean there he was, there was nobody else around, the place was deserted like museums were in the 1950s, and there he was with this eight-year-old girl; we were closed in the back stores, sifting through drawers and looking at things and handing things round and this went on for day after day while I was there. He'd be run in these days—you couldn't possibly do something like that! I never looked back, really. I suspect it was one of these moments in time and space. It couldn't have happened anywhere but in England in the early 1950s.

Editors: It was so inspiring though, wasn't it! Fantastic! . . . You have developed a wide range of interests since those early days, Sue, and I wanted to ask you about poetry; I love your work on James Fenton (Pearce 1994). To what extent you do think it's possible for museums to work with creative writing and poetry?

Pearce: Well, of course a lot of museums have done this. They've had writers in residence. I know that the Wellcome has had people like that and Brighton has had two, I think.

Editors: Well, there are lots of artists in residence, but not so many writers in residence, which would be good, I think, theoretically interesting too.

Pearce: Well, yes, I think so. One of the things I would like to look at in greater depth is the way in which objects are central, to a lot of novels in particular, in the nineteenth and twentieth century. Walter Benjamin talks about how detective stories depend upon the notion of evidence and the way in which the object moves through and leaves its traces behind. The concept is that these traces are forever recoverable if you have the right techniques. It's this notion of the object being the lodestone of reality, the actual fundamental evidence of things happening that detective stories in particular rely on (Benjamin 1999). As indeed does actually, English law, common law does. The notion that you can swear that something happened in time and place. Materiality is absolutely fundamental to the way the law operates, and it is fundamental to the way the detective story operates. It creates the reality in nineteenth-century novels, which are always very thick on description and materiality. It's something that starts to happen in literature, probably toward the end of the eighteenth century. Certainly it's started by the time of the romantic novels from about 1800 onward. There is a fundamental shift in the way in which the material world is experienced around 1800, because before that, particularly in relation to historical objects of the past—the stuff from Greece and Rome, people regard them superficially. They look at the surface detail with the eye of a connoisseur and they tend to think of objects as contributing to a decor. So that if you bring them back from you grand tour, you put them in your garden or you incorporate them into the decor of your drawing room and they add to the *mise-en-scène*. They created a connoisseurship and a sort of style. But after about 1800, you get the development of a perception that says that you don't look at objects you look through objects, to the "real" past—from which they really came. So that you start to get reconstructed rooms, you know, the Tudor room, the medieval room, the Roman room; you start getting these at the British Museum and other places. It is quite a different appreciation of what constitutes the reality of an object. And of course an awful lot hangs on this change, because as you start to see this x-ray vision of objects belonging to the real past from which they really come, and to which they can offer a real entry, so you start to get historical novels, the novels we've been talking about, that depend on the richness of the material scene but also the historical genre paintings that are very characteristic of the late eighteenth and early nineteenth century. Also museum exhibitions that claim to take you back to what it was "really" like, and then moving onward into Cecil B. De Mille and all the films that reckon to recreate the "real" past. And I think there is an absolutely fascinating period—sort of 1780ish to about 1830ish—that fifty years, where this change happens, and I would

like to try and disentangle what it is about that period that makes this happen. I'm working on these letters Charles Cockerell wrote back from Greece to his father, and while he was there he and the young men he was with acquired a couple of temples, and then they were a bit hard up, so they auctioned them off, and now one is in Munich, the Aegina Marbles in the Alte Pinakothek, and the other, the Bassae Marbles, is in the British Museum. There is something about the way in which they looked at these things that's different in the eighteenth-century view. They thought they could see "real" Greeks doing "real" things with these. And it has got something, I'm sure, to do with the Napoleonic wars, which lasted as far as Britain was concerned, from 1792 to 1815, with a couple of short breaks. It's a long time. And I think something about the materiality of warfare changed people's idea of what objects are and what they can do.

Editors: In Schleiermacher's hermeneutic thought is the idea that you could actually, as a historian, transport yourself into this past world if you did enough research (Schleiermacher 1977).

Pearce: If you tried hard enough you could make it work . . . If you put the objects in the right place you could do it.

Editors: But what Gadamer (2004) says is that, in this process of interpretation, when we look at things from the past, whether they are in museums or wherever, we have a deep conversation with them and we try to come to an understanding of them and ourselves, not by transporting ourselves into that past world, although we try to of course as best we can to do that. It is from our present day positions and the questions that we ask ourselves today in this conversation that affect what we see and how we approach those things in the past. Is it something like that you seem to be alluding to, Sue?

Pearce: Yes. Well, also I'm interested in historical sequence, I mean, up until, what shall we say, 1500, in round figures, everyone thought that if God wanted an object to be in two places at once this was perfectly possible. You know, this can happen. Or time can take all sorts of shifts. Nothing is fixed, because divine intervention, in the material world or the physical world, can move mountains. No one had any fixed ideas about that time, of what you had to do or be or what constituted reality, because it could shift at any time if God had good enough reason. And then comes modernism, and suddenly we start to think, well, you know, "Well, yes, actually, measurements don't change." That's what science is based on. They don't change and they are infinitely repeatable. An object can't be in two places at once. [Objects] have to be fixed in quality and quantity and in character. Their original fixing in character is their superficial appearance, which is to do with the connoisseurship I was talking about, but later on after 1800 they are fixed in historical reality. These are two kinds of realities and they are perfectly compatible. But of course this ended again, about 1960ish, and once again we started to think that actually, these things are infinite. That meaning can be multiple and is multiple and context is everything. So you have

a kind of curve in the way in which the reality of objects is perceived in a historical formation. Where there is a time of the object as a fixed thing, between very roughly 1600 and perhaps 1960—on either side of it, everything is fluid and flexible and everything goes.

Editors: A colleague had been to America and was excited at seeing children using a musical instrument as a saw or a hammer or something and constructing their own knowledge, but I thought that's a terrible thing to do! You know a musical instrument isn't a saw or a hammer; you should show the child how the musical instrument is used, and maybe that's a musical instrument from a culture, that by association, you are bashing! We have a responsibility to tell our "real" stories—not to say that people can't tell creative stories, but I think there has to be clear bounds, to make it clear—now we are doing this creative work and now we are doing something different.

Pearce: You've got to give what you can, I think; it is a very basic to humanity, sharing your experience. Handing on to the next lot whatever it is you've got. I think that's kind of fundamental; that's what mammals do. But there are fixed points, aren't there? Charles I was executed. Water is two hydrogen and an oxygen. There are some fixed things. I think we do have to take that on board as well. The tenor of the times is to try and avoid that. Because I think people don't like being confined. Partly it has to be said that if you allow that there are these fixed points, then you have to know them. This involves formal education and the value of formal education, which is a very political issue. You have to be at school for a certain number of years and you have to learn these things properly, and you have to be taught them properly, and that's the problem.

James: I was intrigued about what you said about literature and objects and would like to hear more of your thoughts on this. Do you think that objects have great expectations—that in their formality they themselves have great expectations?

Pearce: Well novels presumably are one step removed—if we live in a world of objects, experienced through our senses, the next "station along the line" is writing about all of this, in imaginative form, which is what constitutes a novel. So, if you could unpick how people make novels work, make objects work in novels, you can perhaps begin to see, how they work in their own real societies.

James: And so then when people read the novels, they then use the objects in their lives differently?

Pearce: Yes, I suspect that they do.

James: Then the book is an object that changes the way other objects use other objects?

Pearce: Well, yes if you take the view that both material culture and intellectual culture has agency. Yes, then once it's there it does things itself. Then I think that must be true. But it's a subject I've promised myself I'll try to do a bit more work on again.

Foti: When we talk about the object being transportation into a different world— I wonder when that kind of story, those time travel stories, started. It is always about an object. There's an object—more often than not it's a watch or a cup or a painting—that transports you into a different time, generally in the past.

Pearce: Like the wardrobe that the kids walk through in *The Lion, the Witch and the Wardrobe*. Well I mean the other aspect of the same thing is the huge quest literature where you have to go and find The Grail or whatever form the grail takes and again it is an object. It dominates the medieval literary scene from about 1050 onward, but they get it from Celtic legend. Celtic myth and legend probably. It goes back to absolute roots really; [these stories] focus on objects. It is always a focal object that is the key to all of these literary endeavors.

Foti: There are many legends involving King Arthur, but the two myths that seem to resonate, generation after generation, are the sword in the stone and the search for the Holy Grail.

Pearce: And they focus on objects. It still a focal object that is the key to all of these literary endeavors.

James: It is difficult to find a hero's journey that doesn't have something—an object (Campbell 1968).

Pearce: It is.

Foti: You can move all the way back to the ancient Greeks with a helmet . . .

Pearce: Or the fleece. It is something that is interesting that I would like to get into rather more . . .

Editors: I suppose that links up to journeys—routes to knowledge—rooted in the objects.

Pearce: But do you think the journey is the more important thing, or the object? Which dominates the journeying?

Editors: For both of us the objects have always been hugely important . . . Thinking about the cycle of things we return to the object.

Pearce: An allied but very interesting field is to sort of chart the way material culture and the object has been studied. Over the last couple of hundred years and you do actually get some interesting peaks and troughs. The object was riding high, with Pitt Rivers

in England through the late nineteenth century and probably early twentieth century. But it took a bad dip in the 1930s, 1920s to 1930s, when anthropologists started wanting to go out into the field rather than look at material. Quite an interesting historiographical plan.

Editors: **And what about cultures that don't have material objects? Enslaved cultures, the transatlantic slave trade, women's, working-class cultures have things that get used and wear out, and oral traditions are very important. I was in Australia last year and heard again how the Aboriginal peoples histories were thought to be "not proper" histories because they weren't written down. People have memories of things and the oral tradition passes those memories down. For me this has validity.**

Pearce: Oh, I think they have validity. They are as valid as any other kind of history; they're no different to written reports, in spite of the fact they [written texts] have always had a prestige, in our culture.

James: **We also have to think about what is an object because the sound of the voice may be an object.**

Pearce: Well I mean clearly it is—in physical terms, because it's produced by air going through things. It's molecules colliding, like every object. That's what objects basically are—when molecules bunch up. The voice produced in actually the same way, so there's no problem there.

James: **I have a terrible time with this concept of "intangible culture."**

Pearce: I had to do a keynote actually at a conference—it was a UNESCO (2009) thing, on intangible heritage. And I did not endear myself to the assembled throng by saying that there was no such thing as intangible heritage because everything is basically made up of stuff! Whether it's handed on through voice or written down, whatever it is. As I said earlier on, I don't believe that there is anything about us that is not material. So clearly all of our culture has to be material in one way, or another.

Editors: **Thank you, Sue, for sharing your thoughts and experiences with us tonight. You gave us all plenty to think about.**

References

Barnes, A. J. and J. Walklate. 2011. "Afterword: A Conversation with Sue Pearce." In *The Thing About Museums,* eds. S. Dudley and A. J. Barnes. Oxford: Routledge.
Benjamin, W. 2002. *The Arcades Project*. Cambridge: Harvard University Press.

Campbell, J. 1968. *The Hero with a Thousand Faces*. Princeton: Princeton University Press.

Catalani, A. 2007. ' "Displaying Traditional Yoruba Religious Objects in Museums: The Western Re-making of a Cultural Heritage." *Library Trends* 56 (1): 66–79.

Doherty, B. 1999. *Inside the White Cube: The Ideology of the Gallery Space*. Berkeley: University of California Press.

Gadamer, H. 2004. *Truth and Method.* New York: Crossroad.

Howes, D. 2005. *The Empire of the Senses: The Sensual Culture Reader.* London: Berg Publishers.

Krmpotich, C. and L. Peers. 2011. "The Scholar-Practitioner Expanded: An Indigenous and Museum Research Network." *Museum Management and Curation* 26 (5): 421–440.

Pearce, S. 1994. *Interpreting Objects and Collections.* New York: Routledge.

Pearce, S. 2009. "Material Matters." In *Constructing Intangible Heritage*, eds. R. Amoeda and S. Lira. Barcelos: Green Lines Institute for Sustainable Development.

Schleiermacher, F.D.E. 1977. *Hermeneutics: The Handwritten Manuscripts.* Atlanta, GA: Scholar's Press.

Shelton, A. 2000. "Curating African Worlds: The Horniman Museum and Gardens London." *Journal of Museum Ethnography* 12: 2–20.

Index

Abolition Act, bicentenary exhibitions, 3, 7, 232, 234, 236, 237–8, 239, 242–3
 1807 Commemorated (2007–2009), 232–3, 237, 238, 239, 242, 243n1
 see also slavery
African Caribbean communities (UK), 203, 232, 234, 236, 239, 240, 241–2
African diaspora, 101, 113, 114, 118, 119, 121–2, 123–4, 125, 135, 276
Afrocentrism, fear of, 135, 136
Aisen, Charles, 260, 262–3, 268–9, 270, 271, 272
Anderson, Benedict, 32
 imagined communities, 32, 44, 125
appropriate museology, 73–4
Arnstein, Sherry, *Ladder of Participation* (1969), 21, 82, 87
artist-curators, 2, 7, 48, 53, 211, 220, 279
Arts and Humanities Research Council (AHRC) 165, 168–9
audiences, 3, 5, 14, 18, 19, 22, 25, 38, 44, 64, 94, 107, 117, 134, 143, 146, 148, 149, 151, 152, 201, 127, 260, 262, 268, 272
 difficult and hard to reach, 203, 205, 211
 multiple and diverse, 1, 25, 86, 113, 139, 145, 166
 new and potential, 2, 6–7, 113, 114, 139, 149, 199, 232, 277
 youth, 6, 22, 223
audiovisual materials *see* digital media
Australia, 2, 6, 114, 144, 146, 260, 283
 migration history *see* Migration Memories exhibitions
authenticity, 208, 235
authority of the museum, 13, 38, 59, 61, 63, 69, 71, 85, 164, 236
 challenges to, 68, 69, 85, 134, 163, 164, 204, 235

expectations of, 134, 139–40
 see also shared authority

Banksy, 202, 206, 208, 209
 Banksy Versus Bristol (2009), 7, 203, 204–6, 207–9, 210, 211
 Wall and Piece, 202–3, 204
"Big Museum Leads Small Museum" program (Taiwan), 59, 61, 64–5, 66, 70, 71, 72–3, 74
Blackfoot Crossing Historical Park (BCHP), Alberta (Canada), 4, 80–1, 82, 86, 88, 89, 90, 93
Blackfoot First Nations communities (Canada and the US), 79, 80, 81, 85, 86, 87, 88, 89, 90, 276
black history, 134, 136, 137, 138, 237
Bridges, Ruby, 221–2, 223, 224, 226
Bristol Museum and Art Gallery (UK), 140, 203, 204, 205, 206
 see also Banksy
British Library, 164, 276
British Museum, 2, 203, 276, 279, 280
 ancient Egyptian collections, 133, 137, 140

Caribbean, the, 100, 101, 196, 197–8, 236
Children's Museum of Indianapolis, (US), 3, 7, 222
 The Power of Children: Making a Difference, 218, 221–4, 225, 226–8, 229
Chimei Amis Indigenous Museum (Taiwan), 59, 64, 65–6, 67, 68, 69, 72
 collections of, 66–7
 see also National Taiwan Museum
citizenship, 2, 125
civil rights, 24, 42, 222, 224
Civil War (US), 4, 34, 35, 36, 41–2, 43–4
 monuments of, 36, 41, 42, 43
Clifford, James, 5, 19–20, 79